The Industrialization
of Design

The Industrialization of Design

A History from the Steam Age to Today

CARROLL GANTZ

McFarland & Company, Inc., Publishers
Jefferson, North Carolina, and London

LIBRARY OF CONGRESS CATALOGUING-IN-PUBLICATION DATA

Gantz, Carroll.
The industrialization of design : a history from
the steam age to today / Carroll Gantz.
p. cm.
Includes bibliographical references and index.

ISBN 978-0-7864-4254-6
softcover : 50# alkaline paper ∞

1. Industrial design — History. 2. Product
design — History. 3. Technology — History. I. Title.
TS171.4.G36 2011 745.2 — dc22 2010043892

British Library cataloguing data are available

Cover images: *(from top)* Chrysler Airflow, 1934 (courtesy of
Chrysler Group LLC); a chair designed for Knoll by
Harry Bertoia (courtesy of Knoll, Inc.); François Pierre Aimé
Argand's oil lamp (Matthew Boulton, 1783)

Manufactured in the United States of America

*McFarland & Company, Inc., Publishers
Box 611, Jefferson, North Carolina 28640
www.mcfarlandpub.com*

To the Industrial Designers Society of America,
its predecessor organizations, and its leaders:
The "little engine that could," and did, establish,
organize, define, transform, and sustain
the profession of industrial design.

Table of Contents

Preface

Industrial design — the external design of products of mass production to make them more attractive, useful, and appropriate to human sensitivities — is fundamental to the way in which we experience daily life. Almost every aspect of our physical, man-made environment was designed with the taste preferences, physical capabilities, economic status, comfort, desires, and lifestyles of the consumer in mind, all carefully considered by industrial designers who shape and control product appearance and function. These products include not only our domestic environment — toothbrushes, kitchen appliances, furnishings, electronic devices, boats and cars — but our public environment as well — trains, planes, and interiors, to name just a few. Industrial designers essentially design products for people, attempting to fulfill their needs and desires alike.

Within my lifetime, the profession of industrial design in America was formally initiated, acquired its current title, became well known during the Great Depression of the 1930s, organized and defined its own formal educational system and standards, envisioned American dreams of a better life after World War II, and shaped the physical form of ever-expanding postwar technologies and material goods affordable to many only through mass production. I was fortunate to be a part of this profession during my entire education and career, through leadership within several of its professional organizations (the American Society of Industrial Designers, and the Industrial Designers Society of America), through the design of dozens of well-known products by a number of household-name manufacturers (Hoover, Black & Decker, Homelite), through a number of national design awards, and more recently, through my writing. In a literal sense, industrial design has been my life.

Since the 1930s many books have been written about industrial design. A number of them have been by prominent designers, writing about their own careers and designs. Design organizations have published many books devoted to current designs by the organization's members. Still others focus on specific periods or styles but without regard to other events during that period. Many are primarily illustrations of specific designs or focused on a specific individual or corporation. Others ignore the political, economic, cultural, industrial, and technological context in which designs were produced, and tend to emphasize only design's stylistic and esthetic aspects. This narrow practice simplistically reduces designs to "works of art" and denies their inherent multidisciplinary context, which includes business, psychological, mechanical, innovative, and promotional aspects as well. Only in the 1970s and 1980s were the first books written about the more comprehensive history of industrial design. Important early works by Jeffrey Meickle, Arthur Pulos, and John Heskett are noted in the bibliography.

Review of design literature back to the 18th and 19th centuries confirms that industrial

1

design has much deeper roots than the usually cited 20th century. Only when we trace the origins of the industrial revolution can we appreciate how industrial design evolved differently than other art and design-related fields.

The present work follows a fairly strict chronology for three centuries, and correlates design examples with concurrent global, national, industrial, economic, artistic, political, and social events. These were all critical factors that influenced the evolution of industrial design and that are embedded in the genetic code of industrial designers. Appendices provide biographical sketches of important figures in the history of industrial design.

I can only hope that the information within will provide readers with a more comprehensive understanding of design's rich heritage and personalities.

Introduction

To many people, the term "industrial design" is not familiar, adequately descriptive, or well understood. It was formalized in 1913 by the U.S. Patent Office to describe "the distinguishing form of products that have marketable value" to be patented and thereby legally protected from copying. These "design patents" applied largely to industrial, mass-produced products, similar to the historical patenting of inventions, mechanical devices, and systems.

The term "industrial design" was rarely used until the early 1930s, when a small group of individual commercial artists, craftsmen, designers, architects, and set designers attracted national attention with their work. They "restyled" ordinary consumer products to make them more attractive during the economic slump of the Great Depression, and sales increased dramatically. Manufacturers were ecstatic, their demand for "industrial designers" became overwhelming, and a new profession was born.

Industrial design soon became an integral new partner in the typical industrial team of engineering, manufacturing, and marketing. Few mass-produced products are introduced without the contributions of at least one industrial designer, who determines the product's visual appearance, configuration, and the way users interact with it. Some practitioners work as independent consultants, others work within large or small industrial design firms, and still others work as corporate employees or executives.

What, exactly, do industrial designers do? The simple answer is that they design all aspects of a product or system that consumers and users can see, touch, feel, or manipulate. The goal of industrial designers is to maximize user convenience, function, and appearance in order to increase sales and user satisfaction. This role is in marked contrast with other industry specialists who design the mechanical and technological aspects of products or systems, or those who design the manufacturing tools and processes that make the product.

Industrial designers perform their function by a process that includes market and user analysis, hand-drawn sketches, computer-generated images, full-scale models, ergonomics, material selection, and final manufacturing specifications. Throughout this process, they collaborate with engineering, marketing, and production people to ensure that the product meets optimum criteria of regulatory and environmental standards, manufacturing costs and limitations, and merchandizing strategies.

These specialized creative skills are applied by industrial designers to a wide range of mass-produced products, from doorknobs to automobiles; from sports equipment to medical equipment; and from earthmovers to iPods. Industrial designers often work on systems more complex than individual products, such as merchandizing environments, corporate strategies and identity programs, exhibitions, transportation systems, and space capsules.

Much of their work is recognized internationally by professional design awards or by public acclaim of individual products as cultural icons.

The above briefly describes the current profession, in the context of our advanced state of science, technology, business practices, consumer culture and global markets. But the practice of what we now call industrial design did not just emerge in the 20th century without precedents. The role now filled by industrial designers has a long and distinguished heritage prior to the 1930s, and yes, prior even to the Industrial Revolution of the 18th and 19th centuries.

This book explores the historical context of design in western civilization, particularly as it affected England's colonies in America. This includes the Industrial Revolution, which originated in England and evolved during America's struggle for independence. Both revolutions had a significant impact on the predecessors of today's industrial designers, whether they were called tradesmen, artisans, artists, architects, craftsmen, weavers, potters, glassblowers, cabinetmakers, silversmiths, clockmakers, scientists, inventors, engineers, entrepreneurs or businessmen.

These individuals struggled to transform the process of design from an individual creative act that produced one artifact at a time into a complex industrial mass production system that made millions of identical products. They struggled with this contradictory threat and blessing, which deprived many talented individuals of their personal livelihood and independence but provided millions of users with products that were previously unaffordable and eventually were also of the highest quality imaginable.

Initially, many designers feared that mindless machines were replacing their very souls, and they rejected industrialization. They struggled to regain their traditional historical role in making consumer products of the highest quality and beauty, a struggle which was finally resolved by adapting to industrial mass production rather than fighting it. To do so, they needed to organize and define new professional roles, establish new standards of design excellence, and finally, collaborate with allied disciplines in order to function as a creative team in a complex industrial society.

Today's industrial designers are the descendants of those creative individuals who evolved and refined the process of designing products over many centuries. They are genetic hybrids: part artist, part architect, part craftsman, part inventor, part engineer, part scientist, part salesman, and part businessperson. They retain the unique, creative, artistic, innovative, and entrepreneurial qualities of their ancestors, and continue to provide millions of users with products that are affordable, functional and beautiful.

Chapter 1

Pre–1800
Twin Revolutions

One must go back in time a long way to find the origins of product design, the primary concern of industrial designers. Unknown individual artisans and craftsmen have been creating functional artifacts since the dawn of civilization, demonstrated by countless archeological finds that include weapons, utensils, buildings, tools, pottery, and clothing. In addition, excavations have revealed art, sculpture, decorative jewelry, toys, and games, proving that our more primitive ancestors desired more than merely useful objects. They wanted such objects to express meaning as well as function. They added decorative patterns, colors, textures, or symbols to express purpose, shared beliefs, or simply to make them more attractive or impressive to others. From a multitude of such artifacts, ancient cultures and technologies have been deciphered and are better understood. One thing is clear — homo sapiens, for at least 160,000 years, has loved possessions that are made special through art and design.

As successful and wealthy civilizations were organized under religious or dynastic principles, functional and decorative artifacts became more and more elaborate through the patronage of ruling classes for which cost or manual labor was of little or no concern. Massive projects were constructed by thousands of workers, many of whom specialized in trades and artistic skills. Visual expression through architecture, sculpture, and decoration defined entire civilizations, fostering a sense of superiority, power, and control over the environment and life itself. Talented Egyptian sculptors and artists produced a visual language, sculptures, constructions, and magnificently decorated artifacts that recorded their beliefs in the afterlife, and also recorded three millennia of their own history. Ancient Greece set the standard in arts for western civilization with exquisite and sophisticated architecture, interiors, decorative arts, and statuary in addition to inventing democracy. The Roman Empire continued the development of artistic excellence based on Greek and Egyptian models. When these sophisticated cultures died, the Dark Ages plunged Europe into religious and secular wars, famines, and plagues for centuries. The only source of hope for a better life and world was religion.

In medieval times, from the 11th to the 14th centuries, during the Crusades, religion controlled daily life as well as all artistic endeavors. Hundreds of Romanesque (later termed "Gothic") cathedrals were constructed, each costing a fortune and requiring several decades to complete — some over a century — by hundreds of craftsmen. Only the most talented craftsmen were allowed to work on them, and they lived a much better life of prestige than their fellow peasants on farms. Craft guilds were formed for each trade specialty in each town, with members of each guild divided into masters, journeymen, and apprentices. The

guilds, somewhat like modern businesses, defined quality standards, established length of apprenticeships, regulated competition, and controlled city economies. Masters took on teenaged apprentices for a period of five to nine years. Apprentices worked with no pay but were provided with food, shelter, and education. When they became journeymen, they worked for wages. When journeymen could demonstrate suitable skills by producing a "masterpiece," as well as proof of their social and economic position, they were advanced to become a master. These guild principles governed the education, advancement, and prestige of craftsmen for hundreds of years and lasted well into the 19th century in some European countries. As a result, crafts became highly specialized, which discouraged creative innovation and broader thinking.

By the fifteenth century, the European Renaissance — a rebirth of learning based on classical sources that included rational thinking, a scientific search for knowledge, and artistic refinement — sprang up in Florence, Italy. Soon, famous Italian artists, architects, engineers, sculptors, and designers dominated the arts as they created paintings, architecture, and sculptures funded by wealthy patrons to glorify religion. Many of these men were incredibly talented in specific fields, which were organized by craft guilds. Others, who mastered many visual art fields, discovered new basic principles; former goldsmith apprentice and later architect Filippo Brunelleschi's (1377–1446) rediscovered perspective in 1425, with the aid of a new mirror technology. It was Italian polymath Leonardo da Vinci (1452–1519) who many present-day industrial designers consider the first "industrial designer" because of his incredible range of talents as painter, engineer, sculptor, scientist, mathematician, anatomist, architect, botanist, musician, inventor and writer. No specialist he! His blending of artistic, scientific, and mechanical expertise produced creative concepts and mechanisms far in advance of his time.

The Holy Roman Empire spread Renaissance culture and art throughout Europe. The Valois Dukes of Burgundy in late 15th century France created a cult of grandeur followed by many European monarchies and set the standards of taste, pageantry, and decorative arts. Among kingdoms that emulated this Burgundian display of royal excess was that of Henry VIII (1491–1547) of England. His nearly 40-year reign (1509–1547) emerged from the Reformation and Renaissance with the most magnificent and costly regal demonstration of decorative arts and architecture on the continent, despite the multiple wife-taking and beheadings for which he is also famous. He essentially founded the British Empire, with its religious, parliamentary, and artistic legacies that led to the founding of British colonies in America 40 years after his death by his daughter, the Virgin Queen Elizabeth I (1533–1603), the last of the Tudor Dynasty. It was these British traditions that eventually inspired our own preconceptions of culture, including standards for artistic and design excellence.

Greek Corinthian column with modified Acanthus leaf.

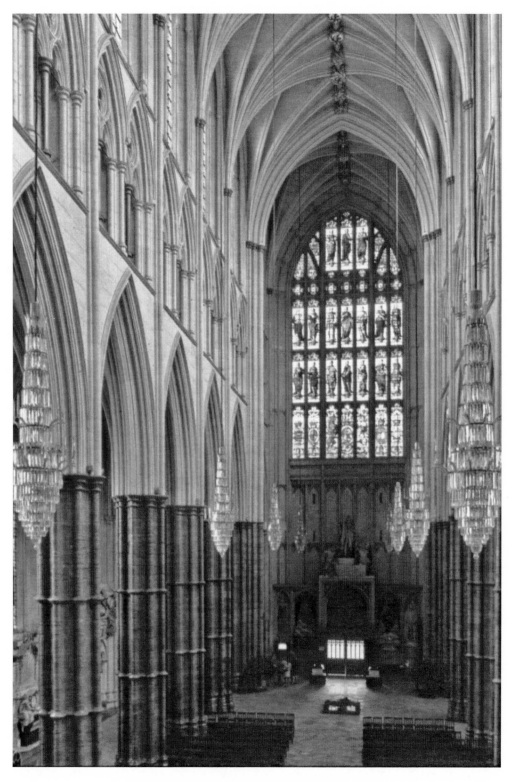

Westminster Abbey nave and Great West Window.

King Henry was financed by an enormous inheritance from his royal forebears, which was added to by taking possession of property and wealth from the Catholic monasteries he acquired while converting England to Protestantism, called the Dissolution of the Monasteries. Henry spent extravagantly during his entire reign, using the visible magnificence of wealth to enhance his image and political power both at home and abroad. He inherited seven castles and 17 "lesser houses." When he died, he owned over 70 residences, most of which he had built, rebuilt, decorated, and furnished at incredible cost. A veritable army of artists, artisans, and craftsmen employed by the crown were required to construct, furnish, or maintain this vast showcase of wealth through design. If they were English subjects, they had to serve at the king's demand, even if they were engaged in other projects. With Henry's bottomless purse, they established a royal tradition of elaborate embellishment and decoration that survives to this day in English royal pageantry, though this is but a faint reflection of past opulence.

It is of interest to examine how Henry VIII created this royal tradition of visual grandeur. Fortunately, detailed records of his court provide us with an opportunity not only to understand the origins and context of British decorative arts traditions that so shaped our own, but also to identify, out of thousands, a few of the extremely talented designers who created these royal masterpieces. Henry drew on Renaissance artists from the Netherlands, Belgium, Germany, Austria, Flanders, and Italy for inspiration and talent. Many were as versatile as da Vinci, able and willing to tackle any problem of design at hand. For castle and residential architecture, Henry engaged a number of men that included John of Padua; Nicholas Bellin of Modena, who also designed interiors and gardens; Anthony van Wyngaerde from Flanders, who designed castles and drew panoramas of London; James

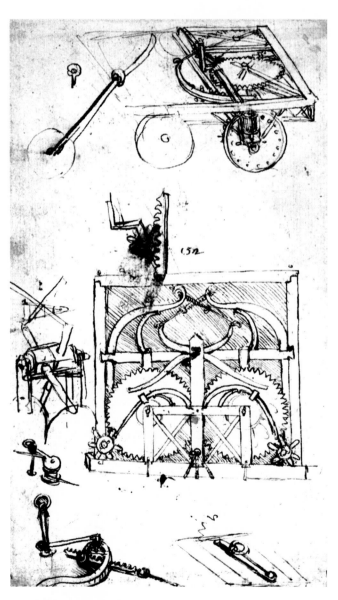

Leonardo da Vinci notebook sketch of a spring-driven vehicle from *Codex Atlanticus.*

Nedcham of England, who also designed royal interiors; Italian sculptor Antonio Toto, who, in addition to architecture, designed scenery for pageants; and Girolamo da Treviso (1508–1544), an Italian student of Raphael who also designed military constructions and painted portraits.

Royal sculptors included Italians Guido Mazzone (1450–1518); Pietro Torrigiano (1472–1528), who embellished tombs and made painted busts of Henry; and Giovanni di Maiano, who also decorated suits of armor. Richard Ridge, a master joiner and carver, decorated interiors of castles and houses and designed furniture. Galyon Hone (d. 1550) was a Flemish glazier of decorative stained-glass windows for castles and residences. Bernard van Orley (c.1490–1541) designed enormous and elaborate tapestries. Richard Gibson designed halls, tents, and pavilions, while Clement Armstrong and Vincenzo Volpe designed pageant settings. Volpe also designed heraldic materials for ships and barges and drew royal maps. German mathematician Nicolas Kratzner (?1487–1550) designed stage sets for royal theaters as well as intricate clocks. Renaissance designers often drew on classical Greek and

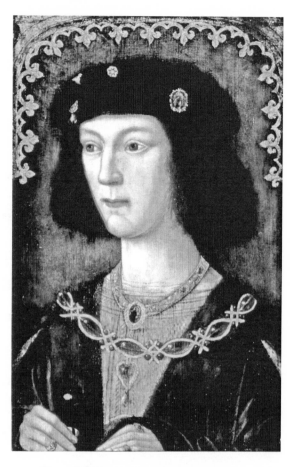

Henry VIII in 1509 by unknown artist.

Roman images for decorative designs in what was even then known as "antik" (antique) style.

Royal suits of armor were no less decorative or elaborate than royal clothing. Martin van Royne supervised a workshop of eleven armorers, including Paul van Vrelant of Belgium, master engraver and gilder; Erasmus Kyrkenar; and Konrad Seusenhofer (c. 1450–1517) from Innsbruck, Austria. Even the king himself designed armor, daggers and gunstocks. Everyone in the royal court wore priceless jewelry, often as gifts from the king. Court jewelers included Peter van der Wale and Hans of Antwerp and goldsmiths Cornelius Heyss and Robert Amadas (c. 1470–1532).

The most famous of all was probably the gifted royal portrait painter Hans Holbein the Younger (1497–1543) from Augsburg, who, along with other court painters like Flemish artist Joos van Cleve (1485–1540), depicted dozens of Henry's family and court in their finest apparel and in settings of grandeur. Holbein also designed interiors, fountains, jewelry, silver-plate, badges, daggers, swords, and mechanical clocks. Flemish artist Lucas Horenbout (?1495–1544), Holbein's teacher, painted miniature portraits, a popular item for ease of transport, and designed great royal seals and coinage.

This royal tradition of decorative arts also established the economic precedent that art and the decorative arts were affordable only by wealthy patrons, and that decorative artists served only the upper class. Accordingly, many perceived the acquisition of personal prop-

erty and possessions, and their degree of embellishment and decoration, as the definitive measurement and display of their own wealth. It was also English decorative arts that initiated the idea of patent protection for inventive ideas and processes. In 1449, King Henry VI, who was in the process of establishing Eton College and King's College, Cambridge, wanted John of Utynam from Flanders to create stained-glass windows for these colleges and to teach others how to create them. Because this art had never been practiced in England, and John was to be teaching these valuable skills to English subjects, the king commanded that none of his subjects could use such arts for a term of 20 years without John's consent. King Henry included these protective terms, conditions, exclusive privileges, and a license to practice, in documents called "letters patent."

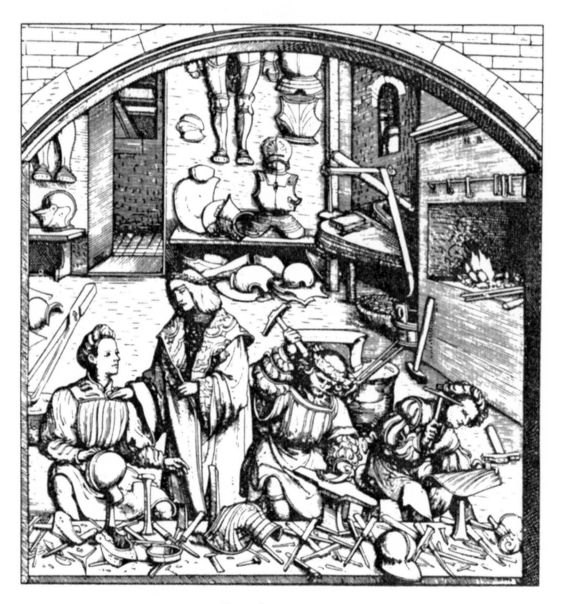

Sixteenth century armory.

It was over a hundred years before the first in the regular series of English patents was awarded in 1552, to Henry Smyth for making Normandy glass. Issuance of letters patent was a royal prerogative. During the reign of Elizabeth I (1533–1603), she issued patents for inventions that created beneficial results and technological progress for all England, but also for things that were already in common use in well-established industries, granting the industry exclusive privilege to sell specific products. This latter practice of Royal Charter had been first granted to the Weaver's Company in 1155 by Henry II (1133–1189).

These precedents would endure for centuries. Even today, "Royal Warrants of Appointments" are issued to those who supply goods or services to a member of a royal court for a period of five years. This tradition is still practiced in today's monarchies of England, the Netherlands, Belgium, Thailand, Denmark and Sweden, lending prestige to any commercial supplier by advertising under a royal seal or coat of arms with warrants that typically read "By Appointment to Queen Elizabeth II," or the title and name of the royal customer, and then the name of the goods provided and the supplier. Similar endorsements of products are imitated in many other countries today, using the names of popular celebrities, who are royalty in the modern sense.

Although the absolute power of English monarchs was subsequently tempered by Parliament in 1689, royalty continued Henry VIII's pattern of decorative extravagance over the subsequent four centuries, and this tradition became the basis of English dominance in this field until the beginning of the 20th century. It is not then surprising that English influence in the decorative arts had an enormous impact both on the American colonies and on their craftsmen before the Revolution, and after, as America rose to international prominence through practical ingenuity and mechanical inventions.

The 18th century spawned two important revolutions that were created and merged to change the world. Without the American Revolution, there would be no United States of America; without the Industrial Revolution there would be no industrial design, which, by its nature, was, and is, inherently bound to manufacturing and mass production. Because the Industrial Revolution began in England and the American Revolution began in the British colonies in America, the United States is what it is today because of its English heritage and traditions.

Together, over the subsequent two centuries, these twin revolutions provided citizens of the United States of America with the highest standard of living in history, established the U.S. as a global superpower, provided ordinary people with both utilitarian products and decorative arts that previously were only affordable to the very wealthy, and fostered the birth of what we now know as the profession of industrial design. This enormous transition from a simple agrarian life of individual self-sufficiency to a society based on technological advances and manufacturing systems began slowly and without much fanfare.

Most historians agree that the industrial revolution began in England during the 18th century and that it was influenced by earlier socioeconomic events. In the 17th century, through the use of fertilizer, England had experienced an agricultural revolution that produced more food and therefore more leisure time for many citizens, enabling them to explore other more creative enterprises. During the 18th century, England's population doubled and many people relocated to cities. Public demand for material products rose proportionally. Hand manufacturers could not keep up with the demand, thus inspiring new methods to increase production to higher quantities at a faster pace and at less cost. This movement to increase production and lower cost through mechanical invention, new power sources,

new materials, new machinery, new tools, and the division of labor characterized what is now known as the industrial revolution.

Iron was a basic material for industrial products, but it was difficult to cast efficiently and inexpensively. An English Quaker and partner in a brass works company since 1702, Abraham Darby (1678–1717) in 1707 patented a new iron casting method that produced iron pots of lighter weight and for less cost than the brass pots then currently in use, and he soon enjoyed a successful business. He established a new ironworks at Coalbrookdale in Shropshire, considered as one of the birthplaces of the Industrial Revolution. In 1572 coal mining had been developed on the site, and by 1658 a major iron industry had been founded there. Darby acquired a blast furnace abandoned in 1703, and in 1711 he modified it to use coke rather than the traditional charcoal fuel, which reduced time and labor in the setup. In 1715 he built a larger furnace that doubled capacity. The cost of iron was cut in half. His son, Abraham Darby II (1711–1763), continued the family business and developed more refined casting techniques. Iron replaced brass in many consumer products and mechanical devices, including steam engines. Grandson Abraham Darby III (1750–1791) constructed the first iron bridge ever built, from 1777 to 1781, designed by architect and interior decorator Thomas Pritchard (1723–1777). The bridge spanned the Severn River near Coalbrookdale. The village of Ironbridge grew up around this spectacular structure, which became an instant tourist attraction.

Iron became the industrial material of choice, replacing centuries of wooden tools and machinery. It was stronger, cheaper to manufacture because of reduced hand labor, and could be machined to fine tolerances for accuracy. Throughout the 18th century, cast iron was used to produce hundreds of affordable everyday consumer products, including window frames, stoves, and household implements, as well as huge industrial machinery, tools and engines. This equipment, powered by water or steam, fostered the development of new industries that produced a range of products faster and at lower cost. Many of these new tools and methods were illustrated and documented from 1751 to 1772 in the exhaustive French *Encyclopédie des Arts et des Métiers* (*Encyclopedia of the Arts and Trades*), published by Denis Diderot (1713–1784).

Many of the famous names associated with designs and manufactured products of the era were not artists or designers, but entrepreneurs and innovators, such as Wedgwood and Boulton in England. Josiah Wedgwood (1730–1795) founded Wedgwood pottery in 1759. He commissioned artists from outside the firm such as neoclassicist sculptor John Flaxman (1755–1826), painter George Stubbs (1724–1806), and painter Joseph Wright (1734–1797). Several key manufacturing innovations by Wedgwood were the casting of liquid clay in molds, rather than throwing individual pieces and shaping them by hand, and the simulation of the whiteness of porcelain by washes and improved mixtures of clay to produce what was called "bone china." In 1765 Wedgwood produced a cream-colored earthenware line that impressed Queen Charlotte (1744–1818), the wife of King George III (1738–1820) and patroness of the arts. The line was soon called "Queens Ware," which became highly popular throughout Europe. The famous Wedgwood blue was arrived at after experimentation with 3000 colors. Wedgwood's factory used mechanical appliances and division of labor, and thereby achieved high volume production. Catalogs in 1773 were published in French, German, and Dutch editions to advertise Wedgwood wares. The firm was run by the descendants of Josiah until 1940 and survived 250 years, until it fell into receivership in 2009.

In 1766, businessman Matthew Boulton (1728–1809) built Soho Foundry near Birmingham, England, to manufacture fashionable neoclassical objects of silver called Sheffield

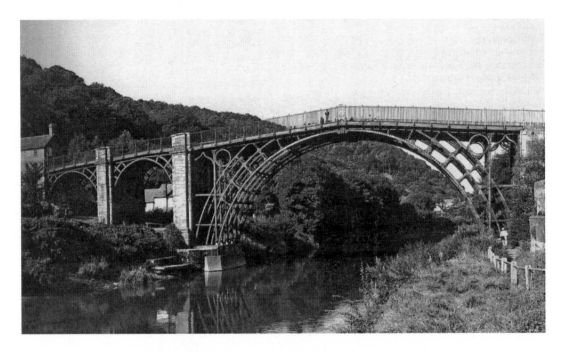

Iron bridge over Severn River built by Abraham Darby III, 1781.

plate. The foundry was powered by water and employed 600 highly skilled craftsmen. Boulton had inherited his father's toy trade business in 1759 ("toys" then referred to small metal products—buttons, buckles, clasps, etc.). The designs were mostly from collections of pattern books, models, and drawings by sculptor John Flaxman, architect James Wyatt (1746–1813), and brothers and business partners Robert (1728–1792) and James Adam (1732–1794), who were both architects and furniture designers. By 1783, Boulton was manufacturing improved oil lamps invented and designed by Swiss physicist and chemist François Pierre Aimé Argand (1750–1803). They became the standard means of illumination in homes and shops until displaced by kerosene lamps in about 1850. In 1788, Boulton established the Soho Mint and produced coinage for a number of countries, including England.

Note that in the foregoing British examples, designers were engaged by business firms to design the products so that the manufacturers could produce merchandise that was more appealing to consumers. The designs were thus unique, not just duplications of standard pattern books. Perhaps more significantly, designers were collaborating with manufacturers to produce many products of the same design, rather than individually hand-producing a single product.

A major British industry, textiles, was dramatically industrialized during this century. John Kay's (1704–1780) "flying shuttle" of 1733 increased the speed of weaving. In 1764, James Hargreaves (1720–1778) invented the "spinning jenny," a multi-spooled spinning wheel mechanism that produced the work of eight people. Angry workers broke into Hargreaves' house and destroyed his machines in 1768. In 1769, Samuel Crompton (1753–1827) developed the "spinning mule," which permitted larger scale manufacture of high quality yarn and thread. That same year, Richard Arkwright's (1733–1792) "water frame" cotton spinning machine made cotton thread thin and strong enough for weaving. Arkwright was the first to build a fortune around manufacturing, but in 1779 his mill in Lancashire was

Pl. XXXVIII.

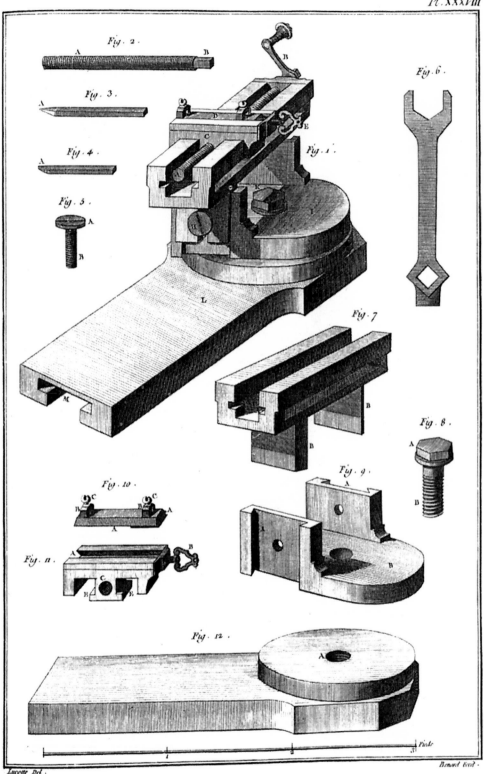

Fig. 2.

Fig. 3.

Fig. 4.

Fig. 5.

Fig. 6.

Fig. 1.

Fig. 7.

Fig. 8.

Fig. 9.

Fig. 10.

Fig. 11.

Fig. 12.

Pieds.

Lucotte Del.

Benard fecit.

Tourneur, Suports Composés.

destroyed by a mob opposed to mechanization. Despite such resistance, cotton mills—the first factory system of manufacture, powered first by horse, then by waterwheel, and finally by steam — were mass-producing yarn in England. Ten times as much cotton yarn was produced in Britain in 1790 as in 1770, and the demand for cotton from America increased exponentially.

Perhaps the most dramatic British invention that defined the industrial age was a new source of power — steam. As early as 1710, ironmonger Thomas Newcomen (1664–1729) developed a low-power steam engine to pump water from flooded coalmines. From 1763 to 1774, inventor James Watt (1736–1819) struggled to increase the efficiency and power of steam engines. Seeking financial resources to build engines, Watt partnered with industrialist Matthew Boulton, and by 1776 the first of a new class of powerful and efficient Boulton-Watt steam engines were put into operation, coinciding with the American Revolution. After struggling with this political revolution, Americans would have to struggle with the industrial revolution over the next century in order to catch up to England.

By 1790, England was the undisputed leader in the industrial revolution. This had been accomplished with three major technological innovations: (1) the substitution of machines for human skill, (2) power cheap enough to justify assembling workers in a factory, and (3) a portability of power (steam) that allowed production to be located away from the animals or water previously required for power.

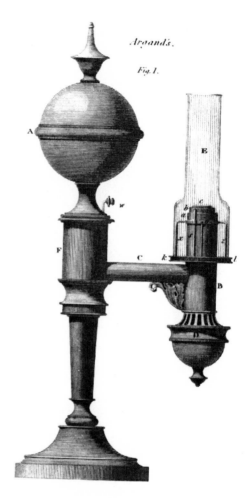

François Pierre Aimé Argand's oil lamp made by Matthew Boulton, 1783.

The industrial revolution in England had very little initial impact in America. In 1750, after two centuries of fitful development and severe challenges, Britain's American colonies totaled 1.3 million people, the population of present-day San Diego, spread over 1500 miles of Atlantic seaboard colonies that stretched from Carolina to Maine. These included the cities and ports of Boston, New York, Philadelphia, Baltimore, Williamsburg, and Charles Town. In these urban centers, wealthy colonists— and, more likely, English civil authorities assigned to administer the colonies— relied upon European imports for decorative arts and designs to re-create their familiar environment back home and to display their colonial wealth. But only 5 percent of the population lived in cities.

Other, less well-to-do, colonists were scattered in remote areas and small villages inland up to the western frontier, which was the Appalachian chain of mountains running from Canada to Alabama. Most were isolated, by distance and primitive transportation

Opposite: Lathe slide rest from Diderot's *Encyclopedia of the Arts and Trades,* 1751.

means, from ready sources of supplies and necessities. One third of the population was in the southern agricultural colonies of Virginia and Carolina, and of those, 40 percent were African slaves. Crops in the south were indigo, rice, tobacco, and cotton, the major colonial exports to the mother country, shipped from major southern ports. In the north, timber was in high demand by the British Navy for ship masts. To the British, these exports were the primary economic justification for maintaining the colonies. To most colonists, England and its traditional culture was a world away in both time and space. They were preoccupied with creating their own culture and personal wealth in a new world, not in re-creating a replica of a world that second-generation colonists had never experienced. As with most family descendants of immigrants, they readily adopted the language, customs, and aspirations of the social environment in which they were born.

Rural colonists were for the most part farmers, and by necessity they grew their own food and created their own material environments, including log cabins, farm implements, tools, wagons, equipment, furniture, and clothing. This "home manufacture" utilized the

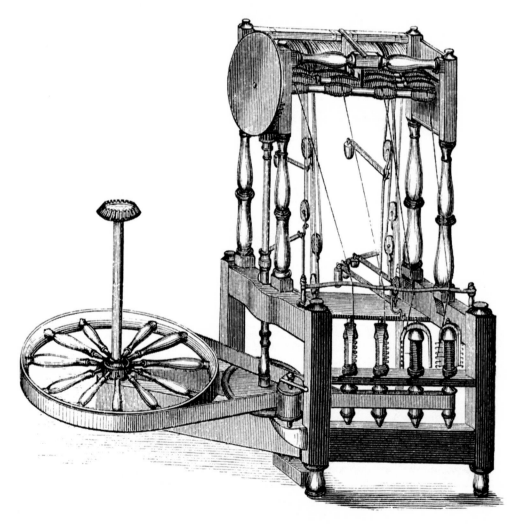

Arkwright's water frame cotton spinning machine, 1769, from *Harper's Monthly*, December 1874.

vast natural resources available and relied on hand labor to make whatever was needed. In small rural communities, a variety of artisans, blacksmiths, potters, wheelwrights and furniture makers set up workshops to serve colonists as they built their homes and tilled the land. For these rural frontiers, functional needs overpowered artistic or decorative luxuries, which, as in Europe, were affordable only by the wealthy. Most ordinary colonists, as well

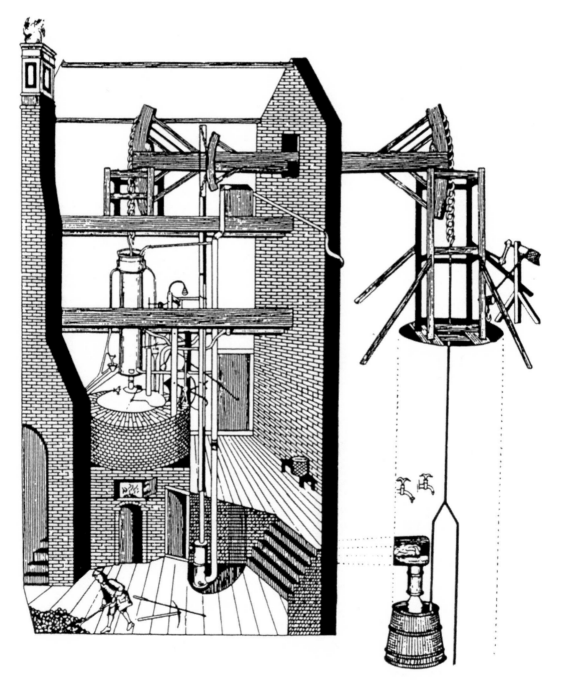

Newcomen steam pump at Dudley Castle, 1712.

as creative artisans in 18th century America, were initially more concerned with producing practical, utilitarian goods needed for exploring, homesteading, and developing their vast new country than with showy embellishments in the style of their wealthy British masters. Those few who desired such luxuries, and could afford them, bought imported European products.

It was not merely that Americans regarded decorative arts as unnecessary. Colonial America's puritan/protestant traditions were still powerful, and those traditions included regarding artistic and decorative possessions as luxuries and extravagances that presaged moral decay and corruption of character. Luxury was believed to render the mind frivolous and to debase the soundness of reason. Many other Protestants associated decorative arts with the elaborate European cathedrals and artifacts of despised Catholicism, and consciously strove to build their own churches simply and plainly, without icons or decorations. Itinerant artists, generally of portraits, were regarded by most as no more than any other useful trade, like that of carpenters, tailors, or shoemakers.

Even though the British government discouraged, and later forbade, any commercial manufacturing whatsoever in the colonies, there were early examples of pragmatic manufacture by experienced colonial craftsmen and entrepreneurs. Since 1719, Pennsylvania-German gunsmiths in Lancaster County had made so-called Kentucky rifles, their "rifled" spiral grooves in the barrel much more accurate than the smoothbore muskets common in Europe. In the same region, German Mennonite settlers, starting in 1749, made Conestoga wagons for pioneer travel westward and for overland cargo transport. Shipbuilding was a major industry in New England, providing vessels for fishing and trade to other colonies and to Britain itself. In the Chesapeake Bay, Baltimore "Clipper" ships would be built for fast transport of exports by 1850.

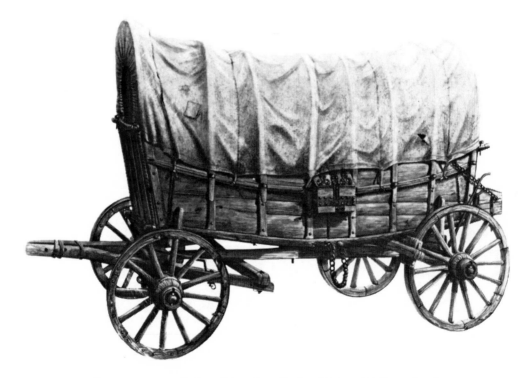

Conestoga wagon (Index of American Design, National Gallery of Art).

One of the colony's most famous entrepreneurs, Benjamin Franklin (1706–1790), already a successful printer and businessman, in 1741 invented, designed, produced, and marketed a cast iron "Pennsylvania Fireplace," later called the "Franklin Stove." This more efficient device essentially removed the traditional fireplace from the chimney as a permanent fixture and made it into a portable and marketable individual appliance. When Pennsylvania deputy governor George Thomas offered to award Franklin a colonial patent, Franklin refused "from a principle that has ever weigh'd with me on such occasions, viz. That as we enjoy great advantages from the inventions of others, we should be glad of an opportunity to serve others by any invention of ours, and this we should do freely and generously."[1]

Franklin was the first to envision a colonies-wide society for the discussion and promotion of science. In 1743, he proposed "promoting useful knowledge among the British plantations in America." This idea was explored over a number of years and came to fruition

Benjamin Franklin's stove, 1741.

in 1768, when the American Society for Promoting and Propagating Useful Knowledge was formed in Philadelphia; Franklin was chosen as its president. He and others recognized that the colonies needed to develop their own intellectual and creative resources rather than relying on European expertise.

Other colonies also had something similar to patents, sometimes called "special premiums," which were offered for "useful discoveries," although some were less than successful. The Connecticut legislature had granted money starting in 1762 to mine iron ore from iron beds in Salisbury. In 1769, it awarded £200 to Abel Buell, a skilled jeweler, type founder, and one-time counterfeiter (he had been paroled), to set up a type foundry, a skill known to few people, even in Europe. He had to agree not to leave the colony for seven years. Apparently his business failed, as he left in 1777 because of debt, but specimens of his type still remain. In Maryland during the Revolution, 22-year-old Oliver Evans (1755–1819), a prolific inventor from Newport, Delaware, began making self-feeding carding machines. In those days, before wool was spun it needed to be carded by hand to align the fibers. To do so, each household with a spinning wheel used two hand-held brushes, or cards, each handmade tediously by inserting hundreds of wire teeth into a leather backing. Evans' machine punched holes in the leather and fixed the teeth in the card, making a one thousand-tooth card each minute. He petitioned the Maryland legislature in 1786 for a 25-year monopoly for making card machines and automated gristmills (see his later 1790 U.S. patent), which was granted.

Skilled European craftsmen had been immigrating to America for some time. These included a number of Huguenot silversmiths from France, including one Apollos Rivoire (1702–1754), who arrived in 1715 at 13 years of age. He immediately apprenticed with silversmith John Coney (1655–1722) in Boston. (Boston had produced many distinguished silversmiths, including the Hurd family, with its patriarch, Jacob Hurd (1702–1758), and his two sons, Benjamin (1739–1981) and Nathaniel (1730–1777). A similar tradition existed in Philadelphia, where Francis Richardson (1681–1729) worked there as a silversmith from 1700 to 1720, followed by his son Joseph Sr. (1711–1784) and his grandson, Joseph, Jr. (1752–1831).) When Apollos opened his own shop in Boston, he probably used the *New Book of Cyphers*, published by Samuel Sympson in London in 1726, to engrave interlaced initials on silverware. In the 1760s, Apollo's son, who had Americanized his name to Paul Revere, Jr. (1734–1818), took over his father's silver shop and worked as a silversmith, engraver, and dentist before becoming involved with the politics of revolution. In 1768 Revere made a silver bowl in tribute to the 92 representatives who wrote the precedent-setting constitution of Massachusetts that year. After the Revolutionary War, he opened a hardware store and by 1788 had established an iron and brass foundry that cast church bells and ship fittings; this eventually grew into a large corporation, the Revere Copper and Brass Company.

In the major colonial cities, all the latest material household possessions were available from Europe in the latest styles, for those who could afford them. Porcelain from Meissen, Germany, in the 1730s featured highly ornamental and artistic products and figurines designed by sculptor and chief "modelmaster" Johann Joachim Kändler (1706–1775). Until mid-century, Meissen dominated the European porcelain trade with Rococo styles.

In furniture, so-called Windsor chairs had been developed early in the century in the vicinity of Windsor, England, by an unknown designer and were popular there. They were "stick built" by inserting round tenons into round sockets on a solid wood seat in a fan pattern for the chair-back. Easier and faster to construct than meticulous mortise and tenon

Silversmith at Colonial Williamsburg.

joints, the chairs were intended for everyday use and were usually painted. Colonists introduced them to America around 1725 and similar designs at lower cost were built, primarily in Philadelphia. By 1760, they were known as "Philadelphia chairs."

This process was typical, as American cabinetmakers in the colonies began to copy English and French designs using pattern books. European craftsmen had published such pattern books for textiles and furniture products for centuries. The earliest furniture imported to America was by English furniture makers who followed Italian Renaissance styles. A 1748 English publication, *A Universal System of Household Furniture*, claimed "above 300 designs in the most elegant taste, both useful and ornamental." In 1754, English interior designer Thomas Chippendale (1718–1779) published his first book of furniture designs, *The Gentlemen and Cabinet Maker's Director*, inspired by Scottish neoclassical architect Robert Adam, who had also designed products for Boulton. Many Chippendale designs still survive in the aristocratic homes for which they were originally made, in progressive styles of William and Mary (1700–1725), Georgian (1714–1760), English Rococo (1720–1760), Louis XV (1720–1760), Neoclassical (1720–1820), and Queen Anne (1725–1755). Chippendale's work was continued by his son, Thomas Chippendale, the younger (1749–1822), until his death. In 1765 Chippendale patterns were copied in the *Cabinet and Chairmaker's Real Friend and Companion*, a publication by Thomas Manwaring, Ince and Mayhew of England. From 1766 to 1776, the finest Chippendale furniture in Philadelphia was made in the workshops of Benjamin Randolph (1737–1791), who made the desk on which Thomas Jefferson composed the Declaration of Independence; William Savery (1721–1787); Jonathon Gostelowe (1744–1795); Thomas Tufts; Benjamin Burnham; and other colonial cabinetmakers. Other makers of American Chippendale included John Goddard (1723–1785) and his son Thomas Goddard (1765–1858), of Rhode Island; the Townsend clan, Job, Christopher and John, all of Newport, Rhode Island; Major Benjamin Frothingham (b. 1734) of Charleston, South Carolina; Col. Marinus Willett (1740–1830) and Andrew Gautier (1720–1784), both of New York; Aaron Chapin of Hartford, Connecticut; and Webb and Scott of Providence, Rhode Island.

Other English furniture designers became popular as the century progressed. George

Hepplewhite's (1727–1786) widow in 1788 published *The Cabinetmaker and Upholsterer's Guide*, which gave his name to his style of light, elegant furniture with distinctive shield-shaped chair backs that was fashionable between 1775 and 1800. Thomas Sheraton (1751–1806) in 1790 set up a consulting business in London and taught perspective, architecture, and cabinet design for craftsmen. In 1793 he published *The Cabinet Maker's and Upholsterer's Drawing Book* in four volumes. It was widely influential throughout Europe and the new United States. His styles were quite fashionable in the 1790s and early 1800s. He did not make the furniture he designed, but it was based on classical architecture, knowledge of which was an essential part of a designer's education. In 1803 he published *The Cabinet Directory*, and in 1805 *Cabinet Maker, Upholsterer and General Artist's Encyclopaedia*.

French furniture designers such as Pierre de La Mésangére (1761–1831), Charles Percier (1764–1838) and Pierre–François-Léonard Fontaine (1762–1853) produced similar journals and books with design patterns that were used by American craftsmen. This long tradition of individual craftsmen establishing standard patterns that were replicated individually by other craftsmen provided gainful employment for thousands of individuals. Teenage boys apprenticed with master craftsmen for six or seven years to learn the critical skills, then went into business for themselves. This pattern would change dramatically as the industrial revolution evolved.

By 1775, population in the colonies since 1750 had doubled to 2.6 million. Since the early 1700s, American colonists had been discouraged from manufacturing by British law because it threatened English manufacturing interests. To Britain, the colonies existed only to provide raw materials. Many colonists ignored the restrictions and engaged in contraband trade. Along with taxation, these restrictions were fundamental complaints that incited the Revolution. As early as 1754, Franklin had proposed the colonies unite in matters of defense, expansion, and Indian affairs, but the plan was highly discouraged by colonial legislatures and King George III for obvious political reasons.

Until 1763, the English Parliament had been preoccupied with the Seven Years' War in Europe, of which the French and Indian War in North America as a part. As a result, England

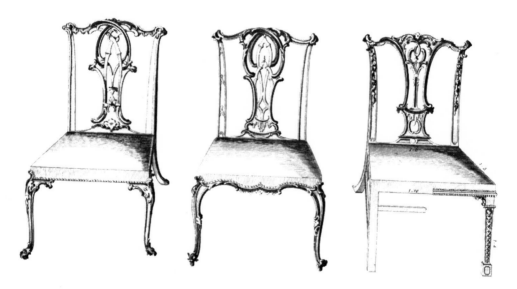

Chippendale chairs, from *The Gentlemen and Cabinet Maker's Director*, 1754.

had generally allowed the colonies to govern themselves. After this war, England was deep in debt, and Parliament's solution was to increase tax revenues from its colonies. Beginning in 1763 up to 1775, dozens of parliamentary acts restricting the colonies were enacted that increased taxation without representation in Parliament, restricted trade, forbade further expansion of the colonies beyond the Appalachian chain of mountains, discouraged manufacture, and severely punished colonial resistance to parliamentary governance. Clearly, England wanted to prevent the expansion and independence of its American colonies. From 1766 to 1774, popular opposition to English fashions, imports, and ideas increased rapidly, and the call for "Made in America" first became a patriotic battle cry for American entrepreneurs to protest foreign competition.

Taking action on these sentiments, the First Continental Congress of 1774 decreed that after that time, no more products were to be imported *from* the British Empire, and after 1775, no products were to be exported *to* England. The United Company of Philadelphia for Promoting American Manufactures was established that year to encourage independence from British trade. This was not exactly consistent with the concept of free trade, but it certainly encouraged the "invisible hand" of capitalism, as defined by Adam Smith.

Adam Smith (1723–1790) was the Scots father of modern economics who knew both Voltaire and Ben Franklin. In his 1776 book, *An Inquiry into the Nature and Causes of the Wealth of Nations,* he advocated that a free market, while appearing chaotic and unrestrained, is actually guided to produce the right amount and variety of goods by what he called an "invisible hand." Smith believed that when an individual pursues his self-interest, he promotes the good of society more so than if he *intends* to benefit society: "[B]y pursuing his own interest, [the individual] frequently promotes that of the society more effectually than when he intends to promote it." Self-interested competition in the free market, he argued, would tend to benefit society as a whole by keeping prices low while still building in an incentive for a wide variety of goods and services. But his book also cautioned that if Americans "stopped the importation of European manufactures ... they would ... obstruct, rather than promote the progress of their country."[2] He was right, as progress was indeed obstructed by the Continental Congress's cessation of exports and imports, as well as by the Revolutionary War that followed.

Some leaders of the new Republic were not initially keen on American manufacturing. John Adams told Ben Franklin in 1780 that "America will not make manufactures enough for her own consumption these thousand years."[3] Jefferson hoped for an agrarian economy with household manufactures in 1785, and warned that the danger to this ideal was the development of machinery. He proposed that, "for the general operations of manufacture, let our workshops remain in Europe."[4] He idealistically favored letting Europe become the dirty, industrial site of the world, allowing European lower classes to provide the cheap labor under poor working conditions. Let Americans remain farmers, and let American cities remain clean and unsullied with industrial factories. But after the war of 1812, he realized that "to be independent for the comforts of life, we must fabricate them ourselves" and "place the manufacturer by the side of the agriculturist."[5]

It was Tench Coxe (1755–1824), a Pennsylvanian lawyer, promoted the movement toward U.S. manufacturing after the war, having been inspired by the 1775 United Company of Philadelphia for Promoting American Manufactures. Coxe was invited by Franklin, who supported his views, to draft a proposal for distribution at the historic 1787 Constitutional Convention in Philadelphia. In it, he encouraged manufacturing and the useful arts in order to serve domestic markets, to insure supplies in time of war, and to balance the agricultural

economy. Later that year, he expounded his views to an assembly of interested Philadelphians, who voted to establish the Pennsylvania Society for the Encouragement of Manufactures and the Useful Arts. Its first venture was to offer a $20 gold medal for the "most useful engine operated by water, fire [steam] or any other means that would reduce the labor of manufactured cloth."[6]

In his 1790 address to Congress, President George Washington (1732–1799) declared that the country had to develop independence in manufacturing for self defense: "A free people ought not only be armed but disciplined; to which end a uniform and well-digested plan is requisite; and their safety and interest require that they should promote such manufactories, as tend to render them independent of others for essential, particularly for military, supplies."[7]

Congress followed by requesting a report to be prepared on the subject by secretary of the Treasury Alexander Hamilton. Tench Coxe was appointed assistant to Hamilton and contributed to Hamilton's Report on the Subject of Manufactures in 1791. The report laid down economic principles and ideas that would later be incorporated in the "American System" program of 1816. In 1792 Coxe became commissioner of revenues and, under Jefferson after 1800, purveyor of public supplies.

Washington, in his 1790 address to Congress, also pleaded to Congress to give "effectual encouragement ... to the exertion of skill and genius at home."[8] Congress responded within a month by establishing the U.S. Patent Office. Patents giving inventors exclusive rights for fourteen years were immediately available for "any useful art, manufacture, engine, machine or device, or any improvement thereon not before known or used."[9] Responsibility for the patent office was vested in a board that included secretary of state Jefferson, a strong proponent of the value of invention and innovation. Jefferson, an accomplished architect and designer, was also quite an inventor but never applied for any patents. In 1776 he commissioned a special desk built by Benjamin Randolph in Philadelphia. In 1787 he designed a macaroni-making device similar to one he had seen in Europe. In 1793 he invented a "wheel cipher" device to code and decode secret messages and, in 1794, an improved moldboard for a plow. His home, Monticello, which he personally designed and had constructed from 1794 to 1809 based on ideas he had seen in Europe, was full of his own ingenious inventions of convenience, including his own improvements on polygraph letter copying devices, revolving book stands, hanging beds that raised out of sight by day, swivel chairs with writing arms, dumbwaiters, clocks, and sundials.

Three patents were filed in the patent office that first year of 1790. The third was to inventor Oliver Evans, who in 1785 had built the first automatic factory in the U.S., near Philadelphia—an automatic gristmill powered by a waterwheel that performed all operations from the top to the bottom of a four-story millhouse. The process consisted of bucket and chain elevators, conveyor belts, and Archimedes' screws—all operated automatically by water power—to dry, grind, spread, cool, and sort flour, providing a continuous flow of the manufacturing process that could be set in motion by one workman. To promote his patented invention, he published *The Young Mill-Wright and Miller's Guide*, through 15 editions, from 1795 through 1860.

Powered boats had been an early application of the new steam power source. A 1791 patent was granted to John Fitch (1743–1798), a Philadelphia inventor, clockmaker and

Opposite: Elevation of Oliver Evans' automatic grist mill, from *The Young Mill-Wright and Miller's Guide*, 1795.

Plate XXI.

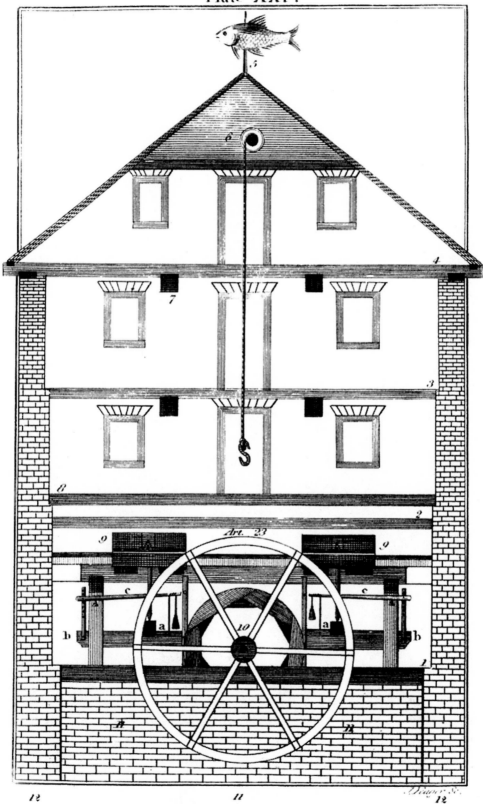

silversmith. From 1785 to 1796 he had developed and built a number of prototype model steamboats with various propulsion mechanisms, including screw propellers, paddles, and paddlewheels. His first successful trial run was in August 1787 on the Delaware River in the presence of delegates to the Constitutional Convention in Philadelphia. A bank of vertical reciprocating oars on either side powered the 45-foot boat. A later, larger version carried passengers between Philadelphia and Burlington, New Jersey, across the Delaware. It was mechanically workable, but Fitch could not make it economically feasible as a business.

The clock-making industry in the 1790s was still a skilled handcraft, as were many entrepreneurial enterprises. Clock maker Daniel Burnap (1759–1838), of East Windsor, Connecticut, was a typical example of the era. He had apprenticed with Thomas Harland (1735–1807), a prominent English clockmaker who had arrived in America and opened his shop in Norwich, Connecticut, in 1773. It was common practice for clockmaker apprentices to train for seven years, starting at age 14. Harland trained 19 apprentices between 1773 and his death, about one new apprentice each year. Harland's shop, in fact, became America's first watch and clock factory. He produced about 200 watches and 40 clocks per year, all by hand with the help of apprentices.

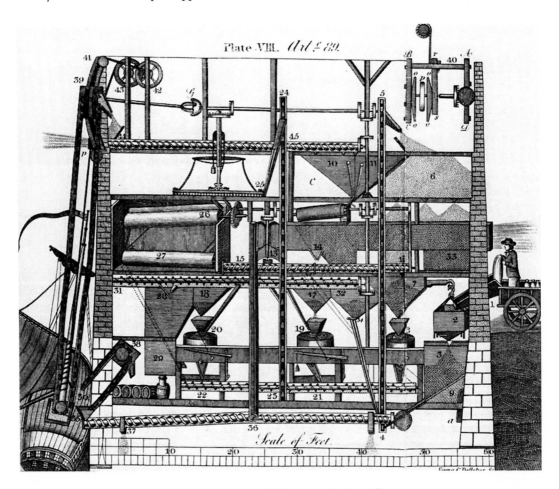

Cross section of Oliver Evans' grist mill.

Burnap established his own shop in 1780, which soon became another small factory producing clocks, silver spoons, buckles, jewelry, and surveying instruments. Burnap's clock cases were obtained from local cabinetmakers in typical English styles. His clocks used the expensive, but superior "dead beat" escapement invented by English clockmaker George Graham in 1715. In 1796, Burnap moved to Coventry, Connecticut. He trained a number of apprentices, from 1785 to 1792, including 13-year-old Eli Terry (1772–1852), who would soon put Burnap and other clockmakers out of business.

In the waning years of the century, the new republic had assumed its awesome responsibility as an independent nation. It had established a constitution. It had embraced technology and encouraged invention through patent protection. It had determined that it would manufacture its own products rather than rely on other nations. It was committed to defending itself, and accordingly, in 1797, it established a navy by building a fleet of six frigates in Boston, including the *Constellation, Constitution,* and *United States,* designed by ship designer-builder Joshua Humphreys (1751–1838) of Philadelphia. They would be put to the test in the War of 1812.

The first major architectural design project initiated by the new federal government was for buildings in Washington, D.C. The design was influenced strongly by Thomas Jefferson, one of the commissioners, who "wanted to exhibit a grandeur of conception, a Republican simplicity, and that true elegance of proportion, which correspond with a tempered freedom excluding Frivolity, the food of little minds."[10] The commissioners deliberately wanted to avoid the visual richness and elaborate ornament typified by European public buildings, which to them expressed only tyranny and extravagance. The preferred

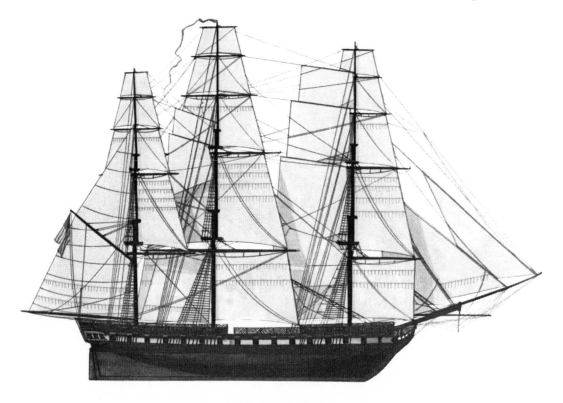

U.S.S. *Constitution.*

style of neoclassicism or Greek revival was seen as "pure and severely Greek ... strong and calm, and cold, like Government and Law."[11]

Jefferson initiated a design competition for the White House in 1792. James Hoban (1762–1831), an Irish immigrant living in Charleston, South Carolina, won the competition and construction began that year. John Adams was the first president to occupy it, briefly in 1800, then Jefferson starting in 1801. Dr. William Thornton (1759–1828), physician, inventor, artist, and amateur architect, an Englishman who arrived here in 1786, won the Capitol Building competition in 1789. With construction underway in 1803, another English immigrant and the first professional architect in the U.S., Benjamin Latrobe (1764–1820), who had practiced in the U.S. since 1797, supervised completion of both Hoban's and Thornton's plans and modified them both considerably. The official government architectural style of Greek revival, including the colonnade, the portico, the pediment and the dome, was instantly applied to almost all new buildings, even to private homes, and would continue to be popular for a century.

The need for manufacturing technology was so great that espionage became a last resort. The Pennsylvania Society for the Encouragement of Manufactures and the Useful Arts, led by Tench Coxe, had attempted repeatedly, from 1787 to 1789, to acquire British knowledge or machines for the spinning and weaving of cloth, but to no avail, as this had been a state secret in England since 1774. It would take a bit of industrial espionage. In

Samuel Slater's replica of Arkwright's cotton spinning machine, 1793 (National Museum of American History).

1793, Samuel Slater (1768–1835), who had earlier been apprenticed to a partner of Richard Arkwright and had secretly emigrated from England in 1789, would build a series of replicas of Arkwright's cotton spinning machines in Pawtucket, Rhode Island, from memory. These machines would be successfully operated with human treadle power. Slater, partnered with Moses Brown and William Almy, was soon operating several cotton mills, using imported cotton, and would amass a fortune of $7.5 million by the time of his death. Andrew Jackson would later call Slater the "father of American manufacture."

Eli Whitney's cotton gin, 1794.

In 1794, American inventor Eli Whitney (1765–1825) patented his cotton gin, which increased cotton production in the southern U.S. forty-fold between 1793 and 1795. However, by 1803, Whitney and his partner, Phineas Miller, had realized no profit, as southern cotton farmers had ignored the patents. Anyone with a few tools and basic carpentry skills could build a crude working version of his design, and state courts were reluctant to uphold Whitney's patent despite 60 lawsuits filed in Georgia alone. Whitney became both exhausted and penniless.

In 1797, Charles Willson Peale (1741–1827), a Philadelphia portrait painter and natural history museum keeper, received a patent for a bridge and another for a fireplace. In 1798, Peale's son Raphael patented the protecting of wooden wharves and ships from worms. In 1804 Charles obtained American patent rights to the polygraph from its inventor, English émigré John Isaac Hawkins (1772–1854), at about the same time that Thomas Jefferson purchased one. He and Jefferson collaborated on refinements to this device, which enabled a copy of a handwritten letter to be produced simultaneously with the original. Jefferson used it constantly.

Up to this point, America was too preoccupied with survival and organization of their new government to pay much attention to competition with Europe, either in technology, art, or consumer product manufacture, let alone design. Pragmatism, patriotism, practicality, frugality, and individual industry were the most admired characteristics in the new nation.

It was hard to shake the long colonial tradition of dependence on Mother England for products of luxury, refinement, and the latest technology. It was even harder to shake the traditional American indifference to art and science. Well-read Americans had for generations believed in the writings of French philosopher Jean-Jacques Rousseau (1712–1778), who blamed art and luxury for the fall of Rome and the downfall of Renaissance city-states. He argued that the arts and sciences did not serve man well, since they arose as a result of pride and vanity rather than from authentic human needs. Unlike their European cousins,

Americans were generally wary of any wealth or artistic luxuries, both of which were perceived as unproductive in a new republic that demanded only productive hard work and preparation for its own defense. The arts in general, and foreign "fripperies' and "gewgaws" were viewed as unpatriotic as foreign trade, all "subversive of the spirit of pure liberty and independence."[12] But these patriotic qualities would not alone enable the new United States to survive in a warlike and economically competitive world.

Chapter 2

1800–1850
The American System

America began the century far behind Europe in the industrial revolution. In 1801, French inventor Joseph Marie Jacquard (1752–1834) invented a mechanical loom, which was controlled by pasteboard cards with punched holes that automatically generated complex textile patterns. In addition to saving labor and unleashing silk weavers' fear of job losses, its use of punched cards to control a sequence of operations would be considered an important step in the history of computing software.

England was the primary driver of the industrial revolution. The first country to conquer infant mortality, half of its growing population was under age 15 and the other half was busy creating a global business empire based on manufacturing, trade, and raw materials from its colonies. Untrained manpower was cheap and available for manufacturing in high quantity. Complex laborsaving machines were being developed to increase production. In 1802, engineer Mark Isambard Brunel (1769–1849) cooperated with manufacturer Henry Maudslay (1771–1831) to produce ship pulley blocks on 22 different machines, a totally new manufacturing process that by 1808 had an annual output of 130,000 blocks. Matthew Boulton and James Watt had since 1775 produced 496 steam engines for British industry. By way of contrast, in 1803, only six steam engines were in use in the entire U.S.

By 1800, the U.S. Patent Office had been established for ten years, and a mere 306 patents had been filed. Working models and precise drawings were required, which were preserved in special libraries and galleries until a fire destroyed the patent office in 1836, along with some 2,000 models and 9,000 drawings, an irreplaceable historical loss. But many mechanical inventions were encouraged by patent protection and by 1820 American patents had outpaced British patents 1,748 to 1,125.

Some were focused on transportation needs as the nation grew. Among them was a steam-powered amphibious dredging machine built in 1805 by Oliver Evans (of the 1785 automatic flour mill) called the Oruktor Amphibolos (amphibious digger). It had a drive belt that powered its four wagon wheels to the water, and the belt was then shifted to a paddlewheel for powering the floating wagon, as a boat, to its place of work. It was successfully operated in the Schuylkill River in Philadelphia. In 1807, funded by Robert Livingston (1746–1813), the U.S. minister to France who negotiated the Louisiana Purchase, artist-inventor Robert Fulton (1765–1815), devised the first successful commercial steamboat with two side paddlewheels, *Katherine of Clermont*, for passenger service on the Hudson from New York to Albany. By 1811, Fulton had built the first sternwheeler steamboat, *New Orleans*, which opened the Mississippi and Ohio rivers between Pittsburgh and New Orleans.

Other pressing needs in the expanding nation were for export production and military

Mark Isambard Brunel's ship pulley-block making machinery, produced by Henry Maudsley, 1802, from *The Cyclopaedia of Arts, Sciences, and Literature*, by A. Rees, 1819.

Robert Fulton steamboat prototype, 1803.

equipment. In 1800, Eli Whitney, of cotton gin fame, set up a factory near New Haven, Connecticut, with 60 employees to produce 10 to 15 thousand smoothbore muskets in two years under a $134,000 government contract signed in 1798. He planned to manufacture the guns on the principle of interchangeability of parts, an advanced French process of musket production observed and first reported to the government by Thomas Jefferson (1743–1826) when he was minister to France in 1785. But before Whitney could begin production, he had to design the musket and its components, prepare patterns and processes for each part, and design or acquire machinery to produce them. He also had to design and build a special milling machine to produce the precision parts needed. But this complex process took longer than expected, and eight years went by before the order was completed and he successfully demonstrated the interchangeability of his musket components in Washington in 1809. In 1811 he was awarded a second contract for 15,000 more muskets, which he delivered in two years. Although Whitney is credited by many as being the "inventor" of what would later become known as the "American System of Manufacture," his muskets did not fully achieve interchangeable parts.

At the same time, there were no fewer than 60 gunsmiths in Lancaster County, Pennsylvania, alone, handcrafting guns to private order. Lancaster County was the home and origin of the famed "Kentucky rifle," made there for the previous 95 years. Each and every part of the rifle was created individually in a private workshop, to protect secrets of the craft. Apprentices served master gunsmiths for eight years to learn the secrets of the trade: engraving metal, casting brass, carving wood stocks, forging metal parts, and rifling barrels. Each gunsmith shop turned out about 15 to 30 rifles per year.

America had doubled its capacity for manufactures since 1790 and by 1810 was exporting more than it was importing in many product areas. This reduced the number of imports from England, which contributed to worsening relations with the mother country.

Manufacturers included those making furniture. American cabinetmaker and manufacturer Duncan Phyfe (1768–1854) had emigrated from Scotland in 1784 and by 1794 had

opened a furniture business in New York. By 1800 he employed over 100 workers. Phyfe introduced English Regency and Neoclassical styles from Sheraton's 1793 book and Thomas Hope's (1769–1831) *Household Furniture and Interior Decoration* (1807). Phyfe's finest work was done from 1800 to 1820. The Greek lyre shape on his chair backs was his personal motif and trademark. Another cabinetmaker, Charles-Honoré Lannuier (1779–1819), trained in Paris as an *ébéniste* (French term for cabinetmaker), and arrived in New York in 1803. He set up his shop in 1804 and until his death produced furniture in Directoire (1795–1799), French Consulate (1799–1804), and Empire (1804–1815) styles. Other New York furniture designers such as John Hewitt copied the work of these two leading designers to increase their own business.

Relations with England were still unsettled. High seas conscription of American sailors by English ships on ships trading with France, British privateering, and English encouragement of Indian resistance to American westward expansion, fearing American expansion into Canada, caused President Jefferson to again stop all trade with England. These circumstances led to the War of 1812 (to 1815) with England, as well as with an Indian nation under Native American chief Tecumseh, who sided with England. The cessation of trade with England was initially a boon to American manufacture, as it encouraged the start-up of many new companies and expanded both the economy and employment. After the war, American-English relations would not only improve, but would form a bond that still exists. But when English imports resumed, many new American manufacturers went out of business in an economic depression that lasted until 1819. Still, demand for manufactured consumer products continued to increase.

For many handcrafted manufactures, this meant hiring more people or devising more efficient tools. For some years, tinsmiths had produced many kinds of consumer products from thin sheets of tinplated iron they imported from Wales. Products included hand-formed tea canisters, pails, pots and pans, small ovens, lamps, and coffee pots that were cut, formed, soldered, painted and decorated, all by hand. Peddlers who traveled the backwoods areas of the country in wagons selling tinware distributed these products, as well as cloth, pins, needles, clocks, furniture, cast iron kettles, combs, brushes, and hundreds of conveniences desired by rural communities. Craftsmen who made tinware soon devised hand-oper-

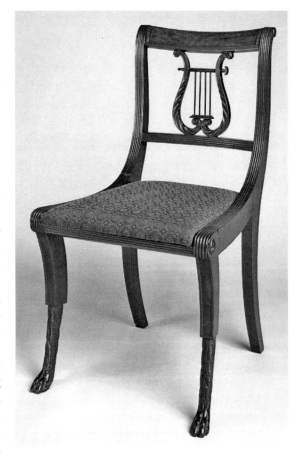

Duncan Phyfe chair (image © Metropolitan Museum of Art).

ated devices that speeded up this process, resulting in extremely inexpensive products that were virtually disposable.

Demand for consumer products was eventually so great that only mechanical means and labor forces could keep up. Individual craftsmen were unable either to produce the quantities required or to reduce their costs to the affordable level of the farmers and laborers who comprised this new mass market. What was needed was the organization and development of manufacturing companies, which required financing by investors in new businesses and facilities. This would begin to happen in 1816.

By then, the economic depression had only gotten worse, and many demanded that the U.S. control its own economic destiny, rather than relying on European imports. Henry Clay (1777–1852), John C. Calhoun (1782–1850) and John Quincy Adams (1767–1848) advanced the concept of what was later called the "American System," intended to strengthen and unify the nation in agriculture, commerce, and industry. When enacted by Congress in 1816, the system included high tariffs on imported goods (20 percent–25 percent) to protect and promote American industries, and a rechartered Bank of the U.S. to promote a single currency and to provide federal credit to fund improvement of the nation's transportation system (canals, roads) for expanded agricultural markets.

This new economic policy essentially initiated America's formal entry into the industrial revolution. In many states between 1816 and 1826, private citizens organized societies—such as New York's American Society of Encouragement of Domestic Manufacture, and the Pennsylvania Society for the Encouragement of Manufactures—were formed to reduce reliance on imports by investing in the formation of profitable new manufacturing ventures. By 1823, over 200 manufacturing companies had been issued charters by the State of New York, and by 1826, Massachusetts had about 240 manufacturing companies.

Government credit also encouraged national transportation systems. Robert Fulton had studied canals in England and as early as 1796 had written a treatise on canal design and construction containing detailed drawings of vertical lifts, aqueducts, and bridges. In 1806, he submitted copies to Governor Mifflin of Pennsylvania, who had appealed to Congress for more affordable transportation systems since 1795. Between 1815 and 1840 some 4 million acres of public domain land were granted to canal projects. The Erie Canal was begun in 1817 and completed in 1825, which initiated a network of canals throughout the country, including the Chesapeake & Ohio Canal in Maryland (1828), the Blackstone Canal in Massachusetts (1828), the Morris Canal in New Jersey (1831), the Ohio & Erie Canal in Ohio (1833), the Blackwater Canal in New York (1836), the Pennsylvania Canal (1840), Ohio's Miami and Erie Canal (1845), the Illinois & Michigan Canal (1848), and many others. Thousands of canal boats were built locally to transport tobacco, grains, whiskey, furs, timber, consumer products, and, of course, people.

The first national road from Maryland to Illinois, 591 miles begun in 1811, was finally finished in 1847. Seven hundred Concord stagecoaches, with their innovative leather shock absorbers, were designed and built by Louis Downing and J. Stephen Abbot in Concord, New Hampshire, from 1827 until the company disbanded in 1847. Stagecoaches initiated national mail service in 1858; and after trains became common, diminishing numbers of stagecoaches were used on short mountain hauls and national parks until eventually replaced by buses in the 1920s.

George Stephenson (1781–1848) developed the first steam locomotive, the *Rocket*, in England in 1829. Shortly thereafter, Peter Cooper (1791–1883) designed and built the first American steam locomotive, the *Tom Thumb*, in 1830. By 1832, there were 1,400 miles of

railroads in operation in the U.S. All these transportation networks facilitated the massive distribution of agricultural and manufactured goods to a growing population.

In 1846, naval architect John W. Griffiths (1809–1882) incorporated his revolutionary design of ship hulls into his *Sea Witch*, the first of the high speed "Clipper Ships," sailboats which ushered in the peak age of sail and enabled the U.S. to compete in the international tea trade.

Congress in 1815 had made a commitment to provide funds for national defense and to maintain a standing army. For this, it needed firearms. Simeon North (1765–1852) a gunsmith in Berlin, Connecticut, had been making pistols since 1799. In 1813, during the War of 1812, he had received a government contract to produce 20,000 pistols. The contract specified that parts of the lock had to be completely interchangeable with any of the 20,000 locks. North completed the order in 1816 and is credited with inventing America's first milling machine, which improved the traditional practice of hand-filing to produce finished parts and made interchangeability of parts more practical.

In 1819, John H. Hall (1781–1841) signed a contract with the War Department for 1,000 breech-loading M1819 Hall rifles, which he manufactured in Hall's Rifle Works, near the federal armory at Harpers Ferry, Virginia; the armory functioned as a development laboratory for the army's Ordnance Department. There, he perfected the interchangeability of parts to the enthusiastic satisfaction of a congressional study group in 1826, and his fabrication techniques became the standard in arms production. In 1828, when Simeon North produced Hall rifles in Connecticut, their parts were interchangeable with those made in Virginia by Hall. Mass production of rifles was greatly aided by the 1820 invention of an "acentric lathe," or "copying lathe," by Thomas Blanchard (1788–1864). It was a machine that replicated wooden gun-stocks automatically like present day key replication machines.

Erie Canal, c. 1903, Syracuse, New York, with Weighlock Building in center, now a museum.

His machine was later adapted to other industries to produce axe handles, shoe lasts, clogs, and wagon wheel spokes. The machine made possible more ergonomically shaped handles for tools.

Textile manufacture was not far behind. In 1813, the first American power loom was constructed by a group of Boston merchants headed by Francis Cabot Lowell (1775–1817). In 1810, during a visit to Great Britain, Lowell had spied on the textile industry and memorized the workings of British power looms. Weaving could then keep up with spinning, and the American textile industry was on its way. By 1814, a mill, the parent of the famous textile mills at Lowell, Massachusetts, was in operation in Waltham, Massachusetts. Government tariffs on foreign textiles initiated in 1816 enabled American textiles to become competitive. By the 1820s, there were textile mills scattered throughout New England that would provide affordable cloth to millions and steady employment to women; but by 1845, women would be working 11 to 13 hours per day, six days a week, for three dollars per week, under harsh working conditions.

Stove manufacturing was another industry developed. William T. James of Troy, New York, had established the basic stove type-form in 1815, when he patented and produced the "Baltimore Cook Stove," which by 1823 was sold in New York and Boston. Cast-iron cookstoves and utensils soon were produced by a number of manufacturers, in a variety of shapes and sizes. Albany and Troy, New York, led in cast-iron production due to the quantity of sand for casting in that area and its use to reproduce fine detail. By 1850 there were seven foundries in each town. Stove makers borrowed their styles from cabinetmaker and architectural

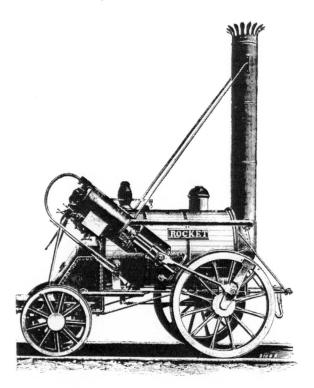

George Stephenson's *Rocket*, 1829 (from Edward W. Byrn, *The Progress of Invention in the Nineteenth Century*, 1900).

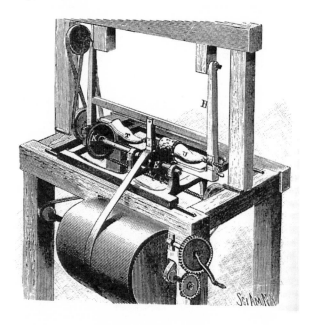

Thomas Blanchard's "acentric," or copying, lathe making shoe lasts c. 1820 (from Edward W. Byrn, *The Progress of Invention in the Nineteenth Century*, 1900).

design books, which included Greek, Roman, Egyptian and Rococo motifs, patriotic symbols, and floral designs. In the 1830s and 1840s, highly decorated parlor stoves were a focal point in many homes.

With a growing number of newly prosperous consumers, skilled clockmakers were also in demand. Profits were good, but clocks were a luxury item (we would say "high tech") and many people could not afford them. Clock making was a demanding craft requiring long apprenticeships. Movements were intricate and required the fabrication of costly precision brass parts to achieve accurate timekeeping. Typical was Phineas J. Bailey (1787–1861) of Chelsea, Vermont, who apprenticed at age 14 (from 1801 to 1809) to John Osgood, who had worked in Haverhill, New Hampshire, from 1793 to 1840 as a silversmith and clockmaker. Bailey then worked as a journeyman clock maker in Hanover, New Hampshire, with Jedidiah Baldwin, clock maker, silversmith, storekeeper, and postmaster. Bailey worked for him less than a year, from 1809 to 1810, then returned to Chelsea and set up a clock-making partnership that was successful until 1816, when the market for brass clocks collapsed due to Eli Terry.

Eli Terry (1772–1852), was a clock maker who had established a shop in Plymouth, Connecticut, in 1793 after an apprenticeship from age 13 to age 20 with Daniel Burnap of East Windsor. In about 1800, Terry had noticed a decline of customers for his brass movement luxury clocks. Seeking a lower cost, he began making clock movements with wooden parts that sold for half the price of his brass clocks. They were less precise and ran for only 30 hours instead of the standard eight days, but they were much easier to produce, weighed less, and were easier to transport. Further, he employed farm boys with woodworking skills instead of more expensive trained craftsmen. By 1806 he had developed special lathes, saws, drills and gear cutters and had orders for 4000 clocks. Through his adaptation to mass production methods, he had established a new mass market for low-cost clocks.

Such functional simplicity was initially popular, but consumers wishing to emulate higher social class wanted more decorative designs. By 1816, in order to compete with imi-

Working women at Lowell, Massachusetts, textile mill, c. 1845 (New York Public Library, Astor, Lenox, and Tilden Foundation).

tators, Terry hired Chauncey Jerome (1793–1868), a case maker, to design an upscale cabinet for his movement in a neoclassical "pillar and scroll" style with a painted landscape scene on glass that rivaled the high class, urban manufacturers of Boston and Philadelphia. By 1820, Terry was supervising 30 workers and annually producing 2,500 clocks in four dominant styles. Many individual clockmakers could not compete. Benjamin Morrill (1794–1857), of Boscawen, New Hampshire, maker of mirror, banjo, shelf, tall, and tower clocks since about 1814, soon abandoned his lucrative career of clock making to make beam scales and musical instruments.

Chauncey Jerome set up his own business and in 1825 introduced a slightly less expensive to produce, but larger, clock called the Bronze Looking-Glass Clock, the name based on the mirror mounted below the clock face. The feature enabled it to be sold at $2 more than the Terry clock, because of its more impressive styling. In 1837, Jerome returned to eight-day

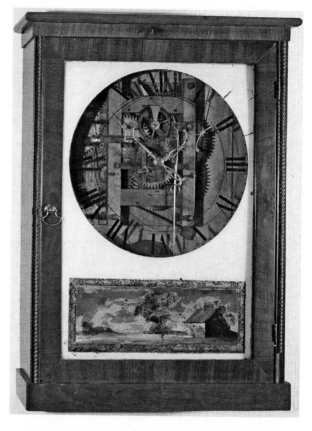

Eli Terry wooden clock, c. 1806 (courtesy Time Museum).

brass movements, with thin brass gear wheels stamped from sheet stock, and sold them for 75 cents wholesale. His first export shipment to England in 1849 was confiscated because its declared value was suspected of being an attempt to avoid import duties. Customs inspectors could not believe the price was so low. By 1850, his firm, the New Haven Clock Company, produced 300,000 clocks annually selling for $1.50 each, and American clocks were outselling British clocks.

Similar cost-reducing processes were developed in the glass industry. Traditional free-blown glass was labor-intensive and very expensive because experienced glassblowers were required. In about 1825, hand-operated pressing machines were developed that pressed molten glass into metal forms and produced inexpensive glass products in a single step. The first small bench press was probably developed by the New England Glass Company of Cambridge, Massachusetts, to produce furniture knobs. The same company in 1827 developed a full-size press to make larger tableware and decorative products that were very affordable.

These advances in manufacture required people with specialized skills. Institutions were being established around the world for specialized learning in the various arts and sciences related to manufacturing. Unlike the traditional apprenticeships that taught craftsmen their specific trades, the complexity and skills required to design products, manufacturing equipment, techniques, and processes required a much more generalized and

extensive body of information. The École Polytechnique engineering school in Paris had opened in 1794. In Britain, the Glasgow Mechanic's Institute was organized in 1800. The Edinburgh School of Arts, a similar school, started in 1821, and was followed by many others, including the London Mechanic's Institute in 1823. In Germany, the first Polytechnic school opened in 1825 in Karlsruhe and within five years there were four more. These schools were later described as "the nurseries of a scientifically cultivated technology which vigorously advanced the industrial movement supported by middle class culture."[1]

Technology included design, because it was recognized that competitively manufactured products, even though cheaper, needed to be attractive to sell. The British parliament established a select committee to examine "the best means of extending a knowledge of the arts and principles of design among the people."[2] As a result, the Government School of Design was founded in London in 1837 and became the National Art Training School in 1853, with the Female School of Art in separate buildings. They were known informally as the South Kensington Schools until 1896, when they became the Royal College of Art.

A year after the London school was established, interested local citizens recommended the establishment of a school of design in the manufacturing town of Manchester, "in order to enhance the value of the manufactures of this district, to improve the taste of the rising generation; to infuse into the public mind a desire for symmetry of form and elegance of design; and to educate, for the public service, a highly intelligent class of artists," noting that "superiority in manufacturing depends, in a great measure, on the fortunate exercise of taste, economy, industry, and invention."[3]

A similar educational movement related to industrialization was occurring in America, despite its traditional suspicion of arts and science. But things were changing with America's newly found independence. As Americans entered competition with Europe, they needed to acquire specialized technical knowledge. Upon his election in 1824, President John Quincy Adams (1767–1848) urged the U.S. to take a lead in the development of the arts and sciences. "Mechanics Institutes" were founded in New York and Philadelphia in 1824, then later in Boston and Baltimore. Art schools often included a range of interests. In his 1834 book, *History of the Rise and Progress of the Arts of Design in the United States*, American artist, writer, and playwright William Dunlap (1766–1839) used the term "Arts of Design" in a general sense in referring to art, architecture, sculpture, and engraving. He described the founding of the National Academy of Design in New York City in 1826, a school which encouraged students of the foregoing arts, and whose first president, incidentally, was artist and faculty member Samuel F.B. Morse (1791–1872), of later Morse code fame.[4]

The Maryland Institute College of Art in Baltimore

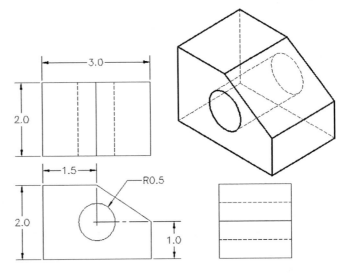

Isometric drawing.

was founded in 1826 as the Maryland Institute for the Promotion of the Mechanic Arts, making it the oldest fully accredited, degree-granting art college in the United States. That same year, the Franklin Institute in Philadelphia initiated separate courses in freehand and architectural drawing. In 1829, Joseph Farish of Cambridge, England, combined these two courses into what was called isometric drawing, which was, and remains, particularly useful in the drawing and design of machinery. Farish had developed this method using drawing boards, T-squares, and triangles, the basic tools of mechanical drawing.

In 1826, the Franklin Institute held the first exhibition of American manufactured products, with medals awarded for outstanding submissions (a practice borrowed from art shows), and continued such exhibits annually for 30 years "to encourage and stimulate the industry and ingenuity of American artisans and manufacturers; to introduce customers and producers to one another; to acquaint our merchants with the elements and materials of commerce; and our statesmen and the public with the resources of the country." Design was cited among the criteria of competition for prizes: "Tastefulness of design, though not as a primary object, will be considered, as far as it is compatible with economy" and "regard will be had ... to the taste exhibited in the design, as well as to excellence in workmanship."[5] The American Institute of the City of New York, founded in 1828, held annual industrial fairs and maintained a permanent collection of machines and models for observation and study by mechanics and inventors.

From the beginning, art and industry were closely related. The "mechanic arts," or "useful arts" as they were often called at the time, included a wide range of technical skills, which eventually would be subdivided into separate specialized skills such as science, invention, mechanical design, decorative design, mechanical drawing, materials analysis, crafts, machine design, production planning, art, factory design, physics, mathematics, etc. Early institutions, in developing educational programs, began this process of identifying, naming, and categorizing appropriate technical specializations. Among these were drawing and model-making, the traditional skills of artists, sculptors, architects and master craftsmen, that were fundamental to the evolution of industrialization in the 19th century, just as they had been to the evolution of mechanical technology since its beginning. Such skills cannot only envision but can also communicate visually to others complex structures and mechanisms in three dimensions. Most historical mechanical inventions and constructions of the Middle Ages are known to us today only by artists' drawings of their overall configuration and intricate, functioning details. The patent office, as we have seen, required careful functional models of inventions, as well as precise drawings of them. Inventors had to visualize their ideas with crude or refined sketches before beginning actual fabrication. Craftsmen, architects, and shipwrights recorded scale plans of their completed products in published stylebooks or pattern books, which were used by others to replicate or modify to their own tastes. It has always been true that the making of complex physical artifacts is preceded by a measurable plan, a scale model, a sketch, or at the very least, a mental visualization.

In the 1830s, French political thinker and historian Alexis de Tocqueville (1805–1859) traveled throughout America to observe and comment on its society and its technical progress. He recorded his observations and conclusions in his book, *Democracy in America*, which was published in two volumes (1835 and 1840). He observed of American technical study that "a science is taken up as a matter of business and the only branch of it which is attended to is such as admits of an immediate practical application."[6]

Technical education was regarded as a path to success in this new era of manufacturing

technology, where inventions and know-how were rewarded with thriving business ventures and personal fortunes. Companies and corporations were formed and workers were hired to work in them. The products and tools formerly designed and produced by a single craftsman were now being designed and planned by educated technicians, and were produced physically by untrained employees who performed simple tasks using specially designed manufacturing machines. Rather than feeling exploited, these early middle-class workers were paid well and felt like they were part of the manufacturing process. They helped improve the efficiency and productivity with creative suggestions related to their specific tasks.

Things were a bit different in Europe. Workers saw technology as a threat. Starting about 1811, the Luddites, named after their anonymous leader, "King Ludd," organized a movement of "machine breaking" textile workers who destroyed wool and cotton mills throughout England. Such actions were declared capital crimes and in 1813, seventeen men were executed for the offense. In 1820, the Cotton Spinner's Association in Manchester, England, organized one of the first strikes of the industrial revolution. A French tailor, Barthélemy Thimonnier (1793–1857), patented the first functional sewing machine in 1830. Thimonnier's machine used only one thread and a hooked needle that made the same chain stitch used with embroidery. The inventor was almost killed by an enraged group of French tailors who burnt down his garment factory because they feared unemployment as a result of his invention.

American inventors fared better. In 1833, Walter Hunt (1796–1859) invented and produced the first lockstitch machine, but refused to patent it. In 1846, Elias Howe Jr. (1819–1867) invented and patented the first domestic sewing machine and earned a million dollars through its manufacture. By 1851, Isaac Singer (1811–1875) added foot power and other features to become the leader in the field of these popular household mechanical seamstresses.

Another innovator, Cyrus McCormick Sr. (1809–1884), patented his horse-drawn reaper to harvest wheat in 1834. He and his brother Leander moved from Virginia to Chicago in 1839 and established a large firm for manufacturing agricultural implements, including the reaper, and took advantage of the new railroads to distribute their products far and wide. They established a network of sales representatives to demonstrate and sell products. In 1851, McCormick and his reaper would win the gold medal at the Crystal Palace Exhibition in London. A famous 1860 painting, *Westward the Course of the Empire Takes Its Way*, by Emanuel Leutze (1816–1868), was slightly retitled as a McCormick company slogan by adding "with McCormick Reapers in the Van."

Isaac Singer's sewing machine, 1851, Patent No. 8,294 (Smithsonian Institution, Washington, D.C.).

McCormick reaper, 1845 (State Historical Society of Wisconsin, McCormick Collection).

Rapid commercial communication was difficult with slow travel by boats, horseback, and stagecoaches. In 1837, an accomplished artist and professor of arts and design then at New York University, Samuel F.B. Morse, perfected recent German discoveries in electromagnetic telegraphy by using poor quality inexpensive wire that could transmit over long distances. He then invented a code consisting of dots and dashes which made the electric signals easily translatable into letters of the alphabet. He gave a public demonstration in 1838 and by 1844 Congress had appropriated funds and erected a telegraph line between Baltimore and Washington to report the first news dispatch by telegraph: the nomination in Baltimore of Henry Clay of the Whig Party for president of the United States.

Samuel Colt (1814–1862) patented his "revolving gun" in 1836 and formed the Patent Arms Manufacturing Company in Paterson, New Jersey. He specifically wanted all parts of his revolver to be interchangeable and made by machine. An economic recession soon forced him to close the plant; but after several years of developing other inventions, he resumed production with a new factory for the Colt Patent Arms Manufacturing Company in Hartford, Connecticut, in 1847. He produced 1,000 single action army Colt .45 revolvers for the Texas Rangers during the Mexican-American War and later built a larger factory called the Colt Armory, which used 1,400 machine tools and provided his many employees with housing and a recreation hall. Colt was worth $5 million at the time of his death in 1862.

After President Andrew Jackson (1767–1845) implemented direct voting for the presidency by the public in 1828, American democracy was seen as a unique institution to be analyzed and studied by Europeans. Along with an extensive analysis of American culture and politics, de Tocqueville included specific references to the effects of mass manufacture:

The artisan in a democracy strives to invent methods which will enable him not only to work better, but cheaper and quicker; or, if he cannot succeed in that, to diminish the intrinsic qualities of the thing he makes, without making it wholly unfit for the use for which it is intended. Thus, the democratic principle not only tends to direct the human mind to the useful arts, but it induces the artisan to produce with great rapidity a quantity of imperfect commodities, and the consumer to content himself with these commodities.[7]

Tocqueville, like many Europeans, viewed American manufactured products as inferior in quality simply because they were less expensive to produce in quantity. This was in contrast to the accepted European standard of "quality" as being evidenced only by the manual skills of craftsmen producing ornamentation that added cost to manufacture. The concept of social value in providing common people with products, instead of only the upper classes, and of consumers who preferred usefulness to ornamentation were strange ideas to Europeans, where only the comfortable and wealthy could afford expensive products. Thus they would adopt a new term to describe this unusual process—"The American System of Manufacture."

Samuel Colt's .45 revolver (courtesy Smithsonian Institution).

Workers in American factories welcomed the opportunity to participate in manufacturing, unlike Europeans, who regarded mechanization as a threat to employment and who destroyed machines in protest. American workers were inspired by the westward expansion of their country and felt that the use of natural resources and human ingenuity would benefit the great nation of which they were an integral part. They embraced the idea of progress and viewed inventions and technology as the best way to advance their productivity and personal well-being. The growing middle class welcomed laborsaving devices to relieve them of hard, manual labor and drudgery, and to achieve material success for themselves and their descendants.

Tocqueville also commented on American's inherent preference for usefulness over adornment and beauty:

> It would be to waste the time of my readers and my own, if I strove to demonstrate how the general mediocrity of fortunes, the absence of superfluous wealth, the universal desire for comfort, and the constant efforts by which everyone attempts to procure it, make the taste for the useful predominate over the love of the beautiful in the heart of man. Democratic nations, amongst which all these things exist, will therefore cultivate the arts which serve to render life easy, in preference to those whose object is to adorn it. They will habitually prefer the useful to the beautiful, and they will require that the beautiful should be useful.[8]

Tocqueville's view of functionality and beauty as separate qualities, a perception that would forever plague the design world, was based on the condescending assumption that only the educated elite could appreciate the classical beauty of western civilization. The classic architecture, art, and statuary of the Greeks and Romans and the cathedrals and art of the Renaissance were the European standards of beauty and taste. While this was obvious to Tocqueville and European upper classes, such refinements of culture were either unknown or irrelevant to all but a few wealthy Americans. These wealthy purchasers considered European products that reflected these classical characteristics through ornamentation or decoration as being "beautiful." The new middle class accepted and adopted this standard as a required evidence of their social and material aspirations.

The intellectual concept that beauty could be created through functional simplicity, quality of workmanship, and gracefulness of form was still a century in the future. However,

a few American craftsmen, totally isolated from both the rush to industrialization and the acquisition of European goods of luxury, proved that it was possible, although that was not their purpose.

A religious sect, the United Society of Believers, better known as Shakers, had been firmly established in small separatist, communal groups scattered throughout Northeast states, with their primary settlement in New Lebanon, New York. The name originated from the uncontrollable spiritual shakings originally practiced by the sect, but which had been modified into simple line dances by 1790. The sect was initiated in 1774 by a working-class woman from Manchester, England, Mother Ann Lee, and eight followers who sought to create a new chaste order based on Christ, free from the corruptions of the Old World. Ann set the spiritual tone for the Shaker work ethic: "Do all your work as though you had a thousand years to live, and as you would if you knew you must die tomorrow. Put your hands to work, and your hearts to God."[9]

New Lebanon, founded in 1787, was the first Shaker organized and planned community. All property was owned in common. Believers could not marry, have children, own property, or maintain contact with the world. They worked daily in numerous trades of self-sustenance: as farmers, weavers, cooks, shepherds, teachers, physicians, printers, stonemasons, builders, tailors, and craftsmen of all kinds. To maintain cohesion among followers, Shaker communities tried to worship, think, act, and look alike. Accordingly, Shaker architecture, clothing, village planning, and household articles, in any of the dozen or so scattered communities of a hundred each, followed the style and appearance of the original New Lebanon.

By 1840, there were about 4,000 members in 18 communities of Shakers from Maine

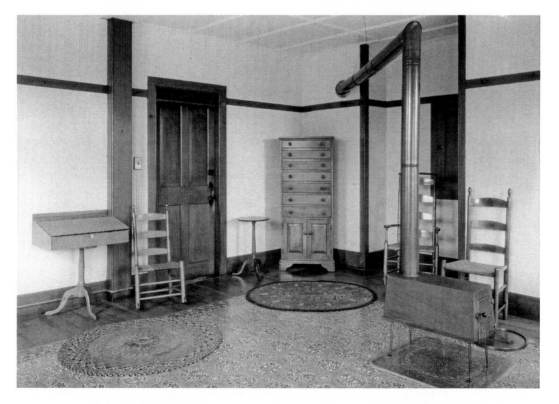

Shaker Church Family House, Hancock, Berkshire County, Massachusetts.

to Kentucky. Free of the demands of marriage or parenthood, financial worries, and daily sustenance, and unencumbered by external stylebooks or formal art and design education, the workshops created simple, functional interiors, furniture, equipment, implements, and articles of clothing that were extraordinary in gracefulness, appropriateness, proportionality, craftsman-like perfection, and quiet beauty. In addition to building and furnishing their own buildings, they sold a number of their workshop products to the outside world to generate income for the community.

We know these products today as Shaker design. Shakers of that time regarded their work without conscious aesthetic appreciation or even awareness. They were simply doing quality work as Mother Ann had instructed them. Their spiritual environment freed them from worldly taste or unnecessary ornamentation, and yet they created a purity of design that we respect to this day.

Although Shaker designs were unusually refined in their aesthetic details, similar products of simple functionality were being created in hundreds of American frontier and farm communities without fanfare or recognition by design authorities. With no access to manufactured goods, or means to obtain them in remote locations, many Americans were making their own furniture, artifacts, and equipment and clothing without aesthetics in mind, but only durability and usefulness. This unique quality of functional and ornament-free American design was recognized only later. The basic Shaker spiritual work ethic of making goods with the personal satisfaction of care, order, and quality, as they crafted their very best, was quite similar to William Morris's Arts and Crafts philosophy of the late 1860s, except for the religious component and the stylistic differences.

Outside of the Shakers' obscure, otherworldly enclaves, the simple, functional, and utilitarian preferences of many Americans were gradually replaced by a desire for more refined, European examples of beauty and decoration. They aspired to possession of such products so that they could display their material success and social status to their less fortunate neighbors.

One of the most common symbols of this desire to impress was household furniture. Most furniture of the early nineteenth century in America was either handmade by families themselves or by local woodworkers. The results were purely functional and often crude. However, to possess "fancy" furniture that was not only utilitarian but that also displayed decorative sophistication was an obvious way to impress one's neighbors with evidence of financial success. If one were wealthy, one could purchase expensive English furniture by the firms of George Hepplewhite, Thomas Sheraton, or Thomas Chippendale, or, comparable but still expensive hand-made copies from well-known Litchfield County, Connecticut, furniture-makers such as Silas Cheney (1776–1821), Joseph Adams (1767–1856), or George Dewey (1790–1853). The design of much of this "fancy" furniture was copied from English pattern books, and in succession, followed Georgian, Greek revival, or Empire styles.

After about 1825, however, one could buy inexpensive, fancy, painted chairs by Lambert Hitchcock (1795–1852), the first of American firms to adapt to quantity production. Hitchcock, an 1814 apprentice to Silas Cheney, had established a Riverton, Connecticut, mill-powered furniture factory in 1818, making unfinished chair parts for other companies as replacement parts; but between 1828 and 1848 he produced his own chairs. Hitchcock was inspired by clock maker Eli Terry's process of making wooden clocks to mass-produce simple, affordable chairs and to distribute them throughout the country. He set up an assembly line process of cutting and assembling various parts. The chairs were small and simple in

design, usually painted black, with rush or cane seats and gold stripes hand-painted here and there. Instead of hand-painting or carving decorations on chair backs, he used a much easier technique of stenciling to speed up production. The stenciling depicted leaves, flowers, or fruit. In general, his design was based on the popular Sheraton style of the time, with a touch of Empire style. At the height of his business, his company was producing 15,000 chairs per year that sold for 25 cents wholesale — probably about 50 cents retail. As Hitchcock was not a good businessman, his company went into receivership in 1832 and was run by his brothers-in-law; but by 1843, he sold his interests and the company shut down.

By this time, manufacturers were well aware that domestic utilitarian consumer products sold better if they included fashionable decoration or ornamentation. Consumers perceived such additions and appearance changes as being more "up-to-date" and felt that products without such periodic improvements were lagging behind. As the demand for more stylish products increased, and as manufacturers scrambled to provide newness, the easiest way for manufacturers to compete was to copy more successful versions of their product line, either European or American. Design piracy, we would call it today. But the demand for "more stylish" products was a result of increasing travel by Americans to Europe in the 1830s and 1840s. There, many saw for the first time the masterpieces of painting and sculpture, the dramatic cathedrals and architecture, and the use of art in every walk of life. Many were totally amazed: "Every idea is made to speak to the senses; and there is scarcely a beautiful or magnificent conception published in Europe that has not been painted, engraved, sculptured, carved, or molded in plaster, and placed in galleries or offered for sale in the shops. Thus the mass of the people can look upon the visible embodiment."[10]

Ralph Waldo Emerson noted that "everything is ornamented ... coats, jackets, cloaks and garters; the very crutches cripples lean on were carved. Every fountain, every pump, every post is sculptured, and not the commonest tavern room but its ceiling is painted."[11] Thousands of similar reactions filled travel books and maga-

Lambert Hitchcock chair (1828–1848) (Index of American Design, National Gallery of Art).

zines, and many Americans began to realize the deficiency of their own country in the arts and in refinement of detail. Attitudes regarding ornamentation were changing.

Mechanical patents for domestic products had increased exponentially compared to those of a commercial or scientific nature, as mass production made more affordable products available to a larger segment of the market. Even Abraham Lincoln, after a term in the U.S. House of Representatives, would became an inventor with his 1849 Patent No. 6469 for a mechanical device to lift boats over shoals. It was never manufactured, but he was the only U.S. president to have held a patent. During the 1850s, he occasionally delivered a lecture called "Discoveries and Inventions."

In 1842 the patent office convinced Congress to pass an "Act to Promote the Progress of the Useful Arts," patterned after an earlier, similar English act, which permitted the commissioner of patents to issue design patents for "any new and original shape or configuration of any article of manufacture not known or used by others before."[12]

Within a year, 14 "design patents" were granted, and within 10 years, the annual number had increased to 100. This encouraged originality by artists and designers of many nonmechanical artifacts from textile patterns to teapots to sculptures. Design patents were a recognition that visual invention was just as important to protect as mechanical invention.

Up until this time, foreign imports had a huge commercial advantage, first because European designs were generally perceived as superior in style, and second because all imports were duty free. Now, in 1842, to encourage domestic production and profitability, the government implemented high restrictive tariffs of about 33 percent on foreign imports (so much for free trade!). However, within 10 years, American production volumes of many items doubled, tripled, and quadrupled. By 1850 the south produced two-thirds of the world's cotton, which fed the factories of the north and Great Britain. Moreover, from 1815 to 1850, U.S. population trebled, dramatically expanding the domestic market for American-made goods. The country also increased by more than 1.7 million square miles due to the acquisition of Texas, California, Arizona, Nevada, Utah, and parts of Colorado, Arizona, New Mexico, and Wyoming as a result of the U.S.–Mexican War of 1846–1848.

England had dominated the industrialization process since its inception and had brought forth a number of influential technological inventions including the arc lamp (Humphry Davy, 1809), the tin can (Peter Durand, 1810), the electromagnet (William Sturgeon, 1825), an early telegraph (Charles Wheatstone, 1837), a mechanical analytical engine (Charles Babbage, 1822–1833) and a primitive fax machine (Alexander Bain, 1843).

France, the most powerful nation in Europe before its revolution (1789–1799) inspired by America's, soon became preoccupied with the military exploits of Emperor Napoleon Bonaparte throughout Europe, Russia, and the Middle East until his defeat at Waterloo in 1815. After this, significant French technological advances included the fresnel lens (Augustin-Jean Fresnel, 1823), photography (Louis-Jacques Daguerre, 1838), and the first cylindrical bullet (Claude Etienne Minié, 1849). France dominated the art world, with artists such as Jean-Auguste-Dominique Ingres (1780–1867), Eugène Delacroix (1798–1863), and Édouard Manet (1832–1883). From the Court of Napoleon came French Empire styles in the first half of the 19th century. French designers were inspired by recent discoveries of ancient artifacts of Rome, Greece, and Egypt by Napoleon's troops, and motifs from these periods soon adorned many French artifacts and furnishings, which found their way into pattern books used by American master craftsmen. By mid-century, France was the world leader of style and taste.

In Germany, cities began to be illuminated by gaslight (1811), Krupp established a steel

plant in Essen (1810), aluminum was first produced (Friedrich Wöhler, 1827), and an improved telegraph was developed (Karl Gauss, 1833). Germany during this period was not noted for style, but for high quality craftsmanship and intricate carving. Traditional German furniture was generally in the Baroque (17th century) or Rococo (1720–1760) styles. From 1815 to 1860, Biedermeier style, based on a simplified interpretation of the French Empire style, became dominant. It was the first style to emanate from the growing middle class. The style used inexpensive wood and initially had clean lines with minimal ornamentation, which influenced Scandinavian styles; but later in the century it became somewhat of an elegant fantasy style. Biedermeier is not the name of a designer, but of a political caricature of a well-to-do middle-class man without culture, as described in a German newspaper.

Furniture styles are a good indicator of general household furniture design, but can become complicated in time frames and duration. Biedermeier style in Germany roughly corresponded with the Regency Style in England (1811–1830), Federal Style in the U.S. (1780–1820), and the French Empire Style (1815–1848).

Creative Americans were well aware of these European developments and styles as they occurred and quickly adopted or improved upon them. By mid-century, America was slowly catching up with Europe in industrialization and productivity, but certainly not in decorative arts or styles. Evidence of innovative styles or design in America was virtually nonexistent. All creative energies were directed to the pragmatic and functional economic needs of a growing nation: transportation, communication, manufacturing, and distribution. American-made goods were needed for self-defense, farming, and homesteading on the rapidly expanding frontier. A growing population of immigrants needed inexpensive and utilitarian pottery, tools and furnishings. The market for expensive luxury goods was restricted to small segments of wealthy individuals in urban areas who had easy access to imports and grand homes to furnish. These luxury goods came primarily from Europe, but American businesses in luxury items also became viable.

American silver manufactories were established, including Gorham Manufacturing in 1831, and Tiffany & Company in 1837. The California Gold Rush of 1849 was one of the most important events in the history of jewelry. The American jewelry industry gradually had grown from small workshops to large factories and from handcraftsmanship to increasingly mechanized production. By the mid-nineteenth century, American jewelers were able to supply their patrons with a wide range of objects, including gold and silver jewelry and medals; hair jewelry to memorialize or honor a loved one; and brooch-and-earring sets inspired by French or English models. Cameos, whether carved here or imported from Italy, were especially prized.

Up until this time, Americans did not have the technology to cast bronze sculpture. Rather, functional objects were cast only in lead or iron. American sculptors had to rely on European foundries for bronze. But in the late 1840s, American sculptor Henry Kirke Brown (1814–1886) had established a foundry in Brooklyn to cast his bronze sculptures and utilitarian objects. He worked with Ames Manufacturing in Chicopee, Massachusetts, which produced bronze cannon and swords and also cast monumental sculptures. The naturalistic esthetic developed by Brown and his former student, John Quincy Adams Ward (1830–1910), would dominate American sculpture in the second half of the century. Appreciation of sculpture in America began with the rural cemetery movement during the 1830s and 1840s, which was related to public demand for city parks similar to those many travelers had seen in European cities. The Washington monument, designed by architect Robert

Mills (1781–1855) and begun in 1848, was a result of a national demand for patriotic monuments, growing since the founding fathers had passed away.

One of the key architectural influences in American towns was landscape architect and writer Andrew Jackson Downing (1815–1852), who advocated building beautiful homes in the Gothic Revival style amid natural settings to be a "barrier against vice, immorality, and bad habits." His popular books included *A Treatise on the Theory and Practice of Landscape Gardening, Adapted to North America* (1841), *Cottage Residences* (1842) and *The Architecture of Country Houses* (1850), the latter two being influential pattern books that included homes as well as their gardens. President Millard Fillmore commissioned him to design the grounds of the White House and the Smithsonian Institute, established in 1846. Downing designs included curvilinear walks and drives intended to serve as a model for national parks. In fact, he collaborated with Frederick Law Olmsted (1822–1903) in the Greensward Plan, selected in the 1858 design competition for New York's Central Park. He is credited with the popularization of the front porch and with initiating the national landscape crusade for beauty.

It was time to test America's progress against international competition for the first time. To many Europeans, America was still a vast, undeveloped frontier populated with unsophisticated and uneducated homesteaders, farmers, and tradesmen, many of whom were still fighting natives for land and were considered totally incapable of artistic or design appreciation. In many instances they were right, but Europeans would soon take notice of the expanding American technological and design challenge.

Chapter 3

1850–1875
International Competition

The 1851 Great Exhibition of the Works of Industry in All Nations, known forever after as the Great Exhibition, was held in Hyde Park, London, and was the first of many similar world fairs that continued for over a century. The exhibition was due in large part to Henry Cole (1808–1882), a British civil servant. Cole not only championed the principles of industrial art, but also, under the pseudonym of Felix Summerly, had designed a number of production products, including a prize-winning teapot made by Minton, Ltd., a major ceramics manufacturer.

As a member of the Society for the Encouragement of Arts, Manufactures, and Commerce, Cole had obtained a royal charter for the Society from Prince Albert in 1847 and had successfully organized exhibitions of "Art and Manufactures" in 1847, 1848, and 1849, coining the term "art manufacture" to describe "fine art or beauty applied to mechanical production." In 1849 he founded the *Journal of Design*—edited by artist and arts administrator Richard Redgrave (1804–1888)—reporting and commenting on all kinds of products and their design over a three-year period. He is probably one of the first to publicly challenge the traditional perception of "design" as simply the addition of artistic and decorative ornamentation onto basically functional objects and to declare this practice as being in poor taste. Redgrave stated the following in an early issue of the *Journal*:

> Design has a twofold relation, having in the first place, a strict reference to utility in the thing designed; and, secondarily, to the beautifying or ornamenting that utility. The word "design," however, with the many has become identified rather with its secondary than with its whole signification—with ornament, as apart from, and often even opposed to, utility. From thus confounding that which is in itself but an addition, with that which is essential, has arisen many of those great errors in taste which are observable in the works of modern designers.[1]

A later article more specifically pointed out the need for a designer to take into account the limitations of mass production rather than total preoccupation with self-expression: "The acme of beauty in design is only to be attained, when the system of ornamentation is conducted in strict accordance with the scientific theory of production—when, in fact, the physical condition of materials, and the economic processes of manufacture, limit and dictate the boundaries within which the imagination of the designer may revel."[2] This prescient point of view was unfortunately in the minority. The opinion of many artists, and certainly the general public, was expressed by another article in the *Journal*, from a lecture by Scottish artist William Dyce (1806–1864), head of the British Government School of Design from 1838 to 1843, claiming ornament was a natural human necessity: "Ornamental art is an

ingredient necessary to the completeness of the results of mechanical skill. I say necessary, because we all feel it to be so. The love of ornament is a tendency of our being. We all are sensible, and we cannot help being so, that mechanical skeletons without a skin, like birds without feathers—pieces of organization, without the ingredient which renders natural productions objects of pleasure to the senses."[3]

Cole hoped that a national exhibition would lead to better and more consistent standards of design for industry. He secured the backing of Queen Victoria in 1850 to establish the "Royal Commission for the Exhibition of 1851" to organize the exhibition as the first of an international nature. Being one of the commissioners, Cole noted that there had been no previous international exhibitions in Europe, and added that such a suggestion had been made by M. Buffet, the French minister of commerce, in 1848. It was to be a celebration of modern industrial technology and design and was opened by 32-year-old Queen Victoria in May 1851.

The Great Exhibition was housed in the Crystal Palace, a dramatic and unique structure of iron framework covered with glass designed by Joseph Paxton (1803–1865), a landscape gardener whose pioneering in greenhouse construction had earned him a reputation as an innovative architect. The building, 1848 feet long by 108 feet wide, was prefabricated, modular, and erected in eight months by 2000 men. Some predicted that the huge glass structure would collapse from the weight of bird droppings on it. Architect Owen Jones (1809–1874) designed the interior color scheme in shades of blue, red, and yellow, which created a dramatic effect.

Exhibits from many countries displayed the latest in decorative arts. Most medals were won by France, then the international leader of style and taste, with designs that tortured

Exterior of Crystal Palace, London, 1851.

Interior of Crystal Palace (courtesy of Raymond Spilman and Wallace H. Appel).

the smallest gas bracket with convolutions of naturalistic leaves and flowers entwined with classical Greek images. English products followed the French lead as best they could. American exhibits tried to imitate the French with ornate carriages, pianos, and furniture. American products, in their first international exposure, were not regarded as serious style competitors to Europe. Some described them as "tasteless," with little ornamental value. In general, the expectations of Cole and other organizers were that public taste would be raised, but they were disappointed with the excess of machine-made ornament, gaudy colors, and imitation of materials that taken all together became known as Victorian design.

The Victorian designer focused on the superficial surface of a product rather than on its structure. The ornamentation was often borrowed from Greek, Roman, or Gothic historical styles, or covered with narrative images of flowers, angels, cherubs or the like. Inspirational mottos were popular, in keeping with the designer's devotion to self-expression. Size was essential, as huge furniture was required to match the large scale and ostentation of Victorian mansions. A particularly popular form in chairs called to mind the general shape of a violin, or, more suggestively, the corseted narrow waist of a full-busted, hoop-skirted woman. Many furniture designers experimented with new materials other than wood, including wicker, papier-mâché, iron, zinc, and hard rubber. Designers were fascinated with simulating one material with another. Glass and wood were painted to resemble marble, electroplated zinc to resemble silver, and pine painted to resemble oak. Another trend was multipurpose furniture. British firms at the exhibition introduced a "steamship sofa" and a portmanteau (suitcase), each of which converted into a dubiously functional life raft.

It was America's pragmatic and functional examples of invention and technology that caught world attention and made headlines at the exhibition. Samuel Colt (1814–1862) displayed his revolving breech pistol, perfected in 1847 with interchangeable production parts. Joseph Saxton's (1799–1873) tidal gauge had provided the first record of an earthquake. Charles Goodyear (1800–1860) exhibited goods of hard India rubber made with his new vulcanizing process. Cyrus McCormick's (1809–1884) ungainly horse-drawn reaper, patented in 1834 and manufactured after 1839, won the highest award at the exhibition, the Gold Medal, after successfully demonstrating his reaper's superiority over a British reaper in English fields.

An American locksmith, Alfred Charles Hobbs (1812–1891), exhibiting a new "Parautoptic" lock for the Newell company, successfully picked the famous British bank lock, the Bramah, which had withstood all challenges since 1784, while the Parautoptic defeated all attempts by British locksmiths to open it.

An American arms manufacturer since 1846, Robbins & Lawrence, of Windsor, Vermont, exhibited six U.S. Army rifles it had

Bramah lock, 1784.

made. The rifles were made with perfect interchangeability of parts and won an exhibition medal that led to an 1854 contract with the British government for 150 machine tools for a new Royal Small Arms Factory at Enfield. This was clear evidence of American superiority in high quality manufacture. Sir Joseph Whitworth (1803–1887), an English machine tool inventor, stated why he thought America excelled in manufacture: "The labouring classes (in America) are comparatively few in number, but this is counterbalanced by, and indeed may be regarded as one of the chief causes of, the eagerness with which they call in the aid of machinery.... [W]herever it can be introduced, it is universally and willingly resorted to."[4]

Finally, America scored a huge public relations victory. In a race held in conjunction with the exhibition in August, the victory of the New York Yacht Club's racing yacht *America* over 15 competitors of the Royal Yacht Squadron astounded the sailing world — particularly the British, with their invincible sea power — by winning the first Royal Yacht Squadron Cup. It would become better known over the years as the America's Cup, and America remained unbeaten in the event despite 25 challenges over 113 years. Yacht designer George Steers (1820–1856) designed the *America*.

There were surprising accolades from the British press for the Americans. The *London Times* reported:

> It is beyond all denial that every practical success of the season belongs to the Americans. Their consignments showed poorly at first, but came out well on trial. Their reaping machine has carried

Yacht *America*, **designed by George Steers.**

conviction to the heart of the British agriculturist. Their revolvers threaten to revolutionize military tactics as completely as the original discovery of gunpowder. Their yacht takes to a class to itself. Of all the victories ever won, none has been so transcendent as that of the New York Schooner. Beside this, the Baltic, one of the Collin's line of steamers has "made the fastest passage yet known across the Atlantic" ... so we think, on the whole, that we may afford to shake hands and exchange congratulations, after which we must learn as much from each other as we can.[5]

The *London Observer*, on the other hand, perceptively compared the unique character of American manufacturing and design philosophy with that of Europe:

> They produce for the masses, and for wholesale consumption. There is hardly anything shown by them which is not easily within the reach of the most modest fortune. No Government of favoritism raises any manufacturers to a pre-eminence, which secures for it the patronage of the wealthy. Everything is entrusted to the ingenuity of individuals, who look for their reward in public demand alone. With an immense command of raw produce, they do not, like other countries, skip over the wants of the many and rush to supply the luxuries of the few.... [T]hey have turned their attention eagerly and successfully to machinery, as the first stage in their industrial progress. They seek to supply the shortcomings of their labor market, and to combine utility with cheapness. The most ordinary commodities are not beneath their notice.[6]

The *Observer* was attempting to describe what was becoming well known as the "American System" of manufacture: the large-scale production of standardized products with interchangeable parts and using powered machine tools in a sequence of simplified assembly operations. This also included organization and coordination of the entire process, and the way in which the products were marketed and distributed, as well as how they were made.

But American design philosophy had yet to be articulated. A prominent American sculptor, Horatio Greenough (1805–1852) — who had created the larger-than-life, half-nude statue of George Washington (now in the National Museum of American Art, Washington, D.C.) and had published a book under the pseudonym Horace Bender in 1852 entitled *The Travels, Observations, and Experience of a Yankee Stonecutter* — posited one of the earliest theories of functionalist design, by comparing the evolution of design to biological evolution seven years before Charles Darwin published *On the Origin of Species*. Greenough walked through the logic of his "Law of Adaptation" in exquisite, poetic language only partly appreciated in these brief excerpts; first, on the natural beauty of animals, no matter what their shape: "The horse's shanks are thin, and we admire them; the greyhound's chest is deep, and we cry, beautiful! It is neither the presence nor the absence of this or that part or shape or color that wins our eye in natural objects; it is the consistency and harmony of the parts juxtaposed, the subordination of details to masses, and of masses to the whole."[7]

He moved on to natural human craftsmanship of functional objects: "When the savage ... shapes his war club, his first thought is of its use. His first efforts pare the long shaft, and mould the convenient handle; then the heavier end takes gradually the shape that cuts, while it retains the weight that stuns.... We admire its effective shape ... [and] graceful form ... yet we neglect the lesson it might teach." The lesson referred to was the process of iterative design and development: "If we compare the form of a newly invented machine with the perfected type of the same instrument, we observe, as we trace it through the phases of improvement, how weight is shaken off where strength is less needed, how functions are made to approach without impeding each other, how the straight becomes curved, and the curve is straightened, till the straggling and cumbersome machine becomes the compact, effective, and beautiful engine."[8]

He cited further examples of graceful and efficient sailing ships that have evolved from

crude historical attempts, and years of refinement that rivaled the natural beauty of animals. He concluded with the heart of his theory, which is simplification of form:

> The normal development of beauty is through action to completeness. The invariable development of embellishment and decoration is more embellishment and decoration. The reductio ad absur-dum [reduction to the absurd] is palpable enough at last; but where was the first downward step? I maintain that the first downward step was the introduction of the first inorganic, non-functional element, whether of shape or color. If I be told that such a system as mine would produce naked-ness, I accept the omen. In nakedness I behold the majesty of the essential, instead of the trappings of pretension.... Beauty is the promise of function.[9]

Greenough was the first well-known artist to advocate and articulate design based on functional principles and to oppose nonfunctional embellishment and decoration, a modern concept that would not be heeded generally in design communities until architect Louis Sullivan renewed it in 1896 as his "form follows function" declaration. When Greenough visited the London Fair in 1851, he predictably criticized British design for its "excremental corruptions" of foreign "gewgaws and extravagance, arbitrary embellishment, and catch-penny novelties" while at the same time defending American simplicity as "the dearest of all styles" because it required "much thought, untiring investigation, ceaseless experiment."[10]

Examples of Greenough's "dearest of all styles" were designed by one of the exhibitors at the fair, a German-Austrian cabinetmaker, Michael Thonet (1796–1871), who in 1849, with his five sons, had founded a new company, Gebrüder Thonet. A producer of furniture since the 1830s, he had recently developed a new construction process of "giving wood var-ious curves and forms by cutting and re-gluing" steamed wooden rods. The resulting fur-niture was not only lightweight and strong, but also decorative and attractive in form without applied and nonfunctional ornament. The forms were not arbitrarily devised, but resulted from the unique character of the material and the production method. The process of making parts was separated from the process of assembling them, thus speeding pro-duction. Gebrüder Thonet won a bronze medal at the fair for its Vienna bentwood chairs, which enjoyed almost instant success.

Within four years Thonet employed 70 workers and was exporting to foreign countries. His Model No. 14 "coffee shop" chair of 1859 became ubiquitous in cafes throughout Europe. Fifty million were produced over 80 years, and the chair is still a classic. When Thonet's patent expired in 1869, competitors such as Jacob & Josef Kohn in Moravia, and countless other international firms, imitated the Thonet design style.

After the Great Exhibition, Henry Cole was instrumental in urging the use of its surplus cash to improve science and art education in the United Kingdom. He was named the first general superintendent of the Department of Practical Art, which had been set up by the government to improve standards of art and design education in Britain in reference to industry; in 1857 he became the first director of the South Kensington Museum, which would be renamed the Victoria and Albert Museum in 1899. Cole believed that "an alliance between fine art and manufacture would promote public taste," and that "elegant forms may be made not to cost more than inelegant ones."[11]

A German refugee from the 1848 Prussian revolution, architect Gottfried Semper (1803–1879) lived in London from 1851 to 1854, taught applied arts at the South Kensington Schools (formerly the British Government School of Design) and was acquainted with Cole. In 1852 he published a pamphlet, *Wissenschaft, Industrie und Kunst* (*Science, Industry, and Art*) based on his impressions of the Great Exhibition. He concluded that the problem of the arts was in failing to come to terms with scientific and technological advances. He

further argued that the legacies of the past, particularly craft traditions, had to be swept away before it was possible to create a new industrial art, based on acceptance and command of mechanization. He felt that style was "the elevation to artistic significance of the content of the basic idea" in designing an artifact. This concept of basic form was modified by the materials and processes employed upon it, and also by "many influences outside the work itself which are important factors contributing to its design," including location, climate, time, custom, and the nature of the user.[12]

Cole, Greenough, Semper, and others were struggling to define how product design was different from the fine arts or handcrafts. As industrialization increased the availability and affordability of household products, many sculptors and craftsmen viewed them as blank canvasses upon which to convey their unique artistic and craft skills to a broader audience, rather than as a collaboration with industry. When one's only tool is an axe, everything looks like a tree.

Industrialists were becoming increasingly interested in the commercial value of trained artists. Additional schools were being organized to meet the growing demand, particularly for females, who were anxious to join the expanding industrial workforce. Some schools prepared female artists for the textile and wallpaper industries. These schools included the Philadelphia School of Design for Women, now Moore College of Art (1848), founded by Sarah Worthington Peter; the Philadelphia School of Design, founded in 1850 by the Franklin Institute; New England School of Design for Women in Boston, organized by abolitionist Ednah Dow Littlehale Cheney (1851); New York School of Design for Women, founded by Mary Morris Hamilton (1852); and Maryland Institute for Promotion of Mechanics Arts in Baltimore with a "Female Department" design school (1854). The Pennsylvania Institute of Design held its first annual exhibition in 1857.

Even more significant was the establishment of a public school system that enabled millions of young people to become educated so that they could participate in the rapidly expanding economy of manufacturing and technology. Most citizens, including youths, worked on farms. Many had little, if any, formal education at all. Horace Mann (1796–1859), Massachusetts' representative to Congress (1827–1833), state senator (1834–1837), and educa-

Gebrüder Thonet's Model No. 18 "coffee shop" chair, 1867 (courtesy Die Neue Sammlung, International Design Museum, Munich).

Philadelphia School of Design for Women, woodcut by a student in 1851 (from S.L. Wright, *The Story of the Franklin Institute*).

tion reformer, in 1852 was appointed the first state-wide director of education. He was instrumental in laws requiring mandatory public education to age 16 in the state, a model soon adopted by the State of New York and the rest of the country. This system fostered a new generation of technically skilled adults who joined the explosion of inventions and manufacturing in the last quarter of the century.

Inspired by the Great Exhibition, America initiated its own world fair in July 1853, the Exhibition of the Industry of All Nations, held in Bryant Park, Manhattan, in an imitative glass structure appropriately referred to as the "New York Crystal Palace." The fair, according to its guidebook, sought "to promote a correct appreciation of what is really beautiful in the arts of design — to awaken in the people of the United States a quicker sense of the grace and elegance of which familiar objects are capable — and to encourage our manufacturers by placing before them the productions of European taste and skill" in order that Americans might appreciate the value of "an alliance of art with commercial industry."[13] What better evidence of American reliance on Europe for all things of quality and good taste!

Just before the fair opened, George Wallis (1811–1891), director of the Government School of Art and Design in Birmingham, England, toured American mills and workshops from New England to Ohio over an 11-week period, with particular interest in consumer products. He concluded that Americans had moved beyond their earlier simple tastes, and now both manufacturers and consumers demanded extravagant decoration and ornamentation on products to emulate the styles of European tastemakers. Wallis regarded this trend as quite disturbing and felt that it needed to be checked. It was the same excessive decoration that plagued design leaders in England.

It was obvious that Americans were more interested in proving their equality with Europe through imitation than capitalizing on their natural tendency toward simple, unadorned, functional designs. Authors of a review of the exhibition wrote that "the plainness that was once satisfactory" was no longer enough for Americans who demanded "decoration in every branch of manufacture."[14]

This statement accurately reflected popular interest in both the highly ornamented European styles and their slavish American imitations. But a growing dichotomy was becoming prevalent in both popular and art/design circles. Household products seen by guests, such as furniture, lighting fixtures, vases, silverware, stoves, fireplaces, wallpaper, carriages, draperies and the like required extensive decoration to demonstrate their owner's rising social status, artistic appreciation, and economic advance. These manufactured products would become well known as the "art industries" and attracted many decorative artists and craftsmen. On the other hand, mechanical, functional products, such as locomotives, telegraph equipment, farm machinery, steam engines, factory machinery, military equipment, and common everyday utensils and tools would become known as the "artless industries," with products generally designed by engineers and manufacturers without any artistic or design consideration. Their value was not in display, but in totally functional, technological, or work-saving roles.

One young man of 17 in London had been appalled at the ugliness of the exhibits at the Great Exhibition of 1851, and this influenced his career choice to design better things. In 1861, William Edward Morris (1834–1896) founded the decorative arts firm of Morris, Marshall, Faulkner & Co., with his Oxford friends Dante Gabriel Rossetti (1828–1882), Edward Burne-Jones (1833–1898), painter Ford Madox Brown (1821–1893), and architect Philip Webb (1831–1915), all as partners, together with architect Charles Faulkner and P.P. Marshall. With numerous changes in personnel and company names, the firm was best known after 1875 as Morris & Co., and William Morris was principle owner and director throughout his life.

Morris was a man of broad talents and interests. He studied architecture and painting, was a published writer of poetry, fiction, and translations of Icelandic sagas, and medieval and classical texts. With Philip Webb, he designed and built Red House (so named because the use of red brick without stucco was a novelty at the time) in 1859 for himself and his wife, which was the first attempt by an artist/architect to apply art throughout a home for the practical objects of daily life, including ceiling paintings, wall hangings, furniture, wall paintings, and stained-glass windows.

His firm, originally located at 8 Red Lion Square in London, initially undertook carvings, stained-glass windows for churches, metalwork, paper hangings, printed fabrics, and carpets. Later work included murals, furniture, metal and glassware, embroideries, jewelry, and tapestries. Work of the firm was shown at the 1862 International Exhibition in London, attracted much interest, and the firm was soon thriving. Serious illness in 1864 required Morris to give up the Red House, and he relocated to his workshops, then at Queen Square, Bloomsbury.

The famed "Morris Chair," designed and produced in 1866, later became symbolic of the Arts and Crafts movement with its simple, unornamented, and straightforward design. However, the chair was not typical of Morris's Gothic revival styles, and was actually designed by Morris's partner and business manager, Alphonse Warington Taylor (1835–1870), who copied it from a country chair by English furniture maker Ephraim Colman (1741–1827). With its hinged, reclining back, adjustable through a row of pegs, holes, and notches in each arm, and with its soft cushions, it exuded comfort and function over ornamentation. In 1867, Morris received an important commission to design the "green dining room" at the South Kensington Museum, now the Morris Room of the Victoria and Albert Museum. The director of the museum, since 1857, was none other than Henry Cole, the influential organizer of the Great Exhibition of 1851.

Morris was deeply influenced by John Ruskin (1819–1900), English poet, artist, art critic and social critic, whose views on art, poetry and design were strongly influenced by his social beliefs. Ruskin was opposed to the industrial division of labor as the main cause of unhappiness of the poor. He felt the rich used the poor as tools in profit-making manufacturing enterprises. He wanted the state to regulate the economy in the service of higher

Edward Burne-Jones (left) and William Morris, 1874.

human values, and he wanted artists to lead the cause of social justice. In an 1865 article in the *Art Journal* he asked, "[H]ow far ... the Fine arts may advisably supercede or regulate the mechanical arts?"[15] Ruskin obviously wanted artists to control, or even replace, the rising specter of industrialization that threatened the livelihood of artists and craftsmen, just as it had the many laborers already replaced by machines.

Ruskin was a highly influential voice and social conscience in the Victorian period. He pointed his finger at industry as responsible for poor working conditions, low wages, low-quality products, and obscene profits. Many citizens shared his views. Morris was particularly impressed with Ruskin's 1853 book, *Stones of Venice*—a foundation text of the Arts and Crafts movement which argued that architecture cannot be separated from morality—and in particular, one of its chapters, "The Nature of Gothic," which declared that the Decorated Gothic style was the highest form of architecture yet achieved.

Indeed, the cathedrals of the 13th and 14th centuries exhibited exquisite decorative details based on recursive and repetitive geometric forms that could not help but impress any decorative designer. Looking closely, one can easily detect in them the later organic forms of Art Nouveau in stone and the brilliant colors of Tiffany in window glass. The blend of incredible artistic beauty and religious inspiration was a powerful and influential combination in the Middle Ages, created by devoted masons and artisans to glorify God. This combination of religion and art was still highly respected in the Victorian age.

Ruskin was not the first to promote the revival of Gothic architecture. He was influenced by Augustus Welby Northmore Pugin (1812–1852), the son of French architectural draftsman Augustus Charles Pugin (1762–1832), who came to England to escape the French Revolution. Beginning in 1821, the father published numerous series of architectural drawing volumes entitled *Specimens of Gothic Architecture*, and trained his son as an architectural illustrator. The son was employed by architect Sir Charles Barry (1795–

Reproduction of "Morris Chair."

1860) to work on the interiors, wallpapers, furnishings, and clock tower of the Westminster houses of Parliament, being built in Gothic style after the fire of 1834 destroyed the old palace of Westminster. In 1836, Pugin published *Contrasts*, his manifesto as a Catholic Gothic architect. He regarded classical architecture as "pagan" and showed it as inferior compared to the ideals of medieval society. He claimed that "the degraded state of the arts in this country is purely owing to the absence of Catholic feeling" and that the Gothic style of architecture was the only one appropriate for a Christian country to adopt. He followed his theory in designing many churches and related buildings for the remainder of his life, and had produced a "medieval court" at the Great Exhibition of 1851.

Although he died shortly thereafter, his legacy was the revival of Gothic architecture throughout England.

Thus, ten years later, Robert Morris became an enthusiastic Gothic revivalist who romanticized the medieval guilds, as did Pugin, and sought to avoid the degradation of industrial labor, as did Ruskin, by replacing it with medieval brotherhoods of craft workers who were rewarded mainly by the pleasure of producing high quality work. Whether Morris realized it or not, such an idealized working environment for craftsmen was being accomplished by the Shakers in America, and had been in existence for nearly a half century. It was not really the machine Morris hated, but industry's sole goal of profit at the cost of human dignity. Rather than having his designs mass-produced, he applied his philosophy to his business as a proprietor of various workshops devoted to woodworking, metalwork, weaving, embroidery, and printing, a practice that was admired, emulated, and known by many in the latter part of the century as the Arts and Crafts movement.

Another designer, a contemporary of Morris, took a completely different direction. Christopher Dresser (1834–1904), born in Glasgow, Scotland, was an exceptionally talented child; one might even say he was a prodigy. In 1847, at age 13, he was accepted to the South Kensington School and studied botany. During his studies there, he met many of the design reformers connected with the school, including Henry Cole, Richard Redgrave (1804–1888), artist/administrator of the Science and Art Department, and Owen Jones, who became Dresser's mentor. After he left college in 1854, Dresser became a lecturer in botany and wrote three textbooks on the subject. But failing to win the chair of botany at the University of London in 1860, he turned his efforts to design and set up his own studio. His study of plants had convinced him that everything in nature had a simple and functional form, and he sought to apply this principle to his designs, the same principle proposed by Horatio Greenough in his 1852 book, *The Travels, Observations, and Experience of a Yankee Stonecutter*. In 1862, Dresser published *The Art of Decorative Design*, describing his own philosophy.

Nature was the primary inspiration of nearly all designers. The ornamentation of most "art industry" products included generously applied natural biological forms such as vines, flowers, leaves, trees, etc., all rendered as realistically as possible in the tradition of classical Greece. A friend of Henry Cole who had worked on the Great Exhibition in 1851 was architect and designer Owen Jones, who had a different idea. In 1856 he wrote *Grammar of Ornament*, which urged designers to abandon the realistic and conventional copying of natural elements, and instead, idealize or abstract the fundamental forms of nature to make them more powerful and unique. Based on his observations of the exhibition of "savage tribes" of New Guinea and New Zealand, of "Mohammedan" countries of India, Tunisia, Egypt and Turkey, as well as examples of ancient civilizations, Jones observed that they were more vital and primitive compared to the repetitive and realistic copying of traditional natural elements in civilized nations like England:

> The ornament of a savage tribe, being the result of a natural instinct, is necessarily always true to its purpose; whilst in much of the ornament of civilized nations, the first impulse which generated received forms being enfeebled by constant repetition, the ornament is often misapplied, and instead of first seeking the most convenient form and adding beauty, all beauty is destroyed.... [W]e must learn to be as little children or as savages ... and return to and develope [sic] natural instincts....
>
> In the best periods of art all ornament was rather based upon an observation of the principles which regulate the arrangement of form in nature, than on an attempt to imitate the absolute form of those works; and that whenever this limit was exceeded in any art, it was one of the

Owen Jones designs from his book, *The Grammar of Ornament*, 1856.

strongest symptoms of decline: true art consisting in idealizing, and not copying, the forms of nature.[16]

In other words, the abstracted forms of nature were more individualistic and more powerful visually than were the realistic renditions.

Dresser's and Owen Jones' theories soon resonated with the group based at the South Kensington Museum (later renamed the Victoria and Albert Museum) where Dresser was an instructor at the design school associated with the museum. The South Kensington theories, however, were dramatically different from those of Ruskin and Morris, which was craft-oriented, dominated by romantic traditions, and sought social and moral reform. The two groups differed not only in design theory, but also in educational and political philosophy. In 1859, Ruskin had criticized the South Kensington group for its "degenerate hedonism" in a lecture. Dresser's 1862 book, *The Art of Decorative Design*, was basically a rebuttal to Ruskin and a defense of his own work.

At this same time in America, the Civil War had divided and devastated much of the country but had also fostered an increase in manufacturing facilities, transportation, and technologies. The armament industries of the North had developed rapidly, and loss of manpower to armies fostered the development of civilian laborsaving devices of all kinds. Patents per year doubled. Among these was the lever-operated repeating rifle developed by Christopher Spencer (1833–1922), who carried one of his rifles past sentries into President Lincoln's office in the White House on August 18, 1863, a month after Gettysburg. Lincoln was intrigued, and with secretary of war Edwin Stanton, immediately joined Spencer on the Mall in target practice. Soon, the government ordered 13,171 rifles for Union forces in the field, and these turned out to be the best shoulder weapons of the war. Lincoln also paved the way for the navy's contract with John Ericsson (1803–1889) to build the ironclad *Monitor* and for the army to try Thaddeus Lowe's (1832–1913) observation balloons.

Other technology was unifying the nation. The first transcontinental telegraph in 1861, installed along the right-of-way of the first transcontinental railroad and completed in 1869, contributed to a new national sense of unity and purpose from coast to coast. The length of U.S. railways grew to more than twice the total network of that in Great Britain. Before the railroads, only 1 percent of the U.S. population lived between the Mississippi and the West Coast settlements. Over 800,000 European immigrants during the war years alone were transported to this area for settlement.

James Jackson Jarvis (1818–1888), American art critic and art collector, had stated in 1864 that "the American, while adhering to his utilitarian and economical principles, has unwittingly, in some objects to which his heart equally with his hand has been devoted, developed a degree of beauty in them that no other nation equals."[17] Jarvis may have been referring to functionally designed products by Shakers, who were diminished in number but still active; or to other unembellished functional tools and implements going back to those exhibited at London's Great Exhibition of 1851, but his observation could have easily been applied to interior design as well as to art objects, as illustrated by two famous sisters.

In 1843, home economist and founding educator at the Hartford Female Seminary, Catherine Beecher (1800–1878), had published *A Treatise on Domestic Economy for the Use of Young Ladies at Home and at School*, which discussed the importance of women's role in society. In 1869, with the help of her sister, Harriet Beecher Stowe (1811–1896), the abolitionist author of *Uncle Tom's Cabin* (1851), Catherine revised and republished her book as *The American Woman's Home*, which made an early and practical impact on the home inte-

riors of America. Subtitled as a *Guide to the Formation and Maintenance of Economical, Healthful, Beautiful, and Christian Homes*, the book proposed that a woman could run her own middle-class home efficiently on scientific principles without the servants required in homes of the wealthy:

> At the present time, America is the only country where there is a class of women who may be described as ladies who do their own work. By a lady, we mean a woman of education, cultivation and refinement, of liberal tastes and ideas, who, without any very material addition or changes, would be recognized as a lady in any circle of the Old World or New. The existence of such a class is a fact peculiar to American Society, a plain result of the new principles involved in the doctrine of universal equality.[18]

The book included efficient floor plans for an ideal home, with a central heating core between a parlor, drawing room, and small compact kitchen suggestive of a ship's galley. The kitchen was arranged with counter working-space, windows, and numerous storage shelves and drawers for utensils and basic foodstuffs. A huge coal stove in the kitchen was equipped with a special coal-storage bin on top that enabled 24 hours of untended heat, a hot water reservoir with a capacity of 17 gallons, a roaster, an oven, and two stove-top burners for tea kettles.

The Beecher kitchen was totally devoid of decorative details or embellishment, in the totally American tradition of utility and economy described by James Jarvis. The authors dismissed the wastefulness of popular "curliwhirlies" and "whigmaliries." The only decorative details suggested in their book were a few chromolithographs and "renowned statues" in the parlor to provide "a really elegant finish."

These random examples of American plain and efficient designs were far from typical in the evolving world of decorative arts, where most middle class people aspired to the elegance and ostentation of European-inspired ornamentation typical of products of the wealthy. England and France were the prime sources of popular design styles. But at the Paris Exhibition of 1867, British technologists were quite disturbed by the evidence of superior inventiveness of other countries, particularly America. As reported by a reviewer of the exhibition:

> At the first glance we see that the Americans' main object is to supply the want of hands by the powerful aid of machinery. The most simple and trivial things are done by its aid. Thus in the Annex a machine for peeling apples, another for beating carpets, and automatic apparatus for cleaning glasses, several sorts of mechanical flour sieves and kneading troughs, and a number of inventions for washing and ironing linen. One of the most ingenious among the latter is that from Browning, of New York; the linen is placed on a ribbed platform, over which hot soap-suds are poured, and by turning a handle, the washing is accomplished in a very short time.[19]

The most popular objects in the German exhibit were the huge cannons made by Krupp. Hundreds of objects from the exhibition were obtained and displayed at the South Kensington Museum in 1868, but not one American product was among them. England may have been a world leader in decorative design, but its technological superiority to 13 European countries and 37 American states, as demonstrated at the Great Exhibition of 1851, was fast fading.

America was taking the lead not only in mechanical invention, but in legal protection of designers from the historical and insidious practice of design copying. In 1861, John Gorham, who held the 1,440th U.S. design patent for a "spoon and fork handle," made by the Gorham Company, sued a competitor, LeRoy S. White, of Rogers & Bros. (now International Silver) for infringement of his design patent based on the Patent Act of 1842. The

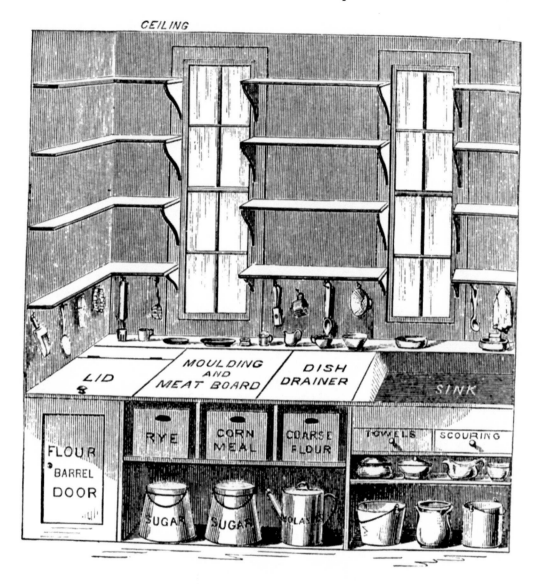

Catherine Beecher's kitchen from her book, *The American Woman's Home*, 1869.

case eventually to the Supreme Court, which in 1871 ruled in favor of Gorham, and established the specific criteria for infringement, still used today: "if in the eye of the ordinary observer … two designs are substantially the same … then the first one patented is infringed by the other."

America's reputation for inventiveness was just a taste of what was to come in the next quarter century, when a flood of American inventions changed the world. An early example was Christopher Latham Sholes (1819–1890), who developed and patented the first commercially successful typewriter. Typewriters of various designs had been attempted since 1714, but none were practical. Starting in 1867, funded by several partners, he perfected the concept including the qwerty keyboard and by 1873 sold the rights to the Remington Arms Company, thus creating the first Remington typewriter.

But consumer products needed more than mechanical inventiveness. The concept of artists turning their talents to mass-produced products was beginning to be considered by some a more reputable occupation than that as a formal artist. By 1860, art had been legitimized. Rome and Florence had become the popular center for American artists to study and work. In his 1863 book, *Americans in Rome*, author/social critic Henry P. Leland (1828–1868), while attacking and ridiculing romantic, egotistic, pretentious American artists for their "Bohemian airs, long hairs, and shares of impudence," he wrote that when an

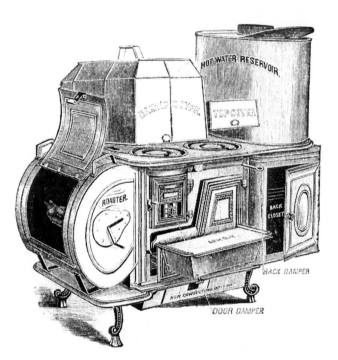

artist finally "turns out a stove that will beautify and adorn a room, instead of rendering it hideous," he will have begun a true artistic renaissance for the general population. Leland's artistic hero was a "designer of patterns for an American calico mill, and though held in contempt by most of the artist community, was polite, refined, and well educated, received by the best in society." Leland was urging artists to adopt more businesslike and practical careers.[20]

Some were already doing so. In 1873, by now a very successful and well-known designer, Christopher Dresser published *Principles of Decorative Design*. His practical method of working directly with the manufacturer to make a product that was attractive and useful

Coal stove from Beecher's book.

Paris Exhibition of 1867.

to the buyer, as well as profitable to the manufacturer, was no different than today's industrial designer. He worked as an independent designer, an advisor to manufacturers, an author, teacher, and lecturer. He had founded the Alexandra Palace Company and became an art advisor to Londos, both importers of Japanese goods. Had the term been known at the time, he would have been called an industrial designer, and some design historians understandably consider him the first. He modestly described himself as "an ornamentalist with the largest practice in the kingdom," A few principles in his book included:

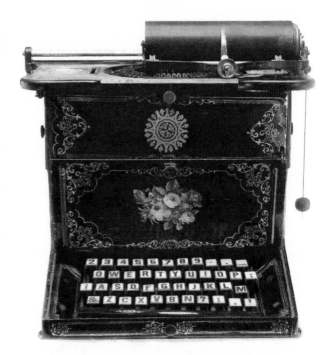

First Remington typewriter, by Christopher Latham Sholes (courtesy Smithsonian Institution).

> A principle of great importance in respect to design is, that the material of which an object is formed should be used in a manner consistent with its own nature, and in that particular way in which it can be most easily "worked."
>
> Another principle of equal importance, is this: that when an object is about to be formed, that material (or those materials) which is (or are) most appropriate to its formation should be sought and employed.
>
> These two propositions ... involve the first principles of successful designing, for if ignored the work produced cannot be satisfactory.[21]

Other principles described by Dresser included the beauty of curves, subtle proportions, principle of order, alternation and orderly repetition. As an art educator, he strongly advised as follows:

> It may be taken as an invariable truth that knowledge, and knowledge alone, can enable us to form an accurate judgment respecting the beauty or want of beauty of an object, and he who has the greater knowledge of art can judge best of the ornamental qualities of an object. He who would judge rightly of artworks must have knowledge. Let him who would judge of beauty apply himself, then, to earnest study, for thereby he shall have wisdom, and by his wise reasonings he will be led to perceive beauty, and thus have opened to him a new source of pleasure."[22] Particularly amusing was his articulate and tactful description of a problem that exists in the design world to this very day: "It is common to assume that women have better taste than men, and some women seem to consider themselves the possessors of even authoritative taste from which there can be no appeal. They may be right, only we must be pardoned for not accepting such authority, for should there be any over-estimation of the accuracy for this good taste, serious loss of progress in art-judgment might result.[23]

While some such as Dresser and Morris promoted new theories of design, others worked to spread English designs around the world. Charles Locke Eastlake (1836–1906), British architect and furniture designer, popularized William Morris's Arts and Crafts prin-

Bookcase from Charles Eastlake's book, *Hints on Household Taste in Furniture, Upholstery, and Other Details*, 1868.

ciples of decorative arts with his book, *Hints on Household Taste in Furniture, Upholstery, and Other Details*, published in Britain in 1868 and in America in 1872. Eastlake, trained by architect Philip Hardwick (1792–1870), promoted "Early English" style and "Modern Gothic" style, both popular in Victorian architecture. After his book was published, "Eastlake Style" became a common reference, though he made no furniture himself, but had his designs produced by professional cabinetmakers.

Generally his philosophy of design identifies simplicity, fitness to purpose, and truth to materials as guiding principles. The following is from his book: "Every article of manufacture which is capable of decorative treatment should indicate, by its general design, the purpose to which it will be applied, and should never be allowed to convey a false notion of that purpose.... [T]he character, situation, and extent of ornament should depend on the nature of material employed, as well as the use of the article itself.... To the violation of those principles we may attribute the vulgarity and bad taste of most modern work.... [I]n the sphere of what is called industrial art, use and beauty are, in theory, at least, closely associated."[24]

American furniture makers quickly followed Eastlake's ideas with their traditional imitation of English styles, but in the preface to the 4th edition of his book (1878) Eastlake chastised them publicly: "I find American tradesmen continually advertising what they are pleased to call 'Eastlake' furniture, with the production of which I have had nothing whatever to do, and for the taste of which I should be very sorry to be considered responsible."[25]

England, of course, had been the source of American products and designs in all manner of consumer products since the first English colonies in the 17th century, and such copying was still unabated. The only difference now was that America was a serious manufacturing competitor in the growing American market that had been an English monopoly for over 200 years. So the British were entitled to be a bit piqued.

Americans not only looked to Britain for design trends, but now began to model its art educational programs upon those in England. Since the Civil War a number of private schools of art and design had been established, including the Minneapolis College of Art and Design (1867), the Art Institute of Chicago (1869), the Columbus College of Art (1870) and the Pennsylvania Museum and School of Industrial Art in Philadelphia (1876), as well as those at private universities such as the University of Cincinnati (1870), Syracuse University (1870), and the Massachusetts Normal School of Art in Boston (1873).

The last one above, now the Massachusetts College of Art and Design, established to train designers in the state's textile and carpet-weaving industries, was headed by an 1871 English émigré, Walter Smith (1836–1886), a graduate of South Kensington School in London, and a former director of the art school at Leeds, England. Henry Cole himself had recommended Smith.

Design education was seen as so vital to the education of future engineers and designers that it was promoted aggressively in secondary public schools by the Massachusetts Drawing Act of 1870, also known as the Industrial Drawing Act, which mandated the teaching of industrial drawing in all public schools of the commonwealth. This practice was followed later by many states. Smith was again recommended by Cole and appointed as director of drawing for the public schools of Boston, and as state director of art education. Smith believed that universal art education, design schools, art museums and exhibitions would promote good design to manufacturers and the public.

Mechanical drawing, essential to specification of machine design and construction, became easy to replicate accurately and quickly in 1872, when the process of preparing blue-

prints was discovered and implemented, based on earlier photographic research by English chemist John Herschel (1792–1871).

By 1883, Walter Smith was discharged from his position and discredited, in part due to academic politics, in part due to the financial monopoly he enjoyed through sale of his drawing books, but mainly because many Americans saw his concept as one of English origin that promoted a fixed role for working classes, denying social mobility and advancement to the more heroic achievements that American education was at the time idealistically intended to foster. Smith returned to England and died soon thereafter.

Thus began the eternal debate between those in industry who favored more "practical" forms of education that were generally referred to as "manual training" or "vocational training" and those educators who regarded such training as "general" rather than "academic" in nature. The debate was further complicated in art schools by differing definitions of "art." To many, art was an individual creative act, featuring traditional and classical imagery to "tell a story." To them, art in industry thus became simply the application of traditional art upon the available surfaces of industrial products. But to others, art had the potential to shape industrial products more appropriately to their natural function, to human usage, and to manufacturing economy.

The concept of industrial design as an art form that integrated the technology of industry with functional needs of users into an appropriate yet attractive form was still in the future. Despite the efforts of Henry Cole, Owen Jones, Horatio Greenough, and Christopher Dresser, stylistic changes over the next 50 years did not eliminate the fundamental Victorian design fetish of excessive product decoration and ornamentation on consumer products. It resulted from an incestuous relationship between the public's demands, commercial interests, and designers' willingness to comply. Tradition was always the enemy of design innovation. But in England, the leader of design trends, a new tradition was emerging.

Chapter 4

1875–1900
The "New" Decorative Art

In 1875, Sir Arthur Lasenby Liberty (1843–1917), a London merchant, opened a shop, Liberty & Co., on Regent Street at the suggestion of William Morris. Several outstanding designers contributed work sold there, Christopher Dresser and Archibald Knox (1864–1933) among them.

Dresser was well known and is described in chapter three. His designs included wallpaper, textiles, stained glass, glassware, pottery and metalware. His name, "Dr. C. Dresser," was used by a number of manufacturers such as Linthorpe Art Pottery and tinware producer Richard Perry, Son & Co., as a marketing tool due to Dresser's huge design reputation. Dresser was influenced strongly by Japanese culture, and was commissioned to visit Japan in 1876 to view craft and manufacturing techniques for the UK government. Tiffany commissioned him to collect Japanese goods, which were exhibited in 1877 in New York with great success.

Another Liberty designer, Archibald Knox, was a designer of Scottish descent from the Isle of Man who was influenced and inspired by Celtic art that he used to develop his own style. He became well known for his hundreds of designs for Liberty, his watercolors, graphic designs, and type fonts. He designed jewelry, inkwells, boxes, bank checks and even the gravestone of Arthur Lasenby Liberty, in 1917. He taught at Redhill School of Art in Surrey starting in 1897, and at Kingston School of Art at Kingston University in London in 1899.

These latest European artistic styles were of little interest in the U.S. Despite the awareness of European design by the American elite and academic institutions, the general public by 1875 had little exposure to, and even less knowledge of, international design. Only the well-to-do traveled abroad, and few had been to international fairs in London (1851 and 1862), Paris (1855 and 1867), or Vienna (1873). Domestic travel was still difficult for many in America in 1853, so the Exhibition of the Industry of All Nations in New York that year attracted only citizens within a hundred miles or so of New York.

By 1876, things had changed. Travel by train drew huge crowds to Philadelphia that year, when America celebrated its own Centennial with its very own first official world's fair. Ten million attended the Centennial from May to November. President Ulysses S. Grant, by proclamation, invited other nations to participate in an exposition "designed to commemorate the Declaration of the Independence of the United States" with a "display of the results of Art and Industry of all nations as will serve to illustrate the great advances attained, and the successes achieved, in the interest of Progress and Civilization, during the century which will have then closed."[1]

The dominant theme of the exposition was the enormous 45-foot high twin-cylinder Corliss steam engine, turned on by President Grant at the opening ceremony, to power, with its 1,400 horsepower, the miles of belts and machinery throughout the exposition. Inventions and industrialization permeated the exhibits. On June 25th Alexander Graham Bell (1847–1922) demonstrated a prototype of his revolutionary telephone, just patented that March, which instantly made world headlines. (On that same day, 2000 miles away, General George Custer and 250 of his men were annihilated by Indians led by Sitting Bull at the Battle of the Little Bighorn in Montana.)

Christopher Dresser.

Remington displayed and demonstrated its typewriter destined to transform the business world. Dry plate photography since 1873 had greatly simplified the complicated wet process of taking pictures. The American Watch Company of Waltham, Massachusetts, maker of the inexpensive "Dollar Watch," displayed the first automatic screw making machinery and won the first international watch precision competition. All would result in high volume, mass-produced consumer products. Visitors to the fair could not help but conclude that technology and industrialization promised to provide common household luxuries— previously affordable only to the wealthy — to all citizens at reasonable cost.

> The principles of mass production were summarized by the American Watch Company: "The product ... must be conceived to be better than its competition ... must be designed specifically for mass production.... [I]ndividual parts must be interchangeable.... [T]ime, space, facilities and capital must be sufficient to support the volume of work and to sustain the organization until it becomes self-supporting.... [D]istribution methods, marketing structures, and advertising programs must be commensurate with projected production quantities."[2]

Europeans attending the exposition recognized that America's manufacturing technology challenged their own. A Swiss commissioner wrote home: "For a long time we have heard here of an American competition, without believing it.... I sincerely confess that I personally had doubted that competition. But now I have seen — and I have felt it — and I am terrified by the danger to which our industry is exposed."[3] As a result of his letter, the Swiss upgraded their production processes.

American manufacturing, in 1860 far behind the European powers of England, France, and Germany, now was competing aggressively, and by 1885 was producing 29 percent of world manufactures, compared to England's 27 percent and Germany's 14 percent. By 1900, America would dominate global manufacturing. An idealistically stated goal of the exposition was to illustrate "the happy mean ... which combines the utility that serves the body with the beauty that satisfies the mind" in "artful living which can be provided by manufactures."[4]

The addition of ornament to functional products to make them more attractive was

traditionally seen as this "happy mean," and was known as "industrial art." Examples of such art abounded at the fair. Europeans had perfected it exquisitely to the point where no square millimeter of unadorned metal or wood remained, but rather, was decorated ostentatiously in symmetric Beaux Arts styles, with neoclassical images of virtuous Greek or Roman gods or goddesses, Gothic details or other historical design allusions, floral or botanical details, filigree, fretwork, or simple geometric patterns. All this was intended to showcase the infinite skill of the artist or craftsman in various materials, and to convey a sense of high artistic value beyond mere utility. In many cases, the functional aspect of the product was largely impractical, and in many cases, totally irrelevant. American artists, of course, imitated and echoed these European styles slavishly.

The largest American industrial art piece was the "Century Vase" by the Gorham Company, designed by George G. Wilkinson and J. Pierpont, that required 2000 ounces of silver. It depicted "100 years of American history with America on top holding an olive branch of peace and a wreath of honor, summoning Europe, Asia, and Africa to join with her in the friendly rivalry with which she enters on the second century of her existence."[5]

A massive Mason and Hamlin organ imitated the eclectic "Eastlake" style recently promoted in

Twin-cylinder Corliss steam engine at Centennial Exhibition in Philadelphia, 1876.

English designer Charles Locke Eastlake's 1872 book. Walter Smith, then director of art and education in the state of Massachusetts and who compiled an extensive catalog of Centennial designs, considered the masterpiece of the fair to be an intricately designed and assembled Gothic style 72-gaslight chandelier of lacquer gilt in imitation of fine unalloyed gold. Smith

said that no line could be drawn between the fine and industrial arts, because artists often select utilitarian objects upon which to apply their art. He wrote, "Ornamental art is the fruition of industrial design,"[6] indicating that the term, "industrial design" not only was already a synonym of "industrial art," but that ornament was indicative of the highest form of industrial design at the time. Other notable pieces included a silver-plated swinging ice-water pitcher covered with infinite botanical detail by the Reed and Barton Company, and a sterling silver vase honoring American poet William Cullen Bryant (1794–1878), designed

Century Vase, by Gorham Company (from Walter Smith, *The Masterpieces of the Centennial Exhibition*, 1876).

by James H. Whitehouse, chief artist at Tiffany & Company, in an allegorical style celebrating the poet's love of nature. It depicted apple blossoms, amaranth, ivy, water lilies, Indian corn, cotton plants, waterfowl and bobolinks, as well as a token image of Bryant.

While these spectacular European imitations were publicly lauded for their refined taste and expensive craftsmanship, they did not represent the general indigenous qualities of American design ingenuity, functionality, practicality, and simplicity. Many Europeans regarded American mass-produced products as inferior to handmade in both quality and beauty, but praised the fact that they were affordable to even the poorest citizens. However, a perceptive German who attended the fair wrote the following: "The hatchets, hoes, axes, hunting knives, wood knives, sugar cane knives, garden knives, etc., are of a variety and beauty which leaves us speechless with admiration.... [W]e are astonished to see how much our well known tools could be improved.... Again and again we see examples of how American industry in its progress breaks with all tradition and takes new paths which seem to us fantastic."[7] These products, of course, were from the so-called artless industries, which had not been touched by industrial artists.

Some Europeans, by similarly comparing American products with their own for the first time, were able to see the beauty in simple functionalism, and would soon begin to develop academic design theories based on utility, rather than on purely artistic surface decorations. A few Europeans pointed to the simplicity of furniture and other crafts by American Shakers who exhibited at the Centennial, but who by now, as a group, were rapidly declining in number.

Utilitarian products exhibited in the Wagon and Carriage Annex of the Exposition included an array of useful domestic mechanical devices, including apple corers, cherry stoners, coffee mills, corn poppers, egg-boilers, flour sifters, knife sharpeners, lemon squeezers, dishwashers, stoves, etc. Singer had its own pavilion at the Centennial, and as the major

sewing machine manufacturer was selling a third of the 600,000 machines sold every year. A clever manufacturer had developed a machine operated with foot pedals similar to a sewing machine, which instead of moving a needle, operated a fretsaw or jigsaw for easy cutting of wood or metal into highly decorative patterns. Other major manufacturing exhibitors included Thonet Company of Germany, which by this time was producing 4,000 pieces daily, with 85 percent being sold abroad. Its revolutionary bentwood furniture, by now some 40 years after its development, was unique in that the manufacturing process and material itself dictated its forms, rather than the arbitrary whim of artists—a fundamental mass production design principle understood by manufacturers, but one yet to be fully appreciated by industrial artists.

Major ceramic industrial art at the Exposition included exhibitions by Doulton & Company of England, founded in 1853, and Haviland, a porcelain company founded that same year by American David Haviland in Limoges, France, to produce china specifically for the

Eastlake style Mason and Hamlin Organ (from Walter Smith, *The Masterpieces of the Centennial Exhibition*, 1876).

American market. His company was the first to engage artists on the site to do the decorating, and Doulton initiated a similar practice in 1871. Japan and China were also major exhibitors of glazed stoneware.

The Centennial was the first exposure to the rest of the world for many Americans who had not traveled abroad. It opened their eyes to many international cultures and design movements, including Arts and Crafts, although the subtleties of differing European design philosophies and motivations were generally indistinguishable to them. Women, in particular, saw the "handmade" movement as an opportunity to extend their domestic skills of sewing, needlepoint, quilting, and the like to income-producing activities outside the home, or even inside. The fretsaw machine described above, for example, appealed to women because it could be used by women in carpenter or craftsman workshops, similar to women operating sewing machines in clothing factories. Making or decorating pottery had a similar appeal to women.

The University of Cincinnati's School of Design had an exhibit in the Woman's Pavilion that demonstrated the work of many female design students. Student work included carved and fret-sawn products such as bedsteads, mantels and boxes, and designs for frescos and illuminations. Fifty women of the 208 graduates since 1870 were employed as lithographers, designers, sculptors, engravers, landscape painters, sign painters, architects, decorators,

and other artistic fields. Generally, skilled female designers could earn $8 per day, compared to seamstresses at $2 per week!

Among those impressed with the unique underglaze decoration techniques used by Doulton and Haviland to give the appearance of oil painting was Mary Louise McLaughlin (1847–1939). Her friend Maria Longworth Nichols (1849–1932) was also impressed by the Japanese stoneware art. Both women, as amateur ceramic painters from Cincinnati, Ohio, and familiar with the Arts and Crafts movement through professors of art at the University of Cincinnati's School of Design, had exhibited their work at the fair. Upon returning home, they worked at incorporating these new techniques into their own work. McLaughlin wrote a book on china painting. They both collaborated in commissioning a special underglaze and overglaze kiln in 1879. That same year, McLaughlin wrote a second book and founded the Cincinnati Pottery Club, inviting other local artists to join, but not Nichols. Nichols, offended, in 1880 founded a business, Rookwood Pottery, which within a year had produced several thousand pieces in 70 shapes. Rookwood at first collaborated with the Pottery Club members, many of whom attended Rookwood's decorating school but soon joined Rookwood as production workers.

In 1883, Maria Nichols hired William W. Taylor (1847–1913) as manager, and he evicted the Pottery Club from their meeting room at Rookwood, causing McLaughlin to sue Rookwood over who had first developed Rookwood's underglaze decoration process. Nichols became a widow in 1885, and married Bellamy Storer the following year. In 1889, Maria won a gold medal at the Paris Exposition and sold the business to Taylor. Bellamy Storer became a member of Congress in 1891, U.S. foreign minister to Belgium in 1897, and to Spain in 1899. McLaughlin continued with the club, but it became a minor amateur activity compared to the success of Rookwood, which by 1891 was producing 11,000 pieces annually, becoming one of the most successful Arts and Crafts enterprises. Both women, however, are credited with initiating the pottery movement in the U.S.

Mary Louise McLaughlin's and Maria Nichols' connection with the University of Cincinnati's School of Design was typical of how the Arts and Crafts movement in America began. Numerous design schools established since the Civil War were becoming aware of, and educating students about, international design movements. Christopher Dresser attended the Centennial and gave three lectures at the Pennsylvania Museum and School of Industrial Art in Philadelphia to celebrate its founding in 1876. Thus the South Kensington design movement also became well known here.

The Centennial's exposure of European arts and crafts to America accelerated the number of similar schools, including the New York School of Decorative Arts (1877), the Rhode Island School of Design (1877), the Cleveland Institute of Art (1882), the Kansas City Art Institute (1882) and Pratt Institute (1887). By 1885 there were about 40 U.S. institutions, public and private, dedicated to teaching designers, artists, and art teachers. America was progressing in its design expertise.

Around the time of the Centennial, many of the newly rich Americans, such as the Rockefellers, Carnegies and Vanderbuilts, employed interior decorators to comprehensively furnish and decorate their new mansions. Among the earliest such decorating firms were the Herter brothers, Gustave (1830–1898) and Christian (1839–1883), German immigrants who came to New York after the Civil War and established workshops and museum-like showrooms that displayed the full range of international styles of furniture, including Renaissance Revival, Neo-Grecian, Eastlake, Aesthetic movement, Anglo-Japanese, Persian, Indian, Chinese, and Moorish, as well as draperies, carpeting, and paneling. By the time of

the Centennial, American firms were following the Herter example to take advantage of the huge demand for upscale decorating services. Among them were Louis Comfort Tiffany and Candace Wheeler.

American artist Louis Comfort Tiffany (1848–1933) was the son of Charles Lewis Tiffany (1812–1902), the founder of Tiffany & Company in 1837. The company had excelled in jewelry and silver work since 1853. Louis studied painting in New York and Paris, and became interested in glassmaking around 1875. After working in several glasshouses in Brooklyn he joined with Candace Wheeler (1827–1923) in 1879 to form a partnership of Tiffany & Wheeler to design interiors, occasionally collaborating with Samuel Coleman (1832–1920), and Lockwood de Forest (1850–1932). Wheeler had been inspired by embroideries from the Royal School of Art Needlework at the 1876 Philadelphia Centennial Exhibition and in 1877 had founded the Society of Decorative Art in New York to help women artists gain training in the applied arts. The partnership ended in 1883, when Wheeler left to open her own textile design firm, and Tiffany reorganized as Louis Comfort Tiffany and Associated American Artists. The business thrived, but in 1885, it broke up when Tiffany decided to establish his glassmaking firm, the Tiffany Glass Company. Tiffany began making his own glass in a variety of colors to create dramatic effects in stained-glass windows by using colored glass instead of the traditional painted clear glass, a process motivated by William Morris's Arts and Crafts movement in England.

In 1893, Tiffany's firm built a new factory in Corona, Queens, New York, called the Stourbridge Glass Company, and introduced the term Favrile (from an old French word for handmade) for his first brilliantly colored blown glass products that would become famous. The invention of the unique Favrile process is credited to English émigré expert glassblower Arthur John Nash (1849–1934), who was employed by Tiffany. Nash, his son Leslie Hayden Nash (1884–1958), and other talented craftsmen helped Tiffany evolve a new style that was very similar to the Liberty Style developed earlier in England. By 1895 Tiffany's factories were employing 300 workers producing his famous colored glass lamps, and his work was being sold at German art dealer Siegfried Bing's decorative arts shop, L'Art Nouveau, in Paris. Tiffany had visited Bing's shop in the 1880s, and made him his exclusive European distributor. The original Tiffany Glass Company was renamed the Tiffany Studios in 1902.

Just as the Arts and Crafts movement was taking a foothold in America, its founder, William Morris, became interested in politics in the 1870s as an increasing number of artists, artisans, and craftsmen felt threatened by the inexpensive and sometimes shoddy products of mass production. They were attracted by Morris's romantic vision of numerous happy Arts and Crafts workshops devoted to quality that would stem the inevitable tide of industry. Morris, at age 43, was already a celebrity, when on December 4, 1877, he delivered his first public lecture, "The Lesser Arts," before the London Trades' Guild of Learning. He argued that beauty and quality craftsmanship were linked to social conditions, and that only a "popular" art grounded in socialist principles could be noble, vital, and beautiful. In essence, he was recruiting craftsmen to wage political war against industry through their work. Here are some excerpts from his speech:

"[B]ut now only let the arts which we are talking of beautify our labour, and be widely spread, intelligent, well understood both by the maker and the user, let them grow in one word, popular, and there will be pretty much an end of dull work and its wearing slavery; and no man will any longer have an excuse for talking about the curse of labour, no man will any longer have an excuse for evading the blessing of labour. I believe there is nothing in the world that I desire so much as

this, wrapped up, as I am sure it is, with changes political and social, that in one way or another we all desire....

The remedy lies with the handicraftsmen ... who have no call to be greedy and isolated like the manufacturers or middlemen; the duty and honour of educating the public lies with them.... When will they see to this and make men of us all by insisting on this most weighty piece of manners: so that we may adorn life with the pleasure of cheerfully buying goods at their due price; with the pleasure of selling goods that we could be proud of both for fair price and fair workmanship; with the pleasure of working soundly and without haste at making goods that we could be proud of?— much the greatest pleasure of the three is that last, such a pleasure as, I think, the world has none like it.

That art will make our streets as beautiful as the woods, as elevating as the mountain-sides: It will be a pleasure to come from the country into a town; every man's house will be fair and decent ... all the works of man ... will be in harmony with nature, will be reasonable and beautiful: yet all will be simple and inspiring ... so in no private dwelling will there be any signs of waste, pomp, or insolence, and every man shall have his share of the best.[8]

The Arts and Crafts movement that William Morris inspired became well known only in the 1880s, when T.J. Cobden–Sanderson (1840–1922), an English artist and bookbinder associated with the movement and a friend of Morris, coined the name. One of his devoted followers, Charles Robert Ashbee (1863–1942), set up a London Guild and School of Handicraft in 1888 based on Arts and Crafts principles. By this time, Morris himself was deeply committed to socialism in England, which was somewhat ironic, because his career and fortune relied on providing services to the wealthy. He was now working directly with Friedrich Engels (1820–1895) and Eleanor Marx (1855–1898), daughter of Karl Marx (1818–1883), who had published *Das Kapital* in 1867, to establish the Socialist movement in England. Morris was not only a member of the Socialist League, founded in 1885, but was also coauthor of its manifesto advocating revolutionary internationalism that was approved by Engels as a valid expression of Marxist policies. Morris was so involved in politics that he virtually abandoned his personal art. Anarchists gained control of the league in the early 1890s, and when Morris finally voiced objections, he was denounced and thereafter regarded with suspicion.

In 1891, Morris returned to art and founded the Kelmscott Press at Hammersmith, London, to produce books by traditional methods. In accordance with the beliefs of the Arts and Crafts movement, he used the printing technology and typographical style of the fifteenth century, to respond to the mass production of contemporary books and the rise of lithography designed to look like traditional woodcuts. It operated until 1898, producing more than 18,000 copies of 53 different works, and inspired many other private presses. His decorating business, Morris & Company, was still thriving under his direction. It was not his intent, but Morris's designs taught industry that money could be made from good product designs, and his work was soon copied and produced by a number of manufacturers at lower cost.

A popular "Japanese cult" arose in the West during the 1880s, as the public was attracted to exotic art objects from Japan. The trend can be traced directly to Christopher Dresser, who had worked with Japan since 1873, importing art goods. In 1880 Dresser was appointed art manager for the new Art Furnishers' Alliance, founded to "carry on the business of manufacturing, buying, and selling of high-class goods of artistic design." Alliance opened a shop at 157 New Bond Street in London, offering "everything for the home," either designed or approved by Dresser. In particular, his designs for common household items like watering cans, toast racks, teapots, and chairs today look more like designs of the 1930s than those of the 1880s, when he designed them. Alliance had financial backing of many of

Dresser's manufacturers, including Sir Liberty, but capital proved insufficient and the designs were too advanced for the public. The general public was still in high Victorian mode, and simple, clean design simply did not appeal at the time. The Alliance enterprise went into liquidation in 1883, and Sir Liberty acquired most of the stock for his own shop. The unusual and fashionable style of products designed by Dresser, Knox, and other designers that were sold at Liberty & Co., was known initially as Liberty Style, and after 1895, became popular throughout the world as the "New Art," or Art Nouveau.

Teapot by Christopher Dresser, 1879, manufactured by James Dixon & Sons (photograph © Victoria and Albert Museum, London).

Perhaps the most extravagant designs of the dying Victorian "gilded" age were the jeweled eggs made by Peter Carl Fabergé (1846–1920), a Russian jeweler who became the court goldsmith for Czar Alexander III in 1885. That year, at the czar's request for an Easter surprise for his wife, Maria Fyodorovna, Fabergé designed and fashioned a white enameled golden egg, which opened to reveal a golden yolk, inside of which was a golden hen, and inside the hen was a tiny crown with a ruby. This matryoshka nesting doll-style creation was made of precious metals decorated with gemstones by Fabergé's team of artisans. Maria was so delighted the czar commissioned Fabergé each year to produce a similar Easter surprise for her. This royal tradition continued under Czar Nicholas II after 1894, until the Revolution in 1917. Twenty-four eggs were eventually produced for the royals, as well as an additional 81 for other clients. In 2002, a Fabergé egg sold at auction for $9.6 million.

The Arts and Crafts movement was becoming well known in America. During the 1880s and 1890s, exhibitions of English products were held at museums in Manhattan, Brooklyn, Newark, and Chicago. Charles Robert Ashbee (1863–1942), and Walter Crane (1845–1915), English followers of William Morris, lectured in Chicago and in 1892 the Art Institute of Chicago mounted an exhibition of Crane's work. Fabrics, wallpaper, and furniture from Morris's workshops were sold at Marshall Field's department store in Chicago. Department stores were becoming showcases for a cornucopia of consumer products, and Marshall Field and Macy's in New York were the prototypes. By 1884, manufacturing had surpassed agriculture in U.S. economic growth. Many Americans now had ready access to countless manufactured products at low prices, thanks to the mail-order giants Montgomery Ward (founded in 1872) and Sears, Roebuck and Company (founded in 1886); their catalogs averaged 300 pages and offered 10,000 items or so each. No matter how remote or obscure their geographic location, people could buy what they needed or wanted from farm machinery to ladies fashions, via the convenience of the U.S. mail.

Americans by now were well aware of many European styles. They had been promoted

by *Ladies Home Journal,* founded in 1883 by Cyrus H.K. Curtis to report on the homes and furnishings of the average American. In 1889, Edward Bok (1863–1930) became editor and embraced the Arts and Crafts philosophy to "make the world a better and more beautiful place to live." He was dedicated to domestic elegance and fought against bad taste in furnishings. By 1896, *House Beautiful* was founded to compete with the *Journal*; *House Beautiful* also promoted Arts and Crafts. In 1900, Edward Bok of the *Journal* engaged William H. Bradley (1869–1962), an Art Nouveau poster artist, to develop illustrations of interiors and furnishings concepts in the latest Arts and Crafts styles, establishing the American practice of generating interest in the potential of new products with concept illustrations, a practice embraced later by industrial designers. By 1901, *House and Garden* had joined the magazine competition for the growing interest and market in home furnishings.

But people were also interested in exploring the world beyond their homes. Personal transportation inventions would soon make the horse and buggy obsolete. In 1876, Nikolaus Otto (1832–1891) patented the first four-stroke internal combustion engine, which would soon begin to compete with steam power. Karl Benz (1844–1929), who had worked for Otto, had by 1878 reduced the size and weight of the engine and used it to power his 1886 Patent-Motorwagen, initiating the automobile industry. In 1888, John Kemp Starley (1854–1901) of Coventry, England, perfected the modern "safety" bicycle, known as the Rover, which popularized what had previously been a daredevil sport. Both men and women were soon cycling everywhere.

Germany had only recently begun international competition in trade when it began to establish South African colonies in 1883–1884. Its chief rival was England, which it had regarded as an enemy for generations. And since England led the world in the decorative arts, as well as industrial development, a number of new German associations were organized in the national economic interests of artists and applied artists. One was the Fachverband für die wirtschaftlichen Interressen des Kunstgewerbes (Trade Association for the Economic Interests of Applied Art), founded in 1892. Another was the Munich Künstlergenossenschaft (Society of Visual Artists of Munich Art), founded in 1892 in the studio of Josef Block (1863–1943), and yet another, the Allgemeine Deutsche Kunstgenossenschaft (Universal German Art Association). Out of a dispute between the

Nikolaus Otto's engine, 1876.

latter two arose the first schism of a group of artists in protest against existing traditional artist's associations— the Munich Secession of 1893. At the time, both Berlin and Munich artists and sculptors joined the Secessionist movement.

In 1892, an advanced cabinetmaker in Herford, Germany, Freidemir Poggenpohl, established Poggenpohl Möbelwerke, specializing in luxury kitchen cabinets with a white lacquer finish. The furniture introduced ergonomic worktop heights and storage innovations. Still in business today, and still known for its design, Poggenpohl is recognized as the oldest kitchen brand in the world.

The 1893 the Chicago World's Fair (also called the World's Columbian Exposition, to celebrate the 400th anniversary of Columbus' arrival in the New World) had significant

Machinery Hall, at Columbian Exposition in Chicago, 1893.

influence on American architecture, the arts, and industrial optimism. The fair was designed by architect Daniel Burnham (1846–1912) and landscape architect Frederick Law Olmsted (1822–1903) to describe what a future city should be. It followed European Beaux Arts design philosophy of classical symmetry and balance, which was, however, on its way out. There were to be very few American palaces after the fair. Chicago architect Louis Sullivan (1856–1915), Frank Lloyd Wright's employer (Wright called him his *Lieber Meister*) at the time, opposed the tradition of using such tiresome, classic, historical styles. His dramatic design of the Transportation Building and his intricate ornamental work demonstrated his rebellion against tradition. It was Sullivan, who in a March 1896 article, "The Tall Office Building Artistically Considered," coined the phrase "Form follows function": "when the known law, the respected law, shall be that form ever follows function ... then it may be proclaimed that we are on the high road to ... an architecture that will live because it will be of the people, for the people, and by the people." His "Form follows function," became the battle cry of modernist architects in the 1930s, and later of industrial designers in the 1950s.

Electricity was celebrated at the fair with dramatic lighting and street lamps illuminating white stucco buildings in the Court of Honor, which earned it the name of White City. Scientific, transportation, and industrial inventions dominated the exhibits, including Edison's Kinetoscope, an electric car, an electrified kitchen, and windmills generating electricity. The first Ferris wheel, a 264-foot high monster with 36 cars, designed and built by engineer George Ferris Jr. (1859–1896) to rival the Eiffel Tower, was in the amusement area, along with hula dancers, belly dancers, and "ragtime" piano music by Scott Joplin.

The Chicago fair influenced young American architect Frank Lloyd Wright, who attended the fair and was impressed with one of the most popular exhibits, "The Ho-o-den," a wooden Japanese Temple of the Fujiwara period erected by the Japanese government on a setting in an artificial lake. At the time, for Americans, including Wright, oriented toward the Arts and Crafts movement, Japan offered "the example of an indigenous culture that embodied the organic quality they found in the middle ages," as architectural historian Richard Guy Wilson (b. 1940) wrote. "Organic" became Wright's lifelong description of his own architecture. A number of historians note elements of later Wright designs that reflected the many international cultures and styles he saw at the Chicago exposition in 1893, while in his youthful formative period.

The industrial arts exhibits were extravagant but undistinguished compared with what was going on in Europe. Only the work of Rookwood Art Pottery of Cincinnati showed that some American artists were in tune with the Arts and Crafts movement. In the exposition's Department of Hygiene and Sanitation was a small house-like building conceived by MIT chemist Ellen Swallow Richards (1842–1911) and known as "The

Rookwood pottery at Columbian Exposition, 1893.

Rumford Kitchen," an educational exhibit which demonstrated to visitors the usefulness of domestic science in the home. Richards would lead the American home economics movement early in the next century.

Art Nouveau acquired its present name in 1895. The name is French, after the Paris decorative arts shop Maison de L'Art Nouveau (House of the New Art), operated by German art dealer Siegfried "Samuel" Bing (1838–1905). Bing had a well-established import-export business starting in 1870 and specialized in Japanese objects d'art. He introduced these new popular eastern styles to the West in his shop very profitably, and they would influence the decorative arts. But by 1895, these items became difficult for him to obtain, and he decided to focus on the "new art" style that had originated in London at the Liberty shop on Regent Street. He renamed his own shop accordingly.

Actually, the French knew it as Le Style Anglais, since it originated out of the English Arts and Crafts movement. In Italy, it was known as Lo Stile Liberty or Stile Floreale, after the 1875 London shop, Liberty & Co. In Germany the style was known as Neue Stil, or Jugendstil, and in Spain, Modernisme. Influenced by ancient Irish and Scottish manuscript images, the style was characterized by romanticized, sensual, and organic floral and plant patterns and symbols, often intertwined with long ivy tendrils, stylized animal forms, and coiled spirals. Repeating motifs included "whiplash curves" that inspired disparaging terms by Belgians as "Paling stil" (eel style), and by Germans as "Schnorkelstil" (noodle style) or "Bandwurmstil" (tapeworm style)—not that these countries were prejudiced, of course.

Bing sought out the most daring designers/craftsmen with these new styles, including American artist/designer Louis Comfort Tiffany, who had recently opened his own glassworks in Corona, Queens; and Belgian painter/designer/architect Henry van de Velde (1863–1957), an Arts and Crafts follower of William Morris. Bing handled fabrics designed by William Morris, as well as work by artists Frank Brangwyn (1867–1956), Louis Bonnier, and Edouard Vuillard (1868–1940); designers Eugène Gaillard (1862–1933), Edward Colonna (1862–1948), William Arthur Smith Benson (1854–1924), Georges de Feure (1868–1943); French architect Louis Bonnier (1856–1946); and the sculptor Constantin Meunier (1831–1905).

Bing's designers were active in an interesting range of fields. Benson directed the Morris and Co. furniture department from 1896, and unlike other Arts and Crafts followers, he created designs "intended for machine mass production." Gaillard and de Feure were Art Nouveau furniture designers; and Colonna, who emigrated from Germany to America in 1882, worked with Tiffany in New York, and in 1885 designed Art Nouveau coach interiors for the Milwaukee, Lake Shore & Western Railway and for Canadian Pacific Railway coach interiors and railway stations before his return to Paris in the late 1890s.

Art Nouveau style was revolutionary because it provided a new vocabulary of form, line, and color, and because the outline and form provided the visual interest, rather than the surface patterns and historical anecdotes that preceded it. Bing closed his gallery in 1904, when the fashion was already beginning to wane.

The same year Siegfried Bing reopened his Paris shop as Maison de L'Art Nouveau in 1895, 28-year-old architect Frank Lloyd Wright established his own practice in Oak Park, Illinois. He had been asked to leave the firm of Adler and Sullivan in 1894 for creating private "bootleg" designs for clients near his own home, which he had designed and completed in 1889. Wright's home was originally decorated with typically eclectic and ornate Victorian furnishings. In 1895, he dramatically redesigned his home interior, including his dining room furniture, in a style that showed the clear influence of Arts and Crafts style.

This was the first indication that he had abandoned the traditional Beaux Arts styles of his previous employers. In 1898, he would double the size of his house by adding a studio for himself and his staff. By 1901 he had completed over 50 architectural projects.

Another follower of Arts and Crafts was Elbert Hubbard (1856–1915). Hubbard had worked for a successful U.S. soap company. He resigned and was inspired by a meeting with William Morris and his Kelmscott Press during an 1892 visit to England. Hubbard soon established Roycroft Press to produce handmade, leather-bound books that were works of art, and he also began publishing a magazine, *The Philistine*, in East Aurora, New York, near Buffalo, to spread the gospel of Arts and Crafts. The magazine became a huge success and encouraged the establishment of a community of workshops dedicated to superior craftsmanship. Initial workshops included printers, leather-smiths, and bookbinders.

In 1896 Hubbard founded Roycroft and began producing simple and functional Arts and Crafts style furniture under the Roycroft name, then added furniture making and metalsmith workshops. Workers were called "Roycrofters," and included Albert Danner, Santiago Cadzow, Victor Toothaker, Karl Kipp and Darl Hunter. Roycroft's motto was "Not How Cheap, but How Good," and its creed was a quotation from John Ruskin: "A belief in working with the head, hand, and heart and mixing enough play with the work so that every task is pleasurable and makes for health and happiness."

After the Spanish American War, Hubbard wrote an inspirational essay in 1899 based on the war entitled *Message to Garcia*. It sold 40 million copies, made him famous, and was made into several movies (1916 silent film by Edison, and 1936 by Twentieth Century-Fox). The message of the story was "don't ask questions; get the job done." By 1910, Roycroft would attract nearly 500 people working in more than a dozen buildings. After Hubbard's death in 1915 (he was a passenger on the *Lusitania*), his son Elbert II maintained the company until 1938. Today, the Roycroft "campus" is open to the public and is on the National Register of Historic Places.

The Arts and Crafts pottery movement in the U.S. continued to grow. Newcomb College Pottery was established in 1895 by artist Ellsworth Woodward (1861–1939) in conjunction with art courses at the College in New Orleans (founded in 1886), and influenced by the Arts and Crafts movement. That same year, Weller Pottery (founded in 1872) in Zanesville, Ohio, purchased Lonhuda pottery. Charles Upjohn became art director and began to produce its first art pottery line, Louwelsa.

Many of the Arts and Crafts followers believed, as Morris proclaimed, that handcrafted objects were inherently more beautiful than mass-produced ones and continued to buy them regardless of their higher cost and

Elbert Hubbard, from 1916 Roycroft catalog.

regardless of the fact that the quality of many manufactured items by this time was equal or superior to those made by hand. American economist and social critic Thorstein Veblen (1857–1929) sought to explain this in his 1899 book, *The Theory of the Leisure Class*. He argued that aesthetics were strongly linked to monetary value and that such value was evident by the less-than-perfect flaws created by hand:

> The utility of articles valued for their beauty depends closely upon the expensiveness of the articles. A hand-wrought silver spoon, of a commercial value of some ten to twenty dollars, is not more serviceable ... than a machine-made spoon ... of some "base" metal such as aluminum, the value of which may be no more than some ten or twenty cents.
>
> The superior gratification of costly and supposedly beautiful products is, commonly, in great measure a gratification of our sense of costliness masquerading under the name of beauty.
>
> Hand labor is a more wasteful method of production ... hence the marks of hand labor ... certain imperfections and irregularities ... take rank as of higher grade than the corresponding machine product.
>
> Hence has arisen that exultation of the defective, of which John Ruskin and William Morris were such eager spokesmen in their time; and on this ground their propaganda of crudity and wasted effort has been carried forward since their time. And hence also the propaganda for a return to the handicraft and household industry. So much of the work and speculations of this group of men ... would have been impossible at a time when the visibly more perfect goods were not the cheaper.[9]

Roycroft chair, 1898.

This was the core philosophical argument for Arts and Crafts. Perfection by cold machines and unskilled labor, even though inexpensive, had no humanistic value. Imperfect products that showed the marks of human handwork were inherently more valuable, just like homemade lumpy cookies were always better than those uniform ones from a factory. This concept appealed to the same Victorian consumers who bought products with ostentatious decoration and ornamentation, which was suggestive of expensive and labor-intensive handwork, even though made by machine. It was this handcraft interpretation of design that overpowered the organic functionalism of Dresser's South Kensington design group and delayed it until modernism took hold in the 1920s.

The Arts and Crafts philosophy had, and still has, the ring of truth regarding products of a highly decorative and artistic nature. But these are but the tip of the consumer product iceberg. The vast majority of consumer products as the 20th century approached were primarily of a functional, "artless industry" nature, including electrical appliances, automo-

biles, bicycles, motorcycles, cameras, airplanes, and furniture, to name a few. Some designers were aware of this approaching avalanche of new products being spawned by new technologies, and they struggled to define a new role for design other than the traditional decorative role. To do so, they needed to embrace, not reject, mass production.

The French, in particular, sought to regain their former lead in design from the English. From 1884 to 1893, an avant-garde group in French-speaking Belgium called Les Vingt (The Twenty) or Les XX, held exhibitions, musical events and readings. Its founders were Edmond Picard (1836–1924), Belgian jurist and author, and Octave Maus (1856–1919), Brussels art critic, writer, and lawyer. They intended to promote avant-garde culture through the unification of the arts. Their exhibitions displayed works of avant-garde artists; performances by avant-garde composers, including Debussy, were held in their galleries, as were readings of avant-garde poetry. Many exiled French artists and writers, such as Baudelaire, were included from Belgium's French-speaking neighbor. For each of their annual art exhibitions, they invited twenty international artists to participate. Over the years, these included Pissaro, Monet, Seurat, Gauguin, Cezanne, and Van Gogh. Their weekly journal, *L'art moderne*, founded in 1881, championed *Les Vingt* and published many articles explaining its philosophy and promoting a socialist agenda. Painting, sculpture, engraving, furniture, and costume design were discussed along with art and music. Belgian Symbolist artists—who used simplified forms, heavy outlines, and primitive cultures—such as James Ensor, Fernand Khnopff, and Henry Van de Velde were members of Les Vingt and merged their styles into the new Art Nouveau style.

In 1897 architect Henry Van de Velde (1863–1957) was advocating a new path for design. He wrote an essay, "A Chapter on the Design of Modern Furniture," in which he encouraged designers to produce a new appropriate style, and, more important, gave them reason to embrace mass production. He wrote:

> We must endeavor to work out the foundations on which to build a new style and in my opinion the origin clearly lies in never creating anything which has no valid reason for existing, even with the almighty sanction of industry and the manifold consequences of its powerful machines.
> But I could be prouder of the certainly far more individual principle of systematically avoiding designing anything that cannot be mass-produced. My idea would be to have my project executed a thousand times, though obviously not without strict supervision.... I can only thus hope to make my influence felt when more widespread industrial activity will allow me to live up to the maxim which has guided my social beliefs, namely, that a man's worth can be measured by the number of people who have derived use and benefit from his life's work.

He followed this with his description of principles an "appropriate" new style should emulate. The organic functionalism of Greenough and Dresser was still alive:

> It is only because I understand and marvel at how simply, coherently and beautifully a ship, weapon, car, or wheelbarrow is built that my work is able to please the few remaining rationalists who realize that what has seemed odd to others has in fact been produced by following unassailable traditional principles, in other words unconditionally and resolutely following the functional logic of an article and being unreservedly honest about the materials employed, which naturally vary with the means of each.[10]

In 1899, Henry van de Velde founded his own decorating firm and factory near Brussels to produce very successful and popular curvilinear Art Nouveau furniture as a designer and businessman. He foreshadowed industrial designers in his adaptability to all mediums. He designed not only posters and furniture, but also architecture, housewares, and even clothes, for his wife.

Henry van de Velde workshop, Brussels, 1899.

Germany also felt threatened by England's dominance in design trade. Interest in the Art Nouveau movement began with the first Jugenstil exhibition in decorative arts at the Munich Glaspalast in 1897 and soon thereafter, progressive organizations devoted to producing marketable products in the new style were formed throughout the country in protest of the "official" art of the academies.

By this time, architect Peter Behrens (1868–1940) had joined the Munich Secession, and along with Munich applied artists Richard Riemerschmid (1868–1957), who wrote for *Jugend* magazine, Bernhard Pankok (1872–1943), illustrator for *Jugend*, Bruno Paul (1874–1968), Franz von Stuck, (1863–1928), August Endell (1871–1925), and sculptor Hermann Obrist (1863–1927), founded the Munich Vereinigte Werkstätte für Kunst in Handicraft (Munich United Workshops for Art in Handicraft) in 1897. Designs by members were made in the company's factories and workshops and a design publication in Munich appeared, *Dekorativ Kunst* (*Decorative Art*), edited by H. Bruckmann and Julius Meier-Graaf.

In Darmstadt, Alexander Koch in 1897 published a magazine, *Deutche Kunst und Dekoration* (German Art and Decoration), "to help Germany achieve victory in competition with other nations." Koch was very fearful that as "The practice of art in the Fatherland again appears dependent upon England, America, and France ... individual German art language threatens to become lost."[11]

Clearly, much of the impetus for design in Wilhelm II's Second Reich in Germany was to maintain nationalistic pride and leadership in product trade competition. The editors of the magazine directed an "Art and Applied Art" exhibition in Darmstadt that same year, showing "middle class rooms of modern character to awaken in the public a feeling for the German way and character in contemporary art" and featuring "changeable furniture."[12]

In Dresden, The First International Art Exhibition was held in 1897 and featured work

by Henry van de Velde and Louis Comfort Tiffany. The following year, the Dresdener Werkstätten für Handwerkskunst (Dresden Workshops for Handcrafted Art) were founded by Dresden carpenter Karl Schmidt with two assistant workers, and soon they employed many artists, including Ernst Walther (1858–1945), J.V. Cizzarz, and architect Wilhelm Kreis (1873–1955), to create simple, solid, functional furniture at reasonable prices. The designs, more along traditional Arts and Crafts style, contrasted sharply with the decorative excesses of Art Nouveau. By 1899, the workshops were a commercial success story with 200 workers and their work was displayed at the Deutsche Kunst-Ausstellung exhibition in Dresden. That same year, the Berlin Secession was founded, echoing the one in Munich.

The Art Nouveau movement simultaneously arose in Vienna in 1897, where a group of artists broke away from the conservative historicism of the Association of Austrian Artists, housed in the Vienna Künstlerhaus, and formed the Wiener Sezession (Vienna Secession), also known as Vereiningung Bildender Künstler Österreichs (Union of Austrian Artists). Members included Josef Hoffmann (1870–1956), Otto Wagner (1841–1918), Koloman Moser (1868–1918), Joseph-Maria Olbrich (1867–1908), Max Kurzweil and Gustav Klimt (1862–1918), the first president. The group's first exhibition was held in 1898, in an exhibition hall designed by Olbrich. Above its entrance was carved the phrase "To every age its art, and to art its freedom." They hoped to create a new style that owed nothing to historical influence. Secessionist style was exhibited in a magazine, *Ver Sacrum*, which the group published from 1898 to 1903.

With the exception of a few such as Tiffany, Roycroft, Rookwood, and a few others, America was still only a backwater of design. American designers of Victorian artifacts—and there were many—are virtually unknown. They were anonymous mechanical reproducers of European designs, churning out products for the industrial machine. One was an unknown German cabinetmaker who carved flowers on the wooden front of the National Cash Register Company's first product in 1883. Americans were largely preoccupied not with design but with lifestyle-changing inventions, technology, and big business; America was the world showcase of Capitalism.

Left: Thomas Edison's first phonograph, 1877. Right: George Eastman's pocket Kodak, 1897 (courtesy Eastman Kodak Company).

Herman Hollerith's punch card calculator, 1890.

American heroes of this explosion of American entrepreneurship are numerous, but among them were Thomas Alva Edison (1847–1931), who invented the quadruplex telegraph (1874), the phonograph (1877), the carbon microphone (1878), the first commercially practical incandescent electric lightbulb (1879), the electric distribution system (1880), the Kinetoscope (a motion picture camera, 1891), and the two-way telegraph (1892); Nikola Tesla (1856–1943), who invented alternating current (1888), the electrical induction motor (1889),

and wireless telegraphy (1893); George Eastman (1854–1932), who invented roll film (1874) and the Kodak camera (1888); Frank J. Sprague (1857–1934), who invented electric streetcars (1880) and electric elevators (1892); Hiram Maxim (1840–1916), who invented the machine gun (1884); Andrew Carnegie (1835–1919), who built a personal empire of steel that by 1889 exceeded the output of the entire United Kingdom; John D. Rockefeller (1839–1937), who revolutionized the petroleum industry and formed Standard Oil of Ohio in 1870; Cornelius Vanderbuilt (1794–1877), who built an empire of national railroads by the time of his death; and Herman Hollerith (1860–1929), who by 1890 had invented a calculator driven by punch cards, the basis of modern computers, to tabulate the national census.

At the close of the 19th century, the automobile, probably the most influential consumer product of the 20th century, was in its infancy. Bicycle-maker brothers Charles and Frank Duryea in 1893 had produced America's first car. By 1900, a total of 8000 cars, powered by steam, electric and gasoline, were registered and in operation, with names such as Packard, Stanley, Locomobile, Winton, Oldsmobile (1897), and some 35 other brands. They would soon be followed by Ford (1903), General Motors (1908) and, literally, over 2200 others.

These men spawned entirely new industries and manufacturing that created what many call the Second, or American, Industrial Revolution, based on electric power, machine tools, and factories. From 1850 to 1900, the U.S. population had tripled, providing unlimited skilled and unskilled labor through mass immigration, largely from Europe, but equally from mass migration from rural farms to urban cities, to support this new revolution. Almost all the new consumer products spawned by these new industries were not decorative, but functional mechanical devices designed by inventors and manufacturing engineers. Most Americans in a rapidly growing middle class were still hungry for function and mobility, not appearance.

Chapter 5

1900–1918
Architects Take the Lead

The 20th century dawned on a world divided by oceans and with separate challenges. Europe, nearing the end of the Victorian era, continued to be the traditional global leader of art and design, with artists defying tradition and architects leading in design innovation. But they were losing markets to American mass production.

America, after its stunning victory in the Spanish American War, became aware of its new political and trading power internationally; and through its inventions, technologies, and new sources of energy (petroleum and electricity), it became aware of its leadership in industrial production. In the first seven years of the century, the wave of industrialization begun in the 1880s peaked. However, the general opinion of the time was that there was no need for the development of industrial arts in the U.S., because the best designs normally came from Europe.

A major international exposition in 1900 demonstrated the qualitative difference between European and American design. In Paris, the Exposition Universelle et Internationale was held from April to November to celebrate the achievements of the past century and promote development into the next. It coincided with the opening of the Paris Métro, which featured cast iron Art Nouveau entrances designed by French architect Hector Guimard (1867–1942).

Art Nouveau was overwhelmingly the most innovative and popular modern style displayed at the exposition, demonstrating traditional European dominance in design. Art Nouveau exhibits included the art glass lamps and jewelry of American Louis Comfort Tiffany, including his famous Wisteria lamp; French art glass designer Émile Gallé (1846–1904), founder of the School of Nancy; and French jeweler René Lalique (1860–1945). Siegfried Bing had his own pavilion, Art Nouveau Bing, with work by Edward Colonna, Georges de Feure, and Eugène Gaillard. But Art Nouveau styles, due to their complexity and intricate forms, were nearly impossible to replicate easily by machines.

The U.S., which had already exceeded all other countries in the volume of production, displayed 7,000 items, more than any other exhibitor, but most were laborsaving devices or inventive mechanisms, demonstrating American dominance in technology and mass production. They were invariably inexpensive and functional, as well as ingenious, but generally devoid of innovative artistic style. Decorations, when used, were tired imitations of historical European styles.

Another event that year was the 8th international exhibition of the Vienna Secession devoted to handicraft and featuring the work of Scottish architect Charles Rennie Mackintosh (1868–1928) and the English head of the London Guild of Handicrafts, Charles

Robert Ashbee, both devotees of Arts and Crafts. Architect Josef Hoffmann (1870–1956), one of the founders of the Secession, and a strong supporter of the Arts and Crafts movement, said the exhibition "strived to achieve an identical goal within any nation: to impart appropriate form to modern perception."[1] This was a goal shared by other countries, and the European design community was, in fact, trying to work together toward this objective. But their interpretations of "appropriate form" differed widely.

In Germany, for example, the Künstler-Kolonie (Artist's Colony), founded in 1899 in emulation of the English Arts and Crafts movement, began construction of

Cash register by National Cash Register Company, 1900.

buildings in 1900 to house its colony on the Matildenhöhe in Darmstadt. A leading member of the colony was budding architect Peter Behrens, of the Munich Workshops, who designed his own Jugenstil house (the only one on the site) and everything in it, including furniture, door handles, and cutlery. Behrens worked closely with Austrian architect Josef Maria Olbrich (1867–1908), a member of the Vienna Secession who designed the "Wedding Tower" exhibition hall that symbolized the colony. Both Behrens and Olbrich were breaking away from Art Nouveau toward more abstract and geometric patterns. In 1901, Behrens organized an exhibition, Ein Document Deutcher Kunst (A Document of German Art), describing the achievements of the colony, which would remain active until 1914.

In America, architect Gustav Stick-

Wisteria lamp by Louis Comfort Tiffany, 1900 (courtesy Chrysler Museum; gift of Walter P. Chrysler, Jr.).

ley (1858–1942), a follower of the Arts and Crafts movement from his travels in England and awareness of William Morris's philosophy, introduced his Stickley Company line called "The New Furniture" at the 1900 Grand Rapids, Michigan, furniture show. He had formed the company in 1898 in Eastwood (now Syracuse), New York. The simple, unadorned, sturdy, durable, rather heavy style made of oak became known as Mission Furniture, based on Stickley's claim that its "mission" was to create "a style beyond style." In 1901 he changed the name of his company to "Craftsman," adopted the motto "*Als Ik Kan*" (If I can), and displayed his line at the Pan American Exposition in Buffalo, New York. That same year he began publishing *The Craftsman*, a monthly journal which promoted the virtues of Ruskin, Morris, and his own furniture, which featured his version of the classic Morris "reclining" chair.

1900 Kodak box camera (courtesy Eastman Kodak Company).

In 1903, Stickley hired architect Harvey Ellis (1852–1904), who refined the line with a lighter, subtler style. Stickley also that year founded the Craftsman Home Builders Club to spread his ideas about domestic, organic architecture. His philosophy included many concepts that would be adopted by Frank Lloyd Wright:

- A house ought to be constructed in harmony with its landscape, with special attention paid to selecting local materials.
- An open floor plan would encourage family interaction and eliminate unnecessary barriers.
- Built-in bookcases and benches were practical and ensured that the house would not be completely reliant on furniture from outside.
- Artificial light should be kept to a minimum, so large groupings of windows were necessary to bring in light.

Together, Stickley published 211 house plans over the next 15 years in *The Craftsman*. By 1905, Craftsman business had grown in popularity to the point where he allowed franchised manufacturing around the country. But demand continued to exceed production, and other furniture companies soon copied the style extensively. It became standard in hotels, dormitories, resorts, and classrooms around the country. By 1915, however, Stickley was in bankruptcy, and the Arts and Crafts movement was pretty much at its end, as well.

The demise of Arts and Crafts was being accelerated by Belgian architect/designer Henry van de Velde, a champion of design for mass production who moved to Berlin in 1900, where he would significantly influence the evolution of design. In 1901 he published *Die Renaissance in Modernen Kunstgewerbe* (*The Renaissance in Modern Arts and Crafts*) that described the designer's ideal relationship to machine production. In 1902, he was called to the town of Weimar, "to provide artistic inspiration to craftsmen and industrialists by producing designs, models and so forth,"[2] and established the Weimar Kunstgewerbeschule (Weimar Arts and Crafts School), an institute where any craftsman or indus-

trialist was offered free advice to analyze and improve his products. Van de Velde designed the institute's buildings and by 1907 the school would become public.

American architect Frank Lloyd Wright shared Van de Velde's optimism regarding the opportunity that the machine offered designers. In a 1901 address to the Chicago Arts and Crafts Society, Wright stated "the Machine is, in fact, the metamorphosis of ancient art and craft: that we are at last face to face with the machine — the modern Sphinx — whose riddle the artist must solve if he would that art live — for his nature holds the key.... [T]he machine is capable of carrying to fruition high ideals in art — higher than the world has ever seen!... [I]t is the great forerunner of democracy ... the tool which frees human labor, lengthens and broadens the life of the simplest man, thereby the basis of the Democracy upon which we insist."

He praised William Morris and John Ruskin but felt that they had "miscalculated the machine" before it had been refined and developed and before the social problems it initially caused were corrected. He said, "most art and craft of today is an echo; the time when such work was useful has gone." Speaking of current Grand Rapids furniture, he described it as being "elaborate and fussy joinery of posts, spindles, jig-sawed beams and braces, butted and strutted, to outdo the sentimentality of the already overwrought antique product." Wright, a furniture designer in his own right, favored "clean-cut, straight line forms that the machine can render far better than would be possible by hand" that could "bring out the beauty of the wood ... a material having in itself intrinsically artistic properties, of which its beautiful markings is one, its texture another, its color a third."[3]

But the Arts and Crafts tradition soldiered on. In 1902, painter Aladár Körösfói-Kriesch formed the Gödöllő Workshops in the Hungarian town of the same name. He was joined by Swedish craftsman/designer Leo Belmonte and architect István Medgyaszay. The workshops produced crafts in a living embodiment of the Arts and Crafts ideal and continued until 1921.

In 1903, the Wiener Werkstätte (Viennese Workshops), modeled on Ashbee's London Guild of Handicrafts, was created in Austria by architects Josef Hoffmann and artist/designer Koloman Moser (1868–1918), both members of the Wiener Sezession. They explained their reason, expressing their resignation to the realities of mass production, and their retreat into the comfort of tradition:

> The boundless evil, caused by shoddy mass-produced goods and by the uncritical imitation of earlier styles, is like a tidal wave sweeping across the world. We have been cut adrift from the culture of our forefathers and are cast hither and thither by a thousand desires and considerations. The machine has largely replaced the hand and the business-man has supplanted the craftsman. To attempt to stem this torrent would seem like madness.
>
> Yet for all that we have founded our workshop. Our aim is to create an island of tranquility in our own country, which, amid the joyful hum of arts and crafts, would be welcome to anyone who professes faith in Ruskin and Morris. We are calling for all those who regard culture in this sense as valuable, and we hope that the errors we are bound to commit will not dissuade our friends from lending their support.[4]

Production was by hand, and included bookbinding, metalwork, leatherwork, jewelry, tapestries, graphics, household goods, furniture and architecture. The Werkstätte's first commission in 1904 was for a fashionable spa outside Vienna, the Purkersdorf Sanatorium, with its buildings designed by Hoffmann as well as the design of all furnishings that were manufactured by Jacob & Josef Kohn. By 1905 the workshops employed 100 craftsmen.

Concurrently with the founding of the Wiener Werkstätte, Steuben Glass Works was established in Corning, New York, in 1903 by British glass designer Frederick Carder (1863–

1963) who had just emigrated to the U.S. from England where he had worked with Stevens & Williams to develop colored glass. Steuben produced colored glasswork rivaling the quality of Louis Comfort Tiffany. After the company was acquired by Corning Glass Works in 1918, Carder continued as Corning's artistic director.

In Düsseldorf, Germany, the School of Applied Arts was founded in 1903 by architect Hermann Muthesius (1861–1927), just named head of the Board of Trade for Schools of Arts and Crafts in the government of Prussia, part of the German Empire. Peter Behrens, a prominent member of the Darmstadt Artist Colony, was appointed as director. Concurrently, Muthesius appointed Bruno Paul of the Munich Secession, a leading artist of the Jugendstil movement, to head the Industrial Art School in Berlin. The school would become much larger in scope and in number of students than the Bauhaus, and his students there, or those who apprenticed with him in his private practice, would include those who would become prominent designer/architects, such as Ludwig Mies van der Rohe, Adolph Meyer, and Kem Weber.

Muthesius had been the cultural attaché to the German embassy to London since 1896, and had investigated English lifestyle and design. He believed that new design forms were needed as "the visible expression of the inner driving force of the age ... not only to change the German home ... but directly to influence the character of the generation. Commercial success marches in step with ruling inner values." He wanted Germany "to assume leadership in the applied arts, to develop its best in freedom, and to impose it on the world at the same time."[5] Clearly, he wanted to unite art and industry for national economic advantage in trade through national standards of architectural and product design. What he called for was "a new style, a machinenstil," whose shapes were "completely dictated by the purposes they serve."[6] In other words, it should be based on form following function. There's that principle again.

Austrian architect Otto Koloman Wagner (1841–1918), a member of the Vienna Secession, in 1904 designed the Austrian Postal Savings Bank with an innovative glass and steel interior and designed office furniture produced by Thonet to complement it. The bank's style is often cited as a forerunner to the modern movement. He also designed the 1902 Art Nouveau telegraph office.

The best-known Danish silversmith, George Arthur Jensen (1866–1935), who was heavily influenced by the Arts and Crafts movement, opened his own shop in Copenhagen in 1904, to make and retail his work.

In Dresden, Germany, Karl Schmidt's Dresden Workshops in 1906 held its Dritte Deutsche Kunst-Gewerbe-Ausstellung (Third German Applied Arts Exhibition). The workshops, recognizing the advantages of mass production, produced a line of Machinenmöbel (machine furniture) designed by Karl Schmidt's brother-in-law, Richard Riemerschmid, of the Munich Secession. The basic box-like furniture pieces were cut in a mechanized production process using plain, low-cost materials. In 1907, the Dresden Workshops merged with the Münchener Werkstätten für Wohnungs-Einrichtungen (Munich Workshops for Domestic Furnishings) and became known as the Deutsche Werkstätten.

In America, the 1904 Louisiana Purchase Exhibition in St. Louis was a showcase not only for U.S. designers such as Louis Comfort Tiffany, but also for many leading European designers. A Belgian exhibit probably included work by Henry van de Velde. Exhibitors included the Gödöllő Workshops from Hungary, and René Lalique of France. Peter Behrens designed the official catalog for "The Exhibit of German Empire," which included designs by Behrens and Josef Hoffmann; complete room interiors by German designers, included

Die Zeit (The Time) telegraph office in Vienna, by Otto Wagner, 1902 (1986 reconstruction).

Bruno Paul, who won a gold medal, and an unusual barrel-shaped chair by Josef Maria Olbrich. Frank Lloyd Wright, who had just designed his famous red square trademark, was fascinated by the fair and was familiar with design events in Europe. That same year, Wright designed a barrel-shaped chair similar to Olbrich's, as well as another completely different straight-backed, plain chair, called the "Plank Chair" that would later inspire Theo van Doesburg's "Red Blue Chair" of 1918.

In 1906, the Werkstätte held a Gedeckte Tisch (Dining Table) exhibition in Vienna that featured a silver place setting by Josef Hoffmann produced in limited quantities for himself and other members of the Werkstätte in 1904. The design was in an extraordinarily elegant and modern style that people often guess today, from its appearance, to be from the 1950s. However, critics of the exhibition panned the silverware as "uncomfortable" and "suggestive of anatomical instruments," and predicted that it would fail "for practical considerations." In 1907, Hoffmann designed his classic café chairs (armchair #728), for the Kabarett Fledermaus in Vienna, which were produced by Jacob & Josef Kohn. The Kabarett, a theatre/restaurant, was built by the Wiener Werkstätte, and was inspired by artist's cabarets in Paris.

A 1907 exhibition of cubist paintings was held in Paris featuring painters Georges Braque (1882–1963) and Fernand Léger (1881–1955), who initiated an art movement that was encouraged by their colleague Paul Cézanne (1839–1906), who urged artists to construct scenes in geometrical forms. Cubism, well known by 1911, would later have a significant impact on design styles.

In London, the Guild of Handicrafts, which had been founded in 1888 by Charles Robert Ashbee and which had been the model for the 1903 founding of the Wiener Werkstätte (Vienna Workshops), was closed in 1907 due to business failure during an economic recession. Ashbee described the circumstances: "In plain business terms the Guild has dropped at the beginning of its twenty-first year and at the end of a period of acute commercial depression, a substantial sum of money, upwards of £6,000–£7,000, the money of its shareholders, many of whom are the workmen themselves, in the attempt to carry through certain principles of workmanship and life." Ashbee defended these "certain principles" of the Arts and Crafts movement:

The Arts and Crafts movement ... is not what the public has thought it to be, or is seeking to make it: a nursery for luxuries, a hothouse for the pro-

Victrola Model XVI, a hand-cranked phonograph concealed inside cabinet designed by Eldridge R. Johnson, of the Victor Talking Machine Company, 1906.

duction of mere trivialities and useless things for the rich. It is a movement for the stamping out of such things by sound production on the one hand, & the inevitable regulation of machine production and cheap labor on the other. My thesis is that the expensive superfluity and the cheap superfluity are one and the same thing, equally useless, equally wasteful, & that both must be destroyed. The Arts and Crafts movement then, if it means anything, means Standard, whether of work or of life, the protection of Standard, whether in the product or in the producer, and it means that these two things must be taken together.

To the men of this movement, who are seeking to compass the destruction of the commercial system, to discredit it, undermine it, overthrow it, their mission is just as serious and just as sacred as was that of their great grandfathers who first helped raise it into being, and thought that they had built for it an abiding monument in a crystal palace of iron and glass [a reference to

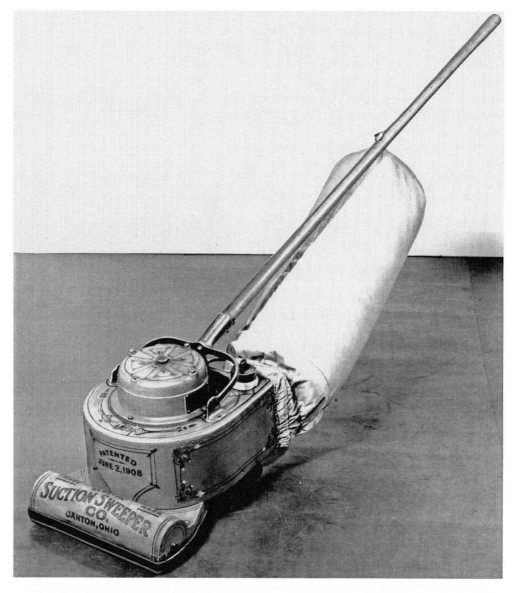

Hoover's first electric vacuum cleaner, 1908, by James Murray Spangler, for the Hoover Electric Suction Sweeper Company (courtesy Hoover Historical Center/Walsh University, North Canton, OH).

Joseph Paxton's "Crystal Palace" in Hyde Park to house the Great Exhibition of 1851]. They want to put into place of the old order that is passing away, something finer, nobler, saner; they want to determine the limitations of the factory system, to regulate machinery, to get back to realities in labor and human life.[7]

It was clear, however, even to Ashbee, that the Arts and Crafts movement was becoming obsolete in the 20th century. While the costs of human labor were rising, the cost of manufactured goods continued to decline due to higher quantities while their quality constantly increased. The fight against mass production was futile, and its only hope was for designers to have a say in controlling and regulating the industrial monster. In Germany, such political representation by craftsmen was granted.

In 1907, under the leadership of Hermann Muthesius, the Deutsche Werkbund (German Union of Work) was founded in opposition to inadequacies of the existing Fachverband für die wirtschaftlichen Interressen des Kunstgewerbes (Trade Association for the Economic Interests of Applied Art), founded in 1892. The Werkbund's new purpose was to marry art and industry and develop a new machine esthetic through an enlightened program of art education and to define industrial, craft, and aesthetic standards. This new trade association consisted of 12 industrialists and 12 artists/architects, including Walter Gropius, Peter Behrens, Josef Maria Olbrich, Karl Schmidt, Bruno Paul, Hermann Muthesius, Richard Riemerschmid, Henry van de Velde, August Endell, Joseph August Lux (1871–1947), Peter Bruckmann (1865–1937), Friedrich Naumann (1860–1919), Karl Ernst Osthaus (1874–1921), Heinrich Tessenow (1876–1950), Fritz Schumacher (1869–1947), Theodor Fischer (1862–1938), and Alfred Grenander (1863–1931).

Architect/designer Peter Behrens, charcoal drawing by Max Lieberman (courtesy Deutsches Technikmuseum, Berlin).

The Deutsche Werkbund lost no time in establishing its dominance in the German design community. A direct connection with industry was achieved when Werkbund member Peter Behrens was appointed in 1907 as artistic consultant to Allgemeine Elektricitäts Gesellschaft (AEG), the German equivalent to General Electric in the U.S., under his stated condition: "It is agreed, we refuse to duplicate handmade works, historical style forms, and other materials for production."[8] Behrens was probably influenced by German architect Joseph August Lux (1871–1947), who, in a 1908 article, said, "The artistic problem of our age does not lie in the arts and crafts, it lies in industry."[9] Behrens opened his own private office in Berlin in 1908, and over the years before the war employed Walter Gropius (1883–

1969), Adolph Meyer (1881–1929), and Frenchman Charles-Edouard Jeanneret Gris (1887–1965), later known as Le Corbusier.

Behrens became intensely involved with architectural, product, and graphic design programs at AEG until the war began in 1914. Significantly, it was the first major corporate design program and is generally recognized as the first implementation of what would eventually become known as corporate industrial design. Behrens designed new AEG trademarks, electric table fans, irons, electric kettles, lighting fixtures, advertising graphics, and the architecturally influential Turbinenfabrik (Turbine Factory) Hall.

In 1908 the Werkbund financed a new museum in Hagen, Germany, called the Deutsches Museum für Kunst in Handel und Gewerbe (German Museum for Art in Trade and Commerce), which was used to disseminate information on German design through its own exhibitions and throughout the world, including the U.S. That same year, Werkbund member Bruno Paul designed the first example of modular furniture, called Typenmöbel (type furniture), conceived to allow an unlimited number of combinations of standardized, machine-made elements.

By this time, of course, the world was marveling at the newest icons of machine technology: the automobile, exemplified by Henry Ford's new Model T, already in production in 1908, and the airplane, pioneered by the Wright brothers in 1903. In France, Louis Blériot (1872–1936) had developed the first successful monoplane — his Blériot V, which flew about 16 meters in 1907. This accomplishment apparently inspired a 15-year-old French schoolboy in 1908 to design and build a model airplane powered with rubber bands. He named it the

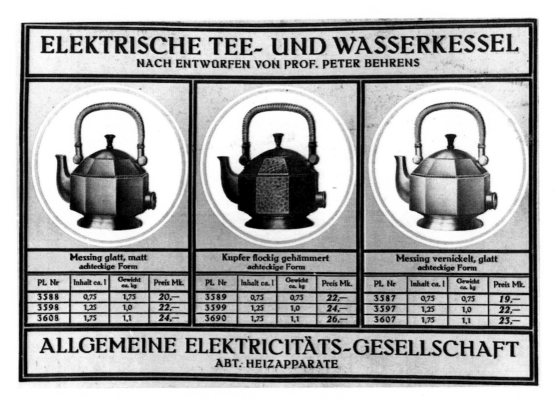

AEG electric tea and water kettle line by Behrens, 1909, 30 style variations, each in three sizes (courtesy Deutsches Technikmuseum, Berlin).

Ayrel, patented it, formed a company, and rented space to put it into production. His name was Raymond Loewy, who would become a pioneer U.S. industrial designer and who would eventually design the classic livery, graphics, and interiors of *Air Force One* for President Jack Kennedy in 1962, as well as functional interiors for NASA's Skylab in the late 1960s.

The avant-garde work of Munich Secession artists was exhibited in America in 1909, the same year that Blériot successfully flew across the English Channel with his XI monoplane and the North Pole was discovered. The Secession exhibition was staged by the Metropolitan Museum of Art in New York. Secessionist artists who exhibited included Max Slevogt (1868–1932), Franz von Stuck, and Richard Riemerschmid, the latter two Secession cofounders. Many say the Secessionist movement laid the foundation for modernism in twentieth-century art, and there is much to support that view.

AEG iron by Peter Behrens, 1910 (courtesy Deutsches Technikmuseum, Berlin).

Scottish architect Charles Rennie Mackintosh, the foremost exponent of Art Nouveau in Great Britain, in 1909 completed his best-known architectural work, the Glasgow School of Art, including the design of the interiors and furniture. He had won the commission for the project in an 1897 competition.

Modern technology was beginning to attract artists throughout Europe. Italian poet Filippo Tommaso Marinetti (1876–1944) in 1909 founded a fine arts movement called Futurism, which promoted speed, technology, youth, automobiles, airplanes, fascism, and war (he called it the world's only hygiene), as well as the destruction of museums, Renaissance art, academies and libraries as symbols of a dying culture. In his manifesto, Marinetti explained his purpose: "It is from Italy that we launch through the world this violently upsetting, incendiary manifesto of ours. With it, we establish Futurism, because we want to free this land from its smelly gangrene of professors, archaeologists, ciceroni [tour guides] and antiquarians. For too long has Italy been a dealer on secondhand clothes. We mean to free her from the numberless museums that cover her like so many graveyards."[10]

Futurism's followers, which in time included artist Giacomo Balla (1871–1958), painter-sculptor Umberto Boccioni (1882–1916), painter Carlo Carrà (1881–1966), painter-graphic designer Fortunato Depero (1892–1960), painter-experimental musician Luigi Russolo (1885–1947), architect Antonio Sant'Elia (1888–1916), and painter Gino Severini (1883–1966), envisioned the power of art, technology, mass markets and global communication to change social structures, a trend that would within a few years be echoed in avant-garde movements in Europe and Russia. Balla painted a speeding automobile as the primary subject. Marinetti said that a roaring motorcar was more beautiful than the *Victory of Samothrace*. Boccioni said they wanted to Americanize themselves by hurling themselves into the all-consuming vortex of modernity through its automobiles, crowds, and relentless competitions. To them, the new technology and art would produce a dynamic, aggressive and strong Italy.

Antonio Sant'Elia became involved in the movement in 1912 and designed a futurist city, La Città Nuova (The New City), exhibited with drawings in 1914 at the Famiglia Artistica gallery at the first and only exhibition of the Nuove Tendenze (New Trends) group, of which he was a member. His concepts featured monolithic skyscraper buildings with terraces, bridges, and aerial walkways. He published a manifesto, Futurist Architecture, in 1914. Unfortunately, as a soldier of the Italian army, he was killed in action in 1916. His work inspired a number of the "international style" architects in the 1920s.

An American architect also began to inspire Europeans. A complete portfolio of the work of Frank Lloyd Wright, entitled *Ausgefürte Bauten und Entwürfe von Frank Lloyd Wright* (*Selected Buildings and Designs of Frank Lloyd Wright*) was published in Berlin in 1910 by publisher Ernst Wasmuth. Wright traveled to Europe (1909–1910) to oversee its printing and to study the current trends in art and design. His book described more than 130 buildings and the 1911 edition contained an introduction by C.R. Ashbee, who had known Wright since 1901. Wright's work impressed a number of leading European architects, including Dutch Architect Hendrik Petrus Berlage (1856–1934), who taught German architect Mies van der Rohe (1886–1969), Dutch architect Gerrit Rietveld (1888–1964), and Walter Gropius. Wright demonstrated perfectly Berlage's theories about the primacy of space and the importance of walls, which were not dissimilar from those of Muthusius. In 1911, Wright completed his new home and private studio, Taliesin, secretly built in Spring Green, Wisconsin.

By 1910 Germany had overtaken England in innovation and originality in architecture, art

1894 AEG trademark, before it was redesigned by Peter Behrens (courtesy Deutsches Technikmuseum, Berlin).

1914 AEG trademark by Behrens (after redesign) (courtesy Deutsches Technikmuseum, Berlin).

education, crafts, and design. Traditional Arts and Crafts workshops, as well as Art Nouveau and other historical styles, were in rapid decline, replaced by functional, simpler styles more suitable to production processes. In general, they were devoid of excessive ornamentation, that key "added value" contribution of the traditional craftsmen of the Victorian era, which to many still represented "quality" and "style."

One who criticized this traditional view publicly was prominent Austrian architect Adolf Loos (1870–1933), an opponent of the Vienna Secession. *Der Sturm*, a magazine of expressionism founded in 1910, published his stinging essay "Ornament und Verbrechen" ("Ornament and Crime"), in which he announced that "the evolution of culture is synonymous with the removal of ornament from objects of daily use." Further, he chastised "those who measure everything by the past [as impeding] the cultural development of nations and of humanity itself. Ornament is not merely produced by criminals, it commits a crime itself by damaging national economy and therefore its cultural development." He addressed the plight of craftsmen, who often had to sell their work in competition with lower cost mass-produced goods: "As a rule, ornament increases the price of an object. If I pay as much for a plain box as I would for an ornamented one, then the difference is in working hours.... The worker's time, the utilized material, is capital that has been wasted." He pointed out the wastefulness of frequent ornamental style changes: "Woe betide the writing desk that has to be changed as frequently as an evening dress, just because the style has become unbearable. Then the money that was spent on the writing desk will have been wasted."[11]

Loos was, in effect, urging his design colleagues to abandon their 19th century Victorian mentality and join the 20th century. Indeed, by 1910, the world had changed dramatically from the 19th, with the advent of the automobile, the airplane, subways, the zeppelin, X-rays, moving pictures, ocean liners, the telephone, wireless telegraphy, electricity, vacuum cleaners, and Einstein. The world would be dragged by technology, kicking and screaming, into the modern era. The year 1910 marked the beginning of what many call the "second phase" of industrialization, where mass production extended into nearly every corner of the manufacturing world.

At the time, few manufacturers were concerned with the appearance of their products, let alone able to articulate about the subject of design. An exception was the Italian Camillo Olivetti (1868–1943), who founded his company and introduced his first typewriters in 1911. He stated then that "The aesthetic side of the machine has to be carefully studied. A typewriter ... should have an appearance that is elegant and serious at the same time."[12]

The U.S. was the technical engine dragging the rest of the world. In 1910, U.S. electric current was standardized (60 cycle alternating current at 120 volts), and universal motors were developed, both of which encouraged the proliferation of electrical machines and appliances. One in ten American homes, mostly urban, had been wired for electricity. Electrical appliances were being promoted as the "modern servant" because of the diminishing number of "real" servants in the domestic scene due to the cost. In New York City, for example, the number of domestic servants for every 1,000 families declined from 141 in 1900 to 66 in 1920, a decrease of over 50 percent.

In transportation, electric trolleys and automobiles were replacing horses and carriages. Annual car production in 1910 was 181,000, and 485,000 cars were registered by owners. There were 1000 miles of concrete roads. In communication, home phonographs, typewriters and telephones were becoming common, as were public Nickelodeons, coin-operated music boxes, and motion pictures by Edison. A million and a half Singer sewing machines

were being sold each year. Sears and Roebuck sold ready-to-build houses by mail order priced from $650 to $5000.

Philadelphia engineer Frederick Winslow Taylor (1856–1915) was at the forefront of manufacturing technology in making production processes more efficient. In 1911 he published *Principles of Scientific Management* and founded the Taylor Society, which would establish "industrial engineering " schools throughout the country. Taylor's methods spawned "efficiency experts" with stopwatches to measure every step in a production line to reduce the time, and "flow charts" to track the process.

"Taylorism" influenced many manufacturers and followers. Frank Gilbreth (1868–1924) and his wife, Lillian (1878–1972), formed a management consulting firm based on Taylor theories; but they focused more on the motions of workers than the stopwatch, concerned that workers remain individuals and not become cogs in a machine. They conducted time and motion studies to break down labor into 18 basic movements they called "therbligs" (Gilbreth backwards). After Frank's death, Lillian sought the "one best way" to perform household tasks. Frank's son, Frank, Jr., wrote a best-seller book in 1948 about the family and their 12 children. The book was called *Cheaper by the Dozen* and was made into a popular film in 1950.

Taylorism also had a huge impact on domestic life. The wife of one of Taylor's followers and household editor of *Ladies Home Journal*, Christine Frederick (1883–1970), applied Taylor's principles to the home in her 1912 articles "The New Housekeeping: Efficiency Studies in Home Management," which would be published in book form in 1913. She advised women on how to arrange kitchen equipment and work stations for efficient traffic patterns, identified laborsaving devices and procedures, proposed efficient record keeping and purchasing habits, and urged women to develop skills of analysis, study, and planning to better manage their household tasks. Her articles appeared in book form in 1913, and in 1919, she published another book, *Household Engineering: Scientific Management in the Home*, which had significant impact on European kitchen design (see 1926 Frankfurt kitchen). The book included "before" and "after" floor plans showing badly grouped

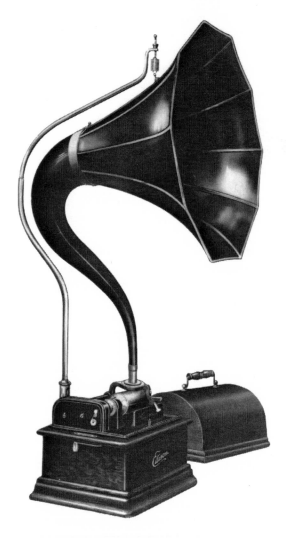

Model F Standard phonograph by Thomas Edison's National Phonograph Company, 1911 (courtesy U.S. Department of the Interior, National Park Service, Edison National Historic Site).

kitchen equipment versus efficient groupings to save steps. She explained the logic behind the illustrations:

> When we study the steps entailed in food preparation, we find that work in the kitchen does not consist of independent, separate acts, but of a series of inter-related processes.... There are just two of these processes: (1) preparing food, and (2) clearing away.... The preparing process includes (1) Collect, (2) Prepare, (3) Cook, and (4) Serve.... The clearing away process [includes] (1) Remove, (2) Scrape, (3) Wash, and (4) Lay away.... It therefore follows that the equipment connected with these two processes and their respective chain of steps should be arranged in a corresponding order. This principle of arranging and grouping equipment to meet the actual order of work is the basis of kitchen efficiency.... If the storage, stove, tables, sinks, etc., are arranged after this fundamental order, the work will proceed in a progressive, step-saving track, or "routing." ... If the equipment is not arranged on this principle, the result will be cross-tracking, useless steps and wasted energy in all kitchen work.

Frederick also anticipated future industrial design ergonomics by pointing out the failure of mass-produced products to consider user comfort:

> Very often a device which fulfils other conditions mentioned above fails in the small but essential point of comfort in use. This is especially true of handles, levers, etc., which either by their shape, finish, or point of attachment prove uncomfortable when used in the hands of the worker. There is a case of a breadmaker with the leverage applied at the top of the pail; otherwise a fine labor-saver, it requires an awkward arm motion which would not be the case if the leverage were applied at the base and side of the pail as indeed it is, in another make. The handles of many eggbeaters, mashers, spoons, etc., are not shaped for the comfort of the hand, although there are others on the market which do offer this point of comfort. Sometimes the handle is too short or too long, flat instead of rounded. Or a lever would be easier to operate if several inches longer, and many other instances occur where the small but important points of comfort are not considered.[13]

She wrestled with the problem of the height of standing work surfaces, which ranged from 311/2 inches for a woman of five feet tall to 341/4 inches for a woman who was five feet six. She concluded that "No absolute rule can be given for invariable heights because not only the height of the worker must be taken into consideration but also the length of her arm, and whether she is short or long-waisted, etc."[14]

Frederick's work followed the earlier work of MIT chemist Ellen Swallow Richards (1842–1911), who had pioneered in setting water quality standards to combat pollution and in applying scientific principles to domestic topics such as nutrition, sanitation, and physical fitness. In 1908 she was the first president of the American Home Economics Association, founded to improve the conditions of housework through research, education, and the application of the newest science and technology to the home. The organization inspired the establishment of home economics classes in thousands of high schools and colleges.

But Taylorism had its most dramatic impact on mass production as illustrated by Henry Ford's 1913 redesigned Model T, produced in the new Highland Park plant designed by architect Albert Kahn (1869–1942). Ford's refined *moving* assembly line method reduced production time from 12.5 hours to 2.5, reduced skilled labor by 40 percent, and cut the retail price of the car in half, from $900 to $440. This made cars much more affordable to thousands of middle class consumers and triggered a national trend of mobility. One hundred sixty-eight thousand Fords were produced this first year, and by 1927, fifteen million Model T's were made. Ford's production line process would be called "Fordism" and would demonstrate American leadership in mass production to the world.

This same year, 1913, the term "industrial design" was first used formally by the U.S. commissioner of patents, Edward B. Moore, who urged modification of existing regulations

to protect the property of "industrial design, the distinguishing form of products that have marketable value." The term would not be used much until the mid–1930s; but in 1913, the U.S. was busy refining the "industrial" part and Germany the "design" part.

In fact, America was just now becoming aware of European "modern art," which dramatically challenged traditional art. The primary event was the so-called Armory Show, or International Exhibition of Modern Art, held in February and March of 1913 at the 69th Infantry Regiment Armory at Lexington and 26th streets in New York. The Association of American Painters and Sculptors organized the show. Some 1,250 paintings, sculptures, and decorative works by over 300 avant-garde European and American artists were on display, including Impressionist, Fauvist, and Cubist work. Some of the work was considered scandalous and immoral, including French artist Marcel Duchamp's (1887–1968) *Nude Descending a Staircase*, which was described as "an explosion in a shingle factory" by a *New York Times* art critic. Francis Picabia (1879–1953) was another French artist who exhibited his abstract work. Both were cubists. President Theodore Roosevelt's response to the show was "That's not art!" In a related commercial art field, graphic artists were inspired to organize the American Institute of Graphic Artists (AIGA) in 1914.

In Germany, members of the Deutsche Werkbund were busy. Walter Gropius established his own office in 1910 after working in the architectural office of Peter Behrens. In 1911 Gropius and his new partner, Adolph Meyer, who had also worked for Behrens, designed the Faguswerk (Fagus Factory), a shoe-last factory in Alfeld-an-der-Leine. The novel design featured the first use of exterior "curtain walls" of glass and steel, flooding the interior workspace with light and inspired by Peter Behrens's Turbine factory of 1909 for AEG. In 1912, Gropius ventured into transportation by designing a Diesel railway locomotive, and in 1914 a compartment in a sleeping car.

Ford Model T production, 1913.

Deutsche Werkbund had nearly 2000 members, including the Wiener Werkstätte and AEG. The Werkbund was anxious to enter the vast American market. In 1912 it sent a 1,300-piece exhibition of its work to the Newark, New Jersey, Museum of Art and other U.S. institutions. John Cotton Dana (1856–1929), founder of the Newark Museum in 1909 and then still its director, saw the museum as a department store for modern ideas of good taste.

In 1914 the Werkbund held an exhibition in Cologne, Germany, with a display pavilion and model factory designed by Gropius and Meyer, and with a dramatic, conical, almost geodesic, all-glass pavilion by German architect Bruno Taut (1880–1938). The display pavilion, by Gropius and Meyer, was influenced by Frank Lloyd Wright's Mason City Hotel (1909) design shown in his Wasmuth publications. This exhibition confirmed the movement initiated by Behrens in his Turbinenfabrik and Gropius's Faguswerk, known as the "factory aesthetic."

Gropius clearly was influenced by America in his designs, which he called the "motherland of industry": "Compared to other European countries, Germany has a clear lead in the aesthetics of factory building. But in the motherland of industry, in America, there exist great factory buildings whose majesty outdoes even the best German work of this order. The grain silos of Canada and South America, the coal bunkers of the leading railroads and the newest work halls of the North American industrial trusts, can bear comparison, in their overwhelming monumental power, with the buildings of ancient Egypt."[15]

In his lectures entitled *Monumental Art and Industrial Building*, Gropius showed photos

AEG Turbine factory by Peter Behrens, 1909 (courtesy Deutsches Technikmuseum, Berlin).

of concrete silos in Baltimore, Buffalo, New York City, and Minneapolis to illustrate forms that expressed the monumentality and power of American technology.

At the Werkbund exhibition, heated debate on official national design policy raged between Herman Muthesius, who favored national standardization of industrial forms for mass production (*Typisierung*), and Henry van de Velde. Muthesius stated, "Architecture, and with it the whole area of the Werkbund's activities, is pressing toward standardization, and only through standardization can it recover that universal significance which was characteristic of it in times of harmonious culture."[16] Henry van de Velde, representing artists and craft workers, opposed this. He wanted to retain creative individuality: "As long as there are still artists in the Werkbund and so long as they exercise some influence on its destiny, they will protest against every suggestion for the establishment of a canon and for standardization." But he agreed with Muthesius that "the Werkbund's exhibitions would have meaning only when they restrict themselves radically to the best and most exemplary."[17] Gropius sided with van de Velde in an unsuccessful attempt to seize control of the Werkbund, but World War I broke out a few weeks after the exhibition and terminated this political debate. The war immediately affected many European countries and profoundly ended European importation of goods to the U.S.

At the outset of war in 1914, van de Velde, a Belgian, automatically became an enemy alien, resigned his position, left the country, and the Weimar Kunstgewerbeschule was closed. Van de Velde recommended three possible successors, one of which was Gropius, to the Wiemar authorities. In 1916, invited by those authorities, Gropius delivered a paper outlining his proposals for an educational program. The school was already requisitioned as a reserve military hospital, but his paper was taken seriously. Gropius and his partner, Meyer, in 1915 had designed steel furniture for the German battleship *Von Hindenburg*. Gropius served as a cavalry officer in the war, was wounded, was distinguished in combat with two Iron Crosses, and was not discharged until 1918.

That same year, Muthesius achieved his objective of national standards with the formation of the Normenausschuss der deutschen Industrie (German Standards Commission) that worked to produce national standards for products of all kinds under the title of *Deutsche Industrienormen* (DIN). Color standards were the subject of a 1916 book, *Die Farbenfibel* (*The Color Primer*), by the German chemist and 1909 Nobel Prize winner for chemistry, Wilhelm Ostwald (1853–1932), a Leipzig University scientist. The book described a system of color classification based on the quality of whiteness or blackness in color, a scientific and theoretical system that is still in use today known as the Ostwald System.

England's contribution to the lively European debate on design was by architectural historian Geoffrey Scott (1884–1929), who thought the German idea of national standards was folly. He published *The Architecture of Humanism: A Study in the History of Taste* in 1914. In it he complained that there was no lack of design opinions and theories, but a lack of a single standard of value to encompass them all. He said there "ought to be three separate schemes of criticism: the first based on construction [science/technology], the second of convenience [human needs], the third on aesthetics [artistic] ... each of which could be rational, complete, and within its province, valid."[18] Because of the subjectivity of all of these, he concluded that it was highly unlikely that there could ever be a single standard to satisfy all three, a reality that still challenges design critics and competition judges today.

In 1915, Cecil Brewer and younger members of the Arts and Crafts Exhibition Society founded the Design and Industries Association (DIA) in London. The DIA was modeled after the Deutsche Werkbund but did not embrace either modernism or standardization.

However, it celebrated an outstanding example of corporate identity in new modern graphics implemented by design patron and head of the London Underground Frank Pick (1878–1941). Calligrapher Edward Johnson (1872–1944) designed the modern red circle trademark with horizontal bar, identifying stations, with a clean, sans-seriph typeface that still survives.

A major event in the U.S. in 1915 was the Panama-Pacific International Exposition in San Francisco, a world's fair celebrating the opening of the Panama Canal, honoring the discoverers of America (Columbus, Cortez, Pizarro) and showcasing the recovery of San Francisco from the 1906 earthquake. Fairgoers were awed by dramatic colored light shows. The Palace of Fine Arts, by architect Bernard Maybeck (1862–1957), displayed art and sculpture from many countries, most of it traditional and classical in nature. Featured were the sculptures of Alexander Stirling Calder (1870–1945), the father of Alexander Calder (1898–1976), and James Earl Fraser (1876–1953), who had sculpted the Indian and Buffalo on the 1913 nickel coin, as well as the famous *The End of the Trail*, the drooping figure of an Indian on horseback, which was done for the fair.

In dramatic contrast to this celebration of traditional art, the most nontraditional European artists were rediscovering America. According to the *New York Tribune*, a number of "modernist French artists," including Marcel Duchamp (1887–1968) and Francis Picabia (1879–1953), arrived in America in 1915, in despair over the war in Europe and attracted by the peaceful and technological vitality in the U.S. Aware of the celebrity status of these artists from their participation in the controversial Armory Show two years before, the

Panama-Pacific International Exposition, Palace of Fine Arts, San Francisco, 1915.

Tribune was impressed: "[F]or the first time Europe seeks America in matters of art, for the first time, European artists journey to our shores to find that vital force necessary to a living and forward-pushing art.... They in turn will pay us with what is perhaps equally necessary, the courage to break from the tradition of Europe."[19] Picabia remarked, "I adore New York. There is much about it which is like the Paris of the old days.... I have been profoundly impressed by the vast mechanical development in America. The machine has become more than a mere adjunct of human life.... I intend to work on until I attain the pinnacle of mechanical symbolism."[20]

Picabia was true to his word. Over the next year, he produced a number of drawings inspired by mechanical or engineering drawings of spark plugs, meshing gears, pistons and cylinders, which he modified creatively and then titled with references to women, men, and quotations from dictionaries. In discovering the machine, he believed he had discovered the spirit of America, which was similar to modern art in its indifference to tradition and commitment to action. His drawings appeared in the journal *291*, just published by Alfred Stieglitz (1864–1946), the avant-garde photographer whose work had documented the machines and industrial landscapes of the dynamic growth of Manhattan and who had opened his 291 Gallery at 291 Fifth Avenue in 1905, exhibiting photography and modern art.

Duchamp and Picabia attracted wealthy modern-art collectors and patrons Walter and Louise Arensberg in New York, who regularly gathered a group of avant-garde artists, including American artists Charles Demuth (1883–1935), Charles Sheeler (1883–1965, and Morton Schamberg. Picabia relocated to Spain in 1916, where he joined the anti-art/anti-establishment Dada movement just begun in Zürich and published a Dada periodical *391*, in which his mechanical drawings appeared. Duchamp remained in America as the focus of the New York Dadist group while helping to support Picabia's *391*. Earlier, he had begun to create "ready-mades," objects he found and presented as art, such as his *Bicycle Wheel* mounted on a stool (1913). In 1917, he submitted a men's urinal, titled *Fountain* and signed with the pseudonym "R. Mutt," into a Society of Independent Artists show in New York. The piece was rejected by the show committee as "not art" and caused an uproar among the Dadaists. Duchamp claimed that such a "ready-made" object that expressed the machine age qualified it for exhibition.

It should not be surprising that in 2004, five hundred renowned artists and historians selected Duchamp's *Fountain* as "the most influential artwork of the 20th century." It marks the point in art history when commercial mass-produced products of technology were first regarded as works of art. The fact that leading French modernist artists from Paris, the center of the art world, regarded American technology and manufacturing culture as worthy of artistic appreciation was a revelation to American artists. Over the next decade or more, led by Demuth, Sheeler and Schamberg, many American artists would abandon their traditional subject matter of landscapes, seascapes and portraits, and instead depict their native factories, machines, steel mills, grain elevators and skyscrapers that expressed America's unique technological and dynamic environment. Art no longer had to be "pretty" to be art.

Over the years, this revolutionary concept led to the conclusion that mass-produced products did not have to be "pretty" either, in the traditional, historical, and ornamental sense, but could have innate artistic value in their own natural and functional machine shapes and forms. This concept is the philosophic basis of modern industrial design.

There were other influences abroad. Across the Atlantic in Sweden, art historian Gregor Paulsson, who had lived in Berlin in 1912 and was influenced by the Werkbund, in 1916, as

director of the Svenska Slöjdföreningen (Swedish Arts and Crafts Society, founded 1845), encouraged the owners of glass, ceramic, and other factories to hire artists and designers to elevate the national level of product design.

In Russia, artist Kasimir Malevich (1878–1935), who was influenced by cubism, at a gallery in Petrograd in 1915 demonstrated a concept he called Suprematism, which reduced pictures to geometric forms in pure colors against a white background and were totally abstract. They were the first paintings with no source in nature. He described them as "the supremacy of pure emotion." Examples included his *Eight Red Rectangles*, *Black Square*, *Black Circle*, and *White on White*. He wrote a manifesto, *From Cubism to Suprematism: The New Painterly Realism*. His ideas soon influenced De Stijl.

De Stijl, a movement of modern artists using primary colors and asymmetrical balance, was initiated by Piet Mondrian (1872–1944) and Theo van Doesburg (1893–1931) in the Netherlands. Mondrian had taken up cubism in 1912 in Paris and returned to Amsterdam in 1914 to explore abstractionism. In 1914 he advanced his theory of horizontal and vertical lines and color on a flat surface as the true expression of beauty, and by 1919 the style for which he was famous emerged. Van Doesburg's real name was Christian Emil Marie (C.E.M.) Küpper, a painter turned architect through the influence of J.J.P. Oud (1890–

1963), who became the Rotterdam city architect in 1918. The movement's journal, De Stijl, was published starting in 1917, and their manifesto in 1918 called for a new culture balancing universality and individualism and for the abandonment of natural form in architecture and art. Primary colors and geometrical shapes characterized their work. Dutch architect Gerrit Rietveld (1888–1964) was also associated with the movement. Rietveld was trained as a cabinetmaker and started his own furniture factory while studying architecture. In 1918, Rietveld, at the request of a client requesting chairs similar to Frank Lloyd Wright's famed "Plank Chair" of 1904, designed a similar wooden chair in primary colors based on De Stijl principles and called the "Red/Blue" chair, which became emblematic of the movement. Van Doesburg joined the German Bauhaus in 1921, and designed the Schröder house in Utrecht in 1924, expressing De Stijl ideas, but the De Stijl movement died out with his death in 1931.

In the U.S., the director of the Metropolitan Museum in New York,

"Red/Blue" chair by Gerrit Rietveld, icon of De Stijl movement (photograph by Ellywa, from wikimediacommons).

Richard F. Bach (1887–1968), began a series of exhibitions of European product designs in 1917 that "owed their design, color, motive, or some other feature to museum inspiration." The message clearly was that for product designs to be artistically worthy they had to pay homage to historical or classical examples. What better way to discourage creative design thought and innovation! Apparently, this recurring museum obsession with the copying of traditional design styles was based on the 19th century traditional practice of art students and apprentices copying the masters in museums to learn their trade. Museums were still often filled with art students and their easels, diligently copying work by European masters.

Meanwhile, U.S. industrial art had a serious setback. The Smith-Hughes Act of 1917 established federal aid for vocational education at the secondary level and encouraged studies in agriculture, trades, industry, and home economics. But such training included no theoretical skills and in practice reduced academics to 50 percent of study time. Back in 1904, Charles Richards of Teachers College, Columbia University, in New York had suggested that the term "industrial arts" replace what had been previously been called "manual training" in schools. These classes had been conceived in the late 1800s to train students to fabricate objects in wood or metal, using a variety of hand, power, or machine tools.

As a result of Smith-Hughes, thousands of high schools initiated "industrial art" classes, which basically taught the use of shop and machine tools to prepare students for nonprofessional trades. The emphasis was on reading mechanical drawings of existing designs and executing them by handwork. No wonder then, that the term "industrial art," which had became the operative description for the process of applying artistic talent to mass-produced products, was regarded pejoratively as a noncreative, trade-level occupation. Such classes were colloquially known as "shop class." This was the primary obstacle that delayed for decades the establishment of appropriate professional industrial design education in the U.S. Even more disconcerting is that the educational effect of the Smith-Hughes Act remained virtually unchanged until the 1960s.

The U.S. did not enter the war until 1917, although the sinking of the *Lusitania* in 1915 shifted American opinion from neutrality to a growing commitment for intervention. Of note was one of the *Lusitania*'s American passengers lost, Elbert Hubbard (1856–1915), founder of Roycroft. When the U.S. entered the fray, many manufacturers converted to wartime production of weapons, ammunition, trucks, and military equipment, using the mass production processes of Fordism and Taylorism. America soon became the "Arsenal of Democracy" that led to the Armistice of November 11, 1918. It was at this precise point in history that America and England changed places, for America, not the British Empire, was now the world's leading international financial power and would remain so for the rest of the century. The mother country had now become a dependent of her rebellious offspring.

Chapter 6

1918–1927
Modern Design Takes Root

After World War I, many European countries were devastated by war and their manufacturing capability was exhausted. It would be years before they recovered and reached their prewar eminence in world markets. During the process of recovery, Europe was influenced in its efforts by the incredible American capability in mass production of war materials demonstrated during the war. Henry Ford's production lines became models of industrial development and progress known in Europe as "Fordism," and the industrial engineering systems established by Frederick Taylor, known as "Taylorism," became the standard for manufacturing efficiency.

While U.S. manufacturers were happily providing America's postwar emerging middle class with material goods, and U.S design, museum, and educational communities were debating the problem of meeting foreign design competition, many postwar European countries were faced with the task of rebuilding and retooling to emulate American productivity. Their respective design communities were intimately involved in the effort.

The revolution of 1917 inspired Russia to attempt to build an industrial culture where none had existed before. In a 1918 speech, Lenin had said, "We must organize in Russia the study and teaching of the Taylor system and systematically try it out and adapt it to our purposes."[1] The Communist Party in the new Soviet Union placed all factories under government control and managed industry to achieve Lenin's goal. Inspired by patriotic and political duty, the first working group of an artistic movement called Constructivism was founded in 1921 by Aleksandr Rodchenko (1891–1956), and his wife, Varvara Stepanova (1894–1958), who was noted for her avant-garde textile designs. They published their Production Manifesto: Programme of the First Working Group of Constructivists in 1922, to "set itself the task of finding the communistic expression of material structures."[2]

They soon were joined by futurist Vladimir Tatlin (1885–1953), who was responsible for Lenin's "Plan for Monumental Propaganda," and who designed his famous monument to the Third International (celebration of the Revolution) in 1920; Kasimir Malevich, founder of prewar Suprematism, Lazar Markovich Lissitzky "El Lissitsky"(1890–1941); theorist Alexei Gan; sculptors Naum Gabo born Naum Neemia Pevsner (1890–1977); his brother, Antoine Pevsner (1886–1962); and painter Wassily Kandinsky (1866–1944), among others.

Communist Party encouragement of avant-garde art was inspired by the belief, led by Leon Trotsky (1879–1940), that to serve the revolution, art had to be on the cutting edge of modernism. The movement rejected fine art, promoted the more "productive" or "constructive" fields of design (architecture, and "agitational" propaganda) and called for artists

115

to "go into the factories, where the real body of life is made." Art was linked to mass production in a political attempt to promote artists as contributors to the new social order. Constructivists' work avoided traditional mediums of oil and canvas and used materials such as wood, metal, photographs and paper to create geometric abstractions relevant to Communist aims and objectives. Abstract political posters and public information plaques typified much of the work. Although the movement resulted in some highly geometric designs of furniture and porcelain before it faded in 1922, and these theoretical designs were exhibited in Germany, they were never put into production because Soviet manufacturing facilities were practically nonexistent. However, Constructivism as an art form influenced the modern movement in Europe.

Rodchenko and Stepanova's manifesto of 1922 inspired the founding of an avant-garde art and design school in Moscow called VKhUTEMAS, an abbreviation of Vysshie Gosudarstvennye KyhUdozhestvenno-TEkhnischeskie MASterskie (Higher State Artistic and Technical Workshops). Its forerunner was the State Free Art Studios founded in 1918 following the abolition of the Stroganov School of Applied Art and the Moscow School of Painting. VKhUTEMAS's purpose was to respond to the actual psychological and physical needs of post-revolutionary Russia, allowing for the training of artists for industry but also for the cultural transformation of the country. It became fertile ground for Constructivism. Among its faculty were Rodchenko, Stepanova, Gustav Klutsis, El Lissitsky, and Lazar Markovich. The school played a similar role to the Bauhaus in Germany, though teaching focused more on ideological discussion than art-making. Starting in 1927, Vladimir Tatlin taught "production art," then the Soviet term for industrial design. The school became known as the VKhUTEIN in 1928 and was dissolved in 1930. In 1932, Stalin handed down his notorious edict, *On the Reconstruction of Literary and Art Organizations*, which required all good socialists to abandon modernism and abstraction and adopt a standardized style called Socialist Realism that presented ideologically approved subjects in a manner that left no question about their meaning. This would become the sole politically correct style in the Soviet Union for 60 years.

It was in Germany that the standard for industrial design education was created. When the Second German Empire (Reich) ended in 1918, a new Republic was created with its capital in Weimar, a city that had humanistic rather than militaristic traditions. Germans believed that they could best restore their manufacturing leadership in the world with the "American System" based on "Fordism" and "Taylorism." Reform in art education was seen as vital for economic reasons in postwar Germany, where designers were needed for their skills in high quality products for export. Accordingly, in 1919, the same year Adolf Hitler (1889–1945) made his first public address in a Munich beer cellar, Das Staatliches Bauhaus was founded in Weimar, the capital of the federal state of Thuringia, combining two art schools interrelating art, science, technology, and humanism.

Before the war, one school had been the Weimar Kunstgewerbeschule, under Belgian Henry Van de Velde, founded in 1902 and the other, the Weimar Academy of Fine Art, founded in 1860. The first director of the Bauhaus was architect Walter Gropius, who had been recommended by Van de Velde in 1915 and who had presented his proposals to Weimar officials in 1916. He accepted the invitation only on the condition that he would be allowed to carry out the ideas of his predecessor at the Weimar Kunstgewerbeschule, Henry Van de Velde, who was linked to the Arts and Crafts movement through the Deutsche Werkbund. When Gropius returned from military service, he began his directorship.

The new school stated its objectives: (1) to train craftsmen, painters and sculptors of

the future to combine their skills in cooperative projects, (2) to elevate the status of the crafts to that of the "fine arts," and (3) to establish contact with leaders of the crafts and industries of other countries (such as Russia and the Netherlands) to develop a vocabulary of forms based on Constructivist and De Stijl experiments based on the two movements were currently influencing European design.

The Bauhaus was under the jurisdiction of the Thuringian ministry of education and justice and from the first was plagued by inadequate financial resources, tools, equipment, and facilities. The school faced numerous community accusations that some students were of non–German (read Jewish) origin and that some faculty members had communistic sympathies. Gropius denied these accusations. Anti-Jewish and antisocialist feelings in Germany were nothing new. Such cultural prejudices had existed there since the 1880s. In addition, local craft guilds feared that school-produced crafts to be sold in local markets would harm their business.

Initial faculty appointments in 1919 were Swiss painter Johannes Itten (1888–1967), German-American artist/cartoonist Lyonel Feininger (1871–1956), and German sculptor Gerhard Marcks (1889–1981). Schooling began with a six-month basic course in exploration of form and materials under "Master of Form" Itten. This course was followed by education in a craft under a master craftsman in the workshops. Marcks was master of form in the pottery workshop. Faculty was added as needed, and there were many changes in personnel and assignments. Painter Oskar Schlemmer (1888–1943) arrived in 1920. He became a master of form in the sculpture workshop, and later, in 1923, headed the theatre workshop, after Lothar Schreyer, who arrived in 1921. In 1920, German painter George Muche (1895–1986) arrived to help Itten in the basic course and after 1921 became master of form in the weaving workshop. Also in 1920, painter Paul Klee (1879–1940) of Switzerland arrived and took over the bookbinding workshop. Artist Theo van Doesburg (1883–1931) arrived in 1921 to lecture on the philosophy and practice of De Stijl. In one of his lectures, he attempted to define the new style needed:

> The needs of our age, both ideal and practical, demand constructive certainty. Only the machine can provide this constructive certainty. The new potentialities of the machine have given rise to an aesthetic theory appropriate to our age, which I have had the occasion to call the "mechanical aesthetic."... The style, far removed from romantic vagueness, from decorative idiosyncrasy and animal spontaneity, will be a style of heroic monumentality (example: American grain silo). I should like to call this style, in contrast to all the styles of the past, the style of the perfect man, that is, the style in which the great opposites are reconciled.... The urge to establish the new style is seen in numerous phenomena. Not only in painting, sculpture and architecture, in literature, jazz and the cinema, but most of all in purely utilitarian production.... In all these objects (whether iron bridges, railway engines, cars, telescopes, farmhouses, aeroplane hang(a)rs, chimneys, skyscrapers, or children's toys) we can see the urgings of the new style. They show exactly the same endeavor as the new creations in the realm of art to express the truth of the object in clarity and purity of form. So it is not surprising that the beauty of machinery is the very core of inspiration for the newest generation of artists.[3]

In 1922, Wassily Kandinsky, Constructivist and founder of the Moscow Academy of Arts and Sciences in 1921, arrived to teach the mural-painting workshop. In 1923, talented graduating student Josef Albers (1888–1976) remained as a junior member of the staff to teach the use of materials in the preliminary course. That same year, Hungarian multimedia designer László Moholy-Nagy (1895–1946) arrived to take over Itten's preliminary course, assisted by Albers, and to head the metal workshop.

The third stage of the Bauhaus program, after the workshops, was intended to be in

Theo van Doesburg and his circle of friends and students at the Bauhaus in Weimar, 1922. Doesburg is in center with sign on hat, László Moholy-Nagy is in last row on right (from H.M. Wingler, *Bauhaus*, 1969, courtesy Bauhaus-Archiv Berlin).

architecture and building, under Gropius. In effect, it became an extension of Gropius' professional architectural practice, with students assisting in his private commissions, such as the Sommerfeld villa (completed 1921) and the Otte villa (completed 1922) in Berlin, which were decorated and furnished with student work and collaboration.

The Bauhaus student enrollment was 137 (78 male and 59 female) in 1920, and over the years averaged about 100 at a time. Tuition fees were 180 marks per year, twice that for foreign students. Students were admitted by application and a review of their work. They were accepted only for a trial period of six months in the preliminary course, and only if it was satisfactorily completed could they become members of the school (there were many rejections). The more committed students then could choose a specialized craft and enroll as apprentices in the Weimar Chamber of Trade. They had to do their best to produce work for sale, and their work became the property of the Bauhaus. If the work sold, they received some of the proceeds. No grades were given, but student work was reviewed periodically by the masters. Their training was complete when they qualified as a journeyman with the local craft guilds. As in many art schools, however, some students were accused of laziness, slovenliness, and promiscuity. And local townspeople were understandably appalled at student defacement of public statuary and their nude sunbathing.

In the fall of 1923, the first full-scale exhibition of the Bauhaus was held at the school after months of advertising and promotion by Gropius. A number of students in the workshops were producing saleable products, especially the pottery workshop in Dornburg, which already had designs being produced by an outside company. The exhibit that best demonstrated what the school was accomplishing was an experimental house, the Haus am Horn (The House on Horn Street), a prototype of inexpensive, mass-produced, simple construction designed by faculty member George Muche with the technical advice of architect Adolf Meyer, Gropius' professional partner. The interior was functionally decorated and furnished by student workshop designs, particularly those of Marcel Breuer (1902–1981). He designed chairs, a dressing table, children's furniture, and a highly functional kitchen with upper and lower cupboards, continuous counter work surface between them, and the main workspace in front of the window.

Fifteen thousand people attended the Bauhaus exhibition, including those also attending a Werkbund conference in Weimar, and other international celebrities such as Igor Stravinsky, Ferruccio Busoni, and Dutch architect J.J.P. Oud. Events included ballet and musical premiéres of works by Stravinsky, Busoni and Hindemith, and lectures by Gropius, Oud, and Kandinsky. Gropius' lecture, "Art and Technology: A New Unity," signaled a significant change in the direction of the school, from theoretical and experimental arts and crafts to functional, pragmatic, and geometric designs. The new direction was influenced in part by the dynamic personality and rationality of Moholy-Nagy, who quickly had overpowered the faculty with logic and whose philosophy of functional design was very similar to that of Gropius.

But there were other external influences, not the least of which was rampant inflation. While the six-week exhibition was in progress, a U.S. dollar worth two million marks became worth 160 million marks. A Bauhaus student, Herbert Bayer (1900–1985) was commissioned by the Thuringian mint to design one- and two million-mark banknotes, as well as a one billion-mark note. By the time they were issued in September 1, 1923, higher denominations were required. Just as the school began to flourish, the new national government was threatened by political unrest, resulting in demonstrations in Weimar. Troops were sent to keep the peace. In December, the government fell and in early 1924, the Thuringian parliament was taken over by right-wing nationalists, who viewed the Bauhaus negatively. In September 1924, the Bauhaus budget for 1925 was cut in half by the Ministry of Education, and new teaching contracts were reduced to six months. At the end of 1924, Gropius announced the closing of the school. After considering a number of alternate locations, he accepted a generous proposal from the industrialized city of Dessau to relocate the Bauhaus there, the only province with liberal Socialist rule and which was within a two-hour train ride to Berlin.

With generous funding by the mayor of Dessau, Gropius designed and began construction in the summer of 1925 of a new facility for the Bauhaus, now with an additional name, Hochschule für Gestaltung (Institute for Design). Tuition was 30 marks per semester for the three semesters of the preliminary course. There was no tuition after that; students could earn money through the sale of their work by the school. Teachers were no longer referred to as "masters" but as "professors." Workshops were changed to reflect their design functions rather than individual crafts. The metal workshop was combined with cabinetmaking to collaborate on household equipment and furniture.

The most significant change was philosophical. In January 1926, Gropius, with probable full support of and agreement by Moholy-Nagy, had told the faculty that the image of the

Bauhaus in Weimar had become too "arty-crafty." Gropius defined the new Bauhaus objective in March 1926, stating in part:

> The Bauhaus workshops are essentially laboratories in which prototypes of products suitable for mass production and typical of our times are carefully developed and constantly improved. In these laboratories the Bauhaus wants to train a new kind of collaborator for industry and the crafts, who has an equal command of both technology and form. To reach the objective of creating a set of standard prototypes which meet all the demands of economy, technology and form, requires the selection of the best, most versatile, and most thoroughly educated men who are well grounded in workshop experience and who are imbued with an exact knowledge of the design elements of form and mechanics and their underlying laws.[4]

It is difficult to find an earlier, or more articulate description of the process of industrial design. The transformation of the Bauhaus from an arts and crafts philosophy to one that prepared designers for industry was a microcosm of the world's slow transition from 19th century traditions to the 20th century's machine age of mass production.

The new facilities were ready for use in October 1926, consisting of a new building with teaching and workshop areas, a theatre, canteen, gymnasium, and 28 studio flats for students, with a roof garden above. The workshop side of the building was an enormous, all-glass curtain wall. An enclosed bridge connected to the administration building and Gropius' private practice. Nearby were three pairs of semidetached houses for staff and a detached house for Gropius. Gropius' architecture, of course, was totally modern, spare, and functional. The facility was officially opened in December 1926.

Half of the staff of twelve in Dessau consisted of former students. Josef Albers now shared the preliminary course with Moholy-Nagy. Herbert Bayer headed the print shop. Marcel Breuer shared the metal workshop and cabinetmaking with Moholy-Nagy. Hinnerk Scheper (1897–1957) taught mural painting, Joost Schmidt (1892–1948) sculpture, and Gunta Stölzl (1897–1983) weaving.

With this new, younger, less specialized generation of faculty in Dessau, Bauhaus students produced designs of clean geometric lines and functionality that established the school's legacy. Many of the designs are still reproduced today. Under Moholy-Nagy's disciplined guidance, students Wilhelm Wagenfeld (1900–1990) and Karl Jacob Jucker (1902–1997) designed their classic table lamp with hemispherical glass globe (1924), and Marianne Brandt (1893–1983) designed her coffee and tea service (1924) and her silver ashtray (1924). Brandt, with Hinrich (Hin) Bredendieck (1904–1995), created attractive Kandem desk lamps (1927). Between 1928 and 1932, the Leipzig firm of Körting & Matthieson produced limited quantities of more than 50 lamps designed at the Bauhaus.

Moholy-Nagy was strict with students. When Wagenfeld changed cylindrical milk jugs into drop-shaped ones, Moholy-Nagy admonished, "How can you betray the Bauhaus like

Bauhaus "Kandem" lamp designed by Marianne Brandt about 1927, made by Körting & Matthieson (from H.M. Wingler, *Bauhaus*, 1969, Bauhaus-Archiv Berlin, © 2010 Artists Rights Society [ARS], New York/VG Bild-Kunst, Bonn).

this? We have always fought for simple, basic shapes, cylinder, cube, cone, and now you are making a soft form which is dead against all we have been after!"[5]

The new faculty also produced outstanding work. Herbert Bayer designed sans serif type-style without capitals that became standard in many Bauhaus graphic designs, a dramatic departure from traditional German Gothic typefaces and despite German language demand for capitalization of each noun. Marcel Breuer's furniture pioneered in the use of chrome-plated tubular steel construction that had evolved in Germany from aircraft production. His first was in 1924 with side tables, and in 1925 he designed his Wassily chair, which was named for Wassily Kandinsky and produced in quantity in 1928 by Gebrüder Thonet.

In 1927, architecture was introduced as a department at the Bauhaus and was located in the administration building. Students could elect it after completing the preliminary course, at 50 marks per semester, instead of choosing a workshop. Gropius appointed Swiss architect Hannes Meyer to head the department, in spite of Meyer's left-wing political philosophy, a dangerous move where the survival of the school depended on its neutrality. Meyer's department assisted Gropius in his commission to design an experimental housing project in the Törten suburbs of Dessau, funded by the government. Gropius used construction techniques based on American mass production technology and used standardized components manufactured on site to reduce transportation costs. Each of over 300 two-story, flat-roofed houses, in rows of eight or more units, were constructed in three days and were sold or rented inexpensively to happy owners. In January 1928, Gropius resigned unexpectedly as head of the school, claiming "that until now 90 percent of my work has been devoted to the defence of the school."[6] He was burned out. He appointed Hannes Meyer to replace him.

Not long after the Bauhaus had begun, another German designer was busy with a more sinister purpose. Adolf Hitler's nascent National Socialist (Nazi) Party in 1920 adopted a modernistic design of a swastika on a red flag. According to his 1926 book, *Mein Kampf* (*My Struggle*), the new flag had to be "a symbol of our own struggle" as well as "highly effective as a poster."

Adolf Hitler, an amateur fine artist, explained how he designed it: "I myself, meanwhile, after innumerable attempts, had laid down a final form; a flag with a red background, a white disk, and a black swastika in the middle. After long trials I also found a definite proportion between the size of the flag and the size of the white disk, as well as the shape and thickness of the swastika." He described its symbolism: "In red

Wassily chair by Marcel Breuer, 1925 (courtesy Knoll, Inc.).

we see the social idea of the movement, in white the nationalistic idea, in the swastika the mission of the struggle for the victory of the Aryan man, and, by the same token, the victory of the idea of creative work, which as such always has been and always will be anti–Semitic."[7] When Hitler attained power in 1933, the flag was flown alongside the German national flag, which used the same colors of red, black and white in horizontal stripes. But after 1935 the Nazi flag became the only national flag and functioned as a powerful propaganda visual communication for the Third Reich used almost everywhere.

Elsewhere in Germany in 1925, Ernst May (1886–1970) was appointed city architect of Frankfurt and embarked on a project to design an efficient working kitchen environment in minimum space, including all furnishings, to furnish new postwar houses in the Römerstadt housing project. One of the key designers was Austrian architect Margarete Schütte-Lihotzky. Known as the 1926 Frankfurt Kitchen, the design was startlingly similar to future kitchens of the 1950s. Contractors were engaged to produce the furnishings in quantity. The design team openly admitted being influenced by Christine Frederick's 1913 book, *The New Housekeeping*, describing the efficient arrangement of kitchens; the book was translated and published in Germany in 1922.

Also in Germany, work was proceeding in the budding aerodynamic science known as "streamlining," which was by then a common term. Since the term appears frequently in later accounts, an explanation is warranted. It was probably derived from an influential 1917 book, *On Growth and Form*, by English biologist/mathematician D'Arcy Wentworth Thompson (1860–1948), who used the term "stream-lining" to describe organic structures that offer the least resistance when they are in motion, and how a fluid medium tends to impress its "stream lines " on a deformable body, like snowdrifts and sand dunes. He concluded that the same principle must have come into play in the evolution of the bodies of fish and birds. Before that, in 1804, the so-called Father of Aerodynamics, English engineer Sir George Cayley (1773–1857), had proposed the shape of early dirigible balloons to be "a

Nazi flag by Adolf Hitler, 1920.

form approaching to that of a very long spheroid" after he had measured trout and porpoises.

During the early 20th century, Germany had pioneered in the design of zeppelins for both military and commercial passenger transport; these were, indeed, "very long spheroids." Early racing cars and aircraft emulated similar forms. Austro-Hungarian Paul Jaray (1889–1974), an employee of the Zeppelin Company at Flugzeugbau, Friedrichshafen, observed that "Automobiles roll along the ground, of course, but, they also move through the air."[8] He started working with his colleague, Wolfgang Klemperer, to place scale model cars in the Zeppelin wind tunnel to determine the best shape to lower air resistance. The best result was a model with a teardrop-shape with a rounded windscreen and enclosed bottom and a drag coefficient of 0.28 (which is difficult for a car to match, even today). In 1922, a full-scale prototype, the Ley T6, was built by German carmaker Rudolph Ley AG in Armstadt. Jaray was soon consulting with a number of European automakers, and Jaray principles were being incorporated into racing cars by Maybach, Audi, and Mercedes-Benz. The Czechoslovakian firm of Tatra built its Type 91 car in 1934, which was designed by Austrian Hans Ledwinka and was a direct descendant of the Jaray philosophy.

All these developments in Germany were significant, but most of the world was not paying attention. Many regarded Germany either with total disinterest, or more probably, with disdain or worse due to its recent history as a defeated villain and instigator of World War I. Anything German was regarded with suspicion.

In America, military success instilled national self-confidence in its global leadership and in the belief that mass production would insure a successful economy, high productivity, and an increased standard of living. American industry returned to peacetime production quickly to meet a renewed consumer demand for products that was stronger than ever; this soon precipitated an economic boom. Half of all cars on the road were Ford Model Ts. Kelvinator marketed the first domestic refrigerator in 1918, and within five years there would be 56 companies producing competitive brands. Walker was producing electric dishwashers, and Launderette electric clothes washers. There was a flood of new electrical appliances and gasoline-powered equipment. These were not decorative products, but functional products. Nevertheless, they were invariably ugly.

There had been growing recognition that the industrial arts community was not prepared to meet the demand for all these new, industrially produced products. In 1918, anticipating this shortcoming, Walter Sargent (1868–1927), director of the Department of Fine and Industrial Art at the University of Chicago had written the following: "The situation regarding industrial design in the United States is improving, but so far as we can estimate ... we shall need after the war about fifty thousand more industrial designers than are now available or in training, and probably few can be imported. Each country will need its own.... [W]e shall have to depend upon ourselves more than in the past, not only for designers but also for styles of design."[9] This quote is interesting evidence that the term "industrial design," initiated by the U.S. Patent Office in 1913, was being used in the design community as a synonym of "industrial art," even though Sargent's official title uses the latter. His estimate of the number of industrial designers needed was somewhat optimistic at the time. Not until 2010 would his wish be realized—when there would be about 50,000 industrial designers.

Sargent also felt America needed to compete with Europeans in originality: "Because we had no comparatively stable aesthetic standards, which we could modify and refine year to year, we had to compensate by producing each season something entirely novel in order

Kelvinator
OLDEST MAKER OF ELECTRICAL REFRIGERATORS

First Electric Refrigerator - 1914 On Permanent Exhibit At The Smithsonian Institute, U.S.A.

First domestic refrigerator by Kelvinator, 1918 (courtesy Raymond Spilman and Wallace H. Appel).

Model H KitchenAid "food preparer" by Hobart Manufacturing Company, 1919 (courtesy Whirlpool Corporation).

to meet an untrained but insistent popular demand.... [I]t will not be sufficient to copy even skillfully, foreign designs. If we are to compete successfully we must cultivate originality."[10]

Although Sargent recognized the need for industrial designers, he had no idea of how to transform existing "industrial artists"—trained solely to apply two-dimensional decorations on three-dimensional products—into "industrial designers," trained to determine the actual physical form of manufactured goods in collaboration with industry. The solution lay not in more designers, but in a different breed of designers trained in manufacturing

methods and materials, and the motivation to participate in the industrial world. The "originality" needed was not in new styles, but in a new paradigm of what industrial designers actually do.

At the 1918 annual conference of the American Federation of Art (AFA) in Detroit, keynote speaker Richard F. Bach, curator of the Industrial Art Department at the Metropolitan Museum of Art in New York, appealed for the establishment of industrial art schools comparable to those in Europe, to improve the artistic quality of all mass-produced household items: "It is our patriotic duty to establish (industrial arts) schools during the war. It will be an evil day for manufacturers and dealers after the war if American taste must again go to Europe for its industrial art products."[11]

It was well known that Europe was far ahead of the U.S. in design training. A 1919 study by H.M. Kurtzworth, head of the Grand Rapids School of Art, compared the number of European design schools to those in the U.S. France had 32, England 37, Italy 24, and Germany 59, for a total of 152. This compared to 18 in the U.S.[12] The Richards study, a year later (see below) noted a bit more optimistically that there were 274 schools of art listed in the 1920 *American Art Annual*, of which 58 were the most serious about the applied or industrial arts.

But these disparate numbers were only part of the problem. In the first place, European countries had for many years before the war recognized the importance of design in industrial arts products manufactured for domestic and export markets. Many European schools were supported by governments and professional trade organizations to train designers and create modern designs and promoted them at home and abroad through public exhibitions. All U.S. schools were privately run, with little government or industry interest, let alone support.

In the second place, students graduating from U.S. schools had little interest in the industrial arts industries. The reason was best stated in a 1920–1922 comprehensive study of the state of the industrial arts education, conducted by Charles R. Richards of the Cooper Union and administered by the National Society for Vocational Education, with grants of $120,000 from the General Education Board of the federal government and the University of the State of New York. The study reported in part,

> One consideration that affects the quality of American youth entering upon applied-art education is the essentially modern quarrel between the fine arts and the applied arts. The idea that the fine arts as represented by painting and sculpture are something superior to the applied arts and that their practice is a matter of greater dignity is an idea that persists tenaciously. There is still a vast difference in the appeal to young persons as between the career of a painter and sculptor and that of a designer. Even in schools where courses in both the fine and applied arts are given, the school authorities are very often found influencing talented students toward painting and sculpture, and away from the study of industrial art.[13]

For those unfamiliar with these fields, it may be helpful to elaborate on the then-perceived semantic difference between the terms "art" and "industrial art." Both required training in exactly the same artistic and visual skills. But for centuries, "art" was an individual work of self-expression, by one's own hands and with total control of its physical characteristics of form, color, subject matter, and visual detail. The artist signed their name visibly to the work and received full individual credit and financial compensation for it when it was sold. The value of the work, if sold, was entirely dependent upon the reputation of the artist.

With the proliferation of mass media such as newspapers and magazines, and before

photography, many artists illustrated news events or advertisements, which were produced in high quantities and their purpose decided not by the artist but by publishers or manufacturers. These artists were described as "commercial artists" to distinguish them from the traditional, more highly regarded "fine artists" because their work was a mere utilitarian commodity. Commercial artists, however, were well paid on a regular basis.

When decorative "art" was applied to mass-produced products to enhance their appeal, another term was needed to distinguish it from "art." The term that evolved was "applied art" or "industrial art." This work was no longer an individual creation, but was produced in large quantities by machine, and its purpose was determined by the manufacturer. The decisions regarding physical characteristics such as form or color had to be shared with engineers or production people to insure the work could be reproduced by machines at a reasonable and competitive market cost. There was no recognition of the designer on the product, and no matter how many were sold, the designer received only a one-time commission or regular salary for their work. "Applied art" was at the bottom of the art food chain along with "commercial art." It was held in the same low esteem as "industrial art," which many high school students associated with dreaded "industrial art" or, more derogatorily, "shop classes"—building birdhouses or other household artifacts. (My anachronistic high school shop teacher in 1949 was called "Birdhouse Brown.")

No surprise then, that the field of art education was favoring the fine arts, not the applied arts. For those few students who were attracted to the latter, the most appealing field was the decorative arts, or "art industries," which included ceramics, glassware, enamels, furniture, leatherwork, metalwork and lighting fixtures, rugs, carpets, silverware, textiles, and wallpaper.

Decorative arts were being promoted as a means of achieving status through expensive luxuries, many of which were of European design and manufacture, because, historically, Americans regarded Europe as the creative source of styles and well-made products. Thus, upper class consumers bought Louis Tiffany's lamps, Louis Cartier's watches, René Lalique's glassware, and Louis Vuitton's luggage.

Many American manufacturers of decorative arts imitated European designs and produced American versions of them, such as Arts and Crafts furniture and accessories by Stickley, Roycroft, or Craftsman. Some decorative arts industries regarded homegrown graduates as inferior to European-born and trained design experts, whom they valued highly and for whom they paid handsomely. In other decorative arts industries, talented U.S. art students were hired to produce the decorative effects required. The lingering Arts and Crafts movement was attractive to some students because the products were in most cases handcrafted and displayed in art museums. Designers were often permitted to place their signatures on decorative products they created, not unlike an artist's signature on a painting or sculpture. This provided artistic dignity and recognition.

But the upper class that supported these "art industries" represented only a small minority of the consumer market. The majority of the U.S. population was of low- and middle-income levels, and could not afford, even if they desired, highly styled European products or their American counterparts. In 1920, half of U.S. citizens lived in rural areas and shopped by mail order. The other half were urban dwellers, increasing rapidly due to waves of new immigrants arriving at a rate of a half million to a million per year. Only one in ten Americans owned a telephone. Only 35 percent had electricity full time. Electricity was being promoted aggressively as a clean source of energy (as opposed to coal and wood), and manufacturers needed it to sell the numerous electrical appliances then being produced

in large quantities to assist the housewife with time and laborsaving products. But "labor-saving" to some manufacturers often meant the ability to lay off workers or reduce pay in order to improve production efficiencies.

A rapidly growing U.S. middle class created a postwar housing construction boom by building new houses. These houses were smaller than those of their Victorian parents, but they all needed major appliances like electric washers, sewing machines, refrigerators, and stoves, and small appliances like toasters, fans, waffle irons, and vacuum cleaners, all of which were now available in quantity and at low prices due to mass production. Women, who were granted the right to vote in 1920, often were the beneficiaries of these new labor-saving devices. With the initiation of radio broadcasting that same year, many would soon buy new radio sets, and by 1922, 60,000 had done so. Most consumers were more than delighted with products that were well made, dependable, and improved their standard of living enormously. The appearance and style of these products appeared to be of minor interest or concern. The frequent conclusion by design historians is that the American public did not appreciate or care about the appearance of products. It was their function that consumers wanted initially, not style. I would submit that in fact, they actually *liked* the appearance of products that looked mechanically made by industry. That mechanical "look" reflected the positive benefits of the industrial age to mankind, not dissimilar from

First radio station, KDKA, in Pittsburgh, Pennsylvania, 1920 (Carnegie Library, Pittsburgh).

the way that consumers of the 1960s liked the "look" of rockets as reflecting man's aspiration to space travel. To consumers of 1920, the mechanical look of Henry Ford's Model T was the equivalent of a space capsule. Unadulterated beauty.

The manufacturers who produced these products of daily life by mass production processes were at the bottom of the applied arts "food chain," with the derogatory title of "artless industries," which by title alone discouraged any "artists" from even considering working on them. These industries produced useful products that included household appliances, aluminum cookware and related food industries, electrical machinery, cash registers, clocks, optical goods, fountain pens, scales, locomotives, and cars— in other words, anything that was more functional and mechanical in nature than decorative. They were regarded in the same functional category as tools such as tractors, shovels and pitchforks. In these industries, engineers were in charge of all design details. They had no incentive to make them more attractive, or to spend money for artists. Their only concern was to meet the ever-increasing demand for higher quantities. Manufacturers couldn't make their product fast enough to meet the growing demand. They had the world's largest consumer market all to themselves as Europe struggled to rebuild.

The negative perception of these "artless industries" by young art students was often warranted. Even if hired by a manufacturing company, a young graduate was often treated no differently than an assembly line worker, nor were they paid better. Without social traditions to value "artless industries" as contributors to the national economic interests, or valuing their designers as performing an important business and sales function, as existed in Europe, there was little hope that the U.S. could compete with European imports, when good designers could expect only anonymity and low pay for their work.

There was, however, one American "artless" mass production industry that began to

Mirro stoveware, 1920 (courtesy Victoria Matranga).

pay attention to the appearance of its products. The auto industry in the 1920s created four million jobs that did not exist in 1900. In a market where half the cars in America were Model T Fords, the postwar economic expansion resulted in a growing demand for luxury automobiles. At first, prestigious European cars like Rolls Royce, Mercedes, Hispano-Suiza, and Isotta-Fraschini met this demand in the early 1920s. American manufacturers like Duesenberg, Lincoln, Packard, and Cadillac responded to this competition with luxury models of their own. But these longer, heavier, more powerful cars were not produced in the same manner as mass-produced cars. To excel in appearance as well as engineering, automakers sent their mechanical subassemblies to separate auto coach-building firms, where skilled craftsmen built the custom bodies. Initially, the craftsmen themselves controlled the process, because the artistry of construction was seen as the primary evidence of value. Typically, they designed them piecemeal as they received components from the original manufacturers.

In 1921, this practice began to change when Raymond Dietrich (1894–1980) and Thomas Hibbard (1898–1982), both employees of Brewster & Company coachbuilders, opened their own European-sounding coach-building firm of Le Baron Carrossiers in New York City as an "automotive architecture" firm. Brewster had begun its production of cars in 1915, and had hired a number of early designers including Dietrich and Hibbard. In 1923, Hibbard would team up with Howard "Dutch" Darrin (1897–1982) to open the Hibbard & Darrin car design office in Paris. These early car designers initiated the process of designing the entire car on paper, in order to integrate the various components into a visually harmonious whole before beginning the actual construction. This process had been used by architects for centuries but now set a precedent for the auto industry. In fact, two other New York freelance auto designers, George P. Harvey and George G. Mercer, also had the phrase "Automobile Body Architecture" on their office doors. Soon, other custom auto coachbuilders would use this same process. In a few years, customers of standard production cars would want the same organized appearance as luxury cars. Car manufacturers would adopt this same process of design for their regular production cars and would establish their own internal design departments. This process would become known as "styling."

Lewis Mumford (1895–1990), an American historian of technology and science, in 1921 defined style as "the reasoned expression, in some particular work, of the complex of social and technological experience that grows out of a community's life. How is it that the modern style has been so slow to realize itself — is still so timid, so partial, so inadequate?"[14] In 1922, he wrote, "With the beginning of the second decade of this century, there is some evidence of an attempt to make a genuine culture out of industrialization."[15]

Mumford may have been optimistically alluding to the recently assumed roles of museums in elevating the public taste and in inspiring industrial artists with historical examples of good taste. Richard F. Bach, curator of the Industrial Art Department of the Metropolitan Museum of Art (informally known as "The Workbench of American Taste"), led this movement. In 1917 he initiated annual exhibitions of industrial arts, offering access to these collections to "all industries in which artistic design is in any way a dominant element." He explained: "There is fertile virgin soil for the art museum offering direct as well as subtle lines of art influence by which, properly used, museums may bind themselves forever to the most intimate feelings of people, reaching them through their home furnishings, their utensils, their objects of personal adornment, their clothing."[16]

The Metropolitan's annual exhibitions ran through 1931. At first, designs had to be

based on objects in its own collections, imitating historical designs, but over the years, original designs were gradually permitted. Other museums, which were very familiar with prewar European design leaders, chose those examples to inspire American industrial artists. The Art Institute of Chicago, with the support of the Art and Industries Association of Chicago, in 1920 exhibited the work of the prewar Wiener Werkstatte. John Cotton Dana (1856–1929), director and founder of the Newark Museum, saw the museum as a department store for European modern ideas of good taste, and in 1922 repeated the museum's 1912 exhibit, Werkbund Exhibit of Industrial and Applied Art, of prewar Germany's Deutsche Werkbund, with 1300 objects. The Werkbund, in its postwar recovery, concurrently published the first edition of its journal, *Die Form*. But others were citing mass production as requiring a new form of design. American master potter Leon Volkmar (1879–1959) said, in 1922, "If you must have the machine, evolve a new type of beauty that will express the machine plus intelligent direction."[17]

Because of the traditional demand for European design by the American upper class and museums, a number of talented foreign émigrés found career opportunities in the U.S. before and after the war, bringing with them modern styles from Europe. They were architects, artists, commercial artists and illustrators, artisans, cartoonists, set designers, and engineers, with the flexibility to adapt to the uniquely American industrial art environment. Many became U.S. citizens, would pave the way for a new industrial design culture in the U.S., and would become part of the field as it matured.

As early as 1911, Viennese architect Joseph Urban (1872–1933), a member of the Vienna Secession, arrived from Austria. He was an illustrator and designer of theatrical sets and upon arrival became artistic director of the Boston Opera House. From 1918 until his death, he was a set designer for the famous *Ziegfeld Follies*, and from 1922 to 1924 he ran the prewar New York branch of the Wiener Werkstätte.

In 1914 German furniture designer Paul Frankl (1887–1958), also a member of the Vienna Secession, arrived, and in 1922 established galleries in New York and Los Angeles. He became known for his "skyscraper" style furniture in the 1920s, and wrote several books on design, including *New Dimensions* (1928) and *Form and Re-form* (1930).

Kem Weber (1889–1963) of Germany was stranded here when the war started in 1914, as he worked on German exhibits for the Panama-Pacific Exposition in San Francisco. From 1922 to 1927 he thrived on the West Coast in furniture and interior design.

Educator Alexander Kostellow (1896–1954) came from Persia (now Iran) in 1916, and studied painting at the National Academy, the Art Student's League, and the Kansas City Art Institute before becoming a prominent industrial design educator in 1934.

Joseph Sinel (1889–1975) came from New Zealand via Australia and England in 1918 to San Francisco, where he taught at the California College of Arts and Crafts while freelancing. In 1921 he was filing Art Deco product design patents while working in advertising agencies, and in 1923 he published *A Book of American Trademarks and Devices*, which was quite influential in advertising design.

Greek cartoonist/author John Vassos (1898–1985) served on a British navy suicide minesweeper that was torpedoed during the war; he was rescued by a U.S. transport and deposited in Boston in 1919. He studied art with John Singer Sargent at the Fenway Art School, and assisted Joseph Urban in set design at the Boston Opera House. He came to New York in 1924 and opened an art and design studio, studying at the Art Students League in his free time. From 1927 to 1935 he illustrated nine books, including a half-dozen of his own.

French Army veteran and engineer/artist Raymond Loewy (1893–1986) arrived in 1919 and worked as a fashion illustrator and costume designer before opening his industrial design office in New York in 1929.

French engineer George Sakier (1897–1988) arrived after the war in the early 1920s and designed machinery and taught machine design while writing and practicing fine art. He designed glassware for Fostoria Glass in Moundsville, West Virginia, for over 50 years. In 1927, while continuing his independent practice, he headed the Bureau of Design Development at the American Radiator & Standard Sanitary Corporation.

Finland's national architect, Eliel Saarinen (1873–1950), emigrated to the U.S. in 1923 after winning second prize in the Chicago Tribune Tower competition. He joined the staff at the University of Michigan and cofounded Cranbrook Academy of Art, becoming its president in 1932. Danish designer Gustav Jensen (1898–1954) was another talented arrival.

In 1923, Syracuse University hired an English designer, Montague Charman, who established a new program, Design for Industry, based on his prior experience of working with industry.

Other postwar émigrés included Swiss architect William Lescaze (1896–1969) and Swiss designer Paul Fuller (1897–1951), who worked as a designer of product displays for Marshall Field & Co. in Chicago. In 1924, the DeVilbiss Company of Toledo hired French designer Frederic Vuillemenot (1891–1953) to design its line of stylish atomizers and accessories. Austrian furniture designer Wolfgang Hoffmann (1900–1969), the son of Josef Hoffmann, arrived in 1925. German commercial artist Otto Kuhler (1894–1977) arrived in 1923. Also from Germany in 1925 came Walter von Nessen (1889–1943). In 1926 German metalworker Peter Müller-Munk (1904–1967), Raymond S. Sandin, and film set designer Alfons Bach (1904–1999) all emigrated to the U.S.

These émigrés added their talents to the small but growing contingent of American designers who remain largely unknown but included Lurelle Van Arsdale Guild (1898–1985), who graduated from Syracuse University in 1920 and soon started his successful design business in New York, specializing in home furnishings and decorative arts. Another early American designer was Chauncey E. "Chick" Waltman, who established a design office in 1925, possibly the first such office in Chicago.

At the same time, various organizations began working to encourage American designers so that future importation of European goods would be unnecessary and to promote the collaboration between industry and the arts. In 1920, the National Alliance of Art and Industry became active under the presidency of William E. Purdy and sponsored competitions and meetings to promote industrial arts. In an article in *Arts and Decoration*, Purdy cited an optimistic quote from W.F. Morgan: "It is gratifying to note that a change of sentiment is taking place. The average citizen is beginning to understand that an article may be useful and beautiful at the same time.... [W]e are realizing that there is really no essential distinction in artistic character between the commonest household objects and the rarest productions of artistic genius."[18]

This suggested that, at least to some, industrial design was of genuine artistic merit, and that functional "artless industry" products could be considered artistically. The alliance formed the Industrial Arts Council, which established the Art Centre organization to bring designers and manufacturers together for mutual benefit. More than 100 organizations joined the center, including the American Institute of Graphic Arts, the Society of Illustrators, the Architectural League, and many trade and craft organizations. Under the direction of William L. Harris, the Art Centre staged exhibitions, conferences and lectures, and

established a bureau for placing designers in trades and industries. Harris wrote in the *New York Times* of February 26, 1922: "[E]very effort should be made to encourage the industrial designers now at work and to enable the rising generation of artists to carry on their studies until our achievements in the practical forms of art not only equal but surpass the achievements of other nations."[19]

There was little evidence that American popular tastemakers were impacted by the modern movement abroad at two exhibitions held in 1923 and 1924 by the Art-in-Trades Club (founded in 1906) at the Waldorf Astoria Hotel in New York. There were 50 rooms, each in a different historical style, displaying decorative interiors and manufactured products. There were Chippendale rooms, Tudor rooms, Elizabethan rooms, Georgian rooms, Queen Anne rooms, Louis XVI rooms, American Colonial rooms and Spanish Colonial rooms. The only token example of recent European modern design was a dining room in Wiener Werkstatte style by Joseph Urban. The exhibitions demonstrated that imitation of European historical styles still dominated popular home décor. Prewar styles of Art Nouveau and Arts and Crafts were no longer much in evidence. "New" styles of Spanish Colonial in the southwest and American Colonial in the northeast were being promoted as "native" or of "genuine" American heritage.

After the war, France was seeking to restore its prewar international dominance in style. Paris in the 1920s was where many artists, including Americans, went to study and absorb modern art and culture. The modern art revolution began with the 19th century French impressionists, and in the 1920s modern artists such as Pablo Picasso, Marcel Duchamp, Fernand Léger, Man Ray, Paul Klee, and Constantin Brancusi, all of whom defied tradition, inspired the French. Paris attracted and nurtured all kinds of creative people and style-setting events.

Architect Charles Edouard Jeanneret Gris (1887–1965), who had just adopted the pseudonym "Le Corbusier" ("the Raven"), and painter Amédée Ozenfant (1886–1966) began publication of *L'Esprit Nouveau* (*The New Spirit*) in 1920, with themes of order, rationality, engineering, and technology. It was published until 1926, and succeeded in defining the nature of a new architecture. Corbusier had worked in 1910–1911 for Peter Behrens in Berlin and was well aware of German design philosophy. He was an avid enthusiast of Fordism and Taylorism. In the design of a slaughterhouse in Paris in 1916, he turned Fordism on its head by using a conveyer-belt system to "disassemble" the animals. In 1917, he established a small company that operated a brick-making factory, and by 1920 he considered himself as an industrialist as well as an architect.

In 1923, Corbusier published *Vers une Architecture* (*Towards a New Architecture*) describing his ideas, which abandoned tradition and connected architecture with mass-produced industrial standards, practices, and forms, in particular, automobiles, airplanes, and ocean liners. His design of a modern Paris studio house, the Maison Citrohan, (a play on the Citroën car name), was intended to illustrate his statement that a house is "a machine for living in."

Paris attracted creative people from around the world, including many artists and students from America. Gabrielle "Coco" Chanel (1883–1971), who had led the way in fashion design since 1917 defying tradition with her simple outfits and suits that allowed freedom of movement, introduced her Chanel No. 5 perfume in 1921. Its square, faceted, glass bottle was the forerunner of all modern cosmetic packaging. In 1922, Irish interior, furniture, and architectural designer Eileen Gray (1878–1976) opened a gallery in Paris.

By this time, some French artists and decorators realized that famous modern artists

had, through their Cubist and other abstract paintings, suggested the basic visual elements of a new style of household products. These included French painter/designer André Marè (1885–1932) and his partner, architect Marie Louis Sue (1875–1968), who had founded the la Compagnie des Arts Français (Company of French Art) in 1919, along with others such as crafts designer Paul Follot (1877–1941), decorator André Groult (1884–1966), jewelry designer Maurice Dufrêne (1876–1955), architect Robert Mallet-Stevens (1886–1945), decorative bookbinder Pierre Legrain (1889–1929), cabinetmaker Emile-Jacques Ruhlmann (1879–1933), and fashion designer Paul Poirot (1879–1944), who evolved new styles based on selective geometric shapes and proportions of French Art Nouveau and Cubism, Italian Futurism, and modern architecture.

In 1923, the first international show of household appliances was held in Paris, initiated by Jules-Louis Breton (1872–1940). One hundred thousand visitors attended this Salon des Arts Ménages (Salon of Domestic Science), which would continue annually until 1939. French manufacturers were receptive to the new ideas and collaborated with designers to adjust their traditional methods and styles to the new, geometric styles. This occurred initially with high end products by Lalique and Coty, at a series of *salons intimes* (intimate rooms) in 1924, but soon in a range of furniture, fabrics, lamps and other products. Design-

Cubist art by Fernand Legér, *Two Women and a Still Life*, 1920 (Von der Heydt Museum, Wuppertal, Germany).

ers were paid for their expenses in developing prototypes and also were paid a royalty for each reproduction of their design. This encouraged designers to share risks as well as rewards with manufacturers, a common practice later in industrial design.

In 1925, France, seeking to boldly reaffirm its prewar global leadership in style, held an Exposition International des Arts Dêcoratifs et Industriels Modernes (International Exposition of Modern Decorative and Industrial Arts) from April to October. This rather clumsy title would later be shortened to Art Deco to describe the variety of designs exhibited there — a potpourri of modern geometric forms, sentimentally stylized animals, and stream-lined, classical nymphs.

This exposition was unlike any of the many international expositions that preceded it. Traditionally, most used the occasion to celebrate past national accomplishments. In this one, the intention was to set new standards. Exhibitors were required to display only "those exhibits that were not dependent of the art of the past."[20] Invitations for participation were sent to all countries except Germany, still a pariah from the Great War. Except for China and the U.S., 26 accepted. China declined because of disruptive political conditions, and the U.S. because the State Department did not recommend appropriations, due to lack of support from commercial interests. Herbert Hoover, then secretary of commerce, explained in part to the 4th Annual Exposition of Women's Arts and Industries: "The advice I received from manufacturers was that while we produced a vast volume of goods of much artistic value, they did not consider that we could contribute sufficiently varied design of unique character or of special expression in American artistry to warrant such a participation."[21]

In other words, America had no innovative examples to show. While this was not surprising, considering the French requirement for new designs, it is also possible that manufacturers had little or no interest, since sales were at their highest since the war. The State Department might well have advised Hoover that a poor showing could damage U.S. prestige. Note also that Hoover asked manufacturers, not design-related organizations, for their opinion. An outcry from the cultural establishment soon followed. Charles Richards, author of the thorough 1920 industrial arts study mentioned earlier, requested that Hoover delegate a commission of 100 representatives of trade associations, along with some architects and designers, to visit and report on the exposition. Hoover gracefully complied.

Though other countries were participating with token displays, many were less than well coordinated or truly representative of their country, and the major part of the exhibition was primarily and comprehensively French. The main entrance to the exhibition was the Porte de la Concorde, with eight towering rectangular pylons and a classical bronze female statue called "Welcome." The American critic Helen Appleton Read (1897–1974) described La Porte d'Honneur (The Gateway of Honor), a wrought-iron gateway designed by French ironworker and armament manufacturer Edgar Brandt (1880–1960): "From this point of vantage the Exposition can be seen at a glance, its cubist shapes and futurist colors stretching away across the Alexander Bridge to the great dome of Les Invalides, looking like nothing so much as a Picasso abstraction."

Helen Read also perceptively described two of the primary tenets of modern design:

> It is characteristic of the new décor that the nature of the material is at all times respected and is allowed to dictate its treatment. Wood is wood, iron iron; the bad taste that invariably ensues when the attempt is made to give the quality of one material to another, to make wood look [like] iron or marble like lace, is avoided. This universal tendency towards simplicity of outline should

Poster for Paris Exposition, 1925.

be of the greatest interest to the American designer if he will recognize that this is the fundamental note. All design in this country is governed by the factor of whether or not it can be reproduced in mass production. It costs no more to get out a good design than it does a bad one, and the fact that the best designs of the new décor are the simplest to the point of being geometric makes them so much the more easy to put on the market.[22]

French displays amounted to two-thirds of the 57-acre site. The work of French furniture and interior designer Émile-Jacques Ruhlmann (1879–1933) was displayed in a special classical "Pavilion for a Rich Collector" designed by French architect Pierre Patout (1879–1965). Famous glass and jewelry designer René Lalique's (1860–1945) work was also prominent. A number of well-known Parisian merchandisers like Bon Marché, Printemps, and Magazins du Louvre produced entire room "ensembles" (arrangements) in modernist styles.

The Soviet pavilion, designed by architect Konstantin Melnikov (1890–1974), showed work by Rodchenko and students from the VKhUTEMAS, the latter winning several prizes. Josef Hoffmann commissioned Austria's work, housed in Frederick Kiesler's (1890–1965) *City in Space* exhibit. Tadeusz Lucjan Gronowski (1894–1990), who won a Grand Prix, successfully represented Polish graphic arts. LOT Polish Airlines still uses the logo designed by him in 1929.

The Swedish pavilion was a popular attraction. The exhibit was simple in form and devoid of decoration, but featured the latest modern crafts with clean and simple, typically Scandinavian, forms. Gregor Paulsson (1889–1977), director of the Swedish Society of Arts and Crafts (originally called Svenska Slöjdföreningen when it was founded in 1845, and later Svenska Form), had published, in 1919, *More Beautiful Things for Everyday Life*, which challenged the past and encouraged craftsmen to express new forms expressive of the modern age. Thus was initiated in Sweden an organic and elegant philosophy of beauty, quite different than the Germanic, French, and Soviet philosophy of geometric severity that evolved in parallel. Still, in the tradition of the Arts and Crafts movement, Paulsson opposed artificial and cheap imitation of craft designs through mass production.

A number of other European designers were also establishing new postwar traditions. Danish designer Kaare Klint (1888–1954), who later influenced "Danish Modern" furniture design, was in 1924 a primary force in the founding of the furniture school at the Royal Academy of Fine Arts in Copenhagen, where he championed function and human factors in the design of furniture. In Italy, the Biennale, Italy's international exhibition of design and architecture, had been initiated in 1923, where Giovanni "Gio" Ponti (1891–1979) introduced modern design with his ceramics and furnishings for Rinacente department stores. He would later become a dynamic leader in Italian design as well as the founder of *Domus* magazine in 1928. A leading manufacturer of fine quality glass objects, Venini of Venice, also began to show modern designs at the 1923 Biennale. The firm was founded by Paolo Venini (1895–1959), and was continued by his son-in-law, Ludovico de Santillana (b. 1931). The Biennale, starting in 1933, was held every three years and was renamed the Triennale. Gropius, Mies van der Rohe, Adolf Loos, and Le Corbusier all exhibited work there in 1933.

In a far corner of the exposition, generally ignored by the press, was a small house built by Le Corbusier and his cousin, Pierre Jeanneret (1896–1967), called the Pavilion de L'Esprit Nouveau, bearing the title of his publication. It was in the clean, simple, style of his Maison Citrohan concept, with a garden terrace, representing his claim that a house was a "machine for living." In style, the architecture differed neither from the work of Walter Gropius nor its furnishings from Bauhaus principles. Le Corbusier had commented

positively on both in early issues of *L'Esprit Nouveau*. The plain, unfinished white-wall interior, with only a few paintings by Léger and Jeanneret, was furnished with commercial products from manufacturer's catalogs such as metal filing cabinets, hospital tables, bent-wood chairs by Thonet, and custom built, spare, rectangular units used for bookshelves, art object display, and desk work. Laboratory flasks were used as vases. It was a complete rejection of traditional decorative arts but more influential to the modern movement than anything else in the exposition.

Over 16 million people visited the exposition. The American Commission submitted a scathing report to the Department of Commerce, warning that the modern movement in applied arts would soon reach the United States:

> [Americans needed to] "initiate a parallel effort of our own upon lines calculated to appeal to the American consumer.... As a nation we now live artistically on warmed-over dishes. In a number of lines of manufacture we are little more than producing antiquarians. We copy, modify and adapt the older styles with few suggestions of a new idea. It is true that this practice of reproducing the older forms has been an invaluable education to our people. It is also true that the adaptation of old motives when performed with intelligence and skill continues and probably will continue to give us a large proportion of the decorative manifestations acceptable to American taste. It would seem equally true, on the other hand, that the richness and complexity of American life call for excursions into new fields that may yield not only innovations but examples well suited to the living conditions of our times."[23]

This somewhat conflicting report was due to the fact that some members of the commission doubted that the modern movement would appeal to Americans. Others urged manufacturers to take the risks in innovation to meet changing public tastes, and for economic competitiveness.

Among the many Americans who visited the exposition were Donald Deskey (1894–1989), a Chicago and New York advertising artist who had studied in Paris from 1920 to 1922, architect Eugene Schoen (1880–1957), furniture designer Gilbert Rohde (1894–1944), and successful New York commercial advertising and package designer Walter Dorwin Teague (1883–1960). They all returned committed to the new modernist styles and would soon become leaders in the American response to increased demand for new designs.

Reports from other Americans who attended the exposition circulated quickly within the art and design communities and received considerable attention in the press. A January 26, 1926, *New York Times* editorial urged industry to change because the public would soon catch up with Europe in recognizing the competitive value of new designs.

U.S. decorative arts associations reminded their constituents that they had been proposing collaboration between artists and industry for some time, just as the French were doing. The Art-in-Trades Club issued a manifesto in 1926 challenging American artists to compete in the design of modern furnishings.

Museums were anxious to promote the new European designs shown at the 1925 Paris exposition. By February 1926, the American Association of Museums imported a collection of French and Swedish products from Paris to initiate an exhibition, Selected Collection of Objects from the International Exposition of Modern Decorative and Industrial Art, at the Metropolitan Museum of Art and subsequently to tour member institutions, "not to stimulate the demand for European products, nor to encourage copying of European creations, but to bring about an understanding of this modern movement in design in the hope that a parallel movement may be initiated in our country ... to bring to us new forms appropriate to the living conditions of the twentieth century."[24]

Art critic Helen Appleton Read tried to explain the source of the "new forms" in the

modern movement: "The whole trend of modern design toward the geometric and the unadorned, had its inception through the omnipresence of the machine. Because we had absorbed the shapes of the machine into our consciousness, we ended up by creating designs which reflected it, and which in turn are the most suitable for machine-made processes."[25]

Most of the 3.7 million Americans who owned cars were not aware of the new Art Deco style trends, but they certainly were aware of their "machines." After all, it was more likely that they invited friends to look at their new "machine," rather than their new "automobile" or new "car." Aware of the latest custom car feature and style improvements, they were becoming increasingly dissatisfied with the looks of the most popular production automobile, the Ford Model T, which in 1923 commanded 52 percent of the U.S. market. In 1926 it was virtually unchanged in style since its dramatic introduction in 1913, except that it was offered in "Rich Windsor Maroon" and a number of other colors in addition to its traditional and ubiquitous black. But despite reduced prices, Ford was rapidly losing market share.

A primary reason was that leading custom car designers like Tom Hibbard, Howard A. "Dutch" Darrin, and Raymond Dietrich were all incorporating more stylish and smoother body details into their designs for luxury custom cars. Owners of low-cost cars were anxious to see these same attractive details in production cars like Ford and the number two in sales, Chevrolet. In 1924 the first Chrysler, a production car, evidenced some of these refined appearance features and was instantly successful. Another major new style trend was the use of color. Cars began to use color in 1923, when Dupont developed its Duco nitrocellulose

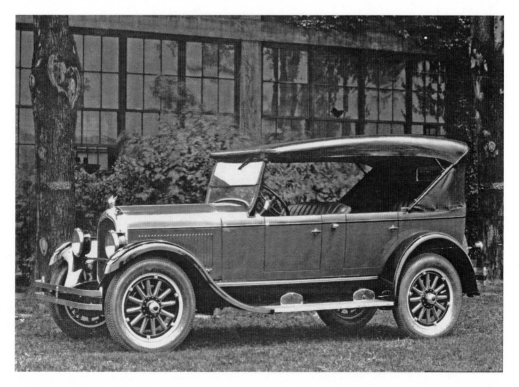

The first Chrysler, 1924, designed by Carl Breer, Fred Zeder, and Owen Skelton (courtesy Chrysler Group LLC).

lacquer, which dried much faster than the previous slow-drying lacquer, thus speeding up production. The first production car to use Duco was the 1924 "True Blue" Oakland Six, introduced by GM. Color soon became popular with buyers.

In 1925, Alfred P. Sloan, head of General Motors, instituted annual model changes, convinced that new styling was the key to future success. When GM introduced the 1926 Pontiac on the same chassis as the Chevrolet, they differed noticeably in appearance and in color. That year, Chevy sales doubled and Ford dropped 25 percent. By 1927, Ford's market share had declined to 15 percent, while GM had risen to 45 percent through improved styling. In May 1927, the same month of Lindbergh's famous transatlantic flight, Henry Ford reluctantly announced that the Model T, of which 16 million had been produced since 1913, would be discontinued and replaced by a new Model A Ford. Henry's son, Edsel Ford (1893–1943), president and chief designer since 1908, worked with body engineer Joe Galumb to upgrade the A's appearance. Many regard this as the seminal event that convinced many in industry of the importance of design to the formerly "artless industries" and therefore triggered the demand for industrial designers. They figured that if Henry Ford himself required styling, they had better follow suit.

Convinced that styling was the key competitive sales advantage, Alfred Sloan hired Hollywood custom body designer Harley Earl (1893–1969), who had earned his reputation designing cars for movie stars, to design the 1927 LaSalle, a cheaper, production model version of GM's luxury Cadillac. The LaSalle was the first mass-produced car to have its appearance completely styled from bumper to bumper by a single individual. Earl used full-scale clay models to preplan every detail and blended all visible parts of the car into an integrated, cohesive form. The LaSalle was an instant hit.

GM hired Earl to create and head a new department. By 1928, he would have a staff of 50 people, including Frank Hershey (1907–1997), Gordon Buehrig (1904–1990), and many others who would later run styling departments in competitive auto companies. By 1929, there would be over a hundred on staff, including John R. "Jack" Morgan (1903–1986), John G. "Jake" Aldrich, Ted Hobbs, John Tjaarda (1897–1962), Vincent D. Kaptur (1895–1987), Carl Peebles, Bob Gregorie (1908–2002), and William Meyerhuber.[26]

The new GM Art and Colour Section was the first styling department of an American automobile manufacturer and would not only dominate car styling for decades, but would also inspire other "artless" industries to follow the example of initiating internal styling staffs.

Meanwhile, in Germany, a

"MR" chair by Mies van der Rohe, 1927 (courtesy Knoll, Inc.).

BREUER-METALLMÖBEL

Marcel Breuer furniture produced by Standard Möbel, 1927 (from H.M. Wingler, *Bauhaus*, 1969).

major housing project exhibition was being held in 1927 to demonstrate houses for modern living, called the Weissenhof Siedlung (Weissenhof Estate). It was under the direction of architect Ludwig Mies van der Rohe (1886–1969), and participants included Europe's top designers: Walter Gropius, Peter Behrens, Marcel Breuer, Le Corbusier, Adolf Loos, Mart Stam, and J.J.P. Oud. The theme was "The Home" and included furnishings and interiors. Mies furnished the house he designed with his so-called MR, or Weissenhof, chairs, tubular steel cantilevered "S" shapes with cane seats. The design was based on Dutch architect Mart Stam's (1899–1986) prototype of 1924, which had been refined and was also exhibited. Marcel Breuer's tubular steel Wassily chair from 1925, now produced as Model B3 by Standard Möbel, as well as a number of his tubular steel chairs, were exhibited. The exhibition promoted the latest in German furniture design innovation.

The stage was set for a major impact of modern design on public awareness. People were beginning to see that design was not just for decorative, expensive "objects of art." It was also for the enhancement of everyday, functional, affordable objects that surrounded them. It was for products previously regarded as "artless" and made by mass production. People began to notice that the products of their parents were crude, unattractive, overly decorated, poorly designed, and in the 1920s, obsolete. They wanted something better.

Chapter 7

1927–1936
American Modern Design

In 1927, America was in a state of euphoria that is hard to describe today without comparing it to public reaction to the landing on the moon in 1969. People were excited about modern technology to the point of mania. Radio was seen as a means to bring world peace, uplift democracy, improve education and renew religion. Some believed that radio-equipped patrol cars would finally defeat crime. Electronic television had just been invented and demonstrated by Philo Farnsworth (1906–1971). Automobiles were seen as similar harbingers of a wonderful future, and Lindbergh's flight over the Atlantic had made him a national hero. Motion pictures had just acquired the wonder of sound with *The Jazz Singer*, starring Al Jolson. The economy was booming, stocks were going through the roof, and people were convinced they were entering a new era. Within a few years, the comic strip *Buck Rogers* would envision the 25th century with rocket powered backpacks enabling individuals to fly. This was the optimistic context in which industrial design was born; modern design had become a visual expression of the times.

Consumer goods manufacturers looked for new styling to increase sales for their products. In the August issue of *Atlantic Monthly*, Ernest Elmo Calkins, head of the Calkins-Holden advertising agency, wrote an influential article, "Beauty, the New Business Tool," which strongly urged manufacturers to incorporate modern design into their products. An increasing number of manufacturers heeded his advice and an increasing number of designers were ready to respond. George Sakier, design director at the American Radiator and Standard Sanitary Corporation, was designing Art Deco plumbing and bath fixtures. Egmont Arens (1888–1966) was designing a line of Art Deco lamps. Gilbert Rohde opened his office in New York, designing furniture and showrooms, as well as consulting with General Electric and Hudson Motors. Kodak engaged Walter Dorwin Teague to design stylish Art Deco cameras and would remain a long-term client of his. Teague had opened his New York industrial design office in 1926, inspired by the Paris Exposition and the classic proportions of Athens architecture during his trip to Europe. Donald Deskey opened his New York office in 1927 in partnership with Phillip Vollmer (Deskey-Vollmer, Inc.), specializing in Art Deco furniture and lighting design. Buckminster Fuller (1895–1983) formed his "design science" 4-D company in Chicago in 1927 to create innovative housing and transportation concepts. Among these was an experimental "4D" House (renamed the Dymaxion House in 1929), a hexagonal structure that hung from wires from the top of a duralumin central mast. Walter von Nessen opened his New York office in 1927, and Gustav Jensen began working as an industrial designer in 1928. In Toledo, Ohio, the Owens Bottle Company convinced the Toledo Museum's School of Design to initiate

courses in industrial design for Owens employees in 1928. Industrial design in the U.S. was on its way.

A number of early designers were concerned with the dishonest practice of manufacturers copying their new designs. In the recent past, manufacturers had copied traditional designs as a normal practice. Museums had even encouraged them to do so. Now, in 1927, designers of modern styles felt that such borrowing "degrades the producers and corrupts the taste of the public." It is not known how aware they were of the protection of design patents. Nevertheless, Donald Deskey, Kem Weber, Lee Simonson (1888–1967) and others formed an organization, the American Union of Decorative Artists and Craftsmen (AUDAC), which aimed "to cooperate with manufacturers and the public in the placing of American arts and crafts on a basis of honesty, dignity and merit."[1]

Promotion of modern design continued unabated. The Metropolitan Museum in 1927 held an exhibition of Swedish industrial arts, introducing the U.S. public for the first time to the simple forms of Scandinavian design. Department stores such as Macy, Wanamaker, Franklin Simon, and Marshall Field, inspired by the success of merchandiser's "ensemble" displays at the Paris Exposition, staged their own exhibitions featuring the new Paris Exposition designs. Typical was the May 1927 Macy's Art in Trade exhibition in New York, attended by 40,000 and hyped by radio reports and talks by notable participants. Jean Heap (1887–1964), editor of a literary journal, *The Little Review*, organized a Machine-Age Exposition, also in May 1927, in Steinway Hall, a commercial building in midtown Manhattan. Influenced by Le Corbusier's *Pavillon de L'Esprit Nouveau* at the 1925 Art Deco exhibition in Paris and by Soviet Constructivism, Heap exhibited actual machines, a Studebaker crankshaft, a Curtis airplane engine, and a Hyde Windlass propeller, along with photographs of skyscrapers, the Bauhaus in Dessau, Soviet industrial buildings, and architecture by Gropius. The *New Yorker* reported that the exposition demonstrated "that the machine is the tutelary symbol of the universal dynamism."[2]

In 1928, The B. Altman department store held an exhibition called Twentieth Century Taste. Lord and Taylor announced an international competition in design and trade symbols. Macy's staged a dramatic International Exposition of Art in Industry, organized by its new department of design head, Austin Purvis. Theatrical designer Lee Simonson (1888–1967) designed the background of galleries that included 15 rooms, each designed by well-known designers. The director of the Austrian Academy of Industrial Art, 58-year-old Josef Hoffmann, designed a powder room with products from the Wiener Werkstatte; French jewelry designer Maurice Dufrêne (1876–1955) designed a dining room; Bruno Paul, head of the German Vereinigte Staatsschulen für freie und angewandte Kunst (United State Schools for Fine and Applied Art), designed a man's study and dining room; American rooms were designed by European émigrés Kem Weber, William Lescaze, and Eugene Schoen, mentioned earlier.

Among the designers exhibited was Italy's Gio Ponti, who designed a living room and a butcher shop. Ponti had just founded *Domus* (*Home*), an architecture and design magazine that promoted the Wiener Werkstatte of Austria as well as the Italian Novecento group to which he had belonged since its founding in 1926. Also just founded in 1928 by Guido Marangoni of Italy was the competing *Casabella* (Beautiful Home) magazine.

To design promotional show windows, furnishings and displays, department stores engaged New York theatrical designers. Stage designers were looking for new clients because of the advent of talking pictures in 1927. Many theaters that in the past had staged live performances were now converting to movie theaters. Franklin Simon department store in

1928 thus engaged one of the most successful theatrical designers, Norman Bel Geddes (1893–1958), who had designed film sets for Hollywood, to develop a modern approach for window display. His windows featured dramatically lit cubistic pyramids and metallic mannequins. When revealed to the public, they caused traffic jams and crowded sidewalks. On Bel Geddes' staff were young designers Henry Dreyfuss (1904–1972), and Russel Wright (1904–1976). Bel Geddes soon shocked the theatrical world when he retired from his successful stage design career and focused his work on industrial design. He was soon designing cars for Graham-Paige. One of his former employees, Henry Dreyfuss, would also leave a successful career in the theater to open his own industrial design office in 1929. Another Bel Geddes employee, Russel Wright, would make his name designing products in a new material, aluminum, when he opened his own office in 1930.

Richard Bach, of the Metropolitan Museum of Art, felt his efforts in promoting the European modern styles had been successful. He decided to emulate the French room "ensemble" in his February 1929 exhibition, Contemporary American Design, which was originally intended to conclude in March, but by then 100,000 had attended and the demand forced him to extend it to October. The contradicting subtitle, *The Architect and the Industrial Arts*, revealed that he favored none of the new American "industrial artists" (industrial designers), but rather rooms by well-known and established American architects like John W. Root, Ralph Walker, Raymond Hood, Ely Kahn, and foreign architects like Eliel Saarinen, Joseph Urban, and Eugene Schoen. A few token industrial designers, Peter Müller-Munk and Egmont Arens, were represented as artisans, but Bach clearly had concluded that establishment architects should assume the leadership of the new profession of industrial design in the U.S. as they had in Europe. AUDAC members were appalled at their exclusion, and began planning their own show the following year. All these exhibitions and promotions had the effect of escalating consumer interest and demand. The new styles were so dramatically different from the existing furnishings and decorative products that people suddenly realized their homes were impossibly obsolete. A number of designers were also convinced by these promotions to enter the emerging field of industrial design. Among them was Raymond Loewy, who opened his New York office in 1929. Business leaders began to promote modern design. In 1929, the American Management Association (AMA) conducted seminars for businessmen on whether "intelligent and profitable use [can] be made of the modernistic style of design."[3] Seminar titles included "How the Retailer Merchandises Present-day Fashion, Style, and Art," "How the Manufacturer Copes with Fashion, Style, and Art," and "The Renaissance of Art in American Business."

Silhouette silverware 1929, Pattern by Leslie A. Brown and Viande style knife (short blade, long handle) by Eliel Saarinen for International Silver Company (courtesy International Housewares Association).

Many industrial manufacturers had no interest in or knowledge of the academic or artistic merits of various design trends, but they could not fail to notice that modern styles were effectively improving sales. They had heard the chorus of appeals from major advertisers urging new designs. They had observed the success of General Motors' styling in forcing the Model T's redesign and in initiating annual model changes in 1927. They had seen American Standard, a prominent manufacturer of bathroom fixtures, engage industrial design consultant George Sakier to head their Bureau of Design Development that same year. They had seen Kodak engage leading industrial designer Walter Dorwin Teague in 1928 to design cameras. Manufacturers knew that there was a huge consumer market out there beyond automobiles that could be tapped. A 1929 study on the Middletown neighborhood of Muncie, Indiana, by Robert and Helen Lynd, found that of 26 working-class families lacking bathroom facilities, 21 nevertheless had automobiles. But by this time, home and car sales were already declining along with other consumer durables, since many purchases made since 1923 had increased consumer debt and many consumers closed their wallets. Excessive stock buying on margin had overpriced the market, which suddenly collapsed like a house of cards.

On October 29, 1929, the same day of the stock market crash, at the AMA annual convention in Detroit, during his keynote address, E. Grosvenor Plowman, advisor on merchandising problems to the Associated Industries of Massachusetts, commented on the high quality of manufactured goods: "There was a time when our best things were hand-made, our poorest made in mass production. Cheap, nasty, poor taste things were turned out by the machine. The reverse seems to be beginning to be true today."[4] During the discussion that followed Plowman's address, Plowman stated that the modernistic style was the "offspring of the jazz age" and that "the modern style will remain as long as the machine in its present form is the characteristic of world production, [changing] its outward form from year to year, just as women's dress styles change," and that manufacturers would have to learn to balance faddism and permanence.[5]

It was generally agreed that manufacturers had serious problems due to the recession. It was stated that "almost all industries have an overcapacity from a product standpoint," and that therefore "there are more goods than there are customers," and "all manufacturers in any given field were attempting to sell much the same articles to the same consumer."[6]

There was general agreement that artistic values had become essential to sales. Examples were cited. Someone stated that although a simple radio costs only $50 to make, "in an artistic cabinet it brings $150 currently, or $750 from the well-to-do buyer." A representative of the L.C. Smith Typewriter Company noted that his company introduced colors in its products in 1926, after years of black only, and soon only 2 percent of sales were black. Another man, from KitchenAid, reported that Egmont Arens' 1928 redesign of the original 1919 KitchenAid mixer had cut its weight in half, reduced its price, and improved its appearance. Sales had increased by 100 percent. Another remarked that "We are going through the golden age of modern industry. We are in the empire period of mass production," and someone else cited "the need of combining mass production with style appeal in order to sustain the structure of American business."

Just as the depression began in earnest, it seemed that manufacturers were becoming committed to style changes for the purpose of regaining sales in a competitive market. The postwar boom was over. Consumer basic needs had been met. Now sales would depend on consumer wants; and the first thing they wanted, when they could afford it, was style.

Throughout the 1920s, it seems clear that, while Europe had a historical advantage of

design education, tradition, and theory, it lacked an infrastructure of mass production manufacturing and large markets. At the same time, America had a historical advantage of mass production and the largest market in the world but lacked an infrastructure of design education, tradition, and theory to capitalize on it. It would not be too long before these elements were merged into a thriving enterprise that produced high quantities of attractive and affordable consumer goods for the general public.

However, the stock market crash of October 1929 led to the Great Depression, which would last a decade. The crash had an immediate effect on many Americans, who reduced their spending dramatically on consumer goods and services. Manufacturing and sales were soon down by 50 percent and unemployment rose to 25 percent. Only half of U.S. households owned a car, but automotive sales quickly declined in 1930 to levels of 1928. General Motors' stock went from $73 in 1929 to $8 in 1932. However, the automobile industry already knew how to increase sales. Its stylists routinely revised new models to be more exciting and attractive; they were also developed with alternative price points. In 1930, GM advertised five brands of automobiles to appeal to a range of socioeconomic levels: Cadillac "for the rich," Buick "for the striving," Oldsmobile "for the comfortable but discreet," Pontiac "for the poor but proud," and Chevrolet "for the 'hoi polloi.'"

Sales of many other consumer goods declined precipitously, as well. RCA stock, one of the decade's most-traded, crashed from $549 in 1929 to almost zero in 1932. But unlike the automobile industry, many consumer product industries had no previous experience or even awareness of the need to "style" their products. Only as the depression began were some manufacturers starting to realize that they needed to pay attention to the appearance of their products. They were now desperate to increase sales, and were willing to pay high fees to industrial designers to redesign their products in attractive, new, modern, styles that were becoming popular, and to finally invest in the significant costs of the retooling required.

The easiest initial style change many manufacturers could implement without tooling expenses was using color, following the automotive trends of the late 1920s. Many old consumer products now appeared in bright colors rather than the traditional natural colors of the materials used in manufacture. In 1930, the very first issue of *Fortune* magazine recalled that in the early 1920s "kitchen and bathroom were a porcelain and surgical white. Furniture was in natural wood tints, surfaced with colorless finish. The stove was black. Faucets were metallic."

In contrast, *Fortune* described a typical home of 1928: "In the cellar stood a Redflash Boiler, more crimson than the flames of the adjacent furnace. On the door of the orange refrigerator was perched a green parrot. Not only the dishes, but the pots and pans were decked in bright gay tints and tones. A green-tiled bathroom was set off with green tub, green towels and, monstrously enough, green toilet paper. For afternoon tea there were blue glasses and a yellow cloth. A yellow alarm clock—a cherry garbage can, a scarlet typewriter—surfaces had turned suddenly into palettes." *Fortune* concluded that: "the acceptance of color was undoubtedly significant from the standpoint of old traditions being abandoned and old suppressions being released."[7]

Consumers soon tired of this temporary fad of using color cosmetically on essentially "old style" products and wanted more significant style changes, as they were seeing in European products. Such change could come only from professional designers. Alas, in 1930, there existed only a few major professional offices that offered industrial design, most mentioned in the last chapter. Norman Bel Geddes, Raymond Loewy, Walter Dorwin Teague, Lurelle

Guild, Gustav Jensen, Russel Wright and Henry Dreyfuss were all located in New York. Their offices were suddenly overwhelmed with clients and projects. Dreyfuss had just won a 1930 design contest by Bell Telephone and was working on a new home telephone design. The contest had paid ten industrial designers, including Dreyfuss and Gustav Jensen, $1000 each to come up with an ideal dial telephone. Teague was busy with cameras for Kodak and working on the 1932 Marmon automobile. Bel Geddes was designing new concept cars for Graham-Paige and a streamlined bedroom suite for the Simmons Company. Loewy was patenting car designs, working on the 1932 and 1934 Hupmobiles, and on a duplicating machine for Gestetner. Lurelle Guild had been engaged by Alcoa to design an aluminum Art Deco giftware line called Kensington Ware.

What was bad news for the economy and for manufacturers was good news for the fledgling field of industrial design. Rapidly increasing demand for product designers attracted numerous designers from other fields, such as furniture design, advertising design, theatrical design, academia, architecture, graphic design, package design and interior design, and from geographical locations around the country other than New York.

Manufacturers scrambled to find any designers they could. A typical example was the heavy equipment manufacturer Westinghouse Electric in Pittsburgh, which took a major step in 1930 to improve sales by hiring Donald Dohner (1892–1943), an industrial design instructor at Carnegie Institute of Technology (CIT), as "director of art," to design the company's commercial products, which ranged from locomotives to ash trays, made in the company's 25 plants. Westinghouse had known of Dohner since 1929, when he was initially engaged as a design consultant to teach their engineers about the basics of industrial design in a 20-week night course at CIT called "Design and Appearance," along with Joseph Balley Ellis of the sculpture studio. Westinghouse as early as 1928 had requested a course "in the fine art of design as applied to electrical machinery."[8] This course was then offered to CIT students as an optional course, and Dohner conducted a similar course at the University of Pittsburgh. When Dohner was hired full time by Westinghouse in 1930, he resigned his position at CIT, and was replaced there by Robert Lepper (1906–1991), who inherited his night class. At Westinghouse, Dohner hired several recent graduates from CIT to serve on his staff, and by 1934 he would have a staff of eight.

In this heady design environment, the Metropolitan Museum in 1930 staged its third International Exhibition of Contemporary Industrial Art, a European-dominated show with designs from England, Holland, Sweden, Switzerland, Czechoslovakia, and Germany. In England, the Society of Industrial Artists had been established. For the first time, Germany sent works to the U.S. by teachers and students of the Bauhaus like Walter Gropius, Marianne Brandt, Wilhelm Wagenfeld, and Hin Bredendieck. By this time, however, the Bauhaus was in serious political trouble because of director Hannes Meyer's Marxism, and some students had even organized a communist cell. Hitler's Nazi party won the second highest number of seats in the Reichstag as the depression forced emergency measures. Meyer was forced to resign, Communist students were expelled, and in August 1930, Mies van der Rohe was appointed as head; he faced a declining situation. Faculty left, students rebelled, workshops were diminished, and the first Nazi students were admitted.

Only a few American designers, like silversmith Paul Lobel (1899–1983), Russel Wright, Donald Deskey, and émigrés, like Eliel Saarinen, Walter von Nessen, and silversmith Peter Müller-Munk, had a small display of work in the 1930 Metropolitan Museum show. By virtue of the title of the exhibition, director Richard F. Bach proposed that the new design styles, previously and progressively referred to as "Art Deco," "Art Moderne," "Modernistic,"

and "Modern," should now be called "contemporary," and this indeed became the commonly accepted formal term for many years.

Museum representatives observed that European craftsmen, particularly the Germans, were stressing "functionalist design," defined as design determined by the process of manufacture and end function — in other words, without conscious "styling" or "popular appeal." But many American designers were criticizing functionalism as inadequate to fit the human form during usage or in communicating the function of the product visually to the user. These arguments clearly were intended to defend their objective of meeting the expectations and desires of real consumers, rather than following European academic or intellectual theory.

Members of the American Union of Decorative Artists and Craftsmen (AUDAC) mounted their own exhibition in early 1930 at the Grand Central Galleries in New York to counter museum promotions of European designs. The exhibition featured five modern interiors filled with mass-produced products already on the market to demonstrate that human comfort and utility were appropriate American design criteria, rather than the typical custom-made, "artistic," and highly decorative designs favored by museums. Included were Russel Wright's aluminum cocktail shaker and a Monel metal (a precursor to aluminum) sink by Gustav Jensen. AUDAC published the *Annual of American Design* in 1930 to promote its members and record the exhibition with 176 pages, 300 photos of products, and essays about design by Frank Lloyd Wright, historian Lewis Mumford (1895–1990), Norman Bel Geddes, Kem Weber, Paul Frankl, Richard Bach and others. Bel Geddes praised the successful collaboration between art and industry.

The new design field was being advanced by a number of corporations in 1931. Montgomery Ward named Ann Swainson (c.1900–1955), a Swedish émigré and fashion coordinator, as head of its new Bureau of Design, to manage package and product design. She staffed her department with arts graduates of Armour Institute of Technology and the Art Institute of Chicago, and trained them in industrial design. Among them was George A. Beck (1908–1977), a recent graduate of the Chicago Academy of Fine Arts.

Harold Van Doren (1895–1957), an assistant director of the Minneapolis Institute of Arts, and Gordon Rideout (1898–1951), a graphic designer from Chicago, partnered in 1931 to establish a design office in Toledo, Ohio. Toledo Scale engaged them to design new public scales in various colors to complement different store interiors. Van Doren and Rideout also designed a dramatic green plastic, Art Deco style, tabletop radio for Air King Products.

In 1932, Belle Kogan (1902–2000), the first female U.S. industrial designer, opened her own office in New York after working for several years as a designer for the Quaker Silver Company. John M. Little (1906–1996) opened his design office in Minneapolis. Herman Miller Furniture Company in Zeeland, Michigan, in 1932 hired Gilbert Rohde, a furniture designer who had opened his office in New York in 1927, to shift the company's style from traditional to modern designs. He also would design a series of modern clocks for the Herman Miller Clock Company in 1933. Egmont Arens had been hired in 1929 by the Calkins & Holden agency to establish an industrial styling division within the agency.

Ernest Elmo Calkins (1868–1964), head of Calkins & Holden, was probably the most prominent advertiser of the time. In 1932, Arens and his industrial design colleague, Roy Shelton, wrote about their design process for Calkins & Holden in a book, *What Consumer Engineering Really Is*. The unfortunate use of the term "consumer engineering," instead of "industrial design," was probably intended to recognize the consumer as the most important

beneficiary of product engineering. In his introduction to the book, Calkins recognized what many did not at the time: despite the bad times, many people had money to spend. His analysis of the depression was spot on:

> Many stopped buying while still able financially to continue, and many are still able but restrained by fear and misplaced thrift. The sudden cessation of buying slowed up the entire industrial machine. Retail storekeepers curtailed orders to factories. Factories cut down production, reduced wages, laid off men, still further reducing the number of customers for goods. In a comparatively short time, with all the resources of the country still intact, we had Depression. There were no longer enough buyers for the large quantities of goods we had learned to make and distribute so abundantly.[9]

Calkins had a theory for solving the problem. He defined the principle of "obsoletism":

> Obsoletism is another device for stimulating consumption. The element of style is a consideration in buying many things. Clothes go out of style and are replaced long before they are worn out. That principle extends to other products—motor cars, bathrooms, radios, foods, refrigerators, furniture. People are persuaded to abandon the old and buy the new to be up-to-date, to have the right and correct thing. Does there seem to be a sad waste in the process? Not at all. Wearing things out does not increase prosperity, but buying things does. Thrift in the industrial society in which we now live consists of keeping all the factories busy. Any plan which increases consumption of goods is justifiable if we believe that prosperity is a desirable thing. If we do not, we can turn back the page to earlier and more primitive times when people got along with little and made everything last as long as possible. We have built up a complicated industrial machine and we must go on with it, or throw it in reverse and go backward.[10]

Radio designed by Americans John Gordon Rideout (d. 1951) and Harold Van Doren (1895–1957), for Air-King Products Co., 1930–1933. Materials used include Plaskon (plastic), metal and glass (courtesy Brooklyn Museum. 85.9. Purchased with funds given by the Walter Foundation).

Such "planned obsolescence," which would acquire a negative connotation 25 years later (*Hidden Persuaders*, by Vance Packard, 1957), nevertheless was precisely what was needed to turn around the depression; it was embraced by industrial designers, and is still a basic source of our material prosperity. Calkins could have added that by initiating a "previously owned" market for goods, many lower economic classes were able to own products at far lower cost than new ones, thus sharing in an ever-expanding standard of living.

The public was also becoming more familiar with, and attracted to, the new modern

design styles. Art Deco was popularized by a number of very public Hollywood films from 1928 onward that featured Art Deco interiors that were seen by 40 million regular moviegoers. Art Deco was also popularized by the 1931 Chrysler Building and by the 1932 opening of Radio City Music Hall in New York, the largest and most opulent theater in the world at the time. Originally called the International Music Hall, it soon became "Radio City" because major spaces were leased to the Radio Corporation of America (RCA). By this time, there were 19 million U.S. households with radios. The Music Hall interior and furnishings were the work of Donald Deskey, a prominent furniture and lighting designer in New York at the time.

Gilbert Rohde, c. 1935 (courtesy Herman Miller, Inc.).

In Philadelphia, a Design for Machine exhibit in 1932 featured furniture by Gilbert Rohde and designs of Russel Wright in a breakfast room that included lamps, tables, flatware and accessories in aluminum, a material that had been used previously only for cookware. Wright had begun a business in 1930 with his wife, Mary, designing and producing decorative aluminum pieces in attractive, modern styles, many of which were cooking utensils attractive enough to go directly from the stove to the serving table.

The Museum of Modern Art (MoMA, founded in 1929) in February and March of 1932 held its first architectural exhibition, The International Exhibition of Modern Architecture, and published a book, *The International Style: Architecture Since 1922*. Organizers of the exhibition were Alfred H. Barr, Jr. (1902–1981), the founder and head of the museum, Henry Russell Hitchcock (1903–1987), an architectural historian, and the wealthy connoisseur/collector/architect Philip Johnson (1906–2005). Hitchcock and Johnson were both fascinated with European modernists as exemplified by Bauhaus architects Walter Gropius and Mies van der Rohe, as well as architects Le Corbusier and J.J.P. Oud, all of whom Hitchcock had called the "New Pioneers" in his book *Modern Architecture*, published around 1929. Others exhibited included architects George Howe, Richard Neutra, Raymond Hood, and Rudolf Schindler. This new modern style featured spare, rectangular, steel, and glass structures. The MoMA term "international style" became the formal name of modern architecture and would dominate the scene for the next 30 years.

Frank Lloyd Wright, America's preeminent architect, now 65, was invited to contribute to the exhibition; but he had misgivings about the new style he detested as counter to his own "organic" architecture and pulled out a month before the exhibition. It is ironic that Wright, the man who had inspired many of the lauded European architects of the "international style," including Walter Gropius, Theo van Doesburg, Le Corbusier, and Richard Neutra, with his 1910 Wasmuth Portfolio, was now regarded by the Museum of Modern Art and many U.S. architects as an old-school, irascible has-been. Philip Johnson had disparagingly referred to him as "America's greatest 19th century architect."[11]

In 1932, *Horizons*, a book by industrial designer Norman Bel Geddes, was published by Little, Brown, & Company, and wonderfully illustrated by Bel Geddes's employee, C. Stowe Myers (1906–1995). The book described and illustrated many of Bel Geddes' futuristic designs, including cars, ships, and aircraft, as well as airports, houses, theaters, restaurants, and corporate headquarters complexes. All his transportation concepts envisioned teardrop shapes, many presaging actual designs soon to be produced. The book also included a portfolio of his own commercial furniture designs for Simmons, radios for Philco, and gas stoves for Standard Gas Equipment Company, establishing his reputation as a leading practitioner and a visionary of design. The following is from his book: "In the perspective of fifty years hence, the historian will detect in the decade of 1930–1940 a period of tremendous significance.... [D]oubtless he will ponder that, in the midst of a world-wide melancholy owing to an economic depression, a new age dawned with invigorating conceptions, and the horizons lifted."[12] His vision was absolutely correct!

As we have seen, the automobile industry had pioneered in the practice of "styling" custom cars since 1921, and in 1927 General Motors had established its own "Art and Colour Section" under Harley Earl to begin applying the styling process to high volume production models. Chrysler established a similar department in 1932, led by Herbert V. Henderson; but Henderson's group had little to do with body design, and design consultant Raymond Dietrich was engaged to become the unofficial head of Chrysler's Art and Color Department. Other car manufacturers had already sought design help from industrial designers Raymond Loewy, Walter Dorwin Teague, and Norman Bel Geddes, as described earlier.

In fact, the automotive industry had refined the specific creative process that was immediately adopted by the emerging industrial design profession. Briefly, in this process, stylists

Bel Geddes car #8 design patent 93,863, 1931 (from Eric Baker and Jane C. Martin, *Great Inventions, Good Intentions*, 1990).

prepared artistic sketches and renderings of a variety of different designs, which were analyzed and modified until a preferred and refined concept emerged. This concept was then modeled in clay or other materials in full scale to represent the final concept in three dimensions and further adjusted by stylists until it was time to prepare final engineering drawings for manufacture.

In 1932, Walter Dorwin Teague designed the new luxury Marmon 16 automobile in collaboration with his son, Walter Dorwin Teague, Jr., and engineer Howard C. Marmon. Although quite elegant in a traditional style, it was soon dated in appearance. The industry was being overtaken by a more exciting style known as "streamlining," based on the aerodynamic lines of aircraft and racing cars. Air races around stationary pylons, such as the Thompson Cup races, had become as popular as NASCAR races are today and in the 1930s were dominated by sleek, teardrop-shaped monoplanes with landing wheels encased in teardrop-shaped wheel "pants." The planes literally consisted of a huge engine with short, stubby wings. Visually, they screamed "speed" and indeed, many sped well over 200 mph. Racing cars at the Indianapolis 500 had adopted the sleek body styles of aircraft. Transatlantic airships like Germany's *Graf Zeppelin*, which operated between 1928 and 1936, were obviously shaped with perfect streamlining and attracted huge crowds. The public was enthralled with speed, and the "look" of speed.

Norman Bel Geddes had embraced streamlining in his transportation designs. His book cited experiments by Glenn Curtiss (1878–1930), an aviation pioneer who increased the speed of a car from 74 mph to 87 mph simply by removing a car body from its chassis and replacing it backwards. Further tests proved the speed of an average automobile could be increased by 20 percent at 25 mph through streamlining.[13]

Detroit noticed this trend toward streamlining and acted on it. Indeed, automotive engineers saw aerodynamics, a "technical" engineering science, as a way to counter the growing corporate influence of the stylists. The 1931 Reo Royale Eight, the first mass-produced car to incorporate aesthetic streamlining, was designed by Amos Northup (1889–1937), the chief designer of the Murray Corporation, Detroit's second largest independent auto body manufacturer. The Royale featured a V-shaped radiator and curved body surfaces

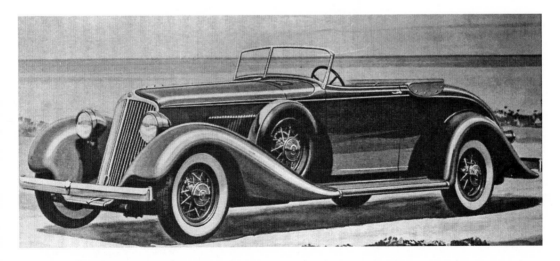

Graham Blue Streak, by Amos Northup, 1932 (courtesy National Automotive History Collection, Detroit Public Library).

that concealed much of its structural frame. In 1932, when car production had declined to about a quarter of its pre-depression levels, Northup surpassed this design with his Graham Blue Streak, which had the first chrome, tilted back, grille concealing the functional radiator, the first fender skirts to hide the "spatter zones" behind the wheels, and a trailing "beavertail" that covered the fuel tank. This peculiarly American style of streamlining with flair had huge popular appeal; it not only instantly changed the direction of automotive styling, but soon appeared on many ordinary stationary products like kitchen appliances and office equipment.

In Germany, the rising strength of the National Socialist (Nazi) German Workers Party under Adolf Hitler began to influence both industry and local politics. In 1932 Dr. Ferdinand Porsche (1875–1951) and his chief engineer, Erwin Komenda (1904–1966), designed a prototype of the Type 32 Kleinauto (small car). When Adolf Hitler came to power in 1933, Porsche submitted a proposal and sketch of the car to him and Hitler subsidized the development of the Kleinauto, which in 1938 would be introduced in Germany as the Volkswagen (People's Car). The Nazi government in 1933 also produced the VE 301 Volksempfänger (People's Radio) in an attractive molded Bakelite cabinet designed in 1928 by Walter Maria Kersting (1892–1970).

Under Nazi pressure in January 1932, the Dessau city council dissolved the Bauhaus due to "Jewish-Marxist art manifestation." As a last-ditch effort to save the school, Mies van der Rohe, the last director, moved the school to Berlin and opened the winter semester on Birkbuschstrasse in the suburb of Steglitz. In 1933, however, when Hitler was granted dictatorial powers, he closed the school and students and faculty scattered around the world. Many came to the U.S. Among the first were Joseph Albers (1888–1976), a former Bauhaus master, and his wife, Anni (1899–1994), a former Bauhaus student, both of whom became faculty members at Black Mountain College in North Carolina, founded in 1933 with an innovative program in the visual arts. Many others would soon follow. One who stayed was ceramic designer Hermann Gretsch (1895–1950), who designed the elegant 1931 Arzberg 1382 porcelain dinnerware which won a gold medal at the 1936 Milan Triennale and was produced until 1960. In 1935 he headed the *Deutscher Werkbund* division of the Nazi's *Reichskammer der Bildenden Künste* (RdbK-Reich Chamber of the Visual Arts). Another who stayed was Wilhelm Wagenfeld, who worked in glassware and porcelain.

By the time of the inauguration of Franklin D. Roosevelt as president in March 1933, in the midst of a bank panic, the depression had deepened severely. Industrial production was only half of what it had been in 1929, and so were retail sales. Stores required cash purchases. Unemployment reached a peak of over 25 percent. Two million were homeless, and nearly one-half of America's houses still lacked complete indoor plumbing.

Spirits were lifted by the Century of Progress Exposition, which opened for two summers (1933 and 1934) in Chicago and attracted over 48 million visitors. It was a showcase of new technology, transportation, architecture and modern design. It attracted a number of talented designers to design the many buildings, exhibits, and products. Entry to the exposition was by "Passimeters," turnstiles designed by John Vassos. Donald Dohner, the company's director of art, painted murals for the Westinghouse pavilion. There was a 12-sided, glass and steel frame House of Tomorrow designed by architect Fred Keck, with an all-electric kitchen, plastic wall partitions, air conditioning, fixed window panes with built-in blinds, and, incredibly, an airplane hanger. Paul Fuller designed The Black Forest exhibit. Walter Dorwin Teague designed the Ford Rotunda, which featured the "Briggs Dream Car," a prototype designed by John Tjaarda (1897–1962) and Howard Bonbright of the Briggs

Proposal sketch for Type 32 Kleinauto, by Ferdinand Porsche and Erwin Komenda, 1932.

Manufacturing Company, Detroit's largest body supplier. The design was quite similar to another prototype car in Germany, Dr. Ferdinand Porsche's Kleinauto.

Another unusual automobile displayed at the Chicago exposition was a prototype, teardrop-shaped Dymaxion Transport Unit, designed by R. Buckminster Fuller (1895–1983) and yacht designer William Starling Burgess (1878–1947) with a center tailfin, two front-drive wheels, and one rear wheel controlled by the steering wheel. In 1937, Fuller would also design a Dymaxion Bathroom, a prefabricated single unit with all necessary functional bathroom fixtures. He coined the word "Dymaxion," which was derived from the words dynamic, maximum, and tension.

One of the exhibit designers at the exposition was Raymond E. Patten (1897–1948), the consulting designer for the Edison General Electric Company (GE) in Chicago who supervised appearance design. In 1933, General Electric established an internal design group at its headquarters in Bridgeport, Connecticut, and named Patten as its head. Under his leadership, GE engaged Henry Dreyfuss to redesign a new "flat-top" refrigerator to replace its successful but clumsy 1927 "monitor-top" model designed by engineers. Dreyfuss had this same year designed a "Toperator" washing machine for Sears, Roebuck and Co., with a replica of his signature on each one of the 20,000 sold. By 1934, the Hotpoint and GE brand productions were integrated and Raymond S. Sandin (d. ca. 1986) became industrial design head of the Hotpoint division. From 1936 to 1942, George Beck, previously with Montgomery Ward and Sears and Roebuck, was assistant director of design for GE under Patten.

In 1933 RCA also established an internal design staff headed by John Vassos (1898–1985), industrial designer, artist, and author. In 1934, he designed RCA's first plastic tabletop radio cabinet, replacing what Vassos called the "wooden tombstones" of the 1920s, and the first living room console radios without obvious, furniture-like "legs."

Another exhibit designer at the Chicago exposition was Jean Reinecke (1909–1987), who in 1934 partnered with James Barnes to form the design firm of Barnes & Reinecke in Chicago. Yet another, architect Dave Chapman (1909–1978), was appointed head of product design at Montgomery Ward, by Ann Swainson, where he soon had a staff of 18. Other designers on Swainson's staff included Joseph Palma, Fred Preiss, and Richard Latham (1920–1991), all of whom went on to become important industrial designers. Other designers were either busy in, or entering, the new, rapidly expanding field of industrial design. Chicago sculptor Alphonso Iannelli (1888–1965) entered the field in 1933 and would design a range of appliances for the John Oster Manufacturing Company until 1954. Robert Davol Budlong (1902–1955), in Chicago, began his lifelong relationship with Zenith designing radios in 1934. Brooks Stevens (1911–1995), in Milwaukee by 1934,

Donald Dohner c. 1936 (courtesy of Hampton Wayt).

was designing outboard motors for Evinrude. Carl Sundberg (1910–1982) and Montgomery Ferar (1910–1982), both recently fired from GM's styling section, established a design office in Detroit that same year. Walter Dorwin Teague designed Kodak's famous Baby Brownie camera in 1934, of which four million were sold at $1.00 each. Graphic designer Egbert Jacobson (1890–1966) was hired by Walter Paepke (1896–1960), the owner of the Container Corporation of America (CCA), in 1936 to formulate a new look for the company.

Meanwhile, designers and museums aggressively publicized modern design in 1934. Designers organized an Art and Industry exhibition at Rockefeller Center, sponsored by the National Alliance for Art and Industry, that featured 1000 products by 100 designers, illustrating "what designers are doing ... to help the engineer sell his mechanical devices." Included in the exhibition were Loewy's chrome-plated teardrop pencil sharpener, a check printer by Dreyfuss, a bathroom scale by Van Doren, furniture by Gilbert Rohde, and a Wurlitzer radio by Russel Wright. By this time, the popularity of French "Art Moderne" and "Art Deco" was fading, and "streamlining" was becoming more popular. Egmont Arens reported "an amazing response and welling up of national enthusiasm for streamlining, which had captured the American imagination to mean modern, efficient, well-organized, sweet, clean, and beautiful."

The Metropolitan Museum mounted an exhibition, Contemporary American Industrial Art (industrial design), that featured a full-scale replica of Raymond Loewy's design office and studio, reflecting the historical bias of museums and architects that all design should be related to architecture; and in fact, most of the exhibits were by architects.

Briggs Dream Car design patent 94,396 by John Tjaarda, 1932 (from Baker and Martin, *Great Inventions, Good Intentions*, 1990).

But a number of industrial designers were invited to participate, including Walter Dorwin Teague, Donald Deskey, Gilbert Rohde, Gustav Jensen, Walter von Nessen, and Russel Wright.

The 1934 Machine Art exhibition at the Museum of Modern Art, curated by architect Philip Johnson (1906–2005), celebrated the abstract "beauty" of shapes made by machines. As stated in the catalog,

"The Exhibition contains machines, machine parts, scientific instruments and objects useful in ordinary life. There are no purely ornamental objects; the useful objects were, however, chosen for their aesthetic quality. Some will claim that usefulness is more important than beauty, or that usefulness makes an object beautiful. This exhibition has been assembled from the point of view that though usefulness is an essential, appearance

Kodak Baby Brownie camera by Henry Dreyfuss, 1934 (courtesy Eastman Kodak Company).

has at least as great a value." The objects displayed were divided according to use in six categories:

> **Industrial units:** Machines and machine parts, insulators, cable sections, propellor blades (aircraft and ship), etc. (including SKF ball bearings, springs, and a Sears Waterwitch outboard motor designed by John R. Morgan (1903–1986).
>
> **Household and office equipment:** Sink, furnace, bathroom cabinets, dishwasher, carpet sweeper, and business machines (including an NCR cash register designed by Walter Dorwin Teague).
>
> **Kitchenware**
>
> **House furnishings and accessories:** Objects used in daily life: tableware, vases and bowls, smoking accessories, lighting fixtures, and furniture (including the Beta chair designed by Nathan George Horwitt (1898–1990).
>
> **Scientific instruments:** Precision, optical, drafting and surveying instruments.
>
> **Laboratory glass and porcelain:** Beakers, hydrometer jars, Petri dishes, and boiling flasks.

The catalog clearly implied that products did not need cosmetic decoration to be beautiful: "Machine art, devoid as it should be of surface ornament, must depend upon the sensuous beauty of porcelain, enamel, celluloid, glass of all colors, aluminum, brass, and steel." In other words, beauty was a result of form and materials. Director Alfred H. Barr wrote that "fortunately the functional beauty of most of the objects is not obscure and in any case, so far as this exhibition is concerned, appreciation of their beauty in the platonic sense is more important,"[14] and "Machines are, visually speaking, practical applications of geometry."[15]

In 1934, the railroad industry was viewing machines not as "practical applications of geometry" but as "practical applications of streamlining." At the Chicago Century of Progress Exposition, the new Burlington Railroad's Silver Streak Zephyr arrived after a record-breaking run from Denver. The entire aluminum, diesel-powered, streamlined train weighed the same as a single conventional train car and reached 112 mph on its record run. The train, its nose a slanted half-cylinder, what was known as "bathtub shrouding," was designed by Albert Dean of the E.G. Budd Manufacturing Company.

Another streamlined diesel train, the Union Pacific's M10,000 (its design patent number), later known as the City of Salina, visited the Chicago exposition after a tour of 68 cities. Round-nosed and with super graphics, it looked like a bullet with a small cab on top. It was designed by William B. Stout (1880–1956), an aircraft designer, almost identically to a 1932 design by Norman Bel Geddes. The Pennsylvania Railroad engaged Raymond Loewy to style the exterior of its GG1 double-ended electric locomotive. His contribution was to suggest the

Sears Waterwitch outboard motor, by John R. Morgan, 1934, design patent no. 114,597 (from Baker and Ingram, *Great Inventions, Good Intentions*, 1990).

elimination of rivets by using a welded steel shell, and to modify the racing stripes on the sides. However, former Westinghouse industrial design head Donald Dohner, working with Baldwin, the manufacturer, had already designed the basic overall form, a model of which still exists. Loewy's claim triumphed due to his own aggressive self-promotion, and Dohner never got credit for this iconic design.

New York Central Railroad added a streamlined shell over a locomotive called the Commodore Vanderbuilt. An undergraduate student at Cleveland's Case School of Applied Science, Norman F. Zapf, designed the shell. Zapf had tested scale models of the shell design in a wind tunnel. The nose form was similar to the Burlington Zephyr.

The Milwaukee Railroad introduced new streamlined steam locomotives called Hiawathas, designed by Otto Kuhler (1884–1977). Their nose forms were similar to the Zephyr. These designs were intended to increase passenger business in the depression, and so were promoted to the public with much fanfare, especially touting the futuristic and streamlined styling. Millions viewed them and embraced them as symbols of the future.

Chrysler Corporation had streamlining in mind when it designed its 1934 Airflow. Billed as the first functionally streamlined car, the Airflow was designed by Chrysler's best engineers: Carl Breer, Fred Zeder, George McCain, and Owen Skelton. Breer had designed the first Chrysler in 1924, a most successful introduction. The team shared the premise of many automotive engineers that "functional" streamlining alone would make cars more beautiful, and therefore stylists were not necessary. Unlike at GM, engineers, not stylists, dominated Chrysler, and the Airflow was a marvel of engineering innovations. It pioneered unitary body construction, a welded steel cage that saved weight but was very strong. The motor was moved forward over the front axle, and the passenger compartment also moved forward to better distribute weight, increase interior space, and provide a better ride. Chrysler stylist Herbert Henderson contributed cosmetic touches like Art Deco trim, and a grille of fine vertical chrome bars that ran up and over the bulbous sloped hood. Chrysler

Union Pacific M10,000 (design patent no. 100,000), by William B. Stout and Union Pacific engineers, 1934 (from Baker and Ingram, *Great Inventions, Good Intentions,* 1990).

promoted Airflow's aerodynamic form with photos of it beside the M10,000 train, dirigibles, and airplanes. But the Airflow's style was quite different from other cars. Too different.

Poor sales soon confirmed that the public did not like the dramatic change in appearance, and only sales of Chrysler's more conventional cars saved the company. It seemed to be a matter of going too far too fast. Car stylists like Amos Northup and industrial designers understood style changes need to be progressive and retain some familiar forms so that people could become accustomed to them. Chrysler engineers did not. After the Airflow fiasco, they sought Norman Bel Geddes' advice for minor changes and put Raymond Dietrich in charge of styling. Over the next few years, Dietrich revised the Airflow's front end into a more conventional appearance.

Amid all this frantic design activity, *Fortune* magazine, in February 1934, published a feature article that did more than anything to publicize the new profession of industrial design. The article, written anonymously by the 1932 winner of the Rome Prize in architecture, George Nelson (1908–1986), since 1933 assistant editor of *Architectural Forum* and later to become a prominent industrial designer. It was titled "Both Fish and Fowl," alluding to the dual role of industrial designers as artists and businessmen.

He began the article by quoting Oliver M.W. Sprague, an economic advisor to the Roosevelt administration in 1933. After Sprague left Washington and was free to express his views publicly, he placed the blame for the deepening depression squarely on manufacturers: "Failure of industries to adapt policies designed to open up additional demands for industrial products is, in my judgment, the chief cause of the persistence of the Depression." Nelson described the "Depression-weaned" profession in a historical context and cited the work of many leading industrial designers in particular, who, in fact, were the primary "openers" of "additional demands" by consumers as Sprague suggested. At the time, there were only about 25 industrial designers in the field. The *Fortune* article included more than half of them, many already mentioned. Quotes are from the article[16]:

Norman Bel Geddes, well-known for his book, *Horizons*, was characterized as a "bomb-thrower" and the "P.T. Barnum of industrial design." **Donald Deskey** was just now entering the industrial design field. **Donald Dohner**, director of art in Westinghouse's engineering department in Pittsburgh, had "contributed to the design of 128 products: every-

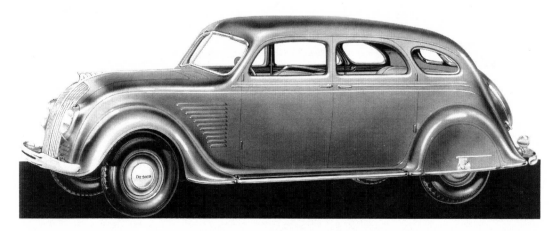

Chrysler Airflow, by Carl Breer, Fred Zeder, George McCain, and Owen Skelton, 1934 (courtesy Chrysler Group LLC).

thing from micarta ash trays to Diesel-electric locomotives. His electric range outsold previous models seven to one. His water cooler captured 40 per cent of the national market in a few months." **Henry Dreyfuss** was "the youngest of industrial designers." He had designed the Sears Toperator in which he "put all the controls of a washing machine in one place on top." **Lurelle Guild** worked "almost entirely at his drawing board" and redesigned "about a thousand products a year," including the Wearever aluminum cookware line for Alcoa. He was said to have been "more interested in sales points than in classic grace." **Gustav Jensen** was "generally regarded as the top man from the purely artistic point of view" who believed that "the value of the industrial designer is vastly overrated at present, that eventually the designer will take his place as a link in the chain of mass production." **Raymond Loewy** was "one of the largest earners" and "discovered that all Americans like the color green and the smell of lilacs." **Joseph Platt** had just designed the Parker Vacuumatic Fountain Pen in 1932 with its arrow pocket clip, which at $7.50 outsold $5 pens two to one. **George Sakier**, of all the designers described in the article, was considered to be "probably the purest type of industrial designer." He believed "in giving the public what it wants, not what some artistic individual thinks it ought to have." **Jo Sinel** was a "Top trademark and package designer." **Walter Dorwin Teague**, "the generally acknowledged doyen of the profession," designed cameras and "the stores in which to sell them" for Eastman Kodak and had "an unbroken record of commercial success." **Harold Van Doren** designed lower-cost scales for Toledo Scale "that multiplied sales by ten." **John Vassos** had just established the first internal design group at RCA in New York and was designing radios, and **Russel Wright** was now also designing radios and furniture, including the first sectional sofa for Heywood-Wakefield, which was introduced at Bloomingdale's.

The article described the designers' backgrounds, clients, and, remarkably, the fees they charged. The fees were quite incredible, with average annual retainer fees of $50,000 and hourly rates of $50. In today's dollars, these numbers would be well over $1 million annually and $1000 per hour. In 1934, typical corporate executives were making only $5,000 per year and laborers 50¢ per hour. But the high fees were nothing compared to the sales increases resulting from the use of industrial designs cited in the article. They ranged from 25 percent to 900 percent, with an average of 350 percent. Manufacturers would, and did, pay anything for those kinds of sales increases.

The *Fortune* article did not garner the national headlines that followed the Bonnie and Clyde shootout the following May, but it impacted the profession in a number of important ways. First, it legitimized the role of industrial designers in the business community. Engineers no longer had a monopoly on the design of mass-produced products. Second, it popularized and made permanent the title of "industrial design" for the profession. After this, the previous alternative terms of "art in industry" and "industrial art" were infrequently used. Industrial designers were no longer "just" artists decorating products, but were regarded as essential to the success of them in the marketplace. Third, it demonstrated that American design was incredibly popular with the public, compared with their European competition. It turned some prominent designers into national celebrities, and their names alone became sales features. They had so many clients they had to increase their staffs significantly to cope. Finally, but not least, the article initiated a new wave of demand for design from manufacturers and a new wave of designers entering the profession. Soon, there were hundreds of industrial design practitioners.

The field of industrial design was finally acquiring public stature and recognition. Artists were beginning to recognize that their visual skills were valued in industry, and that

they could achieve prestige through their work. Their personal motivation was enhanced by the realization that their work was appreciated and used by thousands of people because of its attractiveness, usefulness, or competitive price. And they enjoyed the collaboration with engineering, production, or sales people who helped make their work possible and successful.

Educators were realizing that they needed to provide formal education to train industrial designers. Arts and Crafts courses were not enough. Many art schools already had initiated night classes and courses requested by companies for their engineers to learn more about the strange (to them) world of product design, and practicing industrial designers began to lecture or teach these courses. Many art and design schools began to initiate industrial design courses or lectures into their curricula. As mentioned, Carnegie Tech initiated such classes in 1930. In 1932, Pratt Institute engaged Donald Dohner, head of design at Westinghouse, as a "consultant and lecturer in industrial design." The Chicago Art Institute offered industrial design courses in 1932. Around this time, the University of Cincinnati initiated an "Art in Industry" option in its School of Applied Arts. In 1933, at the Cleveland Institute of Art, Viktor Schreckengost (1906–2008) had initiated a program in industrial design, and the Detroit Society of Arts and Crafts had made national news by recognizing the automobile as an "art form." At Carnegie Institute of Technology (CIT) in Pittsburgh, optional classes in industrial design were offered to students in 1933, based on the 1930 syllabus by Donald Dohner.

At CIT, faculty were inspired in 1934 to initiate the first formal four-year degree in industrial design, a move that occurred due to a quirk of fate. Donald Dohner, one of the designers cited in the *Fortune* article, was fired by Westinghouse, where he was director of art, because Westinghouse executives learned from the *Fortune* article, to their shock and dismay, that his department was costing them $75,000 per year. The news of Dohner's firing was greeted at CIT with joy. Alexander Kostellow reportedly exclaimed, "Donald's on the loose! Let's get him. It's [industrial design] the wave of the future! Painting is dead! Start an option [degree] in industrial design!"[17]

Dohner, who had previously been a faculty member in the Art and Design Department at CIT and had taught an industrial design course for Westinghouse engineers, was invited back by his former colleagues in 1934 to head the new degree program. Dohner was assisted by faculty members Alexander Kostellow (1896–1954), Robert Lepper, Wilfred Readio, Russell Hyde and Fred Clayter. Sophomores who had completed their art and design foundation were offered a major in industrial design and were scheduled to graduate with a BFA in industrial design in 1936. Five students applied. After one year at CIT, Dohner left to establish a similar, three-year certificate program at Pratt Institute in Brooklyn and was replaced at CIT by Peter Müller-Munk (1904–1967). In June 1936, the first of the five students, as they were awarded alphabetically, ever to receive a formal degree in industrial design was Maud Bowers (later Rice), an émigré from the Philippines.

The Roosevelt administration had initiated numerous national programs to put people to work. One of these, the Works Progress Administration (WPA) was formed in 1935. That year, along with many grants for artists to paint murals and design posters, it provided a grant to establish a design school for industry in New York City called the Design Laboratory. Gilbert Rohde was appointed director, with Walter Dorwin Teague, Henry Dreyfuss, and others on the board of directors. Rohde stated that the curriculum was patterned on the Bauhaus. Within a year, the school closed when funds were cut, but the Federation of Architects, Engineers, Chemists, and Technicians provided new support, and the school was

reopened and renamed the Laboratory School of Industrial Design, which survived until 1940.

In 1935, the field of industrial design was expanding rapidly. Dave Chapman, Montgomery Ward's head of product design, opened his own design office in Chicago. Ward's competitor in Chicago, Sears & Roebuck, had initiated an internal design department headed by John Richard "Jack" Morgan in 1934. In New York, Russel Wright opened a showroom for his work after his Modern Living natural maple line of furniture that he designed and that was made by Conant Ball Company for Macy's became a highly popular success in the market. The line made him famous, and was later called American Modern. Norman Bel Geddes designed the interiors of the Pan American M-130 China Clippers, long-range, amphibious, luxury flying boats, and Walter Dorwin Teague was designing clean, white service stations for Texaco. Ten thousand of the stations would be built around the country. Henry Dreyfuss designed the interiors of the new Douglas DC-3 — the first aircraft to make commercial aviation feasible — and was retained by the Hoover Company to design vacuum cleaners. Van Doren and Rideout were designing a range of streamlined vehicles for children, including the Tot Bike, Skippy Racer Scooter, Skippy Sno-Plane Sled, Skippy Streamline Racer, and the Streamline Velocipede. They separated in 1935, when Rideout moved to Cleveland to establish his own firm, John Gordon Rideout and Staff.

In 1935, Raymond Loewy designed the Coldspot Super Six refrigerator, advertised as "lovely modern design," for Sears, Roebuck and Company that increased sales by 400 percent. Loewy's staff member Clare Hodgman (1911–1992) executed the design and was soon hired by Sears to design refrigerators.

Kitchen appliances were evolving into simplified, white, box-like appliances integrated architecturally into the coun-

Hoover Model 150 upright cleaner, by Henry Dreyfuss, 1936 (courtesy Hoover Historical Center/ Walsh University, North Canton, Ohio).

ters and cabinetry that we are familiar with today, rather than the free-standing engineering monuments of stoves, refrigerators, and sinks of the 1920s, all of which had obvious legs. The concept transformation started with Christine Frederick in 1919 and progressed with the Frankfurt Kitchen of 1925.

This kitchen design process was not without controversy in the U.S. Counter height, previously about 31 inches, had been standardized at 36 inches to match the height of a standard free-standing sink. Inspired by Norman Bel Geddes' 1932 prototypical modern stove-as-a box design for the Standard Gas Equipment Company featured in his book (but not produced until 1935), range ovens, previously located above and beside the stovetop surface for convenience, were lowered to keep the stovetop at the standard 36-inch height. They were then called "console-ranges" or "cabinet ranges." Cleveland designer Onnie Mankki described the resulting ergonomic conflict in his article of 1934: "Stoves are rapidly reaching the style consciousness which we are accustomed to in the automobile industry. The introduction of the cabinet type range also has brought certain features which are still controversial. Whether or not we are justified in lowering the oven door to the somewhat inconvenient low position necessary to produce a low table top, will find many people strongly defending both points of view."[18]

This integration of kitchen appliances into a specialized and efficient room for food preparation, with spacious storage cabinets and countertops, became the envy of millions of housewives with antiquated 1920s versions. Manufacturers were quick to capitalize on this. At the Chicago Century of Progress exhibition from 1933 to 1934, the Briggs Manufacturing Company exhibited a Kitchen of Tomorrow, designed by John Tjaarda, which was one of the first of many to come. It included a cylindrical electric range center island lit by a lamp that rose from the center like a periscope.

New synthetic materials and processes flourished in the 1930s, particularly in plastics development. Polystyrene and acrylic were both developed in 1930, the latter marketed in 1936 in the U.S. as Plexiglas and Lucite. Neoprene and fiberglass for insulation were developed in 1931. In 1933, British chemists developed the first man-made polymer, polyethylene. Nylon was developed by DuPont in 1934, as was urea formaldehyde, or Plaskon, which permitted colors unachievable in Bakelite (1909). Polyester was developed in 1936. In 1937, the American Cyanamid Company developed melamine formaldehyde, called Melamine, which featured color stability and abrasion resistance. Teflon was discovered in 1938 and Dacron in 1941.

Industrial designer Belle Kogan (1902–2000), one of the first female industrial designers of the time, was designing clocks in plastics for the Warren Telechron Company when she was quoted in 1935 articles in plastics magazines. She urged manufacturers to use plastics: "In plastics the manufacturer has a material with tremendous possibilities. It is still in the active process of growth and development, but it is rapidly gaining its stride. It is a material which no manufacturer, if he be alert and watchful of his competition, can afford to overlook. Radios, clocks, dishes, jewelry — all being developed in plastics today — have an enormous significance." She warned them to be aware of women buyers:

> And to those manufacturers who are using or who are planning to use plastics in the production of commodities, the feminine viewpoint is one to be studied, to be understood, to be coddled. Objects are being produced now in plastics, which demand improved design before they can enjoy a wider consumer acceptance. Other things cry out for creation, which have not yet been conceived by any manufacturer.
>
> In considering the marketing and merchandising of any commodity, the modern manufacturer is confronted with the problem of pleasing the American housewife. Thirty million women — all potential customers — constituting practically the entire buying structure of the nation — comprise

a force, which cannot or should not be disregarded. The tastes of the American woman, her reaction to color and form, are of vital importance to the manufacturer.[19]

In another article, Belle also advised designers to do their homework: "It is the designer's job, therefore, to know materials, to know their qualities, their basic structures, their resistance to wear, and their cost — as well as to know markets and trends — in order to intelligently design for the manufacturer."[20]

In 1935, Henry Ford reluctantly joined the other major carmakers by establishing a styling department, under Eugene T. "Bob" Gregorie, formerly with GM's Art & Colour Section, who had joined Ford in 1929 and who recently had designed a British Ford front end. Henry's son Edsel, artistically inclined since childhood, had for some time urged more attention to styling; he was probably inspired by frequent visits to the fifth floor studio of John Tjaarda, Ford's design consultant from Briggs Company, the maker of Ford bodies. Edsel selected Gregorie because of their mutual interest in sailing and yachts. Among Gregorie's original staff members were engineers Willy P. Wagner, Ed Martin and Martin Regitko. Walter Kruke from Ford Aircraft designed interiors, and James Lynch was model shop foreman.

With the intent of developing a smaller, lower-cost model Lincoln, Edsel had initiated the rear-engine "Dream Car" designed by John Tjaarda of Briggs Company. The concept car was displayed at the 1933–1934 Century of Progress Exposition. Briggs happened to also be the major body supplier for Chrysler, and unknown to Ford, was concurrently developing the Chrysler Airflow body. After the Airflow was introduced in 1934, it became clear that the design was not popular, and Edsel became concerned particularly about the front end of Tjaarda's design, which was similar to the Airflow. Edsel also thought the entire

Cord 810 by Gordon Buehrig, 1936, design patent no. 93451 (from Baker and Ingram, *Great Inventions, Good Intentions*, 1990).

design was "too Teutonic," possibly alluding to the Volkswagen being developed in Germany.

Tjaarda was reluctant to change the design, so in frustration, Edsel called on Gregorie to work with Tjaarda. Gregorie avoided the rounded, sloping hood of the Dream Car (and the Chrysler Airflow) by moving the engine to the front, and housing it in a sharp, inverted ship-prow shaped hood with a V-type grille. The teardrop fenders and fastback were retained. Introduced as the 1936 V-12 Lincoln Zephyr, an obvious reference to the name of the Burlington Line's 1934 streamlined train, it won public and critical acclaim at the annual New York Automobile Show, along with the exquisite 1936 Cord 810 designed by Gordon Buehrig (1904–1990). These designs set the direction of Detroit styling for years to come. The Museum of Modern Art later acclaimed the Zephyr as the first successfully streamlined car in the U.S.[21]

In a matter of only four years, automobile design had been transformed from that of clumsy boxes to forms that were not much different from today's sleek chariots of desire. However, the automotive industry was not the only one using design to compete. Other industries were scrambling to climb on the design bandwagon.

Chapter 8

1936–1945

Dreams of the Future and War

Railroads were now focusing on their steam locomotives to make them more competitive with the new streamlined, diesel-powered locomotives. Designers were trying to make them more distinctive and modern in appearance. Henry Dreyfuss in 1936 designed the Mercury K-5 Pacific steam locomotive for New York Central. It featured cutout holes in the "white-walled" driver wheels, which were lit by concealed spotlights at night. In 1937, Loewy wrote a book, *The New Vision Locomotive*, that described his theories of locomotive aesthetics. That year Loewy designed the K4S steam locomotive for the Pennsylvania Railroad with a bullet shape for the boiler, which was refined into his classic 1938 S-1 design, built primarily for promotional purposes. On the same day the S-1 debuted, New York Central introduced ten new Twentieth Century Limited steam locomotives and cars designed by Henry Dreyfuss, upgraded versions of his Mercury K-5, with a bullet nose topped with a fin suggestive of a Roman helmet. But diesel power, typified by the Santa Fe Chief Type F that was introduced in 1939 and was styled with a "warbonnet" color scheme by the GM styling section and produced through 1960, marked the demise of steam and became the standard for the industry.

Household appliances and equipment were not left out of the design movement. Kitchens were adopting a new look, advanced by the 1937 modular design by Dutch architect Piet Zwart (1885–1977) for Bruynzeel Kitchens in the Netherlands. New plastics allowed the use of bright colors, which were becoming more and more popular with the public. In 1936, the Homer Laughlin Company introduced Fiesta ceramic dinnerware designed by Frederick Hurten Rhead (1880–1942) with clean, simple lines and in brilliant primary colors that were mixed and matched in table settings. The line was an instant success and is still being produced. Corning Glass established a design department that same year. In 1937, Bell Labs introduced a new black phenolic plastic "300" tabletop phone designed by Henry Dreyfuss that combined the transmitter with the receiver in a single "combined handset" resting in a horizontal cradle; the phone would be produced until 1950. The Hobart Manufacturing Company debuted its KitchenAid Model K stand mixer designed by Egmont Arens, a design that was still highly popular in 2009. Lurelle Guild designed an Electrolux Model 30 that would become the typeform for "cylinder" or "tank" vacuum cleaners. Waring, a company named after its famous bandleader backer, Fred Waring, introduced a food "Blendor" with a chrome "waterfall" base designed by Peter Müller-Munk. In 1938, McGraw Electric Company was producing Toastmaster toasters in sleek, streamlined chrome shells designed by Jean Reinecke. The new style increased sales dramatically, caused the company to change its name to Toastmaster, and set the type-form for toasters well into the 1960s.

Fiesta dinnerware, 1936 (courtesy Mr. and Mrs. Robert Schott).

The term "setting a type-form" in the design field refers to a particular design in a specific category of products that differs significantly from its predecessors in appearance, and for years afterwards all products in that category resemble that particular design in order to emulate its market success. While imitation is the sincerest form of flattery to the original designer, some would call this "copying," and in a sense, it is. But it is quite legal, unless the originator filed a design patent with the U.S. Patent Office, and the "copy" is so close to the original that consumers cannot tell them apart. In the field, this is referred to as "design piracy," and lawsuits are often filed. Most imitators vary the details of the design to achieve just enough noticeable differences to avoid legal challenge but retain the overall visual character of the design. During the 1930s, industrial designers, in redesigning ordinary products, set numerous new type-forms in many product categories that lasted for decades, and were accepted by the public as the "correct" shape for that particular product until it eventually went out of style or was replaced by a new type-form.

Industrial design was already moving beyond products. According to a May 1936 *Business Week* magazine, "Well-rounded design service embraces virtually every department of a business, even including legal aspects and labor problems. [It was] proving its power to sell not only articles of merchandise but such intangibles as service and company reputations.... But the soundest foundation on which design builds for the future is its unquestioned ability to determine what the public wants, to build products to meet those demands, to cut cost in the process."[1]

With the Nazi regime's escalating war preparations and hostility to the arts and intellectuals in Germany, Bauhaus and other émigrés were coming to the U.S. regularly to participate in the expanding design and design education fields. Walter Gropius, founder of

Waring Blendor, by Peter Müller-Munk, 1937 (courtesy Peter Müller-Munk Associates, c/o Wilbur Smith Associates).

the Bauhaus, in 1937 became a professor in architecture in the graduate school of design at Harvard University, along with his former Bauhaus student Marcel Breuer. A Bauhaus foundation course master, László Moholy-Nagy, was recommended by Gropius in 1937 to establish a four-year design program in Chicago called the New Bauhaus–American School of Design. Moholy-Nagy was joined by Hin Bredendieck (1904–1995), a former Bauhaus student; Gyorgy Kepes (1906–2001), a Hungarian designer who had worked for Moholy-Nagy in his Berlin studio; and Alexander Archipenko (1887–1964), a Russian artist and sculptor who had worked in Berlin and emigrated to the U.S. in 1929 and had designed the Ukrainian pavilion at the Chicago Exposition in 1934. Financial difficulties closed the school after one year, but it reopened in 1939 as the School of Design in Chicago with the help of Walter Paepcke (1896–1960), who was president of the Container Corporation of America (CCA) and had the previous year established a design department at CCA under Egbert Jacobson (1890–1966) and set a strong precedent for corporate design consistency.

Cooper Union Art Schools in New York offered a 4-year certificate in "Plastic Design" in 1937 that included industrial design instructed by Paul Feeley and Lila Ulrich, a former Bauhaus student. At Cranbrook Academy of Art in Bloomfield Hills, Michigan, in 1937, Charles Eames (1907–1978) was hired to head a department of experimental design and explored new materials such as plastics and plywood for furniture. Eero Saarinen (1910–1961), the son of Cranbrook's founder, Eliel Saarinen, had graduated from Yale with a degree in architecture in 1934 and had joined his father at Cranbrook in 1935. In 1937, Eero began working with Eames, along with Italian émigré Harry Bertoia (1915–1978).

The California Graduate School of Design was organized in 1937 to teach principles of product engineering and industrial design, with advice from Richard F. Bach of the Metropolitan Museum of Art; Royal Bailey Farnum, of the Rhode Island School of Design; Peter Müller-Munk of Carnegie Tech; and architect George Howe (1886–1955). Hunt Lewis was named director and was soon joined by Kem Weber, an industrial and furniture designer.

In prewar Detroit, automotive styling had reached a level of refinement that many feel has not been equaled since (the 1999 Plymouth PT Cruiser and the 2005 Chevrolet HHR are still currently popular "retro" designs emulating late 1930s and early 1940s styling). In

1937, GM led the industry with Harley Earl's styling staff of 200, a fourfold increase over the time of its inception in 1927. Tom Hibbard was hired in 1932 and William Mitchell (1912–1988) in 1935.

Earl was still looking for more designers. GM and its Fisher Body Division initiated a search in 1937 by sponsoring a national student 1/12-scale model "Dream Car" design competition, awarding college scholarships to the best of them. Called the Fisher Body Craftsman Guild, it continued for 10 years and encouraged a new generation of designers, many of whom eventually landed in Detroit.

Harley Earl established the direction of styling for years ahead with his 1937 experimental Buick "Y-Job" convertible, designed by Oldsmobile studio head George Snyder. With its low height (58 inches), rounded fuselage body without running boards, suitcase fenders blended into the hood, a low, horizontal grille, hidden headlights, push-button door handles, and electric windows, it became a prototype for GM car designs over the next ten years. Some of its features appeared on the 1938 Cadillac 60 special, designed by Bill Mitchell, and over the years, were incorporated into the rest of the GM line. In 1938, GM made Earl a vice president.

In 1936, Studebaker retained Raymond Loewy for exterior and Helen Dryden (1887–1981) for interior consultants for the 1937 models. Dryden was a well-known fashion illustrator for *Vogue* magazine. In 1938 Loewy established an office and staff in South Bend, Indiana, to work on the 1939 Champion, a low-cost car. His staff included Claire E. Hodgeman (1911–1992) and Virgil Exner (1909–1973), formerly with Harley Earl at GM. Loewy was the first American designer to go international by opening an office in London in 1938; the office was headed by Carl Otto (d. 1986) until it closed in 1940.

In Germany, Adolf Hitler in 1938 was also interested in transportation design. He awarded "cultural prizes" to Ferdinand Porsche for his design of the new Type 38 KdF Volkswagen, which Hitler had commissioned in 1933 and which was now being initially produced only for Nazi officials (German citizens could purchase certificates for "eventual" delivery); Fritz Todt for the Autobahn, the first "superhighway," of which over 3000 km had been completed; Ernest Heinkel for his HE 111 bomber design; and Wilhelm Messerschmitt for his Me 109 fighter plane design. (By this time, it was obvious to the world that Germany was on the path to war, as Austria was annexed into Nazi Germany that March.)

Designers were becoming better organized. The first professional design organization evolved in Chicago. In 1933, the National Furniture Designers' Council (NFDC) had been founded to submit a code for prevention of design piracy to the National Recovery Administration (NRA). It disbanded in 1934 when the NRA was declared unconstitutional. In 1936, Lawrence H. Whiting, director of the Furniture Mart, invited furniture designers to a luncheon to form a new organization called the Designers' Institute of the American Furniture Mart (DIAFM). Generally, these designers, like Leo Jiranek (1900–1990), Ernie Swarts, Al Lambach (b. 1912), Alfons Bach (1904–1999), C.E. "Chick" Waltman, Belle Kogan, and others, mostly specialized in furniture, fabrics, or ceramics. Noted speakers at this luncheon included Kem Weber, Donald Deskey, Leo Jiranek, and Gilbert Rohde.

When this group met again in 1938, the principal speaker was John Vassos, head of RCA design. In his address, he suggested that the organization divorce itself from the patronage and sponsorship of the Furniture Mart, and expand its individual practices beyond that of furniture design into consumer products, packaging, automotive design, or any number of additional design opportunities then available. The group, comprising 45 founding members, agreed with him, and changed their name on the spot to the American Designers'

Institute (ADI). According to design historian Arthur Pulos in his 1983 book, *American Design Ethic*, even though Vassos was not a member of this group before his presentation, the group elected him the first president of ADI, which would become incorporated in the State of Illinois in 1940. (Leo Jiranek's obituary claimed that he, Jiranek, was the first president of ADI, but this has not been verified.) Vassos certainly was one of the founders. ADI soon had chapters in Chicago and New York.

The rise of design activity in the 1930s produced numerous new design styles that included "streamlining" from transportation, "Art Deco" from the Paris Exposition, "skyscraper" from the New York skyscraper era, and "futuristic," which imagined a world of the future. "Art Deco," and "Art Moderne" had evolved into "Modernistic," Modern," and then "Contemporary." All used romanticized and exuberant visual imagery that appealed to popular taste and expectations of the times. All were "modern" in the sense that they were new, exciting, and different from traditional designs of the past. Together, these eclectic styles represented a uniquely American style, different from the European styles that had for centuries set design standards in America. For the first time, world design leadership resided in the U.S. This had been achieved not by following any formal design standards, by academic theory, or by museum promotions but by industrial designers simply providing low-cost designs that attracted popular interest and as a result providing incredible sales results for their manufacturing clients. This was pure capitalism at work. Everyone was happy. Well, not exactly everyone.

Engineers were not happy with industrial designers intruding on their historical turf in manufacturing firms, whose salesmen were urging the use of expensive design services to increase sales. After all, engineers had been regarded for several generations as the creative geniuses who had brought the world rail travel, electricity, automobiles, airplanes, and

John Vassos (courtesy IDSA).

countless laborsaving devices. In terms of mass-produced products, they were the highest authority in most companies on how to design and produce practical mechanical products at the lowest possible cost. These pragmatic engineers were not pleased with the demands of designers to change traditional production processes and materials and often to add cosmetic costs of additional materials or decorative trim for purely visual, nonfunctional purposes. Many designers, including major ones like Loewy and Dreyfuss, had to fiercely battle in-house engineering cultures for their proposed design changes. But often, when designers proved they also could reduce manufacturing costs by making forms simpler or using less expensive materials, engineers began to work more collaboratively with them.

The Museum of Modern Art, which some respected as *the* authority on "modern" design and which had as its commit-

ment to monitor, shape and elevate the quality of the man-made environment, was not happy either. It regarded the new U.S. industrial designs of the last decade as inadequate in academic and intellectual substance, devoid of sophisticated and historical European tradition and, worst of all, driven by popular public and commercial taste, which museums believed needed to be elevated, not catered to. It regarded U.S. design in general as "vernacular" and common.

Back in 1932, at its International Exhibition of Modern Architecture, MoMA had succeeded in redefining the architectural profession along the lines of Bauhaus luminaries like Walter Gropius and Mies van der Rohe. These and other distinguished Bauhaus émigrés like Marcel Breuer, László Moholy-Nagy, and Josef Albers had by now achieved high visibility in U.S. architectural or academic circles. In 1938, architect Mies van der Rohe, the last director of the Bauhaus when it closed in 1933, had arrived in the U.S. amid fanfare and was teaching design at the Armour Institute in Chicago, later to be absorbed into the Illinois Institute of Technology.

In 1938, MoMA dug in its heels in order to redefine the direction of U.S. design patterned on traditional European academic and intellectual theory. It mounted a highly publicized exhibition, Bauhaus 1919–1928, a retrospective of the German design school that had pioneered in simple, functional, geometric forms with an absence of stylistic decorations and whose architect leaders had dominated German design and architecture in the 1910s and 1920s. The closing of the Bauhaus by Hitler in 1933 had enhanced the prestige of these émigrés as intellectual martyrs of Nazi oppression. Herbert Bayer, a former Bauhaus print shop master, came to the U.S. to work with Walter and Ise Gropius in designing the exhibition and stayed on as a consultant to major corporations. By acclaiming Bauhaus design and publicizing its current personalities, MoMA had committed itself to defining a historical and qualitative standard of "modern design" in the U.S., based on the "best of Europe." The standards of excellence were purely esthetical and artistic and had little or nothing to do with commercial success or public acceptance, the grass-root foundations of U.S. industrial design. In fact, MoMA was publicly critical of American industrial designs. That same year, further promoting a European design leader, MoMA featured Finnish architect/furniture designer Alvar Aalto (1898–1976) in a one-man showcase of his work, which had a major impact on American designers.

At the same time, MoMA director Alfred H. Barr initiated a popular annual exhibition at Christmastime in 1938, "Useful Objects under $5," showing "well-designed" objects available on the open market at reasonable prices. Typically, these featured common, ordinary, "non-designed" products such as functional corkscrews, hand tools, kitchen tools, etc., which met MoMA's criteria of simple, geometric, machine forms. These traveling exhibitions continued for years, until the "under $5," became "under $10," and then higher. They enabled MoMA to set esthetic standards based on its own elitist notion of good taste and eventually to initiate aggressive promotions of "good design" to "elevate the taste" of the common public.

Being condescended to by museums was of little interest or concern to most practicing industrial designers, many of whom were rushing to meet client deadlines for the April 30, 1939, opening of the New York World's Fair in New York, optimistically titled The World of Tomorrow. Its trademark symbols, a 700-foot tall Trylon and 200-foot diameter Perisphere, conceived by Wallace K. Harrison and J. Andre Foyilhoux, dominated the site at Flushing Meadows. Walter Dorwin Teague, by then the undisputed dean of industrial design, was not only one of the eight directors of the fair, but also the designer of exhibits

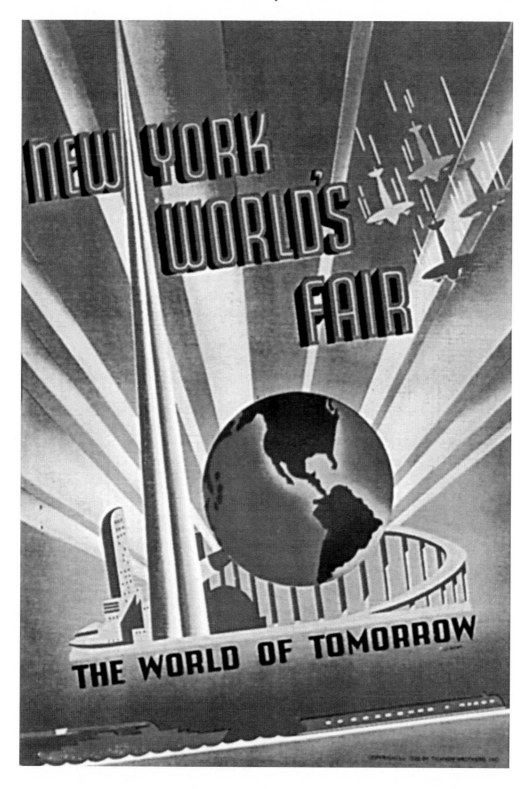

Visitor brochure, *The World of Tomorrow,* 1939 (courtesy Victoria Matranga).

for the National Cash Register Company, Ford, Kodak, and U.S. Steel. He designed the DuPont Building, the pavilion of the U.S. government, and the City of Light Diorama for the Consolidated Edison Building, showing a 24-hour change in lighting in 12 minutes.

The fair's official guidebook proclaimed that "The true poets of the twentieth century are the designers, architects, and the engineers who glimpse some inner vision, create some beautiful figment of the imagination, and then translate it into valid actuality for the world to enjoy."[2]

The statement married art and science, which for centuries had been separated. A better showcase for design could not be imagined, as the fair was designed to promote consumer consumption, which was slowly ending the depression, just as were military contracts initiated by a government that anticipated at least a supporting role for its allies in Europe who were being threatened by Nazi aggression. Americans who suffered during the long depression now could at least dream of better times and believe in all the promising material rewards of technology and productivity that appeared to be just over the horizon. The fair did not disappoint the 45 million people who attended. It would not be rivaled in public enthusiasm until Disneyland opened 16 years later.

In the Perisphere was a model of Democracity designed by Henry Dreyfuss and Julian Everett, which forecast an American city of 2039. Dreyfuss also designed the AT&T pavilion featuring Pedro the Voder, an early voice synthesizer. In the General Motors Building, designed by architect Albert Kahn, was GM's Futurama exhibit, the number one attraction at the fair, designed by Norman Bel Geddes. The exhibit, featuring superhighways, multilevel interchanges and teardrop shaped cars of the year 1960, was an extension of his 1937 City of Tomorrow created as an advertisement for the Shell Oil Company. Bel Geddes also designed the *Crystal Lassies* show. "The Loveliest Dancing Girls at the Fair," said the ticket booth. A single dancer performed (sometimes essentially nude) within an octagonal structure, the inner surfaces of which were mirrored. On could peep through a facet of the structure and see multiple images of the dancer. Bel Geddes was utilizing his earlier, preindustrial design, stage design skills.

John Vassos created the concept for the RCA pavilion, where the first consumer television sets were debuted by RCA chairman David Sarnoff and President Roosevelt announced the opening of the fair in the first public television broadcast. John Vassos designed the television sets themselves, of course. These first picture tubes ranged in size from five inches to twelve inches. They faced upward on the top of the cabinet, and a mirror could be tilted to reflect the image horizontally to viewers. Raymond Loewy designed the House of Jewels exhibit and the Rocketport exhibit in the Transportation Zone. The Rocketport portrayed a passenger rocket fired from a gun that traveled from London to New York in one hour. Loewy's awe-inspiring S-1 locomotive pounded away continuously at high speed on a treadmill for the Pennsylvania Railroad exhibit. The Home Furnishing Pavilion and Community Interests exhibits were designed by Gilbert Rohde, one of whose employees was Henry Glass (1911–2003), who had fled a Nazi concentration camp in Austria. In the Consumers Building, Egmont Arens designed the Good Life main exhibit, and Russel Wright the Food Zone exhibit. International exhibits from Finland and Sweden exposed Americans to the innovative manufacture of laminated wood furniture and the modern design style later known as Scandinavian, which was characterized by warm, flowing, simple, natural wood forms, quite different than the geometrical, metal, machine-like forms of the Bauhaus.

The invasion of Czechoslovakia by Nazi Germany in March, and of Poland in Septem-

RCA's first consumer television set, 12 inch TRK 12, 1939, by John Vassos (courtesy IDSA).

ber 1939, enabled by the Soviet-German nonaggression pact, confirmed global fears that war in Europe was inevitable. The fair closed in October under a national cloud of foreboding. When it reopened in April 1940, it was changed in many respects. "Zones" were dropped from the literature and the new slogan was "For Peace and Freedom." Internationalism was replaced by nationalism. Ten nations withdrew for the new season, including Russia, and a number of European designers were stranded due to their countries' being occupied, including Czech pavilion designer Ladislav Sutnar (1897–1976), who in 1941 became art director for Sweet's Catalog Services and stayed in that capacity until 1960. The fair became sort of a country fair, with strong overtones of patriotism, though the major exhibits continued. A new exhibit, America at Home, included rooms, designed by individual designers, that were arranged around a central "Unit for Living" by Gilbert Rohde. One was a Musicorner by John Vassos, with a built-in audio system and television, another was by Russel Wright, Winter Hideout in the Adirondacks.

Russel Wright and his wife, Mary, had formed a new firm, Raymor, to sell Wright's products after they had made headlines in 1939 as designers of the American Modern line of ceramic dinnerware, manufactured by Steubenville Pottery in East Liverpool, Ohio. The forms were soft, abstract, and flowing, and glazes were in rich, earthy colors. American

Pennsylvania Railroad S-1 locomotive, by Raymond Loewy, 1937 design patent no. 106,143 (from Baker and Ingram, *Great Inventions, Good Intentions*, 1990).

Modern became the perfect gift for young brides, and with Wright's name on the bottom of each piece, he quickly became a national design celebrity. Eighty million pieces were sold. In January 1940, the line was included in the Museum of Modern Art's annual exhibition of Useful Products Under $10. Inspired by this success and the deepening sense of national patriotism, Wright organized and launched The American Way, a nationwide craft, design and merchandizing consortium of 100 designers to promote low-cost

American Modern dinnerware, by Russel Wright, 1939.

American style to industry and American furnishings to consumers. Among these was a line of wrought-iron furniture designed by Henry Glass, then an employee of Wright, that became known as the "Hairpin Group," so named because it popularized a trend of hairpin-like, steel wire legs throughout the furniture industry. The American Way was launched at a highly promoted 1940 event at Macy's featuring Eleanor Roosevelt; but due to growing preoccupation with the war, the program was abandoned within a year.

By 1940, the depression was essentially over. A housing boom was in progress. As many as 80 percent of U.S. households were wired for electricity, 79 percent owned electric irons, 66 percent owned a car, 52 percent had electric washing machines and refrigerators, and 42 percent had vacuum cleaners. But now the problem was inventory shortages of household goods. Many stores were limiting sales to their regular customers only. Manufacturers could not keep up with increasing demand and were preparing for enormous increases in production of appliances and cars when the Defense Department began to offer lucrative defense contracts for essential military supplies and equipment. Although still neutral, America

Walter Dorwin Teague (courtesy Walter Dorwin Teague Associates).

was providing allies like Britain with mountains of war materials, and many industries shifted to war production, leaving consumer needs unfilled.

Industrial designers were at a peak of their financial power and visibility. Raymond Loewy redesigned the Lucky Strike cigarette package in a matter of a few hours for $50,000. Industrial designers wrote a number of books in 1940, demonstrating their popularity as celebrities. Walter Dorwin Teague wrote *Design This Day*. Its subtitle was *The Technique for Order in the Machine Age*. In it, he said, "We shall begin with the first source of all form, which is also an incessant variable. And this is the principle of fitness, which is divided into three functions: Fitness of function, Fitness of materials, and Fitness of techniques. It is because of this principle of fitness that the ultimate form of an object — natural or man made — is inherent in the object itself. It must be evolved naturally to suit the function which the object is intended to perform, the materials out of which it is made, and the methods used in its making."[3] He clearly recognized the interdisciplinary nature of problem solving, stating that "we see that we are not building little gadgets. We are building an environment, and we designers have to work with scientists, engineers, technologists, sociologists, and economists."

The same year, Harold Van Doren wrote his book, *Industrial Design: A Practical Guide*. Recognizing that self–promotion by major designers had annoyed their engineering competitors, he described how designers needed to suppress their egotism and celebrity status to blend in with industry:

> Once the industrial designer had made a dent on industry, it was perhaps natural for him to exaggerate his own importance in the scheme of things. Indeed, one might almost say that he would not be a good designer unless he had that sort of excited enthusiasm that makes salesmen sell and designers create. But in sober moments he must have realized that, important as his contribution might seem to him, its relative importance might not be so great. As a rule, the artist is, and should be, only one of the gears in the train that includes management, sales promotion, advertising, engineering, research — all those departments making up the complex mechanism of modern commerce.[4]

Norman Bel Geddes wrote *Magic Motorways* in 1940 using materials from his design of the General Motors Pavilion, called Futurama, at the 1939 World's Fair. Both the book and the exhibit would become influential in the development of postwar freeways and interstate systems. In fact, the Pasadena Freeway in California and the Pennsylvania Turnpike were both opened that year.

Museums continued to support modern design. The Metropolitan Museum of Art in

1940 continued its series of Contemporary American Industrial Art exhibitions with room displays created by architects and designers. Donald Deskey displayed a retreat from the current war threats with his casual and rustic Sportshack, a prefabricated cabin with multifunctional furniture and walls of fir plywood striated mechanically to look like barn-wood. Deskey would patent it in 1942 as Weldtex.

The architectural profession was having a number of problems. They were still feeling the effects of the depression, which had halted most monumental building programs and those of many of their potential clients. Architects were generally disinterested in prefabricated housing, feeling it threatened them with mass-produced housing. They were frustrated by government regulations and by federal employees controlling prefabricated housing work. In addition, because industrial designers had received so much attention at the world's fair and recent exhibitions, and because industrial designers were now publishing books that promoted industrial design, architects felt that the new profession was infringing on their historical turf.

Plastic Scotch tape dispenser, by Jean Reinecke, 1940, design patent no. 118,629 (from Baker and Ingram, *Great Inventions, Good Intentions*, 1990).

Then an architect, and later a playwright and folk music composer/performer, in the 1960s, Eugene Raskin (1909–2004) complained as early as 1939: "Industrial designers realize that people use not only buildings, but furniture, autos, ships, trains, planes, clothes, canned goods, fountain pens—and so on through the whole list of material goods.... [T]hey are out designing all these things, pioneering ahead of us, and making us rapidly obsolete."[5]

Particularly galling to architects was the fact that many architects had historically designed the furnishings and accessories within the houses they designed, both in Europe, and in America by Frank Lloyd Wright. But these served a prepaid, captive client market, and architects did not try to commercialize their designs. Like museums and educators, the architectural professionals (with a few notable exceptions) viewed themselves as above such distasteful commercial activity. Industrial designers, on the other hand, served an open, competitive market and unlike architects, had to take into consideration the human expectations of a product, the competitive costs, and the material and equipment limitations of the manufacturer. In fact, the industrial designer had become a partner with commercialized and industrialized mass production, something museums, educators, and professional architects rarely did.

Architects were also frustrated because they had also pioneered in the techniques of artistic presentation and model building to solve architectural problems, techniques that this motley new group of auto stylists, graphic artists, theatrical designers, window designers, authors, and furniture designers—who now called themselves, and were organizing as, industrial designers—were now using in product problem solving and were becoming commercially very successful at it. Architects were hamstrung because some of their number claimed their code of ethics forbade them to commercialize home furnishings they designed for their architectural clients.

In 1940, *Architectural Record* asked in a survey to readers, "Do you believe you could improve your condition if existing ethical restraints were liberalized, thereby permitting you to duplicate all services offered by industrial designers?"[6] In fact, there was nothing in the American Institute of Architects (AIA) Code of Ethics at the time that would have prevented architects from independent practice as industrial designers in the open market.

Architectural critic Douglas Haskell (1899–1979) stated that no one was better qualified to design home furnishings than the architects of the buildings that contained them, and added: "The design of household objects led historically to the creation of the whole realm of industrial design."[7] This conclusion was certainly true. Architects were as qualified as anyone else. But it was industrial designers who responded to a national industrial and consumer need in the depression, not architects. Nevertheless, a number of out-of-work architects saw the handwriting on the wall and joined the industrial design movement. Others decided to fight it.

The Museum of Modern Art, predominantly under the direction of architects, saw the new profession of industrial design as a serious challenge to architecture. The 1938 organization of the American Designers Institute in Chicago was evidence of an industrial design outpost in the heart of the furniture industry. MoMA needed to devise a strategy to recover its leadership role, and in 1940 it established a separate department of industrial design, headed by a new director, architect Eliot Noyes (1910–1977). Noyes had been recommended by Walter Gropius, under whom Noyes had studied at Harvard and for whom he had worked after graduation. While many industries had been implementing new modern designs, the furniture industry had resisted such change. An exception was the Herman Miller Furniture Company, which that year discontinued its production of all period reproductions because its designer, Gilbert Rohde, had convinced management that imitation of traditional design was insincere esthetically.

MoMA saw furniture as a field yet to be dominated by modern design and also as a field outside of industrial design's reputation in industrialized, mass-produced, mechanical products. MoMA concluded that it needed to (1) take a leadership role in furniture design, and (2) place architects in positions of furniture design prominence.

That same year, MoMA initiated a competition seeking imaginative designers of contemporary furnishings, conceived by Edgar Kaufman, Jr. (1910–1989) and organized by Noyes. Kaufmann was a former architecture student of Frank Lloyd Wright and a promoter of Wright's "organic design," generally defined by Noyes as "an harmonious organization of the parts within the whole, according to structure, material, and purpose."[8] According to Noyes, "The purpose of the contest was to discover good designers and engage them in the task of creating a better environment for today's living. Twelve important stores in major cities throughout the United States sponsored the competition and offered contracts with manufacturers as prizes to the winners."[9]

Prizes in 1941 were awarded to Charles Eames and Eero Saarinen — both Cranbrook Academy educators, and, conveniently for MoMA, architects by training — for their designs of chairs and storage pieces. Their use of layered veneers of plywood and sculptured forms was highly innovative. Entries were exhibited at the museum, as Organic Design in Home Furnishings, in 1941.

Eames had a subtle sense of humor. When once asked about the secret of winning competitions, he admitted that there was a trick:

> It's really Eero's trick but I'm going to break a rule and reveal it. This is the trick, I give it to you, you can use it. We looked at the program and divided it into the essential elements, which turned

out to be thirty odd. And we proceeded methodically to make one hundred studies of each element. At the end of the hundred studies we tried to get the solution for that element that suited the thing best, and then set that up as a standard below which we would not fall in the final scheme. Then we proceeded to break down all the logical combinations of these elements, trying to not erode the quality that we had gained in the best of the hundred single elements; and then we took those elements and began to search for the logical combinations of combinations, and several of such stages before we even began to consider a plan. And at that point, when we felt we'd gone far enough to consider a plan, worked out study after study and on into the other aspects of the detail and the presentation.

It went on, it was sort of a brutal thing, and at the end of this period, it was a two-stage competition and sure enough we were in the second stage. Now you have to start; what do you do? We reorganized all elements, but this time with a little bit more experience, chose the elements in a different way (still had about 26, 28, or 30) and proceeded: we made 100 studies of every element; we took every logical group of elements and studied those together in a way that would not fall below the standard that we had set. And went right on down the procedure. And at the end of that time, before the second competition drawings went in, we really wept, it looked so idiotically simple we thought we'd sort of blown the whole bit. And won the competition. This is the secret and you can apply it.[10]

All for a chair! But this is about the most accurate description of the design process found anywhere.

Despite threats of war, Detroit was busy making styling improvements. One of the most sophisticated designs of the time was the classic Lincoln Continental Cabriolet, by Ford styling leader Bob Gregorie. Conceived as a custom-built luxury car for Edsel Ford, its enthusiastic reviews convinced Ford to allow limited production in 1940. Refined versions were produced through 1948, and it became a classic. Chrysler's 1941 concept car, the Thunderbolt, by Alex Tremulis (1914–1994), was the most advanced in design, with fenders fully integrated into the body shell. Packard's new 1941 Clipper was every bit as stylish as any of the big three. The Clipper was designed by the head of Packard design, Werner Gubitz, and consultant Howard "Dutch" Darrin, with contributions from Alex Tremulis.

After war was declared on December 7, 1941, the shift to war production became total.

Lincoln Continental, by Bob Gregorie, 1940.

The last passenger car, a Pontiac, was produced in February 1942. Detroit began producing for the war effort, as ordered by the federal government. Never before in history had American mass production and ingenuity been demonstrated on such a scale. GM and Chrysler made M-4 Sherman tanks at the rate of 2,000 per month (Porsche was making Tiger tanks for the Germans). Ford designed and reached production of B-24 Consolidated Aircraft Liberator bombers in nine months and produced over 18,000 during the war, using automotive "sub-assembly" methods. Plymouth made Bofors antiaircraft guns and aircraft landing gears. Packard made V-12 engines for PT boats and aircraft. Hudson made engines for landing craft. General Electric made M1 Bazookas. Willys-Overland, Bantam, and Ford made the ubiquitous and eternally popular military vehicle, the Jeep.

The design of the Jeep can be traced back to 1929, when Sir Herbert Austin established the American Austin Company to build his English car in the U.S. The Austin was modified by custom car stylist Alex de Sakhnoffsky (1901–1964), and because of its extremely small size it became the subject of popular movie and cartoon gags. But sales were also small, and in 1934 Ron Evans bought the company and renamed it the Bantam Automobile Company; it was located in Butler, Pennsylvania. Sakhnoffsky worked on it again, with little sales effect, but it was chosen to lead the parade that opened the New York World's Fair in 1939 because of its cuteness.

In mid–1940, the army released specifications to 100 manufacturers for a four-wheel-drive general purpose army vehicle that weighed no more than 1300 pounds and that would

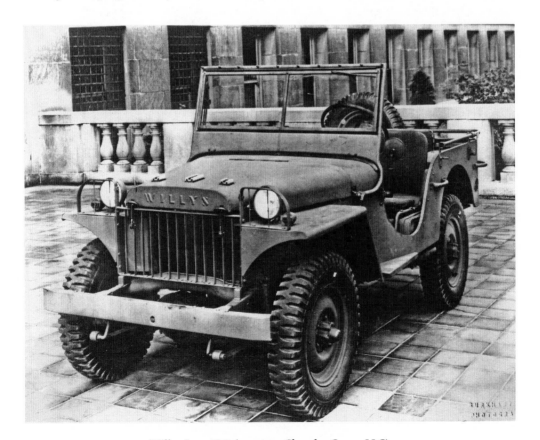

Willys Jeep, 1941 (courtesy Chrysler Group LLC).

carry 500 pounds of payload. Only two companies responded — Willys and Bantam. Bantam's Karl K. Probst originated the first successful design, which was perfected by Willys' engineer Delmar G. "Barney" Roos, based on the 1940 Willys-Overland Americar, the lightest full size car on the road. In 1941, the design was standardized as the MB, and contracts were awarded to Bantam (the BRC, called the "Blitz Buggy"); Willys (the MA, called the "Quad"); and Ford (the GPW, called the "Pygmy"). The final Ford designation of "GP" led it to being called the Jeep, but it was also called the Peep, Jitterbug, Beetlebug, Iron Pony, Leapin' Lena, and Panzer Killer. Over 600,000 were built during the war, and Volkswagen made similar military vehicles called Kübelwagons and Schwimmwagons (amphibious) designed by Ferdinand Porsche. Civilian U.S. jeeps would thrive well into the 21st century.

Another World War II design would last just as long. In 1944, in response to a U.S. Navy request for "seaworthy" furniture, the Electric Machine and Equipment Company (Emeco) of Hanover, Pennsylvania, developed a line of sturdy aluminum furniture that included a seven-pound, square-tubed chair with contoured seat and slat-back known as Model 1006. It became standard postwar equipment in government offices, prisons, and hospitals because it was virtually indestructible. In 1990, it was revived for chic restaurants, and Emeco revived "Heritage" models based on Model 1006. By 2000, half a million had been sold, and more exotic versions had been designed by Philippe Stark (b. 1949) and sold at the Terence Conran Shop in New York. It has become the modern version of the 19th century bentwood Vienna Café chair No. 14 by Gebrüder Thonet (1859).

The GM styling section devoted all its resources to designing camouflage for military vehicles and weapons during the war. In 1941, Harley Earl was allowed to view the new Lockheed P-38 Lightning pursuit plane, which featured twin tail booms, each with a vertical stabilizer. Inspired, Earl went back to the studio and began adapting its characteristics to automotive designs, particularly the concept of tail fins on rear fenders, which after the war would initiate the postwar "tailfin wars" in Detroit.

Many Americans enlisted or were drafted into the military and were hailed as heroes by a grateful and patriotic public. Others relocated to new "defense towns" being built near defense plants around the country and joined the rest of the public in tolerating the rationing of gasoline, shoes, butter, flour, fish, canned foods, coffee, cheese, sugar and meat, and in collecting metal scraps, tin cans, paper, silk, nylon, and grease for the war effort. Americans were told to "use it up, wear it out, make it do, or do without." Roosevelt authorized the Office of Price Administration (OPA) to establish price ceilings on manufactured products like refrigerators, irons, radios, ranges, typewriters, phonographs, and washing machines to avoid inflation. The Museum of Modern Art's 1942 exhibition, Useful Objects in Wartime, featured three displays: household products made of

Emeco aluminum chair for U.S. Navy, 1944 (courtesy Emeco).

non-priority materials; products that had been asked for by men and women in the military; and equipment essential for civilian defense. There were no products made of steel, chromium, tin, aluminum, copper or nickel, or even some plastics like acrylic, nylon, and bakelite, all required for the war effort. Products shown were essentially made of glass, ceramics, plywood, and paper.

Industrial designers joined other Americans in the war effort. In 1941, The American Designers' Institute (ADI) held a conference in New York, Design in the National Emergency, and promised that its members would be available to the government and manufacturers who needed assistance to meet difficulties. Leo Jiranek chaired ADI's committee, which submitted a report to the National War Production Board and the Office of Price Administration suggesting how designers could best serve the country.

Henry Dreyfuss, Walter Dorwin Teague, and Raymond Loewy were called upon to design strategy rooms for the Joint Chiefs of Staff. Furnishings were installed in Washington at the Public Health Service Building and featured a world map on a curved surface 12 feet high and 25 feet wide. Dreyfuss designed and built four rotating globes, 13 feet in diameter, one each for Roosevelt, Churchill, Stalin, and the Joint Chiefs of Staff. Loewy provided assistance to the Office of Strategic Services in the Department of Visual Presentation and developed concepts for many military organizations. Teague worked for the Naval Bureau of Ordinance. Norman Bel Geddes developed photo recognition training programs for the military and prepared war-related scale models of military operations to prepare for invasions. Egmont Arens advised on instrument colors for easy readability. Victor Schreckengost was made head of design in the Department of Training Devices and was joined there by Henry Glass and Paul MacAlister (d. 1986?). Eliot Noyes entered the Army Air

Galvin Manufacturing Corporation (later Motorola) in 1940 developed the Handie-Talkie SCR 536 AM portable two-way radio. This handheld radio became an icon on World War II battlefronts (courtesy Motorola Archives, Inc.).

Force as a major, and as a former glider pilot helped establish and administer their glider program. John Vassos joined the armed forces as a captain in the Engineering Corps in charge of camouflage, and, with a forerunner of the CIA, parachuted into Greece to organize the underground.

In 1941, Charles Eames and his wife, Ray (1916–1988), relocated to California, where Eames took a job with MGM. They continued to experiment with molded laminated wood for furniture and sculptures. Through a contact with the naval hospital in San Diego, Eames proposed a molded plywood splint to replace the padded metal splint then being used. The navy placed an order for 5000, and Eames formed a company in Venice, California, to produce them. The company became the Molded Products Division of Evans Products, owned by Colonel E.S. Evans, which produced additional splints and glider components for the

war effort. Eames hired Harry Bertoia, his colleague from Cranbrook, to help with production. Eames' experiments paved the way for the innovative postwar furniture that made him famous.

Harold Van Doren opened a second office in Philadelphia in 1941, managed by Donald Dailey (1914–1997). The move was encouraged because Van Doren's new client, Philco, was located there. Philco was a major manufacturer of radios, televisions, and major appliances. John M. Little stayed to manage Van Doren's office in Toledo.

Trained industrial design graduates became very scarce during the war. By the start of the war, there were a number of new school programs established in industrial design. In 1939, Hin Bredendieck had left the School of Design in Chicago and initiated and directed a program at Georgia School (later Institute) of Technology. From 1939 to 1943, Donald Deskey and Gilbert Rohde ran a program of industrial design at New York University's School of Architecture. In 1940, Syracuse University sought the counsel of Norman Bel Geddes, Lurell Guild, and Henry Dreyfuss and as a result, revised and renamed an earlier Design for Industry program as Industrial Design. In 1940, the Illinois Institute of Technology was formed out of the Armour Institute, which had been offering a design program under Mies van der Rohe since 1938. In 1940, the California College of Arts and Crafts in San Francisco engaged package designer Walter Landor (1913–1995) and Joseph Sinel to run a program. Cranbrook Academy of Art offered graduate degrees. But there were no graduates yet from any of these new programs.

The half a dozen or so programs that had started up from 1934 to 1937 had graduated only a handful of designers by 1941. Among them were Carnegie Institute of Technology's William Goldsmith (1917–1987) and Arthur Pulos (1917–1997); Pratt Institute's Tucker Madawick (1917–2006), Monte Levin (b. 1917), Olle Haagstrom, Joseph Parriott (1920–2000), Elwood Engel (d.1986); and Cleveland Institute of Art's Joe Oros and his wife, Elizabeth Thatcher Oros. Many of these and recent graduates of these programs were drafted into the military and served throughout the war.

But some of the major industrial design offices, and some companies that were continuing product development work on new consumer products even though their production was making military materials, still needed to hire new industrial designers. So, where could new designers be found? A not untypical solution occurred at the Hoover Company in Ohio, where Henry Dreyfuss had been a consultant since 1934. Although the war stopped production of vacuum cleaners to make bomb proximity fuses, development work continued on vacuum cleaners. Dreyfuss, like other major consultants, visited his clients only occasionally. When he visited, he liked to have a client employee to help him by assembling the necessary prototypes for review and by preparing crude mock-ups of emerging product ideas. There were few young applicants available.

So in 1942, Dreyfuss offered to train 37-year-old E. Russell Swann (1905–1958), a Hoover employee since 1925 who had interest in such an opportunity. Swann was given a leave of absence from Hoover and sent to work in Dreyfuss' New York office for four years to learn about industrial design as an apprentice. He returned in 1946 to become an industrial designer at Hoover and hired a second young man as assistant. Swann set up a small workshop in the drafting room with a spray-booth to make models and engaged several model makers. Soon Swann was functioning as head of an in-house design department, as well as assisting Henry Dreyfuss, and Swann shortly became a full member of SID.

Wartime shortage of essential materials encouraged the use of new materials for traditional purposes. Plywood, in particular, after new waterproof synthetic resins were devel-

Henry Dreyfuss (courtesy Henry Dreyfuss Associates).

oped, was being used in aircraft such as Howard Hughes' enormous "Spruce Goose" transport seaplane, contracted in 1942. Donald Deskey patented his random-width texture pattern of parallel grooves on plywood surfaces called Weldtex, which became popular for years in home paneling after he sold the rights to the United States Plywood Company. In the furniture industry, plywood was being used to design and produce band-sawn standard pieces (tops, sides, and legs) that could be assembled on site. This system of mass-produced, prefabricated furniture, later known as "knock-downs," would become standard practice in the industry and fostered the transition from traditional styles to contemporary.

Plywood was also being used in mass production of prefabricated housing, sorely needed in the severe housing shortage caused by mass defense migrations around the country. The government subsidized the construction of 125,000 trailers (mobile homes) to meet shortages. The Quonset Hut, a steel, prefabricated, half-cylinder developed by Canadian engineer P.N. Nissen, was used on many military bases.

Walter Gropius established a corporation to manufacture a prefabricated house that could be assembled with connectors. Only a few examples were built and his proposal was rejected, but he influenced the government to support research in prefabrication that resulted in 100,000 prefabricated houses being built with federal support during the war.

R. Buckminster Fuller developed one of the most innovative temporary housing solutions. Called the Dymaxion Deployment Unit (DDU), it was inspired by commonly used midwest corrugated steel grain bins. Working with the Butler Company of Kansas City, Fuller developed a circular steel structure intended for worker's housing with a conical roof, 15 to 20 feet in diameter, and submitted it in 1941 to the government. Though wartime restrictions on the use of steel prevented this objective, the government contracted Butler to build DDU's for military use only, and hundreds were used as radar huts.

In 1944, the Beech Aircraft Company in Wichita, Kansas, was looking for postwar business opportunities and engaged Fuller to design a refinement of his original 1929 Dymaxion House for production; it was later called the Wichita House. The refinement included his prefabricated Dymaxion Bathroom of 1937. The prototype Wichita House opened successfully in 1945 at a price of $6500; but the war soon ended, backers lost patience with Fuller's endless revisions, and Beech decided its future lay in small private planes, not houses.

The interior design profession now took notice of the emerging profession of industrial design, as the architects had in 1940. In 1943, *Interiors* magazine, published since 1940 by

Charles E. Whitney, initiated a regular section called "Industrial Design." It was conceived and edited by Donald Dohner, who had just left as head of Pratt Institute's design program to establish a product and package design office in New York in partnership with a fellow faculty member, J. Gordon Lippincott (1909–1998), and the Douglas T. Sterling Company in Stamford, Connecticut. The new firm was called Dohner & Lippincott. Dohner's section in the magazine featured manufactured products. The first employees on Dohner and Lippincott's staff were two 1943 graduates of Pratt Institute, Budd Steinhilber (b. 1924) and Read Viemeister (1923–1993). Both illustrated many of Dohner's design concepts that were subjects of his *Interiors* section.

After Dohner's tragic death in December 1943, Lippincott took over the *Interiors* articles, and by September 1945 the phrase "industrial design" appeared on the title page of *Interiors* for the first time with no editorial comment. In the October issue, however, an advertisement announced that *Interiors* had opened its doors to industrial designers and quoted this item from *Retailing Home Furnishings*: "Industrial designers are having a field day these days. Their advice is being sought as never before ... in short, they have come into their own and are frantically being outbid for on every side by manufacturers who want a designer's name attached to their products."[11]

Industrial designers, too, were beginning to realize the impact of their sudden rise to popular success and notoriety and were beginning to consider what was needed to establish their activity as a new, national, formal profession. The membership base of the Chicago-based American Designers' Institute (ADI) had been shifting to New York since 1941. In 1942, the New York chapter questioned whether the organization should continue to be incorporated under Illinois law. In 1943, the Illinois secretary of state dissolved the corporation for failing to file an annual report as required. In May 1944, the American Designers Institute (with apostrophe omitted) was granted a new charter of incorporation in Delaware after an application was filed by Alfons Bach (1904–1999), Ben Nash, and George Kosmak; its administrative offices were relocated from Chicago to New York City. ADI's first secretary/treasurer there was Belle Kogan.

In 1943, ADI's education committee, headed by Alexander Kostellow with László Moholy-Nagy and Donald Dohner, had surveyed the membership and solicited the advice of John Vassos, Ben Nash, and George Kosmak to develop an idealized educational program. In 1944, ADI announced their "Educational Program for Industrial Design," a prototype, 4-year program combining technical, business, and academic courses, which in fact became a model for many of the new industrial design programs initiated after the war.

In June 1944, Richard F. Bach, of the Metropolitan Museum of Art, hosted a conference on design education attended by many design school administrators. It was obvious that there was still a great deal of controversy as to exactly what industrial design was, who was qualified to practice it, and how precisely to teach it. A summary of the discussion stated that "the definition of industrial design was carefully avoided, fearing such action might restrain discussion."[12]

Clearly, there was no general agreement by educators on precisely how to describe the new profession. Mainly, this was because many schools' programs were so broad in scope that they really were not strictly industrial design programs. The schools should have known the definition very well. Teague and Van Doren had defined it precisely in their 1940 books. It was publicly defined again in July 1944 by the treasurer of the newly established Society of Industrial Designers (SID), Harold Van Doren, in a feature article in *Product Engineering* magazine:

The modern industrial designer is concerned with 3-dimensional products, equipment and machines made only by production methods, as distinguished from traditional handcraft methods. His aim is to enhance the desirability of these products by: (1) Increasing convenience and improving adaptability of form to function; (2) attracting buyers by applying a shrewd knowledge of consumer psychology; and (3) employing to the fullest the aesthetic appeal of form.[13]

Richard Bach and the school administrators knew perfectly well what the definition of industrial design was. Their problem was that many established design schools still were heavily invested in curriculum and faculty focused on traditional, decorative, "applied art" from the 19th century. They would have to totally rebuild curriculum and faculty to properly teach industrial design. They did not know how to begin. So indeed, a definition of industrial design would have "restrained discussion."

John Vassos, Alexander Kostellow and other ADI members in 1945 proposed an amendment to the New York State Education Law (Article 84-A) that would have established educational requirements and licensing regulations for industrial designers. It would have required every future industrial designer to graduate from a qualified higher education program and work six months in a factory and a year or more in a designer's school or office before being licensed to practice industrial design. When the amendment came before the state legislature in 1947 and 1948, it failed, as some designers who lobbied against it feared that it might threaten their independence and would require them to be licensed in every state they practiced.

Some New York designers also had reservations about the ADI as an organization. First, furniture designers in Chicago had formed it, and most well known industrial designers were located in New York. Second, furniture designers worked in a single industry, and many industrial designers worked in many different unrelated industries. Third, ADI's title did not specifically refer to "industrial designers," so it was open to any kind of designer who wanted to join. Leading designers felt such a national organization should specifically refer to "industrial design," should be more exclusive, and that membership should be restricted to those practitioners who had demonstrated their proficiency in a broad range of products.

Aside from these concerns, leading industrial designers had been concerned with tax laws that seemed discriminatory. New York State tax authorities, aware of the financial success of leading designers, decided that industrial design earnings were taxable under the unincorporated business tax statute. When three leading designers, Dreyfuss, Teague, and Loewy, were billed for half a million dollars in back taxes for 1935, 1936, and 1937 by the state, they were shocked. They had thought that, as professionals, they were exempt from the unincorporated business tax.

The state's action basically assumed that industrial designers were not "professionals" in the legal sense. The "big three" contested the state by hiring an attorney to represent Teague in petitioning for exemption of his income from the unincorporated business tax, arguing that "the vocation of industrial design is a 'profession' rather than a 'trade' or 'business' within provision of the Tax Law exempting professions from unincorporated business tax."

At an April 30, 1941, hearing by the New York State Supreme Court, Appellate Division, Teague's attorney also argued that industrial design was a separate field of endeavor because institutions of learning like Carnegie Tech, Pratt, the University of Illinois, Michigan, and New York University offered courses leading to a degree of bachelor of arts in industrial design. Even though none of the leading designers had a formal education in the field, they claimed credit for establishing it.

This petition case, *Teague v. Graves et al.*, was successful, based on the portion of section 386 of the statute that "excludes the practice of law, medicine, dentistry, and architecture, which under existing law cannot be conducted under corporate structure, and in any other case in which more than eighty percent of the gross income is derived from personal services actually rendered by the individual." Henry Dreyfuss stated in an interview, "We won the case and remained both professional and solvent."[14]

Since that time, despite repeated attempts to tax industrial designers under the unincorporated business law, they have always been found exempt. But with the later establishment of "professional corporation" status for those in traditional professions, the tax issue has become moot, as they must pay taxes even if unincorporated. But the decision settled the issue regarding whether industrial design was a profession or not, no small victory at the time.

In February 1944, three months before ADI was rechartered in Delaware, fourteen practicing industrial designers met in Teague's office to initiate a new professional society. They defined an industrial designer as "one who has successfully designed a diversity of products for machine and mass production." On this point, they differed significantly from the ADI. At the group's first annual meeting on August 20, 1944, the group elected Teague as president; Dreyfuss vice president; Harold Van Doren treasurer; and Egmont Arens secretary. Philip McConnell, formerly with the U.S. Treasury Department and former secretary to the New York World's Fair Design Commission, was appointed executive secretary of the new organization. Bylaws and a constitution were drawn up and approved, and on August 29, 1944, it was chartered by the State of New York as the Society of Industrial Designers (SID). Other founding members were Donald Deskey, Norman Bel Geddes, Lurelle Guild, Ray Patten, Joseph Platt, John Gordon Rideout, George Sakier, Joseph Sinel, Brooks Stevens, and Russel Wright.

The qualifications for membership were stated in a 1945 SID flyer: "Membership in the Society shall be limited to practicing industrial designers, and members of industrial design departments in institutions of higher learning. To be acceptable a candidate must have practiced industrial design for several years and in the course of his practice, must have had three or more of his products manufactured and offered for sale in the usual marketing channels. He must have honorably and satisfactorily served three or more manufacturers."[15] These rules specifically excluded specialists (like furniture designers), handcraft designers, engineers, and businessmen, and, of course, there were many ADI members that fell into these categories. The formation of the SID instantly created two competing industrial design organizations, which would remain separate until 1965, when they would merge as IDSA. These organizations representing a specific profession were privately funded and operated, as was typical in the U.S. In contrast, European professions were usually represented by government organizations, as was the Council of Industrial Design (CoID) established in London, also in 1944, to promote good design of products in British industry. This was a major turning point. In the period leading up to the war, design in Britain had been unaffected by the Bauhaus and remained outside the mainstream of modern design. The CoID would change that. In the 1970s the CoID would be renamed the Design Council.

After about 1943, when it became clear that the war was being won, especially after the invasion of Europe on D-Day in June 1944, manufacturers began thinking of how to convert from their wartime materials production to peacetime consumer manufacturing. American workers were making good money in defense jobs and were building personal

resources. Manufacturers knew that suppressed consumer demand would be strong, and they wanted to develop ideas for new products. So, naturally, they sought the advice of industrial designers.

In 1943, Peter Müller-Munk was engaged by the Dow Chemical Company to stimulate interest in plastics for postwar products. During the war, many of the new plastics developed during the 1930s were improved and refined for military use. Müller-Munk used the opportunity to explore the idea of a kitchen as a domestic production line that combines factory efficiency with "charm and livability," where appliances would be part of the architecture of the kitchen rather than individual units. He also proposed, and Dow promoted, Durez plastic housings for lighter weight sewing machines. Over a period of some months, Dow ran a series of magazine ads featuring the ideas of prominent industrial designers for uses of Durex, including those of Egmont Arens, Donald Deskey, and Jean Reinecke. Reinecke observed, "The plastics industry and the industrial design profession grew up together. The plastics group recognized the value of design to its products, and designers saw the new design opportunities provided by the materials."

In 1944, the Libby-Owens-Ford glass company developed a prototype Kitchen of Tomorrow designed by H. Creston Doner (1902–1991) that was exhibited at Macy's. It encouraged the use of glass in cabinet doors and had a refrigerator accessible from both sides. It was the first of many postwar experimental kitchens, and visitors were asked to vote for features they wanted most to become available after the war. In 1942, Freda Diamond (1905–1998) was engaged by the Libby Glass Company, with whom she worked for the next 40 years. By 1954, Libby had sold 25 million products she had designed.

During the war, Henry Dreyfuss, consultant to the Crane Company, a manufacturer of bathroom fixtures, set up a design office within the Crane building in Chicago to study the company's entire line; after the war, he had a complete line of postwar products ready for production. In similar manner, Donald Deskey worked with the Brunswick, Balke and Collander Company to develop postwar recreational products. Among these were billiard tables and bowling centers for postwar shopping malls to attract not just young men, but families. These became very popular after the war.

Many companies established or reestablished internal design departments in anticipation of business after the war, because by late 1943 the military successes of Allied forces in a number of theaters made it obvious that victory was just a matter of time. At Sears & Roebuck, postwar planning began in 1943 with the appointment of Jon Hauser (1916–1999) as head of the design department. When he left in 1945, Carl Bjorncrantz (1904–1978) took over and hired Alan Duncan. In 1943, at IBM, an industrial design department was established and headed by George H. Kress. Regarding computers, which IBM had under development, IBM chairman Thomas Watson, Jr., famously said, in 1943, "I think there is a world market for maybe five computers." In 1944, IBM introduced and dedicated at Harvard the Mark I, a five-ton electromechanical digital computer using paper tape.

George Nelson had become a leading spokesman for the architectural and design communities. In 1943, he introduced the idea of pedestrian malls, in a *Saturday Evening Post* article, "Grass on Main Street." In January 1945, *Life* magazine featured a Storage Wall concept developed by Nelson and Henry Wright, comanaging editors of *Architectural Forum* magazine, as an outgrowth of their book, *Tomorrow's House*, which had just been published. The concept provided an alternative to hated closets and attracted much public attention. Nelson was offered, and accepted, an appointment as design director for the Herman Miller Furniture Company to replace Gilbert Rohde, who had passed away in 1944. In 1940, Rohde

had convinced Herman Miller to cease production of its period furniture and produce modern designs exclusively, the only furniture company to do so. Nelson was attracted to Herman Miller as a potential producer of his revolutionary wall storage system and the opportunity to direct the company's pioneering role in modern furniture design.

Finally, in August 1945, the war was over, and although most of Europe was still in ruins, America, the "Arsenal of Democracy," was at its peak of industrial capability and technical creativity, ready to convert to peacetime manufacturing in order to meet the suppressed material dreams its citizens had harbored over the previous fifteen years. Industrial designers had helped the war effort and had helped manufacturers develop postwar products that would provide Americans with the highest standard of living in the world within a few years. The future, as dramatically predicted by the 1939 World's Fair, was now at hand, and America was more than ready to embrace it.

Chapter 9

1945–1950
Postwar Recovery and Consolidation

As anticipated by many industries that had been converting from wartime to peacetime production since 1943, consumer product demand after the war was enormous. In sequence, the depression, and then the war, had prevented or delayed the acquisition of material goods for most Americans. Prewar cars were worn out, and furniture and appliances were outmoded, even if still functional. Many middle class families were financially well off due to good-paying wartime jobs, overtime, and dual income households with wives working. Average weekly pay had been almost doubled, from $24 in 1940 to $44 in 1945. Many families had their first discretionary income. Millions of returning service personnel married, went to college, and started families. They all desperately needed and wanted homes, cars, furniture, and appliances—all based on their expectations from the 1939 fair's World of Tomorrow that technology would provide miracles. Dick Tracy, the comic strip detective, began sporting an advance tech wristwatch 2-way radio. Manufacturers and services rushed to fill these critical needs and futuristic desires. Many companies had begun selling products that were commercially unfeasible before Pearl Harbor, such as plastics, synthetic rubber, fibers and petrochemicals. But the shortage of industrial designers was acute. The demand far exceeded the supply.

Returning servicemen under the postwar G.I. Bill were anxious to begin or resume their education. Industrial design was an attractive career option because of its high prewar visibility and postwar demand. The Society of Industrial Designers (SID) published its first educational bulletin's list of schools with programs of industrial design in March 1946. They included Alabama Polytechnic Institute in Auburn (later Auburn University), four-year course; Art Institute of Chicago, four-year course; California Institute of Technology, two-year graduate course; Carnegie Institute of Technology, four-year course; Chicago Art Institute; Chicago Academy of Fine Arts, two years; Cooper Union Art School, three-year day course and four-year night course; Georgia School (later Institute) of Technology, four years; Chicago's Institute of Design, four years; Kansas City Art Institute, four years; Minneapolis School of Art, three-year day course and four-year night course; Newark Public School of Fine and Industrial Art, four years; Philadelphia Museum School of Industrial Art (today, the University of the Arts), four years; Rhode Island School of Design, four years; Stanford University, four years; Syracuse University, four years; University of Cincinnati, four years; University of Michigan, four years; University of Southern California, four years; University of Illinois, Urbana-Champaign, four years; and the University of Michigan,

four years. Other programs were under development at the Art Center in Los Angeles, North Carolina State College in Raleigh, and the University of Bridgeport in Connecticut.[1] Not mentioned in SID's bulletin were additional programs available at Alfred University, where the School of American Craftsmen at Dartmouth had just moved, Brooklyn College, and Columbia University in New York.

Industrial design curriculum was in a state of flux. Some of these programs were influenced by the prototype curriculum recommended and copyrighted by the American Designers Institute in 1944, or the SID's second educational bulletin of 1946, which defined the profession and explained how industrial designers work in industry or consulting firms.

In June 1946, Richard F. Bach, dean of education at the Metropolitan Museum held a second conference for the administrative heads of 45 art schools (the first was held in 1944), but only 15 had programs in industrial design; key design schools were excluded. Many faculties of art schools had no academic or professional training in industrial design. SID judged most existing programs as inadequate to the needs of the profession. Walter Dorwin Teague, who had attended the conference, expressed this dissatisfaction in a letter to Bach: "We have created a profession, and some of them are delighted to teach it, with only the vaguest idea of what it is all about."[2]

Professionals wanted to expand traditional art courses to include courses in the physical and behavioral sciences and to add workshops and laboratory courses similar to institutes of technology. In short, they were challenging the traditional "Applied Art" mentality of art schools, petrified after a century of repetition. Art school administrators argued that these proposed changes would drive away some artistic students, which was probably true.

Several of the proposed changes, among them the addition of workshops and laboratories, were key to teaching the many specialized model-making skills required to build three-dimensional representations and presentation of product ideas for clients. Art schools simply were not prepared to teach these skills. Industrial design model-making techniques required a well-equipped workshop with heavy equipment such as lathes, band-saws, planers, drill presses, and vented paint spray-booths, which was a sizable financial investment for schools. Special skills in a range of model-making processes normally included soft and hard clay modeling, plaster casting and forming, plastic heat forming, mold-making, woodworking, metalworking, and high quality finishing for painting. Models usually were full-sized and required considerable additional working space in "laboratories," or as they were later called, "studios" or "student work stations." Specialized training in concept sketching and presentation rendering using pastels or gouache was also required to meet the standards of the profession. Ordinary artistic skills in "applied arts" were totally inadequate, so schools would also need to hire new faculty to teach these specialized skills effectively. All in all, these additional requirements were of considerable cost and concern to art schools.

Later in 1946, Edgar Kaufmann, Jr., who had joined the Museum of Modern Art (MoMA) as director of its industrial design department, invited members of AID and SID' to attend a "Conference on Industrial Design: A New Profession." Attendees included professionals George Nelson, Russel Wright, and J. Gordon Lippincott, as well as educators László Moholy-Nagy of the Institute of Design in Chicago, Alexander Kostellow, industrial design program head at Pratt Institute, and James C. Boudreau, dean of Pratt's art school. The discussion was largely philosophical and resulted in no specific actions.

In 1948, Richard F. Bach, dean of education at the Metropolitan Museum of Art, followed up on his meeting of 1944 with design school administrators by initiating meetings to establish the National Association of Schools of Design (NASD), with 22 member schools.

The organization would accredit art and design education programs. It would be renamed the National Association of Schools of Art and Design (NASAD) in 1981, recognizing the tenacity of the art school mindset. Clearly, museums were seeking leadership roles in the postwar consolidation of the industrial design profession.

The Society of Industrial Designers (SID) decided it would not propose a model curriculum like the ADI to avoid duplication, but instead would offer advice and support on education. In February 1947, SID announced a program of evening courses at New York University for industrial designers, both professional and nonprofessional. Four courses consisting of 15 lectures each were scheduled for each semester of the 1948–1949 academic year. Various individuals presented lectures on a variety of technical and philosophical subjects. In 1949 and 1950, SID assisted Lehigh University in conducting summer seminars on product design led by a number of SID members, including Dave Chapman, Harold Van Doren, and Walter Dorwin Teague and codirected by Raymond Spilman (1911–2000), who had just established his own office in Darien, Connecticut.

While educators and professionals battled over curriculum, housing was in high demand for returning veterans using G.I. loans. The problem was that there was an acute shortage of homes. New home construction had been stopped entirely during the war to make construction materials available for military and government purposes. New low-cost housing in planned suburban communities began springing up around the country. The first, in 1944, was San Lorenzo Village in Alemeda County, California, with parcels for churches, schools and shopping centers. In 1945, Henry J. Kaiser formed the Kaiser Community Home Company to build mass-produced housing in California. Buyers could choose three styles— the Suburban, the Palm Springs, or the New Englander.

On the East Coast, William J. Levitt was building inexpensive new homes faster than anyone else. He was creating new suburbs that required commuting by car, and homes were almost identical. But they were in a planned community, and included a yard, a garage, shrubbery, shutters, and built-in appliances— the ideal new owner package. Levitt's developments were modestly called Levittowns. The first Levittown on Long Island in 1947 was built quickly through a mass production assembly line system using precut lumber and prebuilt components. Crews of masons, carpenters, plumbers, electricians, and painters followed each other down streets, completing 30 homes per day. Additional Levittowns were later built in Bucks County in Pennsylvania, Delanco Township in New Jersey, and Puerto Rico.

The Walker Art Center in Minneapolis had in 1939 built a small "idea house" on the museum grounds to demonstrate innovative architecture for casual living that attracted 50,000 visitors. In 1946, the director of the museum, Daniel S. Defenbacher, initiated the construction of "Idea House II" on museum grounds. When completed in 1947, it was a split-level, shed-roofed bungalow built on a concrete slab, with an open floor plan for a casual lifestyle, generous use of Donald Deskey's Weldtex striated plywood, and furnished with modern furniture by Knoll and Herman Miller. Another popular postwar material was Formica, for countertops, tables, and shelving. Brooks Stevens designed the ubiquitous Skylark "boomerang" pattern that suggested supersonic aircraft wings.

In 1949, the Museum of Modern Art followed the Walker Art Center lead and commissioned architect Marcel Breuer to "design a moderately-priced house for a man who works in a large city and commutes to a so-called 'dormitory town' on its outskirts where he lives with his family." The result was the "House in the Museum Garden," a spare, but-terfly-roofed box with a two-car garage doubling as a patio.[3]

A number of designers participated in attempts to produce low-cost prefabricated houses: Donald Deskey in 1946 with his 1940 Sportshack design; Henry Dreyfuss in 1947 with Consolidated Vultee; Walter Dorwin Teague in 1948 with a design for *Look* magazine; and Frank Lloyd Wright with his 1953 Usonian House. None were as successful as the Lustron House, which started production in 1948 at a nine-mile-long assembly plant in Columbus, Ohio. Of traditional design, it was invented by entrepreneur Carl Strandlund (1899–1974) in 1946 with a steel frame structure upon which porcelain-enameled steel panels in a variety of colors were mounted. It was fireproof and rustproof, and could withstand any weather. A five-room, two-bedroom model was priced at $7000. But after five years and 3000 houses, the company folded. Nevertheless, most of the Lustron houses are still standing today.

From 1945 to 1950, annual housing starts increased from 200,000 to 1,154,000, most by traditional stick-built methods. By 1949, the housing shortage was easing, and more architecturally creative designs appeared, intended for the middle and upper classes. In Santa Monica, John Entenza, the former editor of the California magazine *Art and Architecture*, promoted postwar modern architecture with his Case Study program. He invited eight architects to design individual homes, including his own, on five acres in Pacific Palisades. Charles Eames and Eero Saarinen designed Entenza's home, and Eames designed one for himself and his wife, Ray. Thirteen homes were built by 1949, and the Eames house, in the international style favored by architects and the Museum of Modern Art, was acclaimed as the most noteworthy.

New postwar homeowners in growing suburbia desperately needed cars. In 1946, carmakers rushed to market with only minor changes from prewar models. First out of the barn were Hudson, Nash, and Packard. Willys-Overland began production of civilian Jeeps. The standard CJ-2A Universal Jeep and the 4WD Jeep station wagon were designed by consultant Brooks Stevens, who would design for Willys until the 1970s.

The first genuinely new postwar designs were Studebaker's 1947 Champion, Commander, and Landcruiser, designed by Virgil Exner and Robert E. Bourke (1916–1996), both of Raymond Loewy Associates' Studebaker team in South Bend. Audrey Moore Hodges (1918–1996), hired by Exner in 1944, designed the hood ornament. Design professionals praised the final design, initiated in 1939 and introduced in May 1946, as fresh and highly innovative, with its novel wrap-around rear windows, and low-slung "flush-side" styling.

Preston Thomas Tucker (1903–1956), a former race car developer and wartime developer of gun turrets, had relocated to Detroit to become the first new auto manufacturer since Walter Chrysler in 1924. He founded the Tucker Corporation in 1946 and hired George S. Lawson (1907–1978?), a former General Motors stylist, to design a scale model for promotional purposes. It was billed as the Tucker Torpedo, with dramatic, independent, motorcycle front fenders and a center, third headlight, which turned with the wheels. But many of these features were impractical.

With production nearing reality, Tucker hired Alex Tremulis, car stylist of Chrysler's 1941 concept Thunderbolt who was then with Chicago's Tammen and Dennison industrial design firm, to make the design more practical and to build a full-size clay model. By March 1947, Tremulis' revised design was advertised as the 1948 Tucker: The Car of Tomorrow. But Tucker was not satisfied. He engaged the New York design firm of J. Gordon Lippincott and Company, which would soon be renamed Lippincott & Margulies, recognizing Lippincott's partnership with Walter Margulies (1914–1986), who had joined Lippincott in 1944. Lippincott had just written a book featuring automotive design, *Design for Business*, which

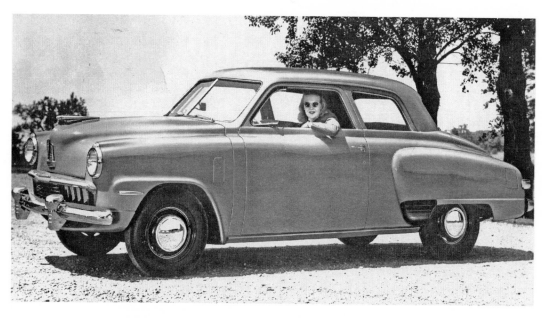

1947 Studebaker Champion (courtesy Patricia Madawick).

could have attracted Tucker. Lippincott sent a design team comprising Tucker Madawick, Phil Egan (1920–2008), Read Viemeister and Budd Steinhilber to Chicago to design and build an alternative full-sized clay model. When production finally began in March 1948, the final design was a blend of various details of the two clay models. Audrey Moore Hodges designed the interiors. Fifty-one cars were built before Tucker and his associates were indicted by the S.E.C. for fraud and S.E.C. violations. Although acquitted in 1950, Tucker's business was forever destroyed, many believe by Detroit carmakers.

Tucker Madawick joined Loewy in 1947 and was assigned to reopen Loewy's London office under the guidance of Carl Otto. Madawick worked on the Austin and Standard Motor Company accounts, and showed the latter's chief stylist how to produce full-sized clay models using automotive clay and American methods.

Other newcomers to the car industry were Henry J. Kaiser (1882–1967), a wartime shipbuilder, and Joseph Washington Frazer (1892–1971), a cousin of George Washington and former head of Graham Paige Motors, whose defunct company was acquired by Kaiser. They formed the Kaiser-Frazer Corporation in 1945 and introduced two models, the Kaiser and the Frazer, in 1947. The slab-sided, fenderless designs were created by well-known car stylist Howard "Dutch" Darrin with contributions by Read Viemeister and Jay Doblin (1920–1989), both of J. Gordon Lippincott and Company.

General Motors and Harley Earl, the dominant styling force in the industry, started the 10-year "tail-fin" wars by adding prominent tailfins on the rear fenders of the 1948 Cadillac, a feature attributed to Earl's 1943 inspiration of the Lockheed P-38 twin-tail fighter plane of World War II. But already, Harley Earl's styling featuring excessive chrome and aircraft icons was coming under criticism by leading designers, and "styling" was becoming a derogatory word when used by professional designers. In 1945, Harley Earl had established an independent styling studio, Harley Earl, Inc., to design non-automotive products, while continuing as styling vice president of GM.

Ford seemed to break from the General Motors styling pattern with its first postwar

design, the 1949 Ford. It was a relatively clean and practical-looking design, except for the distinctive aircraft-style chrome "spinner" in the center of its grille. Eugene "Bob" Gregorie, the Ford styling chief, and his staff, and George W. Walker (1896–1993), an independent industrial design consultant in Detroit, prepared competing designs for review by Henry Ford II. Walker submitted three clay scale models, one each by Elwood Engel, Joseph Oros, and Dick Caleal, all of Walker's staff, though Caleal had just been hired solely because of his model. The Walker design prevailed when Henry Ford II chose Caleal's model over the other three. In 1950, Walker and two of his firm's staff, Engel and Oros, would be invited to join Ford. By 1955, Walker would head Ford's styling department. As with many designs, credit for the '49 Ford was claimed by many contributors, mainly Walker, but including Robert Bourke (1916–1996) of Loewy's Studebaker team, who assisted Dick Caleal, his former employee, in designing the model so that Caleal could get a job with Walker. Bourke said he used one of his own designs for the 1950 Studebaker with an aircraft "spinner" in the grille. In 2001, Ford would show a retro concept model called the Forty-Nine that emulated the original, and in 2003, Ford would belatedly credit Caleal with the original design.

Although the 1949 Ford made Henry Ford II a winner by achieving over a million sales, Henry was unaware that he had recently made the biggest blunder of his career. In 1948, he was offered the purchase of the Volkswagenwerks in Wolfsburg, Germany, which had been largely destroyed by 1944 wartime bombing. With no automotive foreign competition in sight, particularly from Germany and Japan, Ford declared the offer "not worth a damn." The plant was therefore returned to West Germany, and Heinz Nordhoff became its director. In 1949, the first Volkswagens were imported to the U.S., where no one was paying much attention; but the "Beetle" would become West Germany's major postwar industry and would in a few years threaten Detroit itself. By 1952, Porsche introduced its model 356 designed by Erwin Komenda (1904–1966) with elements of the Volkswagen.

In its 1950 model, Studebaker incorporated a prominent aircraft-type propeller "spinner" on the nose of the car, conceived by Robert E. Bourke of Raymond Loewy's Studebaker team in South Bend. Loewy and Studebaker were the only serious challengers to Detroit styling. In a 1955 speech to the Society of Automotive Engineers, Loewy called Detroit cars "jukeboxes on wheels." He was probably referring to the popular Wurlitzer jukebox of 1946, the Model 1015, designed by Wurlitzer designer Paul Fuller, which was chrome-plated, flashing with garish colors and bubbling lights, and which, by the 1950s, provided music for every diner in every town of America.

In the mass production auto and appliance industries, the U.S. had a virtual postwar monopoly due to Europe's struggle to rebuild its industrial infrastructure. In both these industries, U.S. industrial designers during the 1930s had defined these products with modern design based on streamlining and practicality. Consumers were pleased with the appearance of their sleek cars and functional kitchens. They were delighted with their personal freedom to travel and with their efficient laborsaving home appliances that gave them more free time. U.S. industrial design reputation rested on its success in these major product categories.

The situation was far different in the furniture and home furnishings industries, which, by and large, had not yet seen similar dramatic design changes in America. In part, this was due to a stronger commitment to tradition by consumers in these areas. Most young people wanted homes that looked like those of their parents, with traditional styles of furniture, accessories, drapes, tableware, and rugs. In their 1945 book, *Tomorrow's House: A Complete Guide to the Home Builder*, George Nelson and Henry Wright sarcastically wrote, "Home, in the American Dream, is a quaint little white cottage, shyly nestled in a grove of

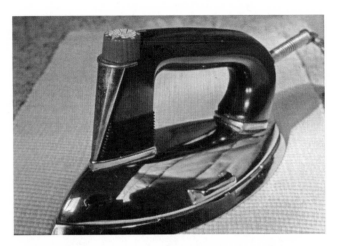

General Mills/Betty Crocker Tru-Heat iron, Model GM1A, by John N. Polivka and Francesco Collura, 1946, had double-pointed soleplate that could iron forward or backward.

old elms or maples, bathed in the perfume of lilacs, and equipped with at least one vine-covered wall."[4] One can imagine that the interior furnishings would certainly not be modern.

The Museum of Modern Art, as we know from the previous chapter, was dedicated to leading the transition of home furnishings design from traditional to MoMA's definition of modern design and to establish architects in a leadership position. After the war, when consumer demand for furniture increased to stratospheric levels due to the housing boom, MoMA resumed its campaign begun in 1940. A number of architects saw design of commercial home furnishings as their new career direction. Among them was Florence Schust (b.1917), an architectural graduate of Cranbrook Academy in 1934 and protégée of Eero Saarinen. She had studied at Armour Institute in Chicago (which later became part of the Illinois Institute of Technology) under Mies van der Rohe and worked in the Cambridge offices of Walter Gropius and Marcel Breuer. In 1943, she relocated to New York and met Hans Knoll (1914–1955).

Knoll had arrived in America from Germany in 1938 and established the Hans G. Knoll Furniture Associates in a tiny New York office. Before he entered the army, Jens Risom (b. 1916) designed a wooden chair for Knoll, in 1943, with surplus military webbing woven to provide a support surface. It was the only modern furniture available during the war and is now a classic.

Schust convinced Knoll she could help by expanding his business into interior design by working with architects. In 1946, they were married and founded Knoll Associates as partners. They established a furniture factory in Pennsylvania and over the next few years established dealerships around the country. They created a "collection" of furniture pieces designed by well-known designers and architects. In 1948, Knoll introduced the Womb Chair, designed by Eero Saarinen in collaboration with Charles Eames. In 1952, Knoll would introduce a steel-wire Diamond chair line designed by Harry Bertoia.

In 1946, the Museum of Modern Art held an exhibition, New Furniture Designed by Charles Eames. Eames, who, with Eero Saarinen, had won a MoMA award in 1941 that had offered contracts with manufacturers, had worked with his wartime employer, Evans Products Company, in Venice, California, to produce prototypes of the plywood chairs that had won the award. The new MoMA exhibition included the all-plywood LCW (Low Chair-Wood), the DCW (Dining Chair-Wood), and the three-legged side chair with plywood seat and back, attached to a frame of metal tubing.

George Nelson, director of design for Herman Miller, offered Eames and Saarinen contracts to produce and distribute their chair designs. The first were Eames' all-plywood chairs that debuted in 1947 and would be produced for 10 years. That same year, Herman

Miller began producing Isamu Noguchi's (1904–1988) classic, glass-topped, sculptural base coffee tables. Hungarian émigré Paul László (1900–1993) also designed furniture for Herman Miller.

It was precisely in this same furniture and home furnishing arena that European design competition heated up after the war. England's Council of Industrial Design (CoID) under Gordon Russell (1892–1980) was promoting good design with exhibitions in the same manner as MoMA, a major exhibition in 1946 being Britain Can Make It, held at the Victoria and Albert Museum. Postwar English furniture designers included Ernest Race (1913–1964), Robin Day (b. 1915), and Clive Latimer (b. 1916).

Canada also promoted postwar design. In 1947, the Canadian government prepared the first Canadian design exhibition, Design in Industry, which toured Canadian galleries and department stores. In 1948 the government established the National Industrial Design Committee (NIDC) and approved the construction of a permanent Design Centre display at the Canadian National Exhibition. The Association of Canadian Industrial

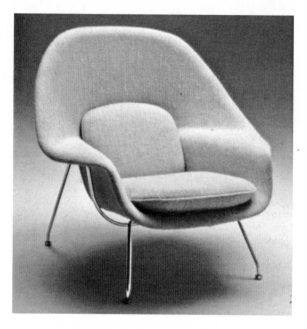

Knoll Womb Chair, by Eero Saarinen, 1948 (courtesy of Knoll, Inc.).

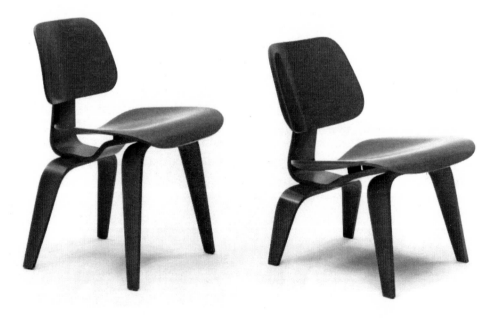

Charles Eames plywood chairs DCW (L), and LCW (R), 1947 (courtesy Herman Miller, Inc.).

Designers (ACID) was founded that same year and elected a representative to the NIDC.

Europe was quick to recognize that design was essential to economic recovery. A new Deutscher Werkbund was reestablished in Germany by Wilhelm Wagenfeld in 1947, and by 1949 it had initiated an organization, Rat für Forgebung (German Design Council). Postwar Scandinavian designers included Ilmari Tapiovaara (1914–1999) and Hans Wegner (1915–2007). Italian designers included Gino Colombini (b.1915), Marco Zanuso (1916–2001), and Franco Albini (1905–1977). In Holland, Switzerland and Denmark, "knock-down" furniture was being developed to reduce manufacturing costs. What Europeans sorely needed was exposure to the huge American markets.

MoMA was happy to provide it. In 1948, the museum held an international competition for Low Cost Furniture Design, which included a chair by Eames with a one-piece metal bucket seat with a structural wire base called the "Eiffel

George Nelson, c. 1948 (courtesy IDSA).

tower." Herman Miller produced it in fiberglass in 1951 as the DAX chair, with many variations for dining, desk, lounge, and rocking chairs. But British designers Robin Day and Clive Latimer won first prize for their wood and tubular metal storage units.

In 1949, Herman Miller produced Nelson's Basic Cabinet Series as a realization of his original 1945 storage wall/room divider concept, as well as Storage Units designed by Charles and Ray Eames. The Howard Miller Clock Company, a subsidiary of Herman Miller, in 1949 produced what was called the "atomic clock" because of individual balls radiating from the center representing the hours. It is the first of many modern clock designs by George Nelson. The clock company also produced Nelson's famous plastic-coated "bubble lamps." In 1953, Herman Miller debuted Eames' DSX fiberglass shell chairs, smaller and simpler than earlier versions.

In 1950, the Winchendon Furniture Company in Massachusetts made and introduced the first affordable system of modular furniture, called the Planner Group, designed by Paul McCobb (1917–1969), who had opened his own New York studio in 1945. His designs, distributed in department stores across the country, had clean, low lines, and trim foam cushions. *Business Week* magazine called McCobb "the creator of the contemporary look for young moderns."

After homes and furniture, postwar buyers wanted a range of home accessories like tableware, fabrics, housewares, hardware, and cookware. Most American products in these categories were still of prewar traditional design. The new modern styles had trickled down from the automotive and transportation industries to the appliance industry and the postwar

furniture industry. For those seeking modern design home accessories, options were very few. Among them were Eva Zeisel's (b. 1906) Museum Service white dinnerware designed for the Museum of Modern Art and produced in 1945 by the Castleton China Company; Flint kitchen tools produced in 1946 by Ecko Housewares and designed by Jack Zimmer, Walter Luneberg, and James Hvale of the Ecko staff; Russel Wright's 1946 Casual China for Iroqois China; and, of course, Tupperware.

George Nelson's Basic Cabinet Series, 1949 (courtesy Herman Miller, Inc.).

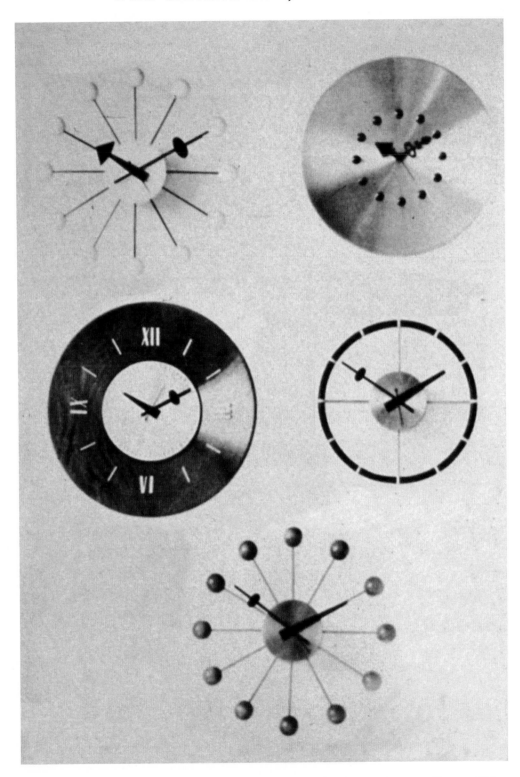

Howard Miller clocks by George Nelson, 1949, "Atomic clock" at bottom (courtesy Herman Miller, Inc.).

The National Housewares Manufacturers Association (NHMA) held its first large "Housewares Show" in Philadelphia's Convention Hall in 1947. Among its many exhibitors, there were only two in the fledgling plastics industry. One was former DuPont chemist Earl Tupper (1907–1983), who had founded the Tupperware Plastics Company in 1938 and produced his first products in 1946. Following the Housewares Show, *House Beautiful* magazine featured an article, "Fine Art for 39 Cents," describing Tupperware's new "Poly-T" polyethylene refrigerator food storage containers. They would later be placed in the permanent collection of the Museum of Modern Art, and Tupperware would become a multimillion-dollar business still noted today for its good design.

After years of olive-drab military colors, postwar consumers were attracted by bright colors in their cars, homes, and apparel, even more so than they had been before the war. During the war, the design head of the Container Corporation of America, Egbert Jacobson, had developed a color specification system of 944 movable color chips, based on the 1916 Ostwald system and called the *Color Harmony Manual*. It was widely adopted as an industry standard to enable accurate communication and specification among designers and manufacturers. In 1948, *House and Garden* magazine initiated a Color Program to identify annual market trends in consumer color preference and to produce specifications of its recommendations for manufacturers. Faber Birren (1900–1988), a prominent author of color books and an industrial color consultant, was engaged to direct the program. In 1949, AT&T was offering telephones in colors and by 1955 General Electric and Westinghouse would be offering their appliances and matching metal kitchen cabinets in bright colors.

After the war, the Society of Industrial Designers (SID) had initiated a massive effort to publicize the work of its growing membership and set its officers to work promoting the profession through articles in popular and business magazines and by speaking to other

Flint 1900 kitchen tool set, 1946 (courtesy IDSA).

professional organizations. Prominent designers were busy writing articles, speaking, and granting interviews. Much of their message was directed at explaining the process and value of industrial design and in assurances that they were willing and able to collaborate with other traditional technical disciplines.

The October 1946 issue of *Electrical Manufacturing* magazine published an article, "Industrial Design in Partnership with Engineering," by Walter Dorwin Teague. He stressed the need for coordination between the two disciplines to produce the best results, and said that "better appearance should be 'built into' and not 'applied to' a product."[5] In 1947, the design and arrangement of Teague's offices and studios were featured in May's issue of *Architectural Record*. The June 1947 issue of *Coronet* magazine featured a biography and personality interview with Henry Dreyfuss by writer J. D. Ratcliff, who referred to

Tupperware plastic cups, 1946 (courtesy Tupperware Worldwide).

him as "one of the top three industrial designers in the U.S."[6] Unmentioned were the obvious other two, Teague and Loewy. Also in 1947, The Society of Industrial Designers organized a photo exhibition of designs by 32 of its members, the first time practitioners had showed their work in friendly competition. The exhibit opened in Philadelphia and traveled to 12 other cities.

A 1949 publication of *U.S. Industrial Design 1949–1950* by the SID, with 190 pages and 389 photographs and illustrations, showcased the work of Reino Aarnio, Egmont Arens, Karl Brocken, Robert Davol Budlong, Dave Chapman, Francesco Collura, Charles Cruze, Thomas Currie, Donald Dailey, Harold Darr, Donald Deskey, Henry Dreyfuss, Gordon Florian, Lurelle Guild, Antonin and C. Heythum, L. Garth Huxtable, Leonard Keller, Ralph Kruck, Raymond Loewy, Onnie Mankki, E. Gifford Mast, Peter Muller-Munk, Palma-Knapp Associates, Joseph Platt, Harper Richards, Hudson Roysher, George Sakier, Viktor Schreckengost, Brooks Stevens, Walter Dorwin Teague, Harold Van Doren, Robert Briers Wemyss, Russel Wright and many others.[7]

Harold Van Doren, then president of the SID, wrote a featured article, "Streamlining: Fad or Function," in the October 1949 issue of *Design*, the monthly journal of the British Council of Industrial Design (CoID), which

First Polaroid Model 95 camera, 1948, invented by Edwin H. Land and designed by Walter Dorwin Teague Associates (courtesy Polaroid Corporate Archives).

had just began publication. American streamlining had come under fire by Europeans and MoMA as being in bad taste and, in many cases, unnecessary. Van Doren, somewhat defensively, stated that "Much so-called streamlining is imposed on the designer by the necessity of obtaining low cost through high-speed production." Using the refrigerator as an example, he compared the traditional costly process of bending sheet metal at sharp angles and assembling multiple components versus the large metal stamping presses adopted by most manufacturers of large parts in about 1936. He continued: "Since steel stamping techniques make it impossible to produce hard, 90-degree edges or pointed corners, any designer engaged by a refrigerator company was already committed to these larger radii and softer contours." He concluded his defense: "Is it fair to damn the designer to eternity because his designs echo the one really new visual phenomenon of his age?"[8]

Henry Dreyfuss, in a December 1949 address to the American Society of Engineering Educators, suggested a revision to the traditional three elements upon which manufacturers relied for success—"utility, quality and price." These, he said, "can easily be duplicated by competitors." He then spelled out the five "vital factors the industrial designer must consider":

1. **Convenience of use** (including utility and safety).
2. **Maintenance**.
3. **Costs** (consideration of tooling; general manufacturing costs and distribution problem).
4. **Sales** (merchandising knowledge, public acceptance and awareness of competition).
5. **Appearance** (last but not least, the designer must add his knowledge of form, line, proportion and color to integrate the product into a pleasing whole).

Dreyfuss criticized the traditional use extraneous decoration, imitation of materials other than those used in manufacture, and sentimental icons:

> With the application of this revised formula by the industrial designer. The extraneous decoration which the manufacturer had previously thought sufficient attraction to sell his product, began to disappear. Sullivan, that great forerunner of modern architecture, said that form should follow function. The industrial designer picked up that phrase for his watchword, and rose buds, griffin's heads, and other doo-dads became increasingly conspicuous by their absence. In short, the industrial designer permitted the function of the product to dictate its appearance.

Mindful of his engineering audience, Dreyfuss added an olive branch to them: "I should like to underscore here the fact that no industrial designer worthy of the name could contemplate this work without the close cooperation of engineers."[9]

Designers were, of course, competing directly with engineers who had traditionally determined the shape and configuration of mass-produced products. So designers had to demonstrate their familiarity with complex manufacturing processes and materials in order to be accepted into the mass production world. Dreyfuss' five factors above became the credo of his office, consistently promoted in magazine interviews and lectures, as well as in his 1955 book, *Designing for People*. In his book, he defined a more specific responsibility of the industrial designer:

> We bear in mind that the object being worked on is going to be ridden in, sat upon, looked at, talked into, activated, operated, or in some other way used by people individually or en masse. When the point of contact between the product and the people become a point of friction, then the industrial designer has failed.
>
> On the other hand if people are made safer, more comfortable, more eager to purchase, more efficient — or just plain happier — by contact with the product, then the designer has succeeded.[10]

To reinforce this philosophy, Dreyfuss in his book introduced a subject he called "human engineering," a measurable process of designing products so that they were compatible with human anatomy, physical capabilities, and limits. Illustrated in his book were charts showing outlines of males and females he called "Joe" and "Josephine" in seated and standing positions. The outlines were surrounded with "average" measurements of many anatomical dimensions, including height, arm length, hand width, etc., all derived from comprehensive and precise measurements of hundreds of people. The dimensions also included maximum (95th percentile) and minimum (2.5 percentile) dimensions of each "average" dimension. He described how his firm used these charts to insure that designs fit the size, weight, and human capabilities of the end-users.

This process attracted both clients and designers as appropriate for all designs affecting users, and soon it was adopted as a necessary part of industrial design. It initially was referred to as "human factors" and became a specialized area for some designers and engineers. In 1956, the Human Factors Society (HFS) was formed to "increase and diffuse the knowledge of man in relation to machines and his environment." Later, when the term "ergonomics" became more common, the name was changed to the Human Factors and Ergonomics Society (HFES). By 1960, the Whitney Library of Design published *Measure of Man* by Dreyfuss, an ergonomic data guide that featured life-size Joe and Josephine charts and popularized the idea of fitting products to human dimensions.

The most prevalent tools for industrial design sketches or presentation renderings since the 1930s had been colored pastel sticks, hard or soft compressed colored chalk that was often shaved to a powder and rubbed with cotton on various paper surfaces to present soft, blended tones that could be highlighted by erasing certain areas or outlined with colored pencils to define clear edges and details. Their quality depended on the artistic skill of the designer, and many were works of art. After this, the real work of sequential clay, wood, or plaster presentation models for management approval was begun. At the time, even the drawings of mechanical designers were works of art requiring weeks of laborious detailed drawing of each nut and bolt. For this reason, the development of new product designs often took three to four years, with several steps of developmental working models, each refined and improved in both mechanical function and appearance by collaboration between engineering and industrial design. Months of testing often followed. The process was essentially one of trial and error.

An internal rift was developing within the profession, however. Since many of the profession's founders and the original organizers of the Society of Industrial Design were independent consultants, they tended to take more credit and attract more public attention than designers who were in the direct employ of manufacturers. The latter were often condescendingly referred to as "in-house" or "captive" designers, implying they were more inclined to follow the instructions of their corporate employers than were the independent, big-name, successful consultants. In 1949, only 15 percent of SID members were of the "in-house" variety.

An example typical of those times was Theodore G. Clement, an architectural graduate of Syracuse University and a mechanical engineering graduate of Rensselaer Polytechnic Institute. Employed by Eastman Kodak since 1930 as an industrial engineer, he worked as an assistant to Kodak's design consultant, Walter Dorwin Teague. With Teague's encouragement, he applied for a position as a renderer with Kodak, and by 1945 he had established and headed a new internal industrial design group. In an October 1949 SID newsletter, Clement offered a defense of "captive" designers:

"Joe" and "Josephine" life-size charts, by Henry Dreyfuss, 1960.

Very few of us use Chanel No. 5 or drive Lincoln convertibles. In fact, we have never even been written up. The only times we ever see our names in print is on those pink slips that say Tickler at the top, and below that it starts off, "If you styling boys would only step on the gas and give us that design — etc., etc!" Yet there is a less seamy side to being the "arty guys" in a big industry. A paycheck comes regularly and you know ahead of time just how much is in it. If you're sick, it still comes. When business is bum, it still comes. When you travel, eat, entertain, lecture, or just meet plain people on the sidewalk, you are fronting for 50 thousand stockholders and 300 million sales dollars, so you hold your head up and walk briskly. At age 65, you may retire, and a check still comes every month until they lay you away.[11]

Silex coffeemaker by Peter Müller-Munk Associates, 1949 (courtesy Peter Müller-Munk Associates, c/o Wilbur Smith Associates).

This type of "captivity" sounded pretty good to many designers as they entered the profession. By 1955, GE would have probably the largest corporate industrial design organization in the country, other than the major auto companies. Arthur BecVar (1911–2003) headed an industrial design staff of 30 in GE's Appliance Park, Louisville, Kentucky, where major appliances were produced. Donald L. McFarland would head a similar design group in GE's Housewares and Radio Division in Bridgeport, Connecticut, and George A. Beck headed industrial design at GE's Light Military Electronics Department in Utica, New York.

George Nelson, anonymous author of *Fortune* magazine's 1934 influential article on industrial design, "Both Fish and Fowl," wrote another influential *Fortune* article in 1949, "Business and the Industrial Designer," under his own name. He retraced the brief 20-year history of the profession, and acknowledged that increasing sales is an important objective of industrial design, but that following fashion trends or the conformity of popular design can be detrimental to small manufacturers. Referring to automotive design, he stated as follows:

[T]he general tendency of the little manufacturer is to tag along with the big three in the apparent hope that this course is the safest, although in point of fact it is the most risky because it means competing on the most unfavorable terms possible." He cited the new 1947 Studebaker Champion design by Raymond Loewy (with a lot of help by Bob Bourke), "which demonstrated with great clarity the one way open to the small manufacturer: design leadership, [which] ... established itself as a distinct entity in the public mind in the only effective way it could — through the appearance of the product itself. In other words, for most manufacturers in the lower brackets, the radical approach to design may be the safest business approach.

Nelson challenged business to "get the most out of their designers" by suggesting that industrial designers of ability and integrity be established "as a member of a company's

policy-making group, with freedom to make his influence felt not only on product design but on all matters of general policy that affect design."[12] In other words, he wanted designers to have an influential managerial role in industry, not simply function as artistic stylists. Nelson himself was a living example of design's future beyond "styling" as an influential director of design for Herman Miller.

Other designers already enjoyed an influential role. It was Raymond Loewy who pulled off the greatest postwar industrial design public relations coup by appearing on the cover of the October 31, 1949, *Time* magazine, with the caption, "He streamlines the sales curve." By this time, the primary holdout for 1930s "streamlining" rationale was General Motors. Most design professionals were abandoning the term "streamline" if not the concept, and a 35-year separation between the "stylists" of Detroit and the organized industrial design community had begun.

By this time, Loewy had a staff of 200 working under partners William Snaith (1908–1974), A. Baker Barnhardt, and John Breen. Employees included many now famous designers who worked then without any recognition, since only Loewy was allowed to receive design credit (as did all the big name designers). Among them were Richard Latham (1920–1991), Peter Thompson, George Jensen, Robert T. Tyler, Joseph Parriott (1920–2000), Jay Doblin, Gordon Buehrig, and Tucker Madawick.

The Korean War of 1950 threatened industry with restrictions of critical materials. Peter Muller-Munk, SID, used this to urge manufacturers to reverse their post–World War II trend of excessive decoration of products: "[T]he electrical and automotive industries ... have reveled in a positive orgy of superfluous shiny decoration and of tricky devices to catch the customer's eye and attention.... The effect of this has been deplored by every serious designer.... Chrome and fancy trim used freely without a design need can now be easily taken off."[13]

In 1950, the Museum of Modern Art established a beachhead at the marketing center of the home furnishing industry, the Merchandise Mart in Chicago, hoping to convert conservative manufacturers to good design. MoMA's Edgar Kauffman, Jr., launched a Good Design exhibition in collaboration with the Merchandise Mart. René

Singer vacuum cleaner by Raymond Loewy, 1947 (courtesy Raymond Spilman and Wallace H. Appel).

d'Harnoncourt, the director of MoMA, and Wallace O. Ollman, the general manager of the mart, issued the following joint statement: "It is the first time an art museum and [a] wholesale merchandising center have cooperated to present the best examples of modern design in home furnishings.... [We] believe and hope that in combining their resources they will stimulate the appreciation and creation of the best design among manufacturers, designers, and retailers."[14]

Meyric R. Rogers, the curator of decorative arts at the Art Institute of Chicago, Alexander Girard (1907–1993), a designer and architect from Detroit, and Kaufmann selected about 250 products, primarily American, but a few from Scandinavia, on the basis of "eye appeal, function, construction and price, with the emphasis on the first."[15] MoMA's contract with the Merchandise Mart required that all selections be made from furnishings already in production and available. The exhibition installation, designed by Charles and Ray Eames, remained in place until November, when MoMA promoted the products in an exhibition in its New York museum. Similar Good Design exhibitions were repeated annually at the Merchandise Mart with new products, new judges and new installations. Danish architect Finn Juhl (1912–1989) designed the 1951 installation, where each piece was sold with a Good Design hang-tag designed by Morton Goldsholl (1911–1995). The tag read as follows: "The manufacturer guarantees that this article corresponds in every particular to the one chosen by the Museum of Modern Art, NY, for the Good Design exhibition at the merchandise Mart, Chicago. A registered description of this artifact is available for inspection at the museum, at the mart, and in the manufacturers [*sic*] files."

Subsequent annual Good Design exhibits were designed by architects Paul Rudolf (1918–1997) in 1952, Alexander Girard in 1953 and 1954, and Daniel Brennan and A. James Speyer in the last exhibition of 1955. This last exhibition strayed from home furnishings by including a camera, telephones (Model 500 desk model by Dreyfuss), kitchen equipment, and appliances. It also shared billing with rooms of traditional furniture designs (by popular demand) called "Good Companions," a rather snide comparison to "Good Design." Arthur BecVar, industrial design manager at General Electric (GE) and president of the American Society of Industrial Designers (ASID), was one of the judges, a rare MoMA recognition that American corporate industrial designers were part of the "elite" design community.

MoMA, dedicated to setting the standards of what it judged to be "good design" and "improving" the taste of American consumers and manufacturers, devoted enormous resources to exhibitions and promotion of "good design." What exactly was "good design?" Edgar Kaufman, Jr. defined it: "A frequent misconception is that the principle purpose of good modern design is to facilitate trade, and that big sales are a proof of excellence in design. Not so. Sales are episodes in the careers of designed objects. Use is its first consideration."[16] Thus was sales success tossed aside as a measure of good design. Eliot Noyes defined design as an aesthetic choice: "Good design in everyday objects ... show[s] the taste and good sense of the designers. On none is there arbitrarily applied decoration.... These things look like what they are."[17] This was "art" masquerading as "design." No onerous limitations of cost, sales effectiveness, manufacturing means, or human ergonomics, as normally required for mass production and considered by the industrial design process.

It is interesting to compare the MoMA definitions of "good design" with the pragmatic business definitions of industrial design by Henry Dreyfuss in 1949 (page 204). He was not impressed with museums' idea of good design. When asked in 1952 in which museums he would like his work exhibited, he said, "They are called Macy's, Marshall Field's and the

May Company."[18] The bottom line was that "good design" depended entirely on how it was defined and judged. MoMA's definition was quite different from that of Dreyfuss.

Kaufman would resign from MoMA in 1955, convinced that MoMA's foray into the commercial world had made consumers and manufacturers aware of good design. In hindsight, it inspired only the elite design community and the relatively small, progressive, furniture market segments led by Knoll and Herman Miller. At the end of the program, MoMA had to concede it did not influence the dominant furniture market as it had intended. Average consumers continued to prefer traditional furniture and most U.S. manufacturers continued to produce traditional design for the rest of the century.

Concurrent with MoMA's Good Design campaign of five years, modern design was fast becoming an international competition, and consumers benefited from an expanding choice in home furnishing designs. Seeking good design, wherever it might be found, MoMA's curatorial assistant for architecture and design, Ada Louise Huxtable (b.1921), had organized a traveling exhibition, The Modern Movement in Italy: Architecture and Design, in 1950. In 1952, Edgar Kaufmann, Jr., organized a MoMA exhibition, Olivetti: Design in Industry. Olivetti, an Italian pioneer in typewriter manufacturing since 1896 who had utilized modern design since 1936, was the first European company invited to show its products and graphic work at the MoMA. Marcello Nizzoli (1887–1969), who was hired by Olivetti full time in 1938, designed Olivetti's latest Lettera 22 typewriter in 1950. The Olivetti exhibition inspired U.S. companies such as IBM to consider design as a corporate strategy.

Another museum was promoting and providing Italian design access to American markets. In 1950, the Art Institute of Chicago held an exhibition, Italy at Work, in cooperation with the Italian government. It was the result of an intensive field survey of three months in Italy by a team consisting of Walter Dorwin Teague, Meyric Rogers, architect Charles Nagel (1899–1992), director of the Brooklyn Museum, and Ramy Alexander, vice president of the Compagna Nazionale Artiginia (CNA), representing Italian artisans producing products for U.S. distribution. The team selected about 2500 items for the exhibition from a wide range of designers, including Giovanni "Gio" Ponti, Fabrizio Clerici (1913–1993), Luigi Cosenza (1905–1984), Roberto Menghi (1920–2006), and Carlo Millino (1905–1973). Most of the items were craft-based decorative home furnishings and available in limited quantities, but a few were mass manufactured — espresso machines, office machines, and a Lambretta motor scooter designed by Corradino D'Ascanio (1891–1981) among them.

European imports had begun in 1946. By 1948 Scandinavian products were available at the George Jenson Store and the Bonniers Store in New York. Swedish Modern, Inc., was distributing products in New York, Dallas, and San Francisco. West Germany mounted an exhibition of their products at the Museum of Science and Industry in New York in 1949.

Olivetti Lexikon 80 typewriter, by Marcello Nizzoli, 1948 (from Society of Industrial Designers' *Industrial Design in America*, 1954, courtesy IDSA).

That same year, France opened a showroom in Rockefeller Center called Formes Francaises. By 1950, the French Le Creuset line of porcelain-enameled cast iron cookware was being imported to the U.S. In the Netherlands that year, the Institute for Industrial Design was formed; by 1962 it functioned as the Centre for Industrial Design with a permanent exhibition of designs.

In 1946, Walter Gropius and several of his Harvard architectural colleagues, including Benjamin Thompson (1918–2003), had founded The Architects Collaborative (TAC) to promote modern design. In 1951, Thompson established a retail shop, Design Research, Inc. (D/R), in Cambridge, Massachusetts, the first of its kind selling well-designed, mostly imported products in the U.S. D/R soon opened branches in New York and San Francisco. Among D/R's many imported products were Hans Wegner's 1949 teak armchair with cane seat and nesting sets of classic 1950 Margrethe melamine mixing bowls designed by Bernadotte & Bjørn, both produced in Denmark. Another was English designer Ernst Race's 1951 Antelope Chair with molded plastic seat. Domestic designs included Isamu Noguchi's 1948 paper Akari lamps by Knoll. But for Americans who were looking for museum quality "good design" products, they were most likely to find them in European imports.

Chapter 10

1950–1965
Imports and Contradictions

Imports increased dramatically as European countries and manufacturers recovered, found distribution means in the large U.S. markets, and increased trade promotion through exhibitions. In 1951, Britain's Council of Industrial Design (CoID) commemorated the centennial year of the Great Exhibition of 1851 with the Festival of Britain, held on the south bank of the Thames in London. The CoID carefully screened submissions to keep out anything that failed to display the highest quality of design; they also planned an international design congress to be held at the Royal College of Art as an official event of the festival. As speakers, they invited hardheaded business executives from Britain and foreign firms who evidenced consistent design policies. Arthur A. Houghton, Jr. (1907–1990), vice president of Corning and president of the Steuben companies, and Arthur BecVar, director of design at General Electric, represented the U.S.

U.S. industrial designers were adapting to the postwar design culture, and consolidating their position of leadership. In 1951, the American Designers Institute (ADI) changed its name to the Industrial Designers Institute (IDI) and absorbed the Chicago Society of Industrial Designers (CSID), founded by Dave Chapman. In 1955 IDI would open new national headquarters in New York City with 200 members. The IDI, perhaps inspired by MoMA's "Good Design" program, initiated the first annual national industrial design awards, recognizing the best designs and crediting individual designers. Among the 1951 winners were a DAX molded fiberglass chair by Eames, and the Schick Model "20" electric shaver by Carl Otto, who had just left Loewy's office in London, which he had managed since its reopening in 1947, and had just established his own office in New York. Annual IDI awards would continue until 1965.

The "big three" designers, Dreyfuss, Loewy and Teague, all members of the rival Society of Industrial Design (SID), were horrified at the idea of publicly crediting individual designers rather than their own name as firm principal. But this was the trend, to the benefit and reputations of many young designers.

The first design conference in Aspen, Colorado, was initiated in 1951 by Walter Paepcke, head of the Container Corporation of America (CCA), at the urging of CCA consultant Herbert Bayer and CCA director of design, Egbert Jacobson. Bayer had been engaged by Jacobson in 1946 and had conceived the "Great Ideas of Western Man" advertising campaign to let well-known illustrators, artists, and graphic designers illustrate important quotes by historical figures. The program, which ran from 1950 to 1975, demonstrated the way business and design could collaborate to advance corporate visibility and prestige. The Aspen conference followed up on this initiative, and would become a major annual event as the International Design Conference in Aspen (IDCA).

Also in 1951, The Package Design Council (PDC) was formed in New York City by a number of package designers and industrial designers. The first president was James Nash. A number of industrial design firms were involved with the expanding package and graphic design business.

Raymond Loewy established an office in Paris in 1951, Compagnie de L'Esthétique Industrielle (CEI), headed by Harold Barnett. Henry Dreyfuss (SID) appeared on the cover of *Forbes* magazine that year, and Loewy published his book, *Never Leave Well Enough Alone*, a flamboyant, romanticized, and self-promotional autobiography that attracted hundreds of young men to a profession that promised wealth, celebrity, and influence. That same year, Russel Wright (SID) and his wife, Mary, published *A Guide to Easier Living* to promote their convictions and concerns about modern lifestyles. In 1952, Hull

Edison portable Voicewriter dictaphone, by Carl Otto, Industrial Designers Institute national award, 1952 (from Society of Industrial Designers' *Industrial Design in America*, 1954, courtesy IDSA).

Cutlery produced the first U.S. modern stainless steel flatware, Pattern Highlight, designed by Wright, and Knoll its Bertoia collection. In 1953, the Northern Industrial Chemical Company introduced Wright's Residential, the first plastic (a melamine called Melmac) dinnerware for consumer use, in mix and match colors. It encouraged other manufacturers to enter the emerging plastic dinnerware market.

American designers were becoming more visible to Europeans. In 1952, Walter Dorwin Teague, SID, in an article in Britain's *Art & Industry* magazine, while promoting American design chided British design colleagues for "a certain amount of 'ribbing' ... on what they consider our penchant for 'streamlining.'... [which has become] 'a popular metaphor for anything smooth and svelte'... and is carefully avoided by designers except when it can be used with technical accuracy [as in aerodynamics]."[1] After 20 years, the term "streamlining" was finally disappearing.

European manufacturers were seeking out American designers to design their products for American markets. In 1954, Pott GmbH, Germany, produced Design 1, stainless steel flatware designed by U.S. designer Don Wallance (1909–1990) and distributed by H.E. Lauffer, New York. Philip Rosenthal of Germany's Rosenthal China had engaged Raymond Loewy Associates as consultants with Richard Latham, head of Loewy's Chicago office, in charge. In 1954, urged by Latham, Rosenthal began using outstanding international designers for its special division of Studio-Linie products, starting with Coffee Service 2000 by Latham for Loewy. They were distributed internationally in special showrooms called Studio Houses. Over the next 30 years, Rosenthal would employ more than 100 designers from 11 nations for this line.

Japan was seeking to establish industrial design programs with American assistance. A number of American designers, including Russel Wright, George Nelson, Freda Diamond, and Jean Reinecke, traveled to Japan after 1950 to design products and packages. Japan sent

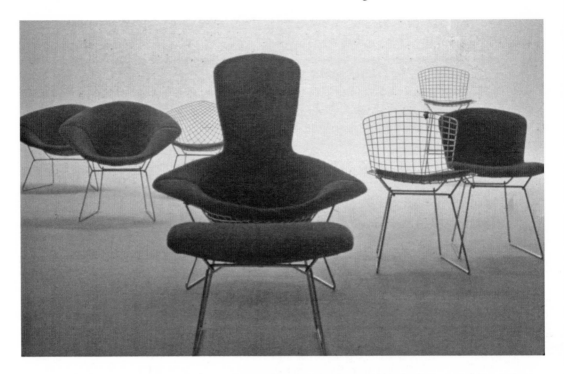

Knoll's Bertoia collection, designed by Harry Bertoia (courtesy of Knoll, Inc.).

about 70 students to the U.S. and Europe to study industrial design and initiated similar programs in Japan. In 1952, the Japan Industrial Designers Association (JIDA) was formed, and a Japanese Trade Center was opened in New York in 1954. In 1956, the Art Center School in California sent a team to advise the Japanese regarding industrial design practice and education. In 1959, Jay Doblin and Dave Chapman taught a special class at the Japanese Industrial Arts Institute on design concepts and development. The Japan Export

Design 1 stainless steel flatware, by Don Wallance, 1954.

Trade Organization, in collaboration with the Walker Art Center and the Smithsonian Institution, in 1960 staged an exhibition, Japan: Design Today, which toured 14 American museums and art centers.

The first consulting industrial design practice in Japan was GK Design Group, established in 1957 by Kenji Ekuan (b. 1929). Ekuan explained the secret to Japanese design success: "Tradition has it that we Japanese lack originality and are adept only at imitating foreign behavior and products.... This had been the custom since the prehistoric Jomon age. We begin by replicating an imported object — and make out of it something quite supe-

rior to the original — We Japanese believe we cannot understand the soul of foreign things, so we attempt to grasp this by making an imitation."[2]

European design was increasingly visible to Americans. As if to reinforce this trend, in 1951, the Museum of Modern Art held an exhibition, 8 Automobiles, chosen as historical "works of art," the standard MoMA definition of "good design." Foreign cars were in the majority, except for the 1936 Cord, 1940 Lincoln Continental, and the 1941 Jeep. That same year, General Motors and Harley Earl exhibited a concept convertible called LeSabre, as far from European design as possible. Named after the North American F-86 Sabre jet fighter of the Korean War then in progress, it was designed by Homer LaGassey (b.1934) with the first true, curved, wrap-around windshield, tail-fins, and a "jet" air intake for a grille. The design would set GM style trends for ten years. Cars would become lower without reducing headroom, by lowering the floor level and reducing seat height.

In 1953, GM debuted the Chevrolet Corvette, the first U.S. sports car produced in quantity and the first with an all-fiberglass body, which was designed by Harley Earl and his staff members Robert McLean, Clair McKeegan, and Larry Shinoda. It was an instant success and would become a classic. The same year, Studebaker introduced its Starliner, acclaimed by the Museum of Modern Art as "a work of art." The design, by Robert E. Bourke, head of Raymond Loewy's design group in South Bend, assisted by Randall D. Faurot and Holden "Bob" Koto, blended European and U.S. design styles into a low, graceful masterpiece. In 1954, at GM's annual Motorama, Harley Earl exhibited his Firebird "dream car," along with the Kitchen of Tomorrow unveiled by GM's Frigidaire Division, designed by Alexander and Rowena Kostellow with stainless steel appliances that retracted into cabinets. Ford responded to GM's Corvette in 1955 with its Thunderbird sports car by Bill Burnett, William F. Boyer, and Franklin Hershey (1907–1997) under Ford's vice president of styling, George Walker.

1953 Studebaker Starliner, by Raymond Loewy's South Bend group, headed by Robert E. Bourke. Raymond Loewy is standing behind car (courtesy Patricia Madawick).

In 1954 the Society of Industrial Designers had 126 members and regional chapters in New York, Chicago, Cleveland, and Los Angeles. These major urban centers essentially defined the geographical limits where designers could find work at this time, as most manufacturing companies and design offices were located in these areas.

SID marked its 10th anniversary with the publication of *Industrial Design in America*, publicizing the work of its members in a 224-page hardcover book with color illustrations and case studies. That same year, SID sent exhibits with 40 U.S. industrial designs to the Tenth Triennale in Milan, Italy, under its theme, Industrial Aesthetics. Exhibits were displayed in two, just-patented, Buckminster Fuller geodesic domes, the structural innovation that would make him famous. Recognizing its growing role interacting with international organizations of design, the SID changed its name to the American Society of Industrial Designers (ASID) to better represent its nationality.

Foreign competition was increasing exponentially, both in imported designs and in design organization. The U.S.'s 20-year monopoly was coming to an end. In connection with the 1954 Triennale, La Rinascente department store in Milan, Italy, established annual Compasso d'Oro (Golden Compasses) awards for good design. The Italian Associazione per Disegno Industriale (ADI) presented the awards. At the same time, Alberto Rosselli published *Stile Industria* (*Industrial Style*) in Italy as a sister periodical to *Domus*. Dansk International Designs was founded by Danish designer Jens Quistgaard (1919–2008) and U.S. businessman and retired industrialist, Ted Nierenburg (1919–2009). Quistgaard's designs interpreted the beauty of wood with modern forms into attractive and popular

Servel portable refrigerator, the Wonderbar, by Donald Dailey, 1953 (courtesy Deanne Dailey Hansen).

housewares. In 1958, Ingmar Kamprad would found IKEA in Sweden, with showrooms of modern furniture to "further the era of functionalism in design," and which would evolve into a huge international retail chain in the 1970s.

Industrial Design, the first industrial design magazine, published its first issue in 1954. It was founded by Jane Fiske Mitarachi (Later Jane Thompson), and designed by prominent graphic designer Alvin Lustig (1915–1955). It initiated its "Annual Design Review" that featured the magazine's selection of the year's best designs and would become an important promotional tool for the recognition of current designs and designers. Designers continued to be regarded as critical to business success. That year, the film *Executive Suite* starred William Holden as a vice president of design who saved a company in trouble by convincing other executives to improve the quality of their furniture; they voted him president of the company.

By 1955, a new generation of designers, formally educated in post–World War II academia, began to fill the ranks of industrial design and to look more critically at the profession and the world about them. In architecture, glass-box design was being recognized as being visually at war with its surrounding buildings. As architect/furniture designer Eero Saarinen stated in an address to ASID's annual conference in 1955, "An otherwise excellent architect builds a modern building next to some very fine historic buildings on an old campus and ignores all relationships of scale, mass, material and texture.... [I]t looks terrible because it is in disharmony with its surroundings, and the total view is more important than the individual building." Industrial designers were not without fault, either. Saarinen cited

Pedestal or Tulip chair by Eero Saarinen, for Knoll, 1956 (courtesy Knoll, Inc.).

"the hours of modeling and sketching and planning you [industrial designers] have done on the ice box [he probably meant "refrigerator"] but not until very recently was there one on the market that could be integrated with the community of objects that makes a kitchen." His point was that "Every object, small or large, has a relationship with its neighbors and this is so often ignored by our profession. There is too much egocentric concentration on the object itself.... They cannot live in isolation. They are part of the community of objects, which is man's environment."[3]

This is one of the earliest uses of the term "environment" by a designer as a better and more contextual standard for "good design." Ironically, his statement was made just as MoMA's "good design" program, based on "design as objects of art" was ending rather unsuccessfully, a program in which he had starred as one of MoMA's favored designers since 1941. In fact, Knoll Associates were about to introduce Saarinen's highly acclaimed Pedestal Chair and related table and stools—graceful, white

organic shapes supported by a single stem flowing from a circular base. Ironically, they were admired as "objects of art" amidst an environment of horizontal and vertical interiors.

Saarinen's prescient comments and point of view at the ASID conference, however, would take some time to become commonplace, particularly in architecture. Although Le Corbusier had reacted against the International Style of MoMA with his flowing forms of a chapel in Ronchamp, France, Notre-Dame-du-Haut, in 1954, the International style, promoted by the Museum of Modern Art since 1932, was just getting started. The Lever House by architects Skidmore, Owings, and Merrill had recently been completed in New York in 1952; and in 1958, the Seagram Building in New York would be completed across the street, designed by Mies van de Rohe, who had inspired the movement. These glass boxes would become the prototypes for office buildings of the 1960s and 1970s until, finally, many other architects would share Eero Saarinen's contrary view. Frank Lloyd Wright had always opposed the International Style, and had the last say in 1959, the year of his death, when his Guggenheim Museum demonstrated his own organic and elegant answer to glass boxes.

In Germany, another legacy of Mies van der Rohe, the Bauhaus, was being resurrected, at least in spirit, in 1953 by the Hochschule für Gestaltung (HfG, Institute for Form), a school of design in Ulm founded as the "New Bauhaus" and funded by the German government and the American High Commission to foster national recovery for Germany. Max Bill (1908–1994), a former Bauhaus student, was named director, with Argentinean Tomás Maldonado (b. 1922) as deputy.

At the same time, Max Braun's sons Artur and Erwin were reorganizing the German appliance company Max had established in 1921. They engaged Dr. Fritz Eichler (b.1911) to direct a new design program for Braun in collaboration with the Hochschule für Gestaltung and the initial Braun design was the SK 2 radio by Artur Braun and Eichler in 1955. Eichler then hired Hans Gugelot (1920–1965), Otl Aicher (1922–1991), Gerd Alfred Müller (1932–1991), and 23-year-old Dieter Rams (b. 1932). The new department established the most consistent corporate and product aesthetic style to date, using spare, undecorated, geometric forms and neutral colors in the classic Bauhaus tradition.

The school abandoned its focus on product design in 1956 in favor of theory, but after 1957, Rams headed the Braun program that would achieve global recognition as a model of corporate industrial design quality and consistency. The first product to attract widespread international attention was the Braun Model KM 3/KM 31 Kitchen Machine, designed by Müller, and introduced in 1957. Soon, the Museum of Modern Art enthusiastically celebrated this renewal of Bauhaus design philosophy with the creation of a permanent display of Braun products in 1958, thereby conferring its imprimatur upon an outstanding example of international style.

Another major corporation in the U.S., IBM, had adopted design as a corporate business strategy in 1956. Thomas J. Watson, Jr., president of IBM, engaged Eliot Noyes as consultant design director to improve the visual quality of IBM products, graphics, exhibitions, interiors, packaging and architecture, in order to compete esthetically with Italian competitor Olivetti. Noyes engaged additional consultants, including graphic designer Paul Rand (1914–1996), Charles Eames, and Edgar Kaufmann, Jr. The program would become a model of an effective "house style," controlled by an extensive and comprehensive *IBM Design Guide*, which would inspire a number of corporations to follow suit.

The success of the IBM program emboldened industrial designers to expand their services beyond consumer products. Basic material suppliers now realized that designers not only could specify their material in new products, but they could also promote their cor-

porate image as innovative and forward-looking. In 1958, U.S. Steel set up a department under automotive designer John Reinhart, who engaged Lippincott & Margulies to create a corporate identity program, including their famous Steelmark. It was adopted by the entire steel industry, and after many years of industry service would become the trademark of the Pittsburgh Steelers football organization.

The Aluminum Company of America (ALCOA) in 1958 used design to promote its corporate image as a creative, inventive company, and to encourage designers to use aluminum creatively. It initiated its Forecast series of advertisements, featuring concepts by well-known designers, including the Sun Machine, a sun-powered "do-nothing" machine designed by Charles Eames. The following year, ALCOA initiated design awards to students of five participating schools, an annual program that would continue until 1971 and featured industrial design awards to Charles Eames, Peter Muller-Munk, and Fred W. Priess.

With international designs now competing in U.S. markets, design organizations were also expanding internationally. In the UK, the Council of Industrial Design (CoID) in 1956 opened the Design Centre in central London, cosponsored by the government and industry, to disseminate design information and to exhibit good design for manufacturers and the general public. That same year, ASID and the Museum of Modern Art cosponsored a seminar in New York on Industrial Design in Europe Today, with speakers from England, France, and Germany.

In Paris, representatives from American, British, French, West German, Belgian, and Italian design organizations met in what was called the International Coordinating Committee of Industrial Design. Their purpose was to serve as a clearinghouse for exhibitions and information, to organize conferences, and to encourage participation by design organizations in other countries. They elected a provisional executive board comprised of Peter Muller-Munk of the American Society of Industrial Design (ASID) as president, Misha Black (1910–1977), of the British Chartered Society of Designers, as vice president, French architect Pierre Vago (1910–2002), of the International Union of Architects, as secretary, and French art critic Robert L. Delevoy as treasurer. The provisional board was charged with developing a constitution for a new international organization, and in June 1957, the International Council of Societies of Industrial Designers (ICSID) was founded, comprising 23 professional and promotional design organizations from 17 countries. Muller-Munk was elected president, Misha Black, executive vice president, Italian architect Enrico Peressutti (1908–1976), vice president, and Pierre Vago, secretary-treasurer. The organization was registered in Paris and the secretariat was set-up at 17 Quai Voltaire. The first ICSID Congress and General Assembly was held in Stockholm, Sweden, in September 1959, and a constitution was adopted. By 1960, ICSID had 40 members from 30 countries. That same year, the Institute of International Education, headed by Paul Reilly, in collaboration with ICSID, initiated the Kaufmann Award of $20,000 to recognize design excellence. The first award went to Charles and Ray Eames "for the practice of design."

Design educators in the U.S., frustrated because neither the IDI nor ASID would accept educators as full members unless they were also practicing professionals, in 1957 founded a third competing design organization, the Industrial Design Education Association (IDEA). Joseph Carriero (1920–1978), chairman of the industrial design department at the Philadelphia Museum School of Art, was its first president. By 1960, IDEA had 50 members.

Many European countries had promotional industrial design organizations that were funded by governments to promote trade and exports. U.S. design organizations were private and had no such funds to promote U.S. design abroad. To address this problem, Walter

Dorwin Teague succeeded in convincing the U.S. Information Agency (USIA) to fund a design exhibit at the 1957 Italian Triennale. It was a creative collaboration between the design community and the government to promote U.S. design (and capitalism) abroad. Paul McCobb designed the exhibit of 200 U.S. designs in a geodesic dome designed by R. Buckminster Fuller. An RCA 8½ inch-screen, 22-pound, "personal" television set designed by Henry Rundle won honors, and the collaboration between the design community and the government would become standard practice.

In 1958, the first world's fair since the war, Exposition Universelle et Internationale de Bruxelles, or Expo '58, was held in Brussels, Belgium, amid cold war rivalry between the U.S. and the Soviet Union. The U.S. pavilion predictably included a number of contemporary products, as well a controversial exhibit designed by Leo Lionni (1910–1999), Unfinished Business, dealing with American social issues such as segregation (the civil rights movement was well under way in Little Rock, Arkansas, with federal troops forcing integration at Central High School), urbanization, and waste of natural resources. A Charles Eames film, *The Information Machine*, sponsored by IBM, was also an attraction. It was a cartoon tracing the history of storing and analyzing information from the caveman to the massive IBM computers, or "electronic brains." That same year, Control Data Corporation had produced the first transistorized "supercomputer."

This effort was followed in 1959 with a sophisticated USIA exhibit, American National Exhibition of American Culture, intended by the government, in the current cold war atmosphere, to illustrate the success of Capitalism over Communism in material goods, and intended by the design community to promote U.S. design. The Cold War had escalated since 1957, when the Soviet Union had launched Sputnik into earth orbit, demonstrating its technical superiority in space orbital flight. The two governments had agreed in 1958 to exchange cultural exhibitions. The Soviet exhibition opened in New York in June. The U.S. exhibition was designed by George Nelson and opened in Moscow's Sokolniki Park in July. It featured presentations by Charles Eames, a geodesic dome by R. Buckminster Fuller, and a model kitchen in a model ranch-style suburban home. It was in this kitchen that the famous "Kitchen Debate" between USSR Premier Nikita Khrushchev (1894–1971) and U.S. vice president Richard Nixon (1913–1994) took place. Fuller's dome attracted worldwide attention that bordered on a fad. USIA would continue similar cultural design exhibitions in communist countries until the demise of the Soviet Union in 1991.

By 1959, one hundred twenty corporations had internal design departments, as compared to 180 industrial design consulting offices, according to a *Fortune* magazine survey. Corporations had done so for the obvious reason of reducing the exorbitant costs of most big-name industrial designers. Of the 300 total organizations surveyed, 180 designers were members of IDI or ASID. Because of this increase in corporate design staffs, the day when a leading design consultant could get $50,000 to design a single cigarette package had passed. It was now more common for retainer fees to range from $500 to $5000 per month, depending on the prestige of the firm and the amount of partner's time (a typical corporate designer made about $5000 per month).

With most traditional consumer products by now apparently redesigned, designers were looking for new areas of service. No one could foresee the vast new wave of electronic products that would soon be spawned by microchips and computers. Industrial design services had therefore broadened from product design into what many called "total service" design that included product planning, architecture, interiors, packages, graphics, merchandising, retailing, public relations and corporate identity. *Fortune* in February 1959

named the 20 largest industrial design firms, based on their gross revenues, which ranged from $2 million to $400,000:

Raymond Loewy Associates, N.Y. and Chicago—architecture, interiors, packages, graphics. Staff: 200.
Cushing & Nevell, N.Y.—engineering services, exhibits.
Lippincott & Margulies, N.Y.—packages, architecture & interiors. Staff: 100.
Walter Dorwin Teague Associates, N.Y—architecture, interiors, products. Staff: 140.
Jim Nash Associates, N.Y.—packages, corporate identity.
Donald Deskey Associates, N.Y.—packages, corporate identity.
Henry Dreyfuss, N.Y. and Pasadena—products, architecture, & interiors. Staff: 50.
Harley Earl, Detroit—products, packages.
Dave Chapman, Chicago—products, packages. Staff: 50.
Peter Müller-Munk, Pittsburgh—products, corporate identity. Staff: 30.
Sundberg-Ferar, Detroit—products, packages. Staff: 50.
Walter Landor & Associates, San Francisco—packages, corporate identity.
Brooks Stevens Associates, Milwaukee—products, architecture & interiors, corporate identity.
Eliot Noyes, New Canaan, Connecticut—architecture & interiors, products, corporate identity.
George Nelson, N.Y.—architecture & interiors, products, exhibits. Staff: 24.
Smith Scherr & McDermott, Akron, Ohio—products, packages.
Becker & Becker Associates, N.Y.—products, architecture & interiors.
Peter Schladermundt Associates, N.Y.—products, packages.
Latham, Tyler, Jensen, Chicago—products, corporate identity.
Russel Wright, N.Y.—provducts, exhibits. Staff: 25.[4]

America was undergoing dramatic internal change in 1956, as the postwar period ended. Change in civil rights, as segregation was ending. Change in technology, as the Cold War escalated into a space race with the Soviet Union, as transistors reduced the size of many electronic devices, as computers like IBM's RAMAC were operating in commercial operations, as microchips were being invented, and as polycarbonate structural plastics came into use. Change in demographics, as there were as many white-collar workers in the U.S. as blue-collar workers. Change in transportation, as "jumbo jets" entered service. Change in infrastructure, as construction began on the Federal Interstate Highway System initiated under President Dwight Eisenhower (1890–1969).

The new interstate system appeared to presage a new age for U.S. automakers, but instead, they were being threatened by foreign competition. From 1955 to 1959, foreign imports of Volkswagens, Karmann Ghias, Porsches, and Mercedes from Germany; Toyotas and Nissans from Japan; Morris Mini Minors, Triumphs, and MGs from England; and Saabs from Sweden increased from less than 1 percent to 10 percent of the U.S. market. Global competitors were making cars cheaper, more fuel efficient, and often of higher quality than was Detroit. Raymond Loewy observed as follows: "Do you not find it significant that in four years, U.S. auto exports were cut down 50%, with imports up 12 times? I do. Designers abroad are forced to substitute intelligence and design shrewdness for our type of lavishness. Our state of plenty is nerve dulling. This happy land is not the safe continental pasture it once was."[5]

Traditional automotive names such as DeSoto began to disappear or merge to form Studebaker-Packard (1954) or American Motors Corporation (1954, Hudson/Nash). Within 10 years Studebaker, Packard, Hudson and Nash would be gone. At Chrysler in 1957, vice president Virgil Exner introduced a new "Forward Look" which featured tailfins even higher and bolder than those of GM cars. GM retaliated with the most dramatic tailfins ever on its 1959 Cadillac, which would be Harley Earl's parting shot as he retired from GM; he was

replaced by William Mitchell (1912–1988). Detroit was the last holdout of aircraft imagery as "streamlining" rather than the genuine aerodynamics of performance. The design profession in general continued to regard Detroit as a pariah and used the term "styling" only as an epithet. Typical were comments by Walter Dorwin Teague: "I agree heartily with millions of others that our characteristic car design has in recent years become lousy, ugly, ostentatious, impractical and excessively costly; and what is worse from management's point of view, this kind of design has come a spectacular cropper in the market."[6]

Ford outsold GM in 1957 for the first time in history, partly because it successfully recreated its classic 1940 Lincoln Continental with its new Continental Mark II, which had no excessive tail fins. But in 1958, Ford came out with a new brand, the Edsel, named after Henry's son. Designed by chief Ford stylist Roy A. Brown under vice president George Walker with exhaustive market research, it was a huge failure. Losses of $350 million would force cancellation of the brand in 1959, and the name Edsel would haunt the car industry for years, as had the Chrysler Airflow of 1934.

There were some U.S attempts to combat foreign competition with smaller cars. The 1957 Nash Metropolitan NX1, a compact car, was the first. In 1959, Studebaker introduced a compact Lark, designed by Duncan McRae, William O. Bonner, and Virgil Exner. In 1960, Chevrolet introduced the Corvair, a compact design with minimum chrome and no fins, quite unlike traditional GM designs. Designed by Ron Hill and GM staff, it was acclaimed by the design community and received an IDI design award, but it was plagued by an oversteering tendency that caused fatalities. Ralph Nader (b. 1934) would later call it "one of the nastiest-handling cars ever built." Nader's criticism of auto safety hazards would initiate government safety regulations in the industry.

The failure of market research for the Edsel closely followed Vance Packard's (1914–1996) 1957 book, *Hidden Persuaders*, which claimed that advertisers manipulated customer's wants and needs with motivational research. Designers were also to be blamed, because they, according to Packard, forced "unnecessary" product design changes on the public. Packard singled out Brooks Stevens as "the crown prince of planned obsolescence." Brooks himself had coined the catchphrase in 1954 to describe the industrial designer's mission as "instilling in the buyer the desire to own something a little newer, a little better, a little sooner than is necessary."[7] There was nothing new about this practice. In fact, it had been the principle engine of America's unparalleled economic growth since 1930, when Ernest Elmo Calkins first defined it: "The styling of goods is an effort to introduce color, design, and smartness in the goods that for years now have been accepted in their stodgy, commonplace dress. The purpose is to make the customer discontented with his old type of fountain pen, kitchen utensil, bathroom or motor car, because it is old-fashioned, out-of-date. The technical term for this is obsoletism. We no longer wait for things to wear out. We displace them with others that are not more effective but more attractive."[8]

It was this principle of generating consumer demand that created the postwar economic boom. Packard's argument was somewhat specious. It would deny advertisers or designers the right to design and promote new products and deny the public choice of free market options and genuine product improvements. To produce products that are functionally "necessary" only because "old ones" are no longer working might be morally "frugal" but totally unacceptable to modern consumers wanting something better. Packard apparently did not understand that consumers have more than "needs." They have "wants" as well. Following Packard's argument to its logical conclusion would mean that any new designs that tempted consumers (with increased quality, decreased cost, or functional improve-

ments, etc.) would be regarded as being forced "unnecessarily" upon consumers, and manufacturers would make only things people did not want.

The issue had now become of interest largely because the public was becoming more sensitized to social injustice and morality than with growing the economy. The launch of Sputnik had made the U.S look technologically impotent, and by comparison, made our consumer culture look shallow and self-indulgent. After 10 years of uninterrupted economic growth, people assumed it would continue indefinitely and automatically. They were wrong. The American economy was being challenged from abroad, just as was our technology. Only innovation and new products could meet such intensive competition, not denying manufacturers the right to compete fairly in the marketplace with product improvements.

Largely because of the notoriety of Packard's book, the industrial design profession came under fire for "too many" new designs, its specialty since the 1930s. Packard's book forced it into a defensive position. In 1958, Dave Chapman, Henry Dreyfuss and Walter Dorwin Teague mounted a campaign against "phony obsolescence" that added gimmicks and superficial changes; but they agreed with planned obsolescence that resulted in genuine product improvements. According to Walter Margulies, "Change fills a basic human need." Dave Chapman commented: "Europe is horrified, but Europe doesn't understand that we produce in one year what they produce in 10." William Snaith of Loewy's office, wanted to know "what's so sacred about goods?"[9] Stevens himself argued that "the item you trade in is never junked, destroyed, or thrown away. It is moved into the used merchandize market and is bought by someone who might not have had the product in any other way. Think how many have been helped that way."[10]

The issue faded after a year or so, but it was an early warning that after 25 years of being in the limelight of public acclaim, the profession of industrial design might be heading for leaner times. Social issues were becoming more relevant to the public than the acquisition of material goods, and postwar product design euphoria was coming to a close. Industrial design, however, still had some public cachet as a somewhat exotic profession, as evidenced in the 1959 classic film *North by Northwest*, where actress Eva Marie Saint played Eve Kendall, who described herself as an industrial designer to Roger Thornhill, played by actor Cary Grant.

The civil rights movement now dominated the national agenda, with sit-ins and forced integration of schools in the south. Hardly noticed was the fact that several African Americans had recently graduated from college and entered the industrial design profession. Charles Harrison (b. 1931) had graduated from the School of the Art Institute of Chicago in 1954 and in 1961 would start as a designer at Sears, Roebuck & Company, where he would design hundreds of consumer products over the next 32 years. Noel Mayo received his degree from the Philadelphia College of Art in 1960 and later founded the first African American design firm, Noel Mayo Associates; he would become the first African American chair of an industrial design program in the U.S. at his alma mater, now the University of the Arts in Philadelphia.

Despite the challenging national problems of segregation and civil rights demonstrations, the country appeared to enter a new era of optimism in 1961, when president John F. Kennedy (1917–1963) took his oath of office. His challenge to reach the moon accelerated the space race, and his concept of the Peace Corps promised to engage young people in international good will. But within three months, the failed Bay of Pigs invasion in Cuba brought the world close to a nuclear war. Baby boomers born in 1946 were now teenagers obsessed with Elvis Presley, who had just been discharged from the army in 1960. Soon they

First automatic copier, 1959, the Haloid Xerox 914, by James G. Balmer, Jr., principal of Armstrong/ Balmer Associates (courtesy Xerox Corporation).

would turn their attention to the Beatles, who were just forming in Liverpool. A 600-foot "Space Needle" symbolized the Century 21 Exposition theme in Seattle in 1962, Man in the Space Age. However, the only "men in space" at that time had been the USSR's Yuri Gagarin (April 1961) and the U.S.'s John Glenn (February 1962), both of whom had achieved only earth orbital flight.

Designers were well aware that they were competing globally. At IDSA's 1962 annual conference, Raymond Loewy expressed his belief: "Nothing great has ever been achieved — whether by a nation, a business, an individual — without quality.... Now, we are at a point where that belief is being put to the test. Americans are in a massive race to maintain our leadership against other nations in trade, training, goods, and taste."[11] At the same conference, August Heckscher (1914–1997), President Kennedy's "special consultant" on the arts, in his address, "The Place of Industrial Design in American Culture," eloquently concluded: "The need is evident, across the whole landscape of man, from the smallest object to the greatest, from the most transient to the most enduring, of a heightened concern for the quality of things. I do not say for their appearance; I do not say for their beauty. I say for their quality as things— their capacity to be the objects it is their nature to be, to serve their function truly, to have an inner spirit made visible and the inner form made dominant."[12]

Design was also becoming a weapon in the Cold War. In 1962 the Soviet Union established the All-Union Research Institute of Industrial Design (VNIITE) with Yuri Borisovich Soloviev (b. 1920) as director. He was trained in the arts, architecture and engineering, and had been an industrial designer since 1943. VNIITE had the urgent charge of "catching up to the West" by inventing new design methods and exploring the relationship between technology, science, and art. By 1967, VNIITE had founded 15 branches and about 200 design groups involving 10,000 people. It was the largest institute for design research in the world in 1991 when the Soviet Union dissolved and state subsidies ceased.

In 1963 and 1964, the U.S. Information Agency (USIA) sponsored a new exhibition in the USSR and Eastern European countries, Graphic Arts USA, designed by Ivan Chermayoff (1900–1996) and Thomas Geismar (b. 1931), with selections made by the American Institute of Graphic Artists (AIGA). Later similar USIA overseas exhibitions would be held in 1965 (Architecture USA), 1966 (Hand Tools USA, designed by George Nelson), 1967 (Industrial Design USA, also by Nelson), and 1969–70 (Education USA).

In 1960, Chermayoff and Geismar had partnered in a firm of that name and would create over 100 outstanding corporate trademarks and identification programs over the next decade, including Mobil, Xerox, Chase Manhattan, Knoll, and PBS. Only Lippincott & Margulies would match them with similar graphic services to RCA, Chrysler, American Express, Coca-Cola, and Amtrak. It is interesting to note that almost all the new trademarks of this era were limited to typography and abstract symbols that were entirely two-dimensional in nature — no suggestion of three dimensions via shading, shadows, or highlights. Graphic designers were also organizing internationally. In 1963, the International Council of Graphic Design Associations (Icograda) was founded. It would hold a congress every two years and would maintain an archive in the Design Museum in London. In 1981, Icograda would hold a joint Congress with ICSID, and thereafter the two organizations would collaborate on many future programs.

In Germany, the Bauhaus was enjoying recognition for its pioneer role in industrial design. In 1960, a massive archive of Bauhaus documents and photographs was established in Darmstadt, Germany. Walter Gropius was awarded the $20,000 Kaufmann International Design Award for "achievement in design education," in 1961. In accepting it, he commented: "The answer to [rising above the fake values of marketing/promotion enveloping us] is more intensified education ... that does not only sharpen and illuminate the mind, but also forms the sensibilities and guides eye and hand as well." The Kaufmann Award in 1962 would go to the Olivetti Company "for outstanding use of design," and in 1963 to Volkswagen.

In 1962, Hans M. Wingler (1920–1984), using the Darmstadt archive, published *Bauhaus*, a comprehensive history of the famous school, and by 1976, the German Democratic Republic would restore the Bauhaus buildings in Dessau to their former glory.

In 1959, the General Agreement on Tariffs and Trade (GATT), formed in 1947 to encourage international trade, had begun to reduce tariffs, which enabled European home furnishings to be imported to the U.S. at lower cost. This provided new opportunities for importers and European designers to compete in U.S. markets. In 1960, Sam Farber formed Copco International to manufacture and distribute porcelain-enameled cast iron cookware designed by Michael Lax (1929–1999) over the next 35 years. Copco would establish cookware shops in specialty, gift, and department stores, and would also import European designs of high quality.

In 1962, Gordon and Carole Segal opened their first Crate & Barrel store in Chicago,

specializing in housewares and furniture. Their U.S. stores would eventually expand to 170 and become known for products of high quality design at low cost. In 1964, Terence Conran (b. 1931) would found Habitat in London, a contemporary home furnishings retail store that would become a U.S. chain called Conran's in 1977.

Corporate design departments continued to flourish. In 1959, Tucker Madawick, formerly of Loewy's office, joined RCA in Indianapolis as industrial design manager to head a staff of 60. He established the Advanced Design Center, which developed future concepts for television sets introduced in 1961 as "Sets of the Seventies." In 1961, 90 percent of households in the U.S. had TV sets, mostly black and white, but RCA chairman David Sarnoff announced optimistically, "It won't be long before color television will be a mass item of commerce." By 1966, it was.

In 1960, Westinghouse had struggled to increase its consumer products market share against giant competitors General Electric and Whirlpool. It hired Eliot Noyes to dramatize the company's image, which had become "non-descript and unsightly." Noyes engaged Paul Rand to design a new "Circle W" trademark and to develop a corporate design manual similar to IBM's. Noyes also recommended the restructuring of Westinghouse's design organization along the lines of General Electric's. Accordingly, by 1964, Westinghouse established a Consumer Products Design Center (CPDC) in Columbus, Ohio, under director of

Copco International's cast iron cookware, 1960, by Michael Lax (from Industrial Designers Society of America, *Design in America*, 1969, courtesy IDSA).

industrial design Cal Graser (1923–2000), who had come from IBM. The Columbus major appliance group was managed by Wallace H. Appel (b. 1925); the Mansfield, Ohio, small appliance group by Raoul A. Lambert; the television group in New Jersey by John Benty; and the lamp group by Walton E. Sparks, who also managed Advanced Industrial Design. By 1968, Westinghouse would establish a Corporate Design Center in Pittsburgh headed by E.W. (Pete) Seay. In 1974, falling profits resulted in the sale of Westinghouse's Consumer Products Company to White Consolidated Industries (WCI), and Wallace Appel became manager of industrial design there until 1980, when he became vice president of design.

Alcoa continued its annual design awards for professionals and students. American Iron and Steel Institute in 1963 joined the major material suppliers in recognizing design by initiating a biennial Design in Steel award program for U.S., Canada, and Mexican designers. The 10 winners ranged from a Pal razor by Henry Dreyfuss Associates to bridges

RCA "Sets of the Seventies," by RCA Advanced Design Center under Tucker Madawick, 1961 (courtesy Patricia Madawick).

and architecture. In 1965, Armco Steel initiated a student design program that would continue into the 1980s.

The International Council of Societies of Industrial Design (ICSID) held its second biennial congress in Venice, Italy, in 1961 with an extensive theme: The Responsibilities of the Industrial Designer in the Community and the Education of the Industrial Designer. At the conference, a past president of ICSID and professor of design at the Royal College of Art, Misha Black (1910–1977), requested research regarding schools of industrial design around the world. In 1976, this task was competed by a graduate student at the Illinois Institute of Technology under program head Jay Doblin. The list included 106 schools from 18 countries, with additional schools being started in India, Brazil and Argentina. In 1963 ICSID convened its third congress in Paris, and the Industrial Designer's Institute (IDI) held an exhibition of American design at the Louvre organized by Alfons Bach. Products exhibited were Studebaker's Avanti, IBM's Selectric typewriter, Lincoln's Continental Mark II, and a selection of U.S. products.

The 1962 Avanti, designed by Bob Andrews, Tom Kellogg, and John Ebstein of Raymond Loewy Associates for Studebaker, had become an instant success and would be produced for 30 years by enthusiasts; but by the time of the Paris exhibition, Studebaker as a company no longer existed. The revolutionary Selectric, designed by Eliot Noyes in 1961 with an elegant sculptured form, replaced the standard type bars with a spherical "golf ball" printing element that moved while the carriage remained fixed. The elegant Continental Mark II, designed with a team picked by Edsel's son, William Clay Ford, and unveiled in 1955, was cleaner than most Detroit designs of that time and was intended as a re-creation of his father's famous 1940 progenitor.

By 1963, 16 American design firms had offices abroad, and more than 30 were serving foreign clients from the U.S. Manufacturers from 22 foreign countries had contracts with American designers for projects. A global economy was becoming a reality, with individual national styles gradually blending into a fairly consistent international style due to the high level of communication among designers around the world.

Raymond Loewy had just designed the interior and livery for Air Force One when in November 1963 President Kennedy was assassinated in Dallas, Texas. This set in motion a decade of tragedies, civil unrest, and social change, when global competition, the Cold War,

1962 Studebaker Avanti, by Raymond Loewy Associates (courtesy Richard Quinn).

the Vietnam War (1960–1973), feminism (1963–1975), race riots (1965–1967), antiwar demonstrations (1968–1973), assassinations—Robert Kennedy (1925–1968) and Martin Luther King (1929–1968)—hippie culture (1967–1969), Charles Manson (1969–1970), and Watergate (1972–1974) would together create a continuous national sense of chaos and uncertainty bordering on schizophrenia.

IBM Selectric I electric typewriter, by Eliot Noyes, 1961 (courtesy IBM).

Nevertheless, the third New York World's Fair opened in April 1964 at Flushing Meadows, Queens, New York, and ran until October 1965, with the ponderous theme of Peace Through Understanding and dedicated to Man's Achievement on a Shrinking Globe in an Expanding Universe. Dominated by a 12-story high, stainless steel model of the earth by U.S. Steel called the Unisphere and a monorail designed by Walter Dorwin Teague, the fair included the most popular exhibit, GM's Futurama, designed by Henry Dreyfuss, and Scholar's Walk, an exhibit by Charles Eames in the IBM pavilion designed by Eero Saarinen. Walt Disney Enterprises, the creator of Disneyland in 1955, designed a number of exhibits (Pepsi, General Electric, Ford, and Illinois State) that demonstrated "audio-animatronics" with life-like, sound-emitting robots of dinosaurs, cavemen, dolls, and Abraham Lincoln.

The fair, intended to replicate the successful 1939–1940 fair, was held despite the fact that the Bureau of International Expositions (BIE) in Paris had requested its 40-member

The Kodak Model 800 Carousel slide projector, 1964, by David E. Hansen, of Kodak staff headed by Arthur Crapsey, Jr., transformed projectors for the rest of the century (courtesy Eastman Kodak Company).

nations in 1960 *not* to participate in the fair because it violated BIE rules that only one exposition may be held in any given country within a 10-year period (the Seattle Fair had been held in 1962) and that the event could run no longer than six months. So Canada, Australia, most European nations, and the Soviet Union did not participate, and the fair returned only 10 cents on the dollar to investors. Critics called the fair, "the design fiasco of the decade." While the fair was in progress, Japan Railways Group unveiled its high-speed, 130 mph, Shinkansen "bullet train" between Tokyo and Osaka, in time for the October 1964 Tokyo Summer Olympics. The design was in the classic "streamliner" style, very similar to the Union Pacific's 1934 City of Salina.

Designers were still fighting excessive chrome and glitter, moving violations of "good-design." In an article in *Home Appliance Builder* magazine, designer/educator Jay Doblin even coined new words for them to urge their omission: "Dingles," "Gorp," and "Bunk." "Dingles" were "something that, if you take a screwdriver and pry it off, hits and goes 'dingle' on the ground — and the product's utility hasn't been damaged in any way (maybe even improved). 'Gorp' is when an already existing functional component such as a headlight, knob, instrument, or air-intake is decorated to an extent far beyond its functional need. 'Bunk' is a dimple, lamination, or extraneous form on the surface of the product to create visual interest."[13]

The auto industry was still in its chrome and glitter period. Ford's new sporty 1964 Mustang was the car of the year in the U.S. It was a huge success with the 16- to 24-year-old crowd and a big feather in the cap of Ford's division president, Lee Iacocca (b. 1924). Designed by Eugene Bordinat, vice president of styling, Joe Oros, head of the Ford styling studio, and Ford's design staff, the Mustang won an IDI award and would become an American classic. At GM, the first "muscle car," the GTO Pontiac, designed by John Z. DeLorean (1925–2005), was introduced the same year. From Germany in 1964 came Porsche's 911, the last car designed by Volkswagen "Beetle" designer Erwin Komenda.

The auto industry faced a double whammy in the 1960s — added regulatory costs and increased competition. Inspired by public fears raised by Rachel Carson's 1962 popular book, *Silent Spring*, warning of ecological damage to the environment, Congress passed the 1965 Motor Vehicle Air Pollution and Control Act, setting automotive emission standards. This was followed in 1970 by the Federal Clean Air Act, mandating a further reduction of 90 percent in pollutants. Also in 1965, Ralph Nadar's book, *Unsafe at Any Speed*, prodded Congress to pass the National Traffic and Motor Vehicle Act in 1966, empowering the government to set safety standards for new cars after 1968, which were soon enacted.

Foreign automotive competition increased in 1965 when Toyota opened a design office in California to perfect its U.S. design style. By 1968, its first result was the Celica sports coupe, which would become the first Japanese car to sell over 1 million units in the U.S. In 1968, Volkswagen had 57 percent of the import market, primarily with the "Beetle." Detroit struggled to stem the tide with smaller cars. That year, American Motors Corporation (AMC) introduced its compact, moderately priced sports car, the AMX. It was followed in 1970 by AMC's Gremlin, the first true compact, designed by Richard Teague. The automotive trend in safety, efficiency, and environmental responsibility shifted the balance of power over design to engineers, the stylist's traditional enemy. Stylists would take a back seat, for nearly 10 years, to marketing and government regulations.

Further government regulations were spurred by President Johnson's wife, Lady Bird, who led the effort to secure passage of the 1965 Highway Beautification Act, which regulated the size and number of roadside billboards and the planting of flowers in the medians of federal highways. In 1966, F. Eugene Smith, principal of his own design firm in Akron, Ohio, toured the design community with slide show seminars entitled "Why Ugliness, Why Not?" to rally community design action to improve urban public furniture, signage, and lighting. Baby-boomer industrial design student graduates, like most students, were increasingly conscious of the design community's responsibility to improve the environment and were increasingly estranged from organized design, which appeared not to be taking positive action to solve the social issues that dominated youth culture. Popular support of environmentalism and recycling would result in Earth Day, initiated in 1970, the same year as formation of the Environmental Protection Agency (EPA), the Clean Air Act, and the Consumer Product Safety Act. The Clean Water Act (1972), the Safe Drinking Water Act (1974), and the Resource Conservation and Recovery Act (1976) would soon follow.

Since 1955, the American Society of Industrial Designers (ASID) and the Industrial Designer's Institute (IDI) had been working together on a variety of programs, including international exhibitions and joint seminars. By 1958, a joint review committee was established to consider a merger. There were several key issues to be resolved. IDI had fixed annual dues of $40, while IDSA's annual dues ranged from $50 to $540, depending on the size of one's office or corporation. IDI membership criteria allowed product submissions manufactured by a single company, while ASID required three products made by companies in different industries (which strongly favored consultant applicants over corporate applicants).

Eventually, negotiators agreed upon a single dues fee for full members and submission of products for membership from three different product categories. In 1964, IDSA and IDI demonstrated their common purpose by holding a joint annual meeting in Philadelphia, and in 1965, ASID, IDI, and the Industrial Designers Education Association (IDEA) merged into a new organization, the Industrial Design Society of America (IDSA), with an estimated membership of 650. The first president was Henry Dreyfuss, and the first casualty was the IDI's annual national design awards program, which had begun in 1951 and concluded with the 1965 awards. Reportedly, Dreyfuss objected to individual designers receiving public credit for specific designs that emanated from major, big-name, offices like his own, where only the principal's name was normally credited. There would be no more national design awards until 1980. However, "Special Awards," "Honorary Membership," and "Personal Recognition Awards" would be conferred annually upon individuals or organizations for notable contributions to the profession, the first being Edgar Kaufmann, Jr. IDSA's national office remained in New York City, staffed only by a single national-office secretary, Ramah Larisch. But it aspired to international prominence.

Chapter 11

1965–1985

Challenges and Computers

Ever conscious of international reputation and representation, the new IDSA and the Package Design Council (PDC), in cooperation with the U.S. Information Agency (USIA), in 1965 sponsored a trade exhibit in London, Design U.S.A., displaying 300 products, packages, and corporate identity programs. In Washington, D.C., the National Endowment for the Arts (NEA) was created in 1965 by an act of Congress to support the arts. By 1967 the NEA would establish a design arts program to fund grants in architecture and design, as well.

Corporate offices were being transformed by design in 1968, led by Herman Miller's Action Office II. Such offices had remained essentially unchanged since the 1930s. Typically, they had comprised an open, large, uncarpeted room (called a "bull pen" by some) with desks or drawing tables (depending on the dominant workers, whether they were secretaries, engineers, draftsmen, or designers) arranged in regimented rows like a schoolroom. Along the walls were small offices for lower-level managers constructed of prefabricated, painted (generally light beige or green) steel walls with large glass windows above waist height facing inward to better oversee the workers. Higher-level manager offices were located on walls with outside windows. Key officers in the pecking order had private, carpeted, corner offices with outside windows in other parts of the building.

Action Office I, designed by George Nelson and Robert Probst in 1964 for Herman Miller, was based on a German office-planning concept developed in the late 1950s called Bürolandschaft (office landscape). Action Office II followed in 1968 and was refined by Probst and vice president of design Robert Blaich (b. 1930) with a more commercialized presentation. The concept, intended to foster a more attractive and livable environment, used modular, moveable, neck-high, fabric-covered, steel screens that supported work surfaces and storage units to provide less regimented and more flexible space organization, resulting in more private, more personable work stations called cubicles. The concept greatly expanded Herman Miller's product line and would transform offices dramatically. Steelcase would introduce similar office systems in 1973, with its Series 9000.

This is an example of how design and social change are often interrelated. They reinforce and respond to each other. It's hard to tell whether office furnishings changed corporate culture or if a new generation of more individualistic and environmentally conscious workers inspired the more appropriate furnishings concept. A similar chicken and egg phenomenon was triggered by Betty Friedan's 1963 book, *The Feminine Mystique*, which Friedan identified as the 1940s and 1950s image of the ideal Happy Housewife, whose only ambitions were marriage and motherhood. She urged women to pursue careers and realize their per-

sonal ambitions. Designers were implicated because it was they who, in the 1940s and 1950s, had fueled the Happy Housewife image with dream kitchens and glittering household appliances.

Social reforms such as these reminded designers that it is part of their responsibility and value to identify trends in social change and to incorporate such change into their designs to better match the consumer's attitude and cultural perceptions. In the 1960s, many young designers eagerly sought to meet these challenges. Architects, too, were feeling change in the air. In 1966, architect Robert Venturi hosted a series of lectures at the Museum of Modern Art that urged a richer and more ambiguous visual language than the pure, clean, International style that had been intimidating architects since the 1940s. His book, *Complexity and Contradiction in Modern Architecture*, led to what would become "postmodern" architecture, developed in the 1970s by Michael Graves, James Stirling, Charles Moore, and Robert Stern.

Trimline telephone, by Donald M. Genaro of Henry Dreyfuss Associates (HDA), 1965 (courtesy HDA).

New architectural language was beginning to appear. Expo 67 was held in Montreal,

Action Office II, 1968, by Herman Miller under direction of Robert Blaich (courtesy Herman Miller, Inc.).

Canada. It included a housing experiment, Habitat 67, designed by Israeli architect Moshe Safdie (b. 1938), and an American pavilion designed by Cambridge Seven in a Buckminster Fuller geodesic dome, a totally new way to enclose large spaces inexpensively. The next year, Fuller would receive the World Medal for Architecture for his domes.

By 1968, however, the industrial design profession was threatened by negative press and social change. An article in February's *Fortune* magazine titled "The Decline of Industrial Designers" claimed that "radical innovation in design is now the exception rather than the rule." In other words, "same old same old." Ironically, *Fortune*, the magazine that had in 1934 promoted industrial design into national prominence, now was predicting its decline.

That same year, Victor Papanek (1925–1998), dean of the School of Design at the California Institute of the Arts, claimed, "Most design in the U.S. today is carried out to satisfy the needs of a mythical middle-class family living in the highest gadget level in the world."[1] Prominent industrial designer Dave Chapman, in a 1970 U.S. Steel seminar, responded that yes, design had to dig deeper into social issues, in effect, agreeing with Papanek: "Designers must learn a lot more about the effect of social factors on products and markets. It is impossible to take a 33½-year-old couple, living in suburbia, having 1½ cars, 2½ kids and all that kind of nonsense and build marketing on it. It may have worked in 1912 but not in 1970."

First single-piece plastic chair, made of fiberglass–reinforced polyester, by Verner Panton for Herman Miller International, 1967 (courtesy Herman Miller Inc.).

He identified potential new markets for medical products, teenagers, pet owners, working women, and boat owners, among others, indicated by a study of social trends.[2] IDSA in 1968 initiated a professional journal to promote new ideas and directions for the profession.

There was a note of desperation and frustration in the air in 1968 because of the national tragedies of the Martin Luther King and Robert Kennedy assassinations and the never-ending Vietnam War. This affected the design profession, particularly students. Some felt that the era of industrial design was over; that all the existing consumer products had already been designed beyond need. Others felt that an obsession with material goods was the source of America's problems. Some felt that the industrial designer's creative talent should be applied instead to solving the great social problems of the cities, of the environment, and of the world.

It was not a coincidence that the theme of IDSA's 1968 annual conference was Contradictions and that it

Buckminster Fuller geodesic dome at Expo 67 (from Industrial Designers Society of America, *Design in America*, 1969, courtesy IDSA).

was held at the Playboy Club in New Geneva, Wisconsin. Design students were influenced by campus unrest throughout the country, and they were looking for design solutions to social problems, rather than new toasters, vacuum cleaners, or washing machines. The 1968 annual Alcoa Student Design Awards, for example, included a wheelchair that allowed the user to rise to a standing position. It was designed by Peter W. Bressler (b. 1946), who later would found a successful design office in Philadelphia.

By this time, the most common rendering tools being used by industrial designers were colored "magic markers," which were replacing the chalk pastels and airbrush techniques used since the 1930s. Magic markers had been invented in 1952 by Sidney Rosenthal, who placed a felt tip on the end of a small, stout bottle of permanent ink. The resulting marks saturated a heavy, absorbent paper surface with rich, permanent color, similar to watercolor washes. The markers were faster, and produced more dramatic renderings.

The first mission to the moon, by Neil Armstrong and Edwin E. "Buzz" Aldrin, Jr., in 1969 lifted American spirits. The Lunar Excursion Module (LEM) looked more like a giant insect than like the streamlined rockets that took it there. The Boeing 747 "Jumbo Jet," with interiors by Walter Dorwin Teague Associates, also made its first commercial flight in 1969. The emerging role of computers in design was the subject of IDSA's annual conference. By 1970, early computer aided design (CAD) systems would be developed on time-shared

Playmate cooler for Igloo Corporation, by Marlan Polhemus of Goldsmith Yamasaki Specht, 1970 (courtesy Goldsmith Yamasaki Specht).

university computers. The future Internet was born in 1969 with the creation of the "Arpanet," a network of university computers established by the Advanced Research Project Agency (ARPA) that had been formed in 1957 by President Eisenhower to respond to Sputnik.

Design continued to become an international enterprise. Braun GmbH in Germany had initiated the first international competition for young student designers, the Braun Prize, in 1968. The previous year, Braun had been acquired by Gillette, in part due to Gillette's stark, formal design's lack of appeal in the U.S. In 1969, Germany's Rat für Forgebung (German Design Council) established its Bundespreis Gute Form design awards program. In 1971, Henry Dreyfuss, representing the American National Standards Institute, chaired the first meeting of the International Organization of Standards Technical Committee (ISO/TC) in Berlin, which set international standards for signs and symbols. The following year, Dreyfuss

Braun KF 20 Aromatic coffeemaker, 1972, by Florian Sieffert (courtesy Braun AG, Kronberg/ Taunus, Germany).

would use these in his publication, the *Symbol Sourcebook*, a virtual encyclopedia of international symbols.

ICSID had expanded to include many noncapitalist countries during the Cold War in order to use design as a bridge between the East and the West. The idea was to bring designers together to study regional problems. The first was Inter-Design 71, sponsored by ICSID and VNIITE, which brought 30 designers from 15 nations and was held in Minsk, USSR, forming a workshop to design street furniture for Minsk streets. In 1974, the ICSID secretariat would move from Paris to Brussels, Belgium.

U.S. morale, however, was at a low point. Dissent dominated America. Antiwar sentiment, building since 1969, had become institutionalized. By January 1973, when President Nixon (1913–1994) announced the effective end of U.S. involvement in Vietnam, he did so in response to a mandate unequaled in modern times. The antiwar, often anti–American, sentiment of youth was almost instantly redirected into a negative reaction against profits, industry, and technology. Further fuel for pessimism came from the Club of Rome, which in 1972 published *The Limits of Growth*. It announced Earth faced environmental disaster if pollution and depletion of Earth's resources continued at current levels. Environmentalism and social change became intensive causes of the younger generation, including young designers. IDSA annual meetings became a battleground for design students challenging the design establishment to expand its support of their future visions of global change. It was a clash of generational philosophy.

In his 1972 book, *Design for the Real World*, Victor Papanek, then chair of design at the Kansas City (Missouri) Art Institute, promoted the moral and social responsibilities of designers. His book illustrated student designs that addressed child disability problems, created cottage industry products for underdeveloped countries, created packages based on pea pods, designed human-powered vehicles, and created radio receivers made of juice cans for the Third World. Papanek's idealistic, socially conscious, and anti-business philosophy attracted many young students who were inspired by the counterculture, environmental, and anti-establishment youth movement.

The postwar generation, who had never known material deprivation as had the depression and prewar generations, did not regard material acquisition as all that important. To them, the industrial and machine age was over. Its benefits were taken for granted. With industry as

Max I stacking melamine dinnerware, designed by Massimo Vignelli in 1964 for a small company in Milan, was introduced by Heller Designs, Inc., founded in 1971 in New York by Alan Heller (courtesy International Housewares Association).

the primary polluter of air and water, the word "industrial" became a negative adjective of design. The postwar generation hated formal, hierarchical organizations. They were better educated. High schools graduated 80 percent of 17-year-olds, compared to 50 percent in early postwar years. Students were less dogmatic, had a higher tolerance for ambiguity, were more analytical ("new math" had been implemented), and more introspective. Nearly 50 percent of all 22-year-olds had a college education. Student design dreams of the future were about a clean environment, of helping disadvantaged populations, and of an egalitarian society that listened to their views, which were no longer black or white but gray. And young people, the so-called baby boomers, were everywhere. Half of the total U.S. population was under 30.

All these youthful perceptions had been identified and documented as a result of a special IDSA Special Study Committee on National Policy chaired by Richard Latham (FIDSA) that met in 1969 and 1970 in Chicago. Several all-day, free-ranging sessions included many young designers. A professional discussion leader wrote an extensive final report led the sessions. Unfortunately, the IDSA executive committee never published the report or a summary of it for its members, and no immediate actions to address the concerns of youth were announced as a result of it. IDSA's reluctance to respond further frustrated those who felt immediate organizational change was needed.

Papanek, in his book, viciously targeted the profession of industrial design with charges bordering on slander. His book jacket characterized Papanek as "an ingenious designer who charges the industrial design establishment with criminal negligence of almost everybody" and stated that "industrial designers go on littering the planet with ugly, unnecessary gadgets very few can afford."[3] His book included such quotes as these: "It is about time that Industrial Design, as we have come to know it, should cease to exist....[4] There are few professions more harmful than industrial design, but only a very few of them....[5] Today, industrial design has put murder on a mass production basis...."[6] Papanek attacked leading designers by name, particularly Dave Chapman's remarks at the 1970 U.S. Steel seminar, and criticized IDSA's "recent" (18-year-old) publication of *Design in America* as "appalling" because everything in it looks "sterile and dehumanizing."[7] He accused the profession of serving business interests: "Unblushingly, industrial design in America has elected to serve as pimp for big business interests."[8]

Papanek was a rebel with a cause. His cause was to transform design education from its traditional, formal, esthetic, and business philosophy to one devoted to solving social and humanitarian problems. He was successful in tapping into the current culture of anti-establishment, antiwar, and free lifestyles already embraced by many youths, and his book had a huge impact on the newest generation of designers.

IDSA leaders were furious with Papanek, but elected not to escalate the issue by responding publicly. Meanwhile, the mainstream profession seemed to continue as usual. The first new U.S. regional transit system in 50 years, the Bay Area Rapid Transit System (BART) of San Francisco, went into service in 1972, designed by Sundberg-Ferar. Under development since 1965, BART pioneered the typeform for modern mass transit. Raymond Loewy was conducting "habitability studies" for Skylab, the National Aeronautics and Space Administration's (NASA) orbiting space laboratory, which was launched in 1973. He considered it the most important work of his career. Just as Museum of Modern Art curator Emilio Ambasz (b. 1943) was declaring in 1972 that we were "through with design as object" in his MoMA exhibition, The New Domestic Landscape, technology was about to provide designers with a whole new world of electronic objects to be designed. A number of designers

were already working on new pocket calculators with microprocessor chips, early portable cellular phones, and early personal computers.

IDSA had become concerned about the quality of industrial design education in 1970. It felt that the National Association of Schools of Design (NASD), which accredited industrial design programs, was not using qualified industrial design practitioners to review industrial design programs, and therefore, was ineffective. Now, Papanek's book was influencing student and faculty attitudes, and design education in general. Some industrial design programs were being renamed as "environmental design." Others were changing to an "information-based" curriculum. Students were forcing other curriculum changes for political purposes that deprived them of the "nuts and bolts" subjects needed by practicing designers. IDSA therefore initiated its own School Recognition Program, providing reviews of programs by IDSA members to insure that minimum educational requirement, established by IDSA, were being met. Schools meeting or exceeding these minimum requirements received formal IDSA approval.

By 1973, according to a survey conducted that year by Professor Joseph Carreiro—chair of the Department of Design and Environmental Analysis at Cornell University—Industrial Design Education in the U.S.A.: A Factual Summary, U.S. industrial design educational programs totaled 41. Of these, 31 were based in art schools, nine in architectural departments, six in engineering colleges, four in schools of design, and one in a college of human ecology (some had multiple organizational connections). There were approximately

San Francisco's Bay Area Rapid Transit system, by Sundberg-Ferar, 1972 (courtesy Tim Cunningham).

2000 students pursuing a career in industrial design, of which 363 were female and 1737 male; 108 were foreign students. Four hundred thirty-eight seniors graduated in 1973. There were also 211 graduate students pursuing master's degrees in 29 programs. Faculty members totaling 1882 were devoted full time to teaching in industrial design programs, plus 129 more part time. Two hundred support people were involved.[9]

With industries moving from northern to southern states for cheaper labor, design opportunities for graduates and new design offices increased significantly in the south. Dallas, Texas, for example, was becoming an electronics products center. Design firms were being established in Atlanta, Houston and Florida.

IDSA however, was having financial difficulty. Reserve funds had dwindled dangerously low and membership was static. The New York facility operation was becoming more costly. Among other things, IDSA terminated publication of its professional journal to save costs. The real center of design action (and federal funding) now seemed to be in Washington, D.C. Accordingly, in 1973, IDSA president Arthur Pulos (1917–1997) announced the relocation of IDSA's national office from New York to the Virginia suburb of McLean, near Washington, D.C., and engaged the services and facilities of Executive Consultants, Inc. (ECI), a professional management group. Tom Stewart of ECI became IDSA's executive director. At the time, IDSA had 723 members and 10 chapters. The primary reason for relocation was to take advantage of design grants being offered by the National Endowment for the Arts and to monitor national legislation affecting design. That same year, the First Federal Design Assembly was held in Washington, with the theme The Design Necessity. In 1974, the U.S. Product Safety Commission was established and listed 369 product categories in order of frequency and severity of injury. IDSA responded by forming a standing government affairs committee under Phil Stevens to monitor federal legislation regarding product safety, visual pollution, consumer affairs, and barrier free design, the latter via a subcommittee chaired by Richard Hollerith, IDSA's representative to the National Center for a Barrier-Free Environment, established in 1975. IDSA also consulted with the Federal Prison Industries to design products made by inmates. These projects were all funded with IDSA grants from the National Endowment for the Arts.

Along with a global oil crisis when Arab nations proclaimed an oil embargo on the U.S, Japanese car companies seemed to be invading the U.S in 1973. Toyota surpassed Volkswagen as the top U.S. import. The Honda Civic was introduced, and Honda, Mazda, Mitsubishi, Subaru, and Isuzu all would establish design studios in California within a few years, as Toyota had done in 1965. The Japanese companies hired American designers to insure that designs appealed to U.S. markets. The oil embargo forced high gasoline prices, encouraged small car sales for better mileage, and precipitated a federally mandated national 55-mph speed limit. Car design was severely impacted by Corporate Average Fuel Economy (CAFÉ) regulations enacted by Congress in 1975. By 1977, standard car size categories would be revised to include "mid-size" and "compact" models.

In an era of humanistic design motivation, ergonomics had become a fundamental criterion for good design. In 1974, Henry Dreyfuss Associates published *HumanScale 1/2/3*, the first of a series of extensive ergonomic data charts for convenient use by designers. In Europe, the Ergonomi Design Gruppen, a Swedish research firm funded by governments, institutions, and foundations, focused on products for handicapped users to accommodate varying levels of muscle strength and mobility but still retained a visually appealing form for the wider public. They termed it "designing for all" but the concept later became known as "universal design." *Industrial Design* magazine soon ran a feature article, "The Handi-

capped Majority," reinforcing the reality that most of us become handicapped with age. In Sweden, design students developed the international pictograph for handicapped accessibility that would become universal and is all around us today at local parking lots.

One of the most visible examples of socially conscious design was that of Patricia Moore, who as a young woman in her 20s traveled throughout the U.S. and Canada for three years (1979–1982) disguised as a woman in her eighties, in order to understand the problems of mobility and safety that the elderly face in public environments. Moore used her experience to write books, conduct lectures, establish a successful design firm specializing in products for the aging, and teach industrial design at Arizona State University.

Many designers were advancing into leadership positions with corporations, and a new organization arose in their support. In 1975, the Design Management Institute (DMI), a forum for corporate design executives, was founded by William J. Hannon, Jr. DMI conducted annual conferences on Nantucket Island, Massachusetts, that were led by Peter Lawrence after 1977 and by Earl N. Powell after 1985. By 2009 DMI would have 1400 members.

The Organization of Black Designers (OBD) was founded in Detroit in 1975 by David H. Rice to promote "the visibility, education, empowerment, and interaction of its membership and the understanding and value that diverse design perspectives contribute to world culture and commerce." As president, Rice stated: "In many ways, design in America is sterile and dead, lacking in valid context and cultural relevance. Frankly, it is too inbred with the ideas and values of primarily white American males."[10]

The Designs of Raymond Loewy was the title of a 1975 retrospective exhibition mounted by the Smithsonian's Renwick Gallery in Washington, D.C. By 1977, the New York office of Raymond Loewy/William Snaith, would close in Chapter 11 bankruptcy after 50 years in operation. Loewy maintained his offices in Paris (Compagnie de L'Esthetique Industrielle), London (Raymond Loewy International, Inc.), and Sweden. In 1979, a one-hour film on Loewy's life and work, *Looking Back to the Future*, was aired on PBS, produced by IDSA's Walter Dorwin Teague Research Trust and enabled by the National Endowment for the Arts. That same year, Overlook Press published Loewy's book, *Industrial Design*. Other design books that year included *In Good Shape*, by Stephen Bayley, and *Twentieth Century Limited: Industrial Design in America*, by Jeffrey L. Meikle. In the Soviet Union, *Komlozitziya v Tyenikya* (*Design in Technology*), by U.S. Somov (1977) was the major textbook used in design education. It illustrated fundamental design principles as well as product and transportation styling based on popular styles in the U.S. and Italy.

In 1976, the Smithsonian opened its "National Design Museum," at the Cooper-Hewitt Museum in New York, the former property of Andrew Carnegie built in 1901. Lisa Taylor directed the museum. That same year, ICSID and the Belgian Ministry of Culture held an international exhibition at the Design Centre in Brussels, Designed for the Common Good. Intended to promote design awareness, the exhibition was designed by then IDSA president James Fulton's (1930–2003) firm, Fulton & Partners, Inc., of New York. In Canada, the National Design Council, established in 1961, established its promotional and executive arm, Design Canada, in 1976, to improve the quality of design in Canada. Since 1973, the council has produced design case histories and held annual lectures on design by prominent design program leaders.

In celebration of America's bicentennial, IDSA held its annual conference in Philadelphia in October 1976, chaired by Peter Bressler. The theme, Evolution/Revolution, aptly expressed the current political dilemma of IDSA. New, younger members in chapters,

Ergon chair, designed by William Stumpf for Herman Miller, Inc. (courtesy Herman Miller, Inc.).

reflecting the more progressive cultural and social changes of the past few years, were demanding a voice in Society affairs and a more progressive agenda. Many prospective young members viewed IDSA as a "good-old-boy's club," out-dated, exclusive, elite, and ineffective. Some progressive IDSA elected officers also believed more reforms were needed to accommodate younger members or the society would lose the new generation.

On the other hand, IDSA's conservative elders genuinely believed the ideas of progressive, younger members would weaken the profession and their own authority. They were threatened by the Papanek charges, by curriculum changes in the academic community, by challenges that the word "industrial" in the profession's name was too limiting (or inappropriate), and by exposure of IDSA members' philosophical differences in the design press. The conservative elders in charge had started their careers in industrial design's days of glory — the late 1930s and early 1940s, and they felt a responsibility to protect this heritage and restore the profession to national prominence once again, as it had been in its heyday. They felt resistance to change was essential.

These opposing, largely generational, concerns divided the Society politically and came to a head at the October board meeting in Philadelphia, when nominations for new officers were to be announced. Conservative past presidents manipulated the nominations and delayed elections for six months in order to defeat the first progressive candidate for president. In the meantime, IDSA discharged its professional management group (ECI), hired a full-time IDSA executive director, Brian Wynne, along with a staff person, Celia Weinstein, and moved to independent IDSA headquarters on N Street in Washington, D.C. IDSA president Jim Fulton and a group of private investors formed Design Publications, Inc., to lease publishing rights to *Industrial Design* magazine in order to increase national visibility of the profession.

In a contentious 1978 national election, the progressive candidate for the presidency had to petition to be placed on the ballot and was publicly reprimanded at the annual meeting by conservatives for conducting the first open political campaign in IDSA history. Days later, he was elected by the membership and led IDSA into a more participative, democratic, and open Society with a two-year plan of action. By 1980, the number of chapters had doubled to 24, membership had increased by over 25 percent, and new IDSA bylaws were initiated to reduce membership requirements, change nominations procedures, and provide

voting rights to young associate members. A Code of Ethics for Industrial Designers was adopted, as was a new formal Definition of Industrial Design (see below). Depleted capital reserves were restored to 1973 levels by reducing administration costs, and a Design Foundation was formed to attract support funds. A five-year budget and program plan were put in place. Automotive designers, for years denigrated by IDSA as "stylists," were invited to join IDSA, and did so. Moreover, IDSA reinitiated and promoted an annual national design awards program, chaired by Ralph LaZar, the Industrial Design Excellence Awards (IDEA), renewing awards that had been discontinued since 1965. Entry Level Professional Qualifications were established, and by 1984, an IDSA committee chaired by James Pirkl applied these to accreditation standards for industrial design programs at schools through the National Association of Schools of Art and Design (NASAD). By 1983, Katherine J. McCoy (b.1945), cochair of Cranbrook Academy of Art, was elected the first female president of IDSA. IDSA had entered a new progressive era of consolidation, equality, growth, and financial strength with the full support and participation of young designers and a new generation of leaders. Membership by 1985 was about 2000, more than double that of 1978. By that time there were 675 industrial consulting design offices nationwide and over 6000 trained designers working within corporations.

This is the revised comprehensive definition of industrial design developed by IDSA in 1978, which is still in use today:

> Industrial design (ID) is the professional service of creating and developing concepts and specifications that optimize the function, value and appearance of products and systems for the mutual benefit of both user and manufacturer.
>
> Industrial designers develop these concepts and specifications through collection, analysis and synthesis of data guided by the special requirements of the client or manufacturer. They are trained to prepare clear and concise recommendations through drawings, models and verbal descriptions.
>
> Industrial design services are often provided within the context of cooperative working relationships with other members of a development group. Typical groups include management, marketing, engineering and manufacturing specialists. The industrial designer expresses concepts that embody all relevant design criteria determined by the group.
>
> The industrial designer's unique contribution places emphasis on those aspects of the product or system that relate most directly to human characteristics, needs and interests. This contribution requires specialized understanding of visual, tactile, safety and convenience criteria, with concern for the user. Education and experience in anticipating psychological, physiological and sociological factors that influence and are perceived by the user are essential industrial design resources.
>
> Industrial designers also maintain a practical concern for technical processes and requirements for manufacture; marketing opportunities and economic constraints; and distribution sales and servicing processes. They work to ensure that design recommendations use materials and technology effectively, and comply with all legal and regulatory requirements.
>
> In addition to supplying concepts for products and systems, industrial designers are often retained for consultation on a variety of problems that have to do with a client's image. Such assignments include product and organization identity systems, development of communication systems, interior space planning and exhibit design, advertising devices and packaging and other related services. Their expertise is sought in a wide variety of administrative arenas to assist in developing industrial standards, regulatory guidelines and quality control procedures to improve manufacturing operations and products.
>
> Industrial designers, as professionals, are guided by their awareness of obligations to fulfill contractual responsibilities to clients, to protect the public safety and well-being, to respect the environment and to observe ethical business practice.[11]

This renaissance of IDSA and what became the "Design Decade" of the 1980s coincided with the maturing of the "information age," so named by Alvin Toffler in his 1980 book,

The Third Wave, the first being agricultural, and the second industrial. Toffler cited the mid–1950s as the beginning of the information age, when IBM's first computer, the 701 Electronic Data Processing Machine, was the first commercially available, the first manu-factured in quantity (19 were produced), and the first to transition from punched cards to electronic circuits. Computer development had been proceeding at a rapid pace over the last decade, driven by microchip and electronic technology of the 1960s. In 1968, Douglas Englebart invented the mouse. In 1973, Alan Kay, at Xerox's Palo Alto Research Center (PARK), developed the first "office computer" based on his Smalltalk software, with mouse, icons, and a windows graphic format. In 1974, a prototype of the first personal computer with graphics, the Altos desktop, was completed at PARK with the participation of both Englebart and Kay. In 1975, 19-year-old William Gates III and 22-year-old Paul Gardner Allen founded Microsoft. In 1976, the first supercomputer, the Cray-1, was delivered to the National Security Agency (NSA) for operations.

Black & Decker Dustbuster cordless hand-held vacuum cleaner, 1979, by B&D design manager Carroll Gantz. Its entry into the housewares business for B&D and its success over the next 30 years would earn it IDSA's Catalyst Award in 2009.

That same year, 26-year-old Steven G. Wosniac and 21-year-old Steven Jobs, while working at Atari, founded Apple computer in a California garage and developed Apple I, a crude prototype. In 1977, Apple computer introduced Apple II, which featured the first spreadsheet, Visicalc. modem software was developed in 1978, enabling PCs to talk over public telephone lines. That same year, the first electronic typewriters with memory appeared, one by Casio of Japan and another by Olivetti's ET range, designed by Mario Bellini (b. 1935). In 1979, Sony introduced its Walkman, designed by a team headed by Mitsuro Ida.

When these electronic products advanced into mass production, industrial designers would become active participants. IBM

Omni steel flatware, by Ellen B. Manderfield, for Oneida Ltd., 1979 (courtesy Oneida, Ltd., all rights reserved).

entered the market in 1981 with the PC model 5150 with Microsoft software and captured 75 percent of the market. Industrial design was by IBM's design team under Tom Hardy. ID Two, a firm started in 1979 in San Francisco by Bill Moggridge (b. 1943) and Steve Hobson, designed the 1982 Compass computer for GRiD Systems. It won an IDEA award, and was the first computer the Museum of Modern Art selected for its permanent collection. *Time* magazine selected "the computer" (generically) as its "Man of the Year" in 1982 and featured a prototypical computer mock-up on its cover, designed and built by Richardson/Smith Inc. industrial design firm, which was cofounded in Worthington, Ohio, in 1960 by Deane Richardson (b. 1930) and David Smith (b. 1932). In 1983, the first handheld cell phone became available, the Motorola DynaTAC 8000x, designed by Rudy Krolopp, director of industrial design for Motorola. Apple Computer, Inc. introduced the Apple IIc in 1984, designed by Apple staff and Hartmut Esslinger (b. 1945) of frogdesign, a design firm founded in the Federal Republic of Germany (FRG) in 1969 by Esslinger. Both received IDEA national design awards, and the IIc was cited as one of the best designs of the year by *Time* magazine.

In architecture, the International Style of Walter Gropius and Mies van der Rohe that had dominated the field since the 1930s was coming under increased criticism. Many saw its absence of ornamentation and decoration as sterile, bland, characterless, or, worse, as hostile to its environment and humanity. Architect Robert Venturi (b. 1925), a critic of the international style, wrote the influential books *Complexity and Contradiction in Architecture* (1966) and *Learning from Las Vegas* (1971). Venturi coined the maxim "Less is a bore" in

Above: GRiD Systems Compass computer by Bill Moggridge and Steve Hobson of I.D. Two (courtesy IDSA). *Right:* Motorola DynaTAC 8000X portable cellular phone, 1983. The world's first commercial handheld cellular phone, the Motorola DynaTAC received approval from the U.S. Federal Communications Commission in 1983. The 28-ounce (794-gram) phone became available to consumers in 1984 (courtesy Motorola Archives, Inc.).

response to Mies van der Rohe's famous modernist dictum "Less is more." Michael Graves, architect of the whimsical Walt Disney Dolphin and Swan hotels in 1996, would then say that at Disney, "More is not enough."[12]

In 1977, the same year the groundbreaking, "inside out, high tech" Pompidou Centre, designed by architects Renzo Piano (b. 1937), Richard Rogers (b. 1933), and Gianfranco Franchini, opened in Paris, American architectural historian and critic Charles Jencks (b. 1939), who was then a leading figure in British landscape design, wrote *The Language of Post-Modern Architecture*, which popularized the term postmodern. He contended that "post-modern" meant the end of a single worldview and a respect for differences in celebration of the regional, the local, and the particular. He

Apple IIc by frogdesign and Apple staff designers, 1984 (courtesy, Apple Inc.).

described postmodernism as a witty, hybrid, eclectic style, concerned with issues of historical memory, local context, metaphor, and ambiguity. This open invitation to personal creativity and expression appealed to many architects bored with grinding out rectangular glass boxes.

It was the Italians who first applied the postmodern philosophy to product design. Studio Alchimia was a Milanese group cofounded in 1976 by Alessandro Guerriero (b.1943), Alessandro Mendini (b. 1931), and Ettore Sottsass, Jr. (b. 1917). In 1981, Sottsass and Italian industrialist Ernesto Gismondi founded Memphis, a group of avant-garde designers in Milan. Memphis created the design media event of the year with garish and irreverent product designs in bold colors and laminates that emphasized surface decoration more than function. It presented many conceptual household products by a variety of prominent designers — to the beat of rock music in the manner of a fashion show — designed deliberately to be anti-functional, preposterous, and faddish. The catalog introduction to the event, written by Italian critic Barbara Radice (b. 1943), stated, "We are all sure Memphis furniture will soon go out of style."[13] Designs were colorful, cheerful, and playful. Sottsass' signature piece, the Casablanca sideboard, would become the icon of Memphis, of postmodernism, and of the Italian avant-garde.

Italian design was in fact making a national statement. The Italian "look" of the era had flair and exuberance — almost the antithesis of Bauhaus sterility, but the influence of Italian style of the 1980s rivaled the Bauhaus of the 1920s and the Scandinavian style of the 1960s. Giorgetto Giugiaro (b. 1938), car designer extraordinaire, in 1974 had designed Volkswagen's replacement for the Beetle, called the Golf in Europe and the Rabbit in the U.S.

He designed the ill-fated but dramatic DeLorean DMC 12 sports car in 1981. All three Detroit companies were turning to the Italians for luxury car design. In 1981 Giorgetto founded Italdesign-Giugiaro, which was also expanding into consumer products. Mario Bellini (b. 1935) was designing award winning products for Olivetti. Rodolfo Bonetto (b. 1930) consulted in a range of automotive, electronic, and machine tool categories. Ferrari and Maserati were the gold standard in sports cars. Alejandro de Tomaso, president of Maserati said, "America colonized us with its culture — Coca-Cola, jazz, TV. Now we in Italy are going to colonize you with our culture and our design, whether you like it or not."[14]

The Memphis exhibition included work by American architect Michael Graves (b.1934), who designed a dressing table, Plaza, for Memphis in 1981 that featured skyscraper forms. Michael Graves & Associates became a leading practitioner in postmodernism with the design of the Portland (Oregon) Public Service Building in 1982, and the movement would soon become the new direction in architecture. Maya Lin's 1982 Vietnam War memorial shattered the traditional view of public monuments. Architect Robert Venturi designed a range of "post-modern" bentwood chairs for Knoll International in 1984 with silk-screened backs that drew on 18th century designs by Sheraton and Chippendale. Graves designed his classic postmodern Bollitore teakettle for Alessi with a whimsical bird spout and a postmodern mantle clock in 1986. By that time, postmodern design as such was already being dismissed as a fad, but Memphis had inspired designers everywhere to modify their notions of formal, Bauhaus-style modernist design for more informal, expressive, and playful visual communication in products.

The postwar, "Modernist" era was coming to a close for industrial design in the U.S. Unlike the 1940s and 1950s, museums no longer were trying to define "good design" but were focused on its history, a sure sign of its age. The retrospective exhibition, Design Since 1945, opened at the Philadelphia Museum of Art in 1983. It was organized by Katherine Hiesinger and was accompanied by an extensive, 247-page, illustrated catalogue by Hiesinger that was like an illustrated obituary of modern design. Retrospective design history was also the subject of a two-volume set of books by Arthur Pulos: *The American Design Ethic* (1983) and *The American Design Adventure* (1988). That same year, Russel Wright: American Designer was a retrospective at the Hudson

Robert Venturi's Sheraton chair, 1982, from *Product Design 2*, edited by Sandra Edwards, 1987.

River Museum in Yonkers. A 1985 exhibition by the Whitney Museum in New York, High Styles: Twentieth Century American Design, assembled 300 pieces of furniture, tableware and appliances that celebrated designs of a century that still had 15 years to go. Industrial designers were challenged by the changing culture and times to reinvent themselves and to abandon tradition.

Notable architectural critics such as Ada Louise Huxtable (b. 1921) were writing industrial design obituaries:

> The 20th century is already in the hands of the historians.... Those who think they know how it was in those days [the 1950s] are in for a surprise. What was admired then is discarded now, and what was rejected is being revived. A field that flourished, and languished, and is now becoming subject of dissertations, is industrial design — that curious amalgam of promotion, marketing, technology, and taste invented by the 20th century to serve and shape a consumer economy.... Industrial designers shared the optimism of the architectural theorists and practitioners of the modern revolution who believed that the marriage of art and industry could provide answers for most of the ills of society, or at least put beauty and utility within the reach of all. But while the tastemakers were in hot pursuit of a mythical "machine art" realized largely in handmade prototypes or limited production for educated users, the industrial designers were successfully creating mass-produced objects for a universal market.[15]

And still were when Huxtable wrote her book. Part of this national pessimism was due to the worst recession since the 1930s, which gripped the country from 1980 to 1982 when the unemployment rate reached nearly 11 percent, worse than it would be even in 2009. Business was negatively affected and industrial designers began to question their traditional commitment to "modern design" as defined by Bauhaus formality.

Some industrial design educators searched for new theories in product design that would free them from the dictates of formal modern design and would be more expressive of the times. In 1984, two German-Americans, Klaus Krippendorff and Reinhart Butter, both graduates of the Hochschule für Gestaltung in Ulm, Germany, wrote an article, "Product Semantics: Exploring the Symbolic Qualities of Form," in IDSA's professional journal. Krippendorff was then professor of communications at the Annenberg School for Communication at the University of Pennsylvania, and Butter was a professor of industrial design at Ohio State University. They proposed that all design communicates and that design should be viewed as a language, which they called "product semantics." In the article, they wrote the following: "Product semantics is the study of the symbolic qualities of man-made forms in the context of their use and the application of this knowledge to industrial design. It takes into account not only the physical and physiological functions, but the psychological, social and cultural context, which we call the symbolic environment."[16]

That same year, the codirectors of Cranbrook Academy of Art's graduate program, Michael and Katherine McCoy, led a seminar entitled "The New Meaning of Form and Function in Industrial Design," based on product semantics. The McCoys, like postmodern architects tiring of the glass box, were tiring of the "black box." Michael observed, "Designers and to some extent companies have now recognized that, as the black box becomes a dominant part of our lives, we need visual clues."[17] Soon Cranbrook students began to explore these theories with designs that used humanistic or animalistic metaphors, expressed humor through visual puns, were whimsical, or simply used sensuous forms to avoid the formal geometric characteristics of Bauhaus styles.

Robert Blaich of the Royal Philips Electronics giant in Eindhoven, Netherlands, who engaged the McCoys as design consultants, furthered the postmodern concept. Blaich, former head of design and communication at Herman Miller Furniture Company in Michigan

Crown Equipment Company's Narrow Aisle Reach Truck, by David B. Smith of Richardson/Smith, Inc., 1980. In 1990, IDSA named it a "Design of the Decade" (courtesy IDSA).

and close friend of the McCoys, had become head of design at Philips in 1980. Blaich was intrigued by the product semantic idea: "So many products are the same today. You could take off the labels and you wouldn't know what company made them. We want to use semantics to differentiate our product."[18]

The first result was the Philips 1986 Roller Radio, a boom box that looked (sort of) like a motorcycle. It sold half a million within a year. The next was a microwave oven for the dining room table that wasn't so successful and didn't go into production because it reminded people of a miniature nuclear power

Philips Roller Radio, 1986, Robert Blaich, design director, from PBC *Product Design 2*, 1987.

plant. Despite some skepticism from mainstream designers, product semantics inspired designs that were more playful, colorful, and dramatic than black boxes. In 1994, Katherine and Michael McCoy would receive the second annual Chrysler Award for Innovation in Design for their influential work on the symbolic and semantic meaning of design.

International competition on a global scale had triggered a serious industry crisis. Chrysler and American Motors were both saved from bankruptcy in 1979 by a government bailout. Chrysler, Ford, and General Motors posted huge billion dollar losses in both 1980 and 1984. Japan by 1980 produced more cars than the U.S., and by 1982 Honda became the first Japanese manufacturer to produce cars on U.S. soil — the Accord, in Marysville, Ohio.

The Japanese were setting the design pace with stereos, cameras and television sets, as well as cars. "They visited our design schools and hired our instructors," said Connecticut designer Niels Diffrient (b.1928). "They are beating us at our own game."[19] Arnold Wasserman, manager of industrial design for Xerox, commented, "The international look of Panasonic and Sony is a Japanese refinement of American design of the mid–1950s."[20] Even the French were showing their technological and design muscle with the introduction in 1981 of their new high-speed train, the TGV (Train á Grande Vitesse) from Paris to Lyon. By 2007, TGV trains reached a speed of 357 mph.

The U.S. was in an economic recession. Acquisitions became common as weaker competitors failed. Globalization became the corporate banner of the day. Industry became "market-driven." Competition motivated businesses to dramatically improve their organizations and sales performance, and design became a weapon of choice as it had in the 1930s. Tom Peters wrote a best-seller business book in 1982, *In Search of Excellence*, on how to achieve success, not through orthodox business practices, but through creative attention to consumer-related issues, including design. In an interview with *Newsweek*, Peters declared, "[T]he fire of design is as important to survival as efficient organization."[21]

Half of the 10,000 practicing industrial designers were on corporate staffs. In Boston, Peter Lawrence established the Corporate Design Foundation to raise the quality of design through business education. IDSA focused on promoting design to business. It conducted several surveys of Corporate Design and Business Attitudes to strengthen its strategies. It

initiated publication of a new, sophisticated quarterly professional journal, *Innovation*, to increase its communication to members and business leaders. In 1984, IDSA renamed and upgraded its monthly newsletter, *Design Perspectives*, for members.

Corporate design was featured at WORLDESIGN 85, the first congress of the International Council of Societies of Industrial Design (ICSID) to be held in the U.S., hosted by IDSA in Washington, D.C., and chaired by Deane Richardson. Two thousand three hundred designers from 93 countries attended, many of whom displayed exhibits of their work. Registrants voted Charles Eames as the most influential designer of the 20th century. Leading global corporate design presentations were made by Dieter Rams, design director for Braun, the German company for which Rams had re-created the Bauhaus style in its purest sense; by Carroll Gantz, design director of Black & Decker, which had just acquired General Electric Housewares and now dominated design in U.S. housewares markets; and by Kyoshi Sakashita, design director of Sharp electronics in Japan, who initiated playful and colorful designs. Together, they demonstrated an incredible range of global styles.

Cooper Woodring, IDSA president during WORLDESIGN 85, later assessed the results: "The Congress allowed designers across the globe to observe and explore each other's work.... U.S. designers learned from their brothers and sisters in Europe, Asia, and South America how to build alliances with government agencies.... Designers had a chance to tell their stories to more than 50 different media outlets.... The resulting worldwide coverage ... paved the way for the partnership between IDSA and *Business Week* magazine."[22]

National attention on design was heightened in 1985 by Ronald Reagan's presentation of the first Presidential Awards for Design Excellence, awarded to 13 government projects, including the Unigrid graphics program developed by Massimo Vignelli (b. 1931) for the National Park Service. Architect I.M. Pei (b. 1917) headed the design jury.

The automotive industry was revived by design. The introduction of the 1985 Ford Taurus and Mercury Sable, designed by Jack Telnack (b. 1937), Fritz Mayhew and the Ford staff, was the keystone. Upon its introduction, Ford chairman Donald Peterson said he "set the design staff free to create cars that tickled the fancy and in came the 'aero look' of the 1980s." The "aero look" was a fundamental change from the traditional visual language of Detroit or foreign imports, characterized as a boxy, sharp-edged look. Based on aerodynamic principles, the "aero look" form was soft and rounded to the point that some called it the "jellybean" design. The aero style had originated in Ford Europe, where Ford's German vice president of design, Uwe Bahnson, in 1982 had designed the Ford Sierra. The softer design strongly influenced the 1983 Thunderbird, designed by Ford North American design section head Telnack with even softer forms. But the Taurus/Sable design, softer than both, exceeded all expectations and was a huge market success. From 1992 to 1996, it was the best-selling car in the U.S. It turned around the ailing industry and established a new automotive style trend that continues to this day.

Industrial design had thus survived the turbulent 1960s and 1970s stronger, with new styles and standards of excellence and a new generation of designers. Industrial design had become an integrated international community, where designers worked on globally distributed products and where designers from any country could work for mass producers anywhere in the world. The dominant global design trend in 1985 was often called "Eurostyle," basically products with clean lines, without frills, lots of white space, and minimal graphics—influenced by the Bauhaus tradition. In the U.S., among the leading designers in this style were Michael and Morison Cousins (1934–2001), Lorenzo Porcelli (b. 1933), and Massimo (b. 1931) and Lella Vignelli. This would soon change, as new trends began to

impact the field. Color had already faded from consumer appliances, and although white was still the most popular color, all-black products had come onto vogue, from major appliances and cars to paper plates.

The industrial design profession learned significant lessons from the 1960s and 1970s. Its very success historically was because of its marriage with industry, but when industry became no longer a symbol of modernity and progress, but a negative symbol of greed, planned obsolescence, excessive pollution, and wasted energy, industrial design became viewed as guilty by association. So the profession began to balance its historical association with industry, by promoting its contribution to social and environmental causes through individual designs. These qualities, over time, and to this day, became additional criteria by which design awards were judged, along with function, esthetics, and innovation. Winning designs rarely touted their benefits to industry, such as cost reduction, sales performance, or profitability. Instead, they pointed to energy savings; value to disadvantaged groups such as children, elderly, or handicapped; conservation of natural resources and the like. Solving of human problems, not industry problems, became the idealized purpose of design to many.

Another lesson learned was the abandonment of the idea that there was one "best" design style, or standard, similar to the "Good Design" museum "standard" set by the Museum of Modern Art in the 1950s. Instead, design in the new global arena offered an infinite variety of styles that could just as easily be based on traditional forms of the 1920s as those of future science fiction. It was difficult to tell if a product was designed in South Korea, Italy, or the U.S. The ideal "style" was that which best fit the specific individual product's function and usage and its primary audience, or consumer.

Finally, separate industrial design organizations learned to merge and unify into a single voice for design, IDSA. IDSA opened its membership to all designers, including students, educators, and young professionals. Abandoned was the idea of an exclusive club for only well-known and experienced professionals. It encouraged a new generation of younger designers to fill leadership positions and guide the Society as well as the profession. Because of this, IDSA flourished and grew, as did the profession.

Chapter 12

1985–2010
Global Design

With a new generation of industrial designers, a new level of global design achievement, and the U.S. economy doing great, one would think that museums would be celebrating design's new directions. Instead, in their time-honored tradition, they were celebrating the past, almost as if current design was no longer of interest. A retrospective exhibition of The Machine Age in America 1918–1941, an era virtually unknown to those under 50, was mounted by the Brooklyn Museum in 1986. The 376-page illustrated catalog would become a standard reference work concerning early icons of industrial design. Concurrently, the Museum of Modern Art mounted an exhibition, Vienna 1900: Art, Architecture and Design, which displayed 700 works between 1898 and 1918. In 1987, the National Endowment for the Arts presented a five-part television series on PBS, *America by Design*, exploring the history of American architecture and design. Raymond Loewy, who had just passed away the previous year, dominated industrial design history in the series.

These nostalgic returns to the past were in vivid contrast to the rapid pace of design and technology in the mid–1980s. Designers were acquiring new computer tools that began to replace their traditional presentation renderings using magic markers. Alias Research Inc. in 1986 introduced Alias, the first practical computer software that allowed designers to manipulate form and color in real time, and enabled a connection to traditional cad/cam systems. The program was developed for industrial designers at the request of General Motors. In 1987, stereo lithography was invented and patented by the U.S. firm, 3D Systems. This new method of making prototypes produced plastic replicas of objects, created by Computer-Aided Design (CAD). A liquid plastic was polymerized by an ultraviolet laser beam that was controlled by a computer to harden into a replica that was then lifted out of the liquid as a solid object. In 1989, Adobe introduced its Photoshop software for graphic designers, followed shortly by Illustrator, T-flex, and ProEngineer cad software, all of it revolutionizing industrial design. These were the first parametric modelers that made the design process intuitive and obvious. Any changes in dimensions or parameters were instantaneously incorporated into the model. All these new software programs required new training for both students and professional designers.

Design continued to be used in the Cold War to promote the U.S. In 1987, the U.S. Information Agency (USIA) produced an exhibition, Design in America, that premiered in Belgrade, Yugoslavia, and then traveled to Zagreb, Ljubljana and Sarajevo, where ethnic nationalism threatened an independent Yugoslavia. From 1989 to 1991, a similar USIA exhibit of U.S. industrial design, architecture, and graphic design, called Design U.S.A., made a 19-month, 10-city tour of the Soviet Union, starting in Moscow and ending in

Vladivostok. It would be the last before the Soviet Union collapsed in December 1991. U.S. industrial designers, among them Peter Bressler, in 1987, were already being invited to the People's Republic of China to lecture and consult in industrial design. China soon would become a major manufacturer for U.S. companies seeking lower labor costs.

Design awards proliferated around the world. At its annual conference and presentation of IDEA national design awards in 1987, IDSA initiated Design Gallery to exhibit actual products that had won awards. That same year, IDSA moved its national office to Great Falls, Virginia. In Europe, the Dutch Association of Industrial Design (Stechting Industieel Ontwerpen Nederland—abbreviated ioN) in 1987 displayed 50 products that had been awarded the ioN designation of "Good Industrial Design." In Germany, Krups presented the first biannual Krups Design Awards. First prize of $10,000 was awarded to Americans Marc Harrison, Dov Z. Glucksman, and their team for the design of a personal heater/cooling fan.

International relations with the USSR improved in industrial design, when in 1988 IDSA president Peter Wooding and Yuri Soloviev, president of the Society of Soviet Designers, signed an Accord of Mutual Cooperation and Exchange. At WORLDESIGN 88 in New York, international design awards were presented to Kenji Ekuan of Japan, Yuri Soloviev of the USSR, and Arthur Pulos of the U.S. for their lifelong service to the international design community. IDSA also initiated annual education awards to outstanding design educators, Arthur Pulos being the first recipient and Robert Lepper the second. In recognition of the growing internationalization of design, *Industrial Design* magazine changed its name to *International Design*. Only ten years earlier, even the suggestion of eliminating the word "industrial" from "industrial design" had enraged IDSA's conservative officers.

A major design and technology event in 1988 was the dramatic introduction of the NeXT computer by Steve Jobs, who founded NeXT, Inc., in 1985 after leaving Apple because of a fierce corporate struggle. The NeXT computer was essentially a black cube designed by Hartmut Esslinger of frogdesign, with a NeXT logo and a 100-page brochure designed by Paul Rand (1914–1996) for $100,000. The name implied the computer to be the "next" generation of personal computers with the speed and capacity of a mini-mainframe computer. Originally targeted at educational institutions at a price of $6,500, it was commercialized in 1989 and sold for $9,999 but failed to meet sales expectations. By 1993, NeXT would withdraw from hardware and became a software company. However, in 1991, Tim Berners-Lee would use a NeXT computer to create the first Web browser and Web server. By 1997, Jobs would return to Apple and become its CEO.

Industrial design was back in the national news and media. The main reason was intense international competition, but IDSA's tireless efforts to promote design were beginning to pay off. David Kelley of David Kelley Design in Palo Alto cited the main incentive: "People are waking up to it [design] because they are scared to death of the Japanese and world competition in general."[1] In 1988, *Business Week* magazine featured an illustrated article on industrial design on its cover entitled "Smart Design: Quality Is the New Style." The article launched a long-term relationship between *Business Week* and IDSA and brought new designs to national attention, particularly in the business community. That same year, *Appliance Manufacturer* magazine initiated annual Excellence in Design awards that were featured and publicized. In recognition that design was now more respected than manufacturing, the magazine would change its name to *Appliance Design* by 2004.

What was "good," or the more current term, "excellent," design was determined not by museums, but by what designers themselves defined in their own annual IDEA excellence

awards promoted nationally by *Business Week*, *Appliance Manufacturer*, and other media. "Excellent design" now was no longer a single formal style, but a range of styles, each with its own sense of personality.

Examples of nonformal designs began to appear in offshore products designed by American designers. William Lansing Plumb's design of a 1987 stereo cassette radio for Sharp was in rainbow-hued colors—not the pastel colors of the 1950s, but intense, brilliant colors that gave it a toy-like appearance. A Sanyei Steamship steam travel iron by Smart Design was in a brilliant purple, and its black handle suggested smokestacks of a miniature steamship. Tucker Viemeister of Smart Design stated their rationale: "We try to give the user more than he thinks he wants: products for a lifestyle still being defined. The color makes it easier to spot in your suitcase and hard to leave behind in your hotel room."[2] Ziba Design, a hot new firm in Oregon headed by Sohrab Vossoughi (b. 1956), designed home exercise equipment in bright yellow and turquoise for Pro-Form, when such equipment had traditionally been in black and chrome. Ziba also designed a sea green bathroom shower door squeegee with s-shaped squeegees expressing ocean waves.

These new design trends could be characterized as designers having fun when finally removed from the straightjacket of formal, Bauhaus-inspired, Eurostyle, geometric design. Bob Blaich of Philips said, "We're all tired of the black box and the white cube."[3] New designs were often brightly colored, playful, warm, whimsical, informal, and organic in form (shades of Frank Lloyd Wright!). Technical electronic products for children or young adults were toy-like rather than hi-tech. Some called it "soft-tech." Hartmut Esslinger explained: "The natural instinct we have as humans is to touch. As designers, we have to give something for the hand as well as for the eye."[4] His own slogan, "form follows emotion," challenged the modernist adage, "form follows function." A prime example of postmodern design was Philippe Starck's Juicy Salif, an insect-like lemon juicer, which became a cult object and was introduced in 1990 by Alessi.

New technical tools had removed another straightjacket. Computer-aided design software enabled designers to specify complex shapes, and the same software enabled machine tools to make them easily. Gone were the days when manufacturing processes dictated the shape of products to easily machined geometric forms. Now designers had the freedom to design products expressively and emotionally. They jumped at the chance.

Microsoft introduced Windows 3.0 in 1990, a graphic-based user interface with mouse and icons like Apple's. The system would soon dominate the home computer market. Another notable product line designed that year was the Good Grips kitchen utensils with oversized, ergonomic handles, intro-

Sanyo Steamship travel steam iron, by Smart Design, 1987, from PBC *Product Design 2*, 1987.

duced by OXO international, a company just formed by Sam Farber, who had also founded Copco in 1960. Farber, committed to good design, had engaged Smart Design, founded in 1989 by Davin Stowell and Tucker Viemeister, to design Good Grips. The design, which would be named as a Design of the Decade in 2000 by IDSA, was typical of what was being called universal design — design of products and environments that provided access to the full spectrum of users, regardless of their level of physical ability or disability; it was also called *trans-generational* design — products that accommodate young and old, able and less-abled users. The names were new, but designers had focused on these kinds of issues since the 1970s, when they were known as "Designs for the Handicapped."

Good Grips kitchen utensils, by Smart Design, 1990, for OXO International (courtesy IDSA).

In fact, a broad range of humanistic qualities, far beyond esthetics, color, function, or semantic expression, defined what was now known as Design Excellence in the 1990s. Environmental and social good were now legitimate measures of design success. When the American Design Council (ADC) was formed in 1990, comprising the executive directors of 10 design-related organizations, the council identified "environmentally responsible design" as a common priority of all design organizations. In 1991, Budd Steinhilber and Tom David introduced the concept of "design for disassembly" on a Tom Brokaw television news broadcast segment on industrial design. This concept urged the design of products for easy disassembly at the end of their lives so that parts marked for recycling could be identified and removed.

In 1990, *Business Week* magazine published two issues featuring design. In September its special issue, titled "Innovation — the Global Race," featured an article, "What's Hot in Product Design," and its December issue featured an article on the 1990 IDEA national design awards by IDSA. The cover, headlined "Rebel with a Cause," featured Hartmut Esslinger, who had become an international design star because of his work for NeXT and Apple. Most important, *Business Week* announced that starting in 1991, it would sponsor the annual IDEA awards program, with IDSA continuing to administer and jury the event. This arrangement, championed by Bruce Nussbaum, *Business Week*'s editorial editor, would continue for years, vastly increasing the national visibility of IDSA and design excellence in the business community as well as internationally. The Japan Industrial Design Promotion Organization, (JIDPO) in 1991 organized an exhibition, Good Design (G-mark) Products, in Yokohama City, Japan, which included winners in the IDEA90 program in the U.S.

There were an estimated 800 to 1000 U.S. product design firms at the time. Among these were three leading California design firms that merged in 1991 to become IDEO: David Kelly Design, Matrix Product Design, and ID Two (along with its associate companies in Europe). New principals included David M. Kelley, Bill Moggridge, and Michael Nuttal.

They offered both engineering and industrial design services, with an initial staff of 140, split 50–50 between the two disciplines. By 2004, IDEO would be the largest and most influential product design and development firm in the world, with a staff of 350, an annual revenue of $62 million, and offices in Palo Alto, San Francisco, Chicago, Boston, London, and Munich. IDEO would win more IDEA annual design awards over time than any other design organization.

In 1992, Congress passed the Americans with Disabilities Act (ADA), which prohibited discrimination on the basis of disability in all places of public accommodation and required that all new public spaces be designed to be readily available to all users. In the instance of trains, buses, and aircraft, this affected industrial designers as well as architects. Vice President Dan Quail served as honorary chair of the conference, Universal Design — Access to Daily Living, sponsored by Pratt Institute's Center for Advanced Design Research, the Cooper-Hewitt National Design Museum, Smithsonian Institution, and Columbia University's Department of Rehabilitation Medicine. Consumer products targeting specific social-conscious markets like gender were not uncommon. In 1992, for example, the Gillette Company introduced a razor specifically for women, the Sensor for Women, designed by Jill Shurtleff.

The Internet was established in 1992, and within two years, over a million Americans were online. By 1990, 22 percent of U.S. households had computers, and by 1999 there were 53 percent. Microsoft, Sun Microsystems, and other companies led a revolution in information technology, and not incidentally a ton of opportunities for new product designs. By 1999, infotech was about a third of all capital investment in industry and there were 56 million Internet hosts.

In 1993, an advisor to president-elect Bill Clinton invited a roundtable of U.S. designers assembled by *International Design* magazine to Little Rock, Arkansas, to "help government restore economic leadership and rebuild our cities." Clinton had campaigned on strengthening the national economy, which had weakened. Roundtable recommendations included the creation of a National Design Council. In 1994, after intensive and exhaustive efforts, and after supportive testimony by IDSA and the National Endowment of the Arts (NEA) to the Department of Commerce, a bill to establish such a council became moot due to an executive order by then-president Clinton "restricting the number of future councils and committees." However, Clinton presented eight Presidential Awards for Design Excel-

Motorola MicroTAC cellular telephone, 1989. Motorola introduced the 12.3-ounce (349-gram) MicroTAC cellular phone in 1989. The phone was the smallest and lightest on the market. By 1996, Motorola's StarTAC would weigh a mere 3.1 ounces and fit literally in the palm of your hand (courtesy, Motorola Archives, Inc.).

Frank O. Gehry wooden chairs for Knoll, Inc., 1992.

lence. Among them was one for an industrial design firm, Design Continuum, for a handheld explosive detector. By 1995, after NEA chair Jane Alexander presented 77 Federal Design Achievement Awards, NEA's budget was cut 40 percent, to $99 million, but by 2009, the annual budget would be raised to $155 million.

Canada's prime minister in 1994 opened the Design Exchange (DX), a private institution housed in the former Toronto Stock Exchange and chaired by Donald Macdonald. DX hoped to increase design awareness and innovation as tools for economic growth. In the U.S., the Council of Federal Interior Designers, the Institute of Business Designers, and the International Society of Interior Designers merged to form the International Interior Design Association (IIDA).

The auto industry rebounded to capture 75 percent of the U.S. auto market share in 1994, and for the first time in 14 years, it led the world in car production. The Big Three reached all-time earning levels. Outstanding designs that year included Ford's Sub-B small compact car, the Ka (inspired by the 1994 Swatchmobile), designed by Jack Telnack and Claude Lobo; Chrysler's Neon, designed by Thomas C. Gale; and Chrysler's purple Plymouth Prowler "drag-racer" retro style concept car, which would be introduced in 1997 in limited production. The design had evolved from a concept by Chip Foose, an Art Center industrial design student who had participated in a 1993 Chrysler sponsored senior project. The Plymouth name would be retired in 1999, after Daimler-Benz of Germany acquired Chrysler and renamed it DaimlerChrysler.

Business Week magazine in 1995 reported that "pressure to install Computer-Aided Design Technology [CAD], cut project costs, and sharply reduce time to market was revolutionizing in-house design departments, from IBM to Rubbermaid, from AT&T to Steelcase." But that was good for industrial design, because, according to Bruce Nussbaum of *Business Week*, "There is more recognition of the value that design brings to the product by the busi-

ness side than ever before." Design budgets were up by 15 percent to 20 percent annually over the five previous years, with most money going for high technology. For designers, cad proficiency was now a prerequisite job requirement. Companies were decentralizing, which led to "massive outsourcing of design work."[5] Brian Vogel, chair of IDSA's Design Management Group and senior vice president of Product Genesis in Cambridge, Massachusetts, said "Increasingly, designers in big corporations play two roles—internal champions for specific products, and integrators who connect with outside design functions with inside functions."[6]

In 1996, General Motors Advanced Technology Vehicles Group introduced the first modern all-electric car from a major automaker, the EV-1. It was based on the technology of the Sunraycer. The Sunraycer had been developed in a joint collaboration between GM, Hughes Aircraft, and AeroVironment, the latter of which built the Sunraycer, and was headed by Paul MacCready (1925–2007), already famous for his human-powered and solar-powered aircraft. The Sunraycer won the 1987 World Solar Challenge 1800-mile race in Australia against 24 competitors by a huge margin, averaging 41 mph. The approximately 1400 EV-1s produced were never sold, but were available on a lease basis only in California and Arizona. In 2003, the program was cancelled because GM said it could not sell enough cars to make it profitable.

Industrial design pioneers were still of interest to museums. A retrospective opened at the Cooper-Hewitt National Design Museum in 1997: Henry Dreyfuss Directing Design: The Industrial Designer and His Work. Concurrently, Rizzoli International published, *Henry Dreyfuss, Industrial Designer: The Man in the Brown Suit*, by Russell Flinchum.

In 1998, Mercedes introduced the Smart (for Swatch-Mercedes ART) car, based on a 1994 Swatchmobile developed by Swiss watch manufacturer Swatch. SMH Automotive of Switzerland designed the Smart car. Also in 1998, precisely 60 years after the original was first produced in 1938, the long-awaited new retro VW Beetle arrived, priced at $18,000 and designed by Design Center California of Volkswagen of America in Simi Valley and Volkswagen Design Center in Wolfsburg, Germany. It had originated in 1994 as a Concept One "retro-Beetle" designed by J. Mays and Freeman Thomas under Charles Ellwood at Simi Valley. Germany had ceased making the original Beetle in 1978, but it continued to be produced in Mexico, Brazil, Nigeria, and South Africa. By that time, 100 million had been sold, over six times that of the Ford Model T. Now there would be more, and the Beetle would become the longest running car design in history, and seemingly an eternal cultural icon.

Design awards continued to multiply exponentially. In addition to IDSA's annual awards, in 1994 the National Housewares Manufacturers

Tupperware Double Colander, 1994, designed by Morison S. Cousins, Tupperware's vice president of design (courtesy Tupperware Worldwide).

Association (NHMA) initiated an annual Student Design Competition, awarding $11,000 in cash prizes. In 1996 the Electronics Industries Association (EIA) had initiated a design awards program, Innovations 96, in conjunction with its annual Consumer Electronics Show (CES). IDSA's 1997 IDEA excellence awards, which had grown to 141 gold, silver, and bronze medals, were described by jury chair Louis Lenzi "as a trend toward more expressive design: a certain element of charm that speaks to the heart as well as the head — in part as a reaction against the sleek, hi-tech, low-whimsy designs of recent years."[7] In 1998, the first-ever Medical Design Excellence Awards debuted, sponsored by Canon Communications and administered and endorsed by IDSA. IDSA by this time had established an internet website to communicate directly to all its members and the design community at large.

A 1997 *Time* magazine article, "Where the Jobs Are," predicted 76,000 new product design jobs by 2005, and called design "one of the hottest professions in terms of job growth and compensation." The forecast was based on figures from the Bureau of Labor Statistics, which stated that industrial designers, currently totaling 9000, were among those design-related professions, and were expected to reach 21,000 by 2005.

In December 1999, *Business Week* magazine published a special issue featuring the winners of The Designs of the Decade: Best in Business 1990–1999 Awards competition, coordinated by IDSA. Winners were selected from previous IDEA award winners, and included OXO Good Grips kitchen tools (1990); Xerox Docutech by Fitch Richardson/ Smith (1990); AVC voting machine (1990); IBM ThinkPad by Tom Hardy and Richard Sapper (1992); Gillette Sensor for Women (1992); Apple Power-Book 100 by Apple staff under Robert Brunner (1992); Black & Decker's PowerShot staple gun by IDI/Innovations & Development, Inc., and Work Tools, Inc. (1993); the Herman Miller Aeron Chair by Bill Stumpf (1936–2006) and Don Chadwick (b. 1936) (1995); Bombardier's Sea-Doo jet watercraft (1996); Palm Computing's PalmPilot 1000 designed by Jeff Hawkins (1996); The new VW Beetle (1998); Motorola's Talk-About radio by Glen Oross, Frank M. Tyneski, Michael Page, and Bruce Claxton of Motorola staff (1998); and Apple's iMac (1999).

Sport Utility Vehicles, popularly known as SUVs, dominated auto sales in 1999. SUV sales had increased from 50,000 to 160,000 over the previous seven years. The first was the 1984 Jeep Cherokee XJ 4-door Sport Utility Vehicle, designed by the American Motors design group under Richard Teague.

Aeron chair by Bill Stumpf and Don Chadwick for Herman Miller, 1995 (photograph by Nick Merrick of Hedrick-Blessing, courtesy Herman Miller, Inc.).

SUVs appealed to consumers because of cargo space, crash survivability, road visibility, and general all-around utility. By 2000, they would account for 50 percent of all new cars purchased.

In 2000, the Cooper-Hewitt National Design Museum initiated annual National Design Awards as an official project of the White House Millennium Council, and the awards were presented in the White House. Recipients included Frank Gehry for his Guggenheim Museum in Bilbao, Spain; Apple computer for corporate achievement; and inventor Paul MacReady for design of technology including human-powered flight (Gossamer Condor, 1977; Gossamer Albatross, 1979) and solar powered cars (Sunraycer, 1987). In 2006, the Museum would add a Peoples Design Award, determined by votes on the museum Website.

The year 2000 was a big year for retrospectives. The Metropolitan Museum of Art opened an exhibition, American Modern 1925–1940: Design for a New Age, which traveled the country for several years. Both well-known and unsung women designers of the 20th century received credit in another exhibit, Women Designers in the U.S.A., 1900–2000: Diversity and Difference, mounted by the Bard Graduate Center for Studies in the Decorative Arts. Included was work by Florence Knoll, Katherine McCoy, Nancy Perkins, Jill Shurtleff, Lisa Krohn, and Lella Vignelli.

In similar spirit of the times, and upon the resignation of Robert Schwartz, IDSA acquired its first female executive director in 2000, Kristina Goodrich, who had served in the national office since 1979 in a range of positions. Schwartz had served IDSA since 1990, when he had replaced Brian Wynne. By 2000, IDSA had 3300 members in 28 chapters around the country. Much of design's prominence, and of good times for business, rested on the 79 million baby boomers, who were then between 35 and 53 years old and at the peak of their earning power. Bruce Hannah, a professor of design at Pratt Institute observed, "They're the richest group of people who ever existed, and they're willing to pay for three things: ease of use, safety, and comfort. That plus the best design."[8] Bill Moggridge, principal of IDEO, commented, "The pressure baby boomers are putting on us is to be normal. Now that their products are associated with disability, they want them to be universal, like computers."[9]

The recent 1994 advent of retro design cars like the VW Beetle and Plymouth Prowler appeared to inspire the entire design profession to look back for new ideas, probably thanks to baby boomer nostalgia. Indiana real estate developer Chris Baker revived production of Loewy's 1962 Avanti with the 1998 Avanti III and engaged Tom Kellogg, one of the original Avanti designers, as chief designer. In 1999, Chrysler introduced the PT ("personal transportation") Cruiser, a 1938-style retro design with full fenders and a running board designed by Bryan Nesbitt (b. 1969), and Ford rolled out a retro Thunderbird. In 2001 BMW reintroduced a retro version of the 1959 Mini Minor, and Ford introduced the Ford Forty-Nine, a tribute to its classic 1949 model. In 2006, Chevrolet would introduce its HHR ("heritage high roof") a retro-styled compact station wagon, also designed by Bryan Nesbitt.

Amtrak unveiled a new high-speed (150-mph) train, Acela, in 2000, which reduced travel time from Boston to Washington to 2½ hours and raised Amtrack's share of the transport market between New York and Boston from 18 percent to 40 percent. The sleek, streamlined design was the result of many designers and was produced by Bombardier and Amtrack/National Railroad Passenger Corporation. The Acela Express was based on earlier European and U.S. designs, including the 1993 AMD-103, the first U.S. passenger locomotive in 30 years to involve an industrial designer, Cesar Vergara, of the Amtrack design staff. It was produced by General Electric.

Target stores in 1999 launched a new 150-item line designed by Michael Graves in the

Chrysler's PT Cruiser by Bryan Nesbitt and Chrysler design staff.

Acela high speed train by Amtrack and Bombardier (from IDSA fall 2001 *Innovation Industrial Design Excellence Yearbook*, courtesy IDSA).

spirit of postmodern design. Items included a new teakettle, toaster, peeler, garlic press, can opener, and spatula. Black & Decker and Mirro, among others, made the products. That same year, Apple introduced its iMac computer in five different dramatic translucent colors, designed by Apple staff under design head Jonathon Ive (b. 1967) and Steve Jobs, who rejoined Apple in 1996 as CEO. The iMac became the fastest-selling computer in Apple's history. It set off a wave of "me-too" bright translucent product colors, including Proctor-Silex irons in strawberry, lime, tangerine, and blueberry in 2000.

Electronic technology was bringing new products to the market faster than ever in the 1990s. By 1996, PalmPilot unleashed a generation of shirt-pocket computers, and Sony's Playstation an avalanche of sophisticated computer games. In 1998, Sony, RCA, Panasonic and other makers introduced high-definition TV sets. The first portable MP3 players debuted. In 1999, Nokia transformed cell phones, such as its 8860 by Frank Nuovo, into fashion statements. Digital cameras were replacing film.

The March 20, 2000, issue of *Time* magazine included the article "The Rebirth of Design" subtitled "The Redesigning of America." The article claimed that "function is out, form is in," and focused on the "design economy," industrial designers, and many current examples of product design. While function was not truly "out," as in "ignored," form was the dominant characteristic of many product designs. Forms were soft, voluptuous, highly ergonomic, and even exotic. Black boxes were definitely out. In effect, the color and form of functional details like keys, levers, and switches became the new decorative ornamentation of the era. Bauhaus geometric shapes were out. Even Braun AG was designing soft, rounded forms. As yet, there was no gen-

Target's Toaster, by Michael Graves, 1999 (courtesy IDSA).

erally accepted descriptive title for this style. Some said the "new black" was not a color, but a mood. Bill Moggridge of IDEO commented in a *Washington Post* interview regarding the 2001 IDEA awards: "We're already seeing the shift [and] likened the next phase to Shinto, the ancient religion of Japan. Religious followers celebrate balance among the forces of man, nature, and the cosmos. Designers following this path presumably will strive for balance and harmony through simplicity of line and use of natural materials. The hallmark of this new design would be elegance in a quiet package."[10]

After decades of government regulations and international oil embargos, the first mass-produced alternative fuel cars reached the market in 2000. The Toyota Prius and the Honda Insight were gasoline-electric vehicles. The National Highway Traffic Safety Administration (NHTSA) created a new class of motor vehicle, the low-speed Neighborhood Electric Vehicle (NEV). Global Electric Motorcars, LLC (GEM), of Fargo, North Dakota, developed the first car in this class: a two-passenger, 48-volt model with a top speed of 20 mph. Daimler-Chrysler acquired GEM and began distribution of the vehicles. By 2002, Ford introduced a line of electric vehicles under the brand name, Th!nk, including one in the NEV Class. By 2004, 80,000 hybrid cars and trucks had been sold in the U.S., out of 17 million sales. By 2005, there were eight models of gas-electric hybrid cars, trucks, and SUVs by Lexus, Toyota, Honda, Ford, and Mercury on the market, and by 2006, Toyota had doubled its annual production of its Prius to 100,000 when gasoline prices begin to soar. In 2008, General Motors would announce the Chevrolet Volt, an extended-range electric vehicle (E-REV). It was slated for release in November 2010, as a 2011 model. With its lithium-ion technology, it would have a driving range of 40 miles on batteries alone, with additional range provided by a gasoline-powered electric generator, and a top speed of 100 mph.

IDSA in 2000 changed its bylaws to allow individual student membership in the Society. Previously, students could only participate in IDSA as members of student chapters at schools. In 2001, IDSA moved into new headquarters in Dulles, Virginia, easing staff con-

Emeco's (Electric Machine and Equipment Company) heritage recreation of its 1944 navy chair, the Hudson Chair, 1999, designed by Philippe Starck. Named for Ian Schrager's Hudson Hotel in Manhattan, it is in the design collection of the Museum of Modern Art and was selected by the Chicago Athenaeum as one of the top designs of 2000, winning the "Good Design Award" (photograph by Mikio Sekita, courtesy Emeco).

gestion and providing convenient access to Dulles International Airport. In 2002, IDSA initiated annual Design and Business Catalyst Awards as a sister competition to the IDEA awards. Catalyst nominees were selected from previous IDEA award winners which over time "provided valuable contributions to business in the context of return on investment"—in other words, financial success. By 2006, the competition was open to all submissions, and the single winner was Motorola's cell phone, the MOTORAZR V3. IDSA proposed to capture design's best stories of success and publish them as case studies, similar to the Harvard Business School Case Studies.

Apple, Inc., introduced the iPod line in 2001, to follow its highly successful iMac computer. The iPod was a portable MP3 media player no larger than a pack of gum that could store music, such as iTunes, downloaded from computers. Later models stored photos, videos games, e-mail and Internet access depending on the storage capacity. By 2007, Apple would debut its iPhone, no larger than a handheld calculator, which operated with a touchscreen and in 2008 would inspire revision of the entire iPod line.

In 2002, IDSA and the China Industrial Design Association sponsored a China-America Education Conference in Beijing. U.S. companies had been using Asian manufacturers for years to produce products at lower costs, and the number of U.S designers and educators traveling to China, Korea, and Taiwan was increasing dramatically. China was churning out thousands of design graduates and they were competing with American practitioners. IDSA Education Committee Chair Jim Kaufman said of China, "The productivity potential of this country is mind-boggling, and when they move from a manufacturing source to a product development position, they will truly have a product design presence in the world."[11] Bruce Claxton, IDSA president, commented: "The new game is to think and convince clients to act strategically with product design and development. The tactical business model is probably gone overseas."[12]

In April 2003, the Cooper-Hewitt National Design Museum bravely tried to capture the current state of American design with an exhibition, National Design Triennial: Inside Design Now. The museum was hard-pressed to categorize a dominant style in the eclectic, expressive menu of what some called "post-modern." So they just referred to the body of work as "by contemporary American designers." Curator Ellen Lupton's catalog observed that "technology has been internalized," meaning that designers now take electronic miracles as much for granted as their pencils. Some designs strayed so far from the traditional clean and simple designs that a magazine editor remarked that "ornament is back, and we've got to relearn how to use it."[13] By that he was alluding to the Victorian period, when designers were fighting to remove excess ornament from designs, a fight that continued well into the 20th century.

In October 2003, *Newsweek* magazine, apparently trying to compete with *Business Week*'s design monopoly, devoted an entire issue to current design. The cover story shouted, "Design Gets Real: How it's changing the way we work and live." Sandwiched between the Iraq War and terrorism were 61 pages featuring designers around the world and their designs from the ordinary to the exotic.

In 2004, IDEA became an international design awards program, open to all designers around the world, and 305 of the 1300 entries were from other countries, clear recognition that design had become an integrated global profession. There were more design competitions and awards throughout the world than one could count, many of them with significant cash awards. Dyson vacuum of the UK, founded by James Dyson, initiated a Dyson/IDSA Eye for Why global student design contest in 2004. The award challenged students to reenvision a product by improving on an existing product that excels in performance. Student winners received $5000 and an opportunity to compete in the global James Dyson Award. Dyson in 1993 had begun to produce innovative, bagless, colorful, Dual Cyclone vacuum cleaners that won many design awards. By 2008 the cyclone had captured 28 percent market share in the U.S. and had sold over 20 million units.

Communication concerning design had been rapidly expanding via the Internet. Since 1995, the Website Core77 had published design articles, maintained discussion forums, job listings, events calendars, and a data base of design firms, vendors, and services. Designers were posting their portfolios on Websites. IDSA, in conjunction with Microsoft, offered 12 on-line Spotlight Speaker seminars (called Webinars) in 2004, available on IDSA's Website via Microsoft Live Meeting technology. Speakers included

2004 IDSA Catalyst award winner, the DeWalt radio/charger, by Daniel F. Cuffaro, Brian Matt, and Charles Sears of Altitude, Inc., and Donald Zurwelle and Martin Gierke, of Black & Decker, Inc. (photograph by Bill Albrecht, from IDSA fall 2004 *Innovation Industrial Design Excellence Yearbook*, courtesy IDSA).

2005 Catalyst Award winner, Palm Zire, by Gadi Amit, Josh Morenstein, Mike Massucco, Chris Lenart and Yoshi Hoshino of newdealdesign, LLC, and Rich Gioscia, Lawrence Lam, Steven Shiozaki, Zita Netzel and Mark Babella of palmOne, Inc. (from IDSA fall 2005 *Innovation Industrial Design Excellence Yearbook*, courtesy IDSA).

prominent designers from corporations, consulting offices, and schools. In 2005, *Newsweek* magazine added a section devoted to covering design on its online magazine to promote innovation and design strategies. In 2006, IDSA initiated a regular e-newsletter for IDSA student members.

The profession had not forgotten its primary and traditional function of increasing sales and value for manufacturers. A 2004 IDSA survey of 183 corporate design offices reported that design increased product sales by 47 percent and increased sales prices 32 percent while only increasing product cost by 24 percent.

The International Council of Societies of Industrial Design (Icsid) in 2005 relocated its secretariat from Brussels, Belgium, to Montréal, Canada, and shared new headquarters with the International Council of Graphic Design Associations (Icograda), under a new umbrella organization, the International Design Alliance (IDA), which was ratified by both organizations in 2003. In 2008, the third partner in IDA would be the International Federation of Interior Architects/Designers (IFI). IDA is governed by a nine-member executive committee with a rotating chairperson. The initial IDA Congress was scheduled for 2011 at the Taiwan Design Center (TDC), established in 2004 by the Industrial Development Bureau, Taiwan, a trade organization promoting design since 1970.

A permanent Raymond Loewy gallery, emphasizing Loewy's transportation designs, opened in 2006 at the O. Winston Link Museum in Roanoke, Virginia. The museum was housed in the restored Norfolk & Western Railway Station, originally designed by the Loewy firm in 1949. Loewy's daughter, Laurence Loewy, was instrumental in establishing the gallery. That year, Loewy was also celebrated as "The Father of American Design" in a symposium held by the Hagley Museum in Wilmington, Delaware, that featured an exhibit, Designs for a Consumer Culture. The exhibit toured the country for several years.

Design awards dominated the profession. At the 2006 International Housewares Association (IHA) Annual Student Design Competition, female students captured the majority of the awards for the first time in the program's 13-year history, winning five of six top honors. Project entries totaled 233 and were submitted from 23 IDSA-affiliated U.S. design schools. Winners divided $8,900 in prizes. The Next-Generation Windows OS PC student design competition sponsored by IDSA and Microsoft's Original Equipment Manufacturers Marketing Group was initiated in 2006. It sought new ideas for computer design, both

hardware and software. Cash prizes totaling $125,000 were awarded. In 2007, the 1st International Design Awards (IDA) were initiated by the Farmani Yamanouchi Inc. (FYI) group, a sibling of the Annual Lucie Awards for photography. Included were architecture and interior, fashion, product, graphic and fashion design.

The annual IDEA awards ceremony at IDSA's annual conference was becoming quite sophisticated, with black ties optional, and with an ambience reminiscent of Hollywood's Oscar awards. The 2006 IDEA awards were indicative of the rise of Asian design, according to Bruce Nussbaum, *Business Week* magazine's assistant managing editor of innovation and design:

> Chinese, Taiwanese, Korean, Japanese and Hong Kong companies and their governments are committing huge resources to design in order to build global brands. Panasonic won six awards, twice as many as the next winner and far more than any U.S. or European corporation. China's Lenovo Group Ltd. computer maker took two golds, the most of any company. Samsung Group won a gold and two silvers and still leads all global corporations, including Apple Computer Inc., for the most IDEA wins over the past five years. The percentage of gold winners with design teams from Asia came to 25.9 per cent, compared with 8 percent in 2005 and 2004.[14]

Indeed, China's president, Hu Jintao, confirmed the country's new emphasis on design and innovation at a national conference on technology in early 2006, stating the following: "Innovation is the core of the nation's competitiveness. Only with strong capacity for innovation can a country win the initiative in the international competition."[15] Lorraine Justice, American professor and director of the School of Design at Hong Kong Polytechnic University, characterized China: "Reminiscent of the [postwar] U.S. is the excitement in the air. The can-do attitude that swept the U.S. in the 1950s and 1960s is prevalent throughout China, and in a much more dramatic way. The Chinese government is focusing on the importance of the design of products. It understands that good product design will help its factories and companies sell more products and that design can make these products more desirable worldwide."[16]

In 2007, the XO-1 laptop computer was first produced in quantities by the OLPC (One Laptop Per Child) Association, a nonprofit organization founded by Nicholas Negroponte in 2005. It was intended to sell for $100 and to be used by children in developing countries, but it was initially priced at $199 in a "give one-get one" promotion (two for $398), the second going to a child in a developing country. Yves Béhar, founder of fuseproject in San Francisco, designed the XO-1 housings in 1999. By 2009, OLPC had sold a total of 1.3 million units, most in developing countries, at a cost of $250,000 per project. Initial hardware cost per unit was $148, but with setup, training, maintenance and Internet access costs, the 5-year total cost per unit was $972 to sponsors or developing countries like Uruguay, Libya, Rwanda, Nigeria, and Brazil.

Connecting 07, IDSA's national conference in San Francisco chaired by Bill Moggridge, hosted a congress of the International Council of Societies of Industrial Design (Icsid), for the first time since 1985. The conference reinforced the global nature of design and provided attendees with a wealth of ideas, exposure to top designers, and, of course, connections to everything.

Chicago's Museum of Science and Industry, during Black History Month in 2007, recognized African American industrial designers in an exhibit, Designs for Life. IDSA executive vice president Eric Anderson was among them, and commented: "Not only does it highlight the diverse talent and contributions of Black designers across industry over the past 50 years, it also serves as a source of inspiration for exhibitors and the general audience, particularly the youth."[17]

In 2008, the same year Barack Obama was elected the first African American president of the U.S., professor Eric Anderson of Carnegie Mellon University was elected IDSA's first African American president in IDSA's first online election, and African American Charles Harrison received a Lifetime Achievement Award at the White House as part of the Cooper-Hewitt's National Design Awards program.

A number of international design organizations contributed to the January 2008 7th CII-NID Design Summit held in India, sponsored by the Confederation of Indian Industry and the National Institute of Design. Individuals representing companies around the world mapped out strategies for developing India's potential in the design industry. Later that year — June 29 — was the inaugural celebration of World Industrial Design Day (WIDD) spearheaded by the International Council of Societies of Industrial Design (Icsid).

Business Week's Bruce Nussbaum saw social responsibility on the world stage as a primary trend of the International Design Excellence Awards (IDEA) for 2008:

A strong sense of social responsibility ran through most of the winning entries, such as the Balance Sport Wheelchair. Designed for physically challenged athletes, the wheelchair frees the hands to play basketball. The "One Laptop Per Child" project won two Golds, one Silver, and one Bronze award. A Gold in packaging and graphics went to *Design for Democracy: Ballot & Election Design*, a book that helps U.S. States design clearer, more useful ballots and polling place signs. And

2007 IDEA gold award winner, the Fuego grill, by Robert Brunner, IDSA, Darren Blum, Victoria Slaker, Kenny Sweet, and Symon Whitehorn of Pentagram Design and Alex Siow of Fuego (from IDSA fall 2007 *Innovation Industrial Design Excellence Yearbook*, courtesy IDSA).

Philips Design took a Bronze for a more efficient wood-burning stove that cuts rural villagers' deaths from smoke inhalation.[18]

A sense of social responsibility inspired designer Valerie Casey to organize Designers Accord, a coalition joined by design firms, colleges and corporations who agreed to follow five "green" guidelines, including reducing the carbon footprint, educating staff in sustainability, and discussing environmental impact issues with every client. Designers Accord would hold a Global Summit on design education and sustainability in San Francisco in October 2009. By then, there were 170,000 signatories.

The popular buzz-word "sustainability" permeated U.S. design competitions, design conferences, education, and debates. It became the unassailable high ground of political correctness. This umbrella word seemed to encompass the well-being of the earth, the health of our bodies, the quality of food we eat, the purity of the air we breathe, and the survival

2008 IDEA gold award winner, the Crown RC 5500 Series Rider Counterbalance Lift Truck, by Craig J. Rekow, IDSA, Adam Ruppert, IDSA, and Roger Quinlan, IDSA, of the Crown Design center and Thornton Lothrop, Ryan Berger, and George Chow of Design Central for Crown Equipment Corporation (from IDSA fall 2008 *Innovation Industrial Design Excellence Yearbook*, courtesy IDSA).

of the plants and animals we share the planet with. All become part of the designer's responsibility, according to many people. The term seemed to replace or include universal design, trans-generational design, renewable design, environmental design, "green" design, energy conservation, recycling, and all similar socially responsible enterprises. This perception of design as a global solution to social and environmental problems is in ironic strategic contrast to the invigorated and vital Chinese design community, which is committed to design excellence for the singular purpose of achieving global competitive economic superiority in manufactured goods!

U.S. industrial design was, of course, in the process of following the latest technology, as it has always done. U.S. designers are attracted by the potential for new products and systems required for environmental improvement and energy conservation, while Chinese designers are attracted by potential for manufacturing opportunities. Industrial designers, like artists, always seek new frontiers of expression, interpretation, and meaning in their work. Then again, industrial designers may be emphasizing their laudable role in social responsibility in order to disassociate themselves from the negative aspects of their historical partners, industry and business, which are creating pollutants, spawning greed, and committing fraud — much of which makes global headlines.

But as in all new technologies, designers must acquire new technical and scientific knowledge to participate effectively. There is always a risk that designers, untrained in specialized new technologies and rushing to be perceived as a leading cultural edge, may not be able to distinguish between realistic and unrealistic solutions. Incidentally, China leads in both carbon dioxide emissions as well as manufacturing, because the two have always gone hand in hand. The industrial revolution, which initiated our own profession, continues to raise the standard of living as well as harm the environment in many areas of the world. Questions abound. Do we have the right to deny millions of people the same material benefits that we now enjoy as a result of our own industrialization? Does the design profession have realistic aspirations? Is it at all concerned about the financial sustainability of an ever-expanding national debt, global competition, and the declining value of the dollar?

Budd Steinhilber, an industrial designer for 66 years, offered a sobering thought: "Sustainability? Sometimes when I hear that word I want to groan. The term, not unlike its cousins 'green' and 'renewable,' has become so pervasive, overworked, distorted and misused that it has lost much of its intended meaning. The primary definition of 'sustainability' is 'a characteristic of a process or state that can be maintained at a certain level indefinitely.' By indefinitely do we mean perpetually?... The laws of nature are telling us that sustainable may not be obtainable."[19]

Another example of unrealistic aspirations in the face of scientific facts is the popularly expressed urgent need for the reduction of carbon dioxide emissions caused by humans, when the "warming effect" of such emissions constitute a mere one tenth of one percent of the impact of all "greenhouse gases," which are 95 percent water vapor. Could this infinitesimal amount be among the primary causes of global climate change, or is regulation of carbon a political means to a taxation end? In this era of intense politicalization, designers needed to understand political, as well as artistic, manufacturing, and marketing processes. When design (or art) promotes political agendas, history has shown that it often places its technical reputation for excellence at risk.

The 2008 IDEA awards were the first that used actual products during the final jury phase, the first to incorporate an international feeder competition, and the first to use a

student juror. Fifty-three designs out of 343 entrants to the IDEA/Brazil Awards program became finalists in the global IDEA competition, with 12 receiving honors. Additional feeder competitions in other countries were being promoted. Out of 1500 entries, there were over 200 awards in the 2008 global IDEA competition. IDEA sponsors included *Business Week* magazine, Target, and Autodesk Inc. IDEA award winners were publicized in *Business Week* magazine, featured in a spectacular 216-page fall issue of IDSA's *Innovation*, and exhibited at the Cameron Art Museum in Wilmington, North Carolina, exhibition Winning IDEAs: Selected Designs 2008, in April, 2009.

By 2009, the estimated number of industrial designers in the U.S. was around 50,000; 3000 were members of IDSA. Median annual salaries were around $55,000. IDSA had a full-time staff of 12, an annual budget of about $5 million, and 27 chapters in five national districts, each of which conducted annual spring conferences, for professionals and students, where IDSA student design awards were presented. Many chapters had their own Websites. There were also 17 IDSA Professional Interest Sections where designers joined in projects and discussions via e-mail or Websites to further their special design-related interests. Forty-five corporations, manufacturers, and consulting firms had become Patrons of Industrial Design Excellence and were generously supporting IDSA's programs promoting the profession and recognizing designers for their work.

The severe financial recession of 2008–2009, however, crippled the U.S. and global economy. Home foreclosures, job losses, tightened credit, failed banks, and stock market losses of 50 percent made it tough for many businesses and individuals. Chrysler and GM both entered bankruptcy and received federal bailout funds. However, many saw investment

IDEA 2008 gold award winner iPhone by Apple Industrial Design Team of Apple, Inc. (from IDSA fall 2008 *Innovation Industrial Design Excellence Yearbook*, courtesy IDSA).

in innovative design as a primary strategy for recovery, just as it was in the depression era of the 1930s. The editor of IDSA's Journal, *Innovation*, Gregg Davis, reported: "*Business Week*, the *Wall Street Journal*, and the heads of many thriving corporations recommend increasing budgets for innovation, or at least maintaining them at similar levels to last year.... Experts from many perspectives are saying that if there was ever a time to spend on innovation, now is that time."[20] Even at the depth of the recession in November, 2009, when national unemployment topped 10 percent, there were over 20 positions advertised on the IDSA Website for industrial designers and thousands more posted on the Internet. Industrial design is traditionally a recession-proof profession.

As if to reinforce the economic value and potential of innovation and design, IDSA's Catalyst program, showcasing design's power to effect positive change on the bottom line, was relaunched without awards and conducted by Catalyst executive director Ravi Sawhney, founder and CEO of RKS Design, Inc., in Thousand Oaks, California, who originated the original Catalyst Award concept in 2002. The 2009 Catalyst winners included OXO's Good Grips, designed by Smart Design and Sam Farber (1990); Whirlpool Strategy, the bold idea to infuse an entire corporation with innovation (1999–2009); Apple's iPod/iTunes/iPhone (2001–2009); and Black & Decker's original Dustbuster, designed by Carroll Gantz (1979).

The IDEA annual awards were rapidly becoming global design awards. Out of 1,631 entries, there were 150 IDEA design awards presented in 2009, 66 of them to 15 countries other than the U.S., including Australia, Brazil, Canada, People's Republic of China. Denmark, France, Germany, India, Italy, the Netherlands, Singapore, South Korea, Sweden, Taiwan, and the United Kingdom. The top award winners from consulting offices over the previous five years were IDEO (37), fuseproject (23), Continuum (15), ZIBA (13), and Smart Design (13). Top winners for corporations over the same period were Samsung of South Korea (23), Apple, Inc. (20), DECATHLON/Oxylane Group of France (14), Hewlett Packard (13), and Philips Design of the Netherlands (13). Top winners for students were the Art Center College of Design (18), Samsung Design Membership/SADI (Korea) (12), Royal College of Art (UK) (5) and Seoul National University (Korea) (5), and Purdue University (4).

In 2009, as the industrial design profession celebrated the 75th anniversary of its dramatic appearance on the American business scene in 1934, it could look back with pride and a sense of accomplishment. From a handful of eclectic practitioners has grown a global industry of design, well recognized not only as the source of business success for countless enterprises, but also

2008 IDEA silver award winner, the Whirlpool Duet Steam Washer, by the Global Consumer Design Staff of Whirlpool Corporation (from IDSA fall 2008 *Innovation Industrial Design Excellence Yearbook*, courtesy IDSA).

for providing millions of consumers with products that are innovative, attractive, safe, comfortable, usable, and affordable. In addition, as stated by 2009 *Innovation* editor, Larry H. Hoffer, "Breathtaking designs are certainly among this years [*sic*] winners and finalists, but so are products created to save lives, improve living conditions, help those with disabilities, protect (or improve) the environment and detect disease, as well as make life easier and more entertaining. And the strategies and research programs recognized this year only reinforced the broadening of the design umbrella — both IDEA and industrial design continue to expand beyond solely the design of products."[21]

The 2009 IDEA gold award winner, the Samsung Dual Cooking Oven (BTS1), was designed by Kang-Doo Kim, Joo-Hee Lee, Seon-Ju Lee, Chan Young Lee, and Ji-Young Shin of Samsung Electronics (from IDSA fall 2009 *Innovation Industrial Design Excellence Yearbook*, courtesy IDSA).

This evolution of design has been accomplished by the personal dedication of thousands of creative individuals who used their artistic and inventive skills to mold technology and manufacturing into tools, environments, and artifacts that are compatible with human needs, emotions, tastes, capabilities, and preferences. They have tamed the initial threat of industrialization into a never-ending source of human experience, convenience, enrichment, and satisfaction. These benefits are now so common that they are automatically expected and accepted with little thought of how they have been achieved. Industrial design is now a huge global business.

But what is now regarded as ordinary has been achieved only through a long historical process of extraordinary effort as our design ancestors struggled to adapt to, and finally control, their physical environment through creative collaboration and problem solving. Without industrialization, we would be among undeveloped countries, of which there are still many. Without a growing and globally competitive economy, industrial design, too, is at risk.

Let us celebrate the successful blending of technology, industry, and art that has provided us all with the highest standard of living in history. Industrial design can indeed be proud of its participation in this revolutionary process. But let us not forget that our livelihood depends on the business, manufacturing, and marketing health of the country.

Appendix I

Biographies

Aalto, Alvar (1898–1976) Finnish architect and furniture designer/manufacturer, studied architecture at Helsinki Polytechnic 1916–1921 and opened an office in 1923. After 1929, he associated with László Moholy-Nagy, Georges Braque, and Fernand Léger. Aalto developed a new process for laminating plywood that was shown at an exhibition in Helsinki and led to the establishment of his export company, Artek. His inexpensive chairs humanized International Style by emphasizing organic form, and he was featured in a one-man show at the Museum of Modern Art in 1938 that had a major impact on American designers. He was a visiting professor at MIT from 1946 to 1947.

Adam, Robert (1728–1792) Scottish architect who was court architect of George III of England. After much time in Italy in the 1750s witnessing excavations of ancient culture, he initiated furniture designs in the Roman and Greek styles, known as Neoclassical style. Robert's brother **James** (1732–1794) also an architect and furniture designer, joined Robert in his business in 1761; they typically designed both furniture and accessories in homes they designed. They both also designed metal products for Matthew Boulton's Soho Foundry.

Albers, Josef (1888–1976) Born in Westphalia, Germany, he studied art in Berlin, Essen, and Munich from 1913 to 1920. He studied at the Bauhaus, became a teacher there in 1923, and was the first student to become a Bauhaus master in 1925. In 1928, he succeeded Marcel Breuer as head of the furniture workshop, where he remained until 1933, when he came to the U.S. He taught at Black Mountain College, North Carolina, until 1949, and lectured at Harvard and Yale. In 1950 he became professor of color theory and chair of the design department at Yale. In 1963, he published *Interaction of Color*.

Appel, Wallace Henry (b. 1925) U.S. industrial designer who was born in Boston, attended Penn State University, and graduated from the Rhode Island School of Design. He joined Westinghouse in 1950 and was appointed manager of Consumer Products Design in Columbus, Ohio, in 1955, and design manager for Mansfield Center in 1969. After Westinghouse was acquired by White Consolidated Industries (WCI), he was appointed manager of industrial design for Mansfield Products Company of White Westinghouse from 1975 until 1980, when he became vice president of design. In 1982 he was named vice president of design for WCI International, a position he held until his retirement to Venice, Florida, in 1991.

Arens, Egmont (1888–1966) A U.S. package and industrial designer, he was sent by his family to New Mexico to recover from tuberculosis and began a career as a sports editor for the *Albuquerque Tribune-Citizen* in 1916. He moved to New York, operated the Washington Square bookstore, and established the Flying Stag Press to publish magazines. His interest in art led to editorship of *Creative Arts* magazine, *Playboy* (the first magazine devoted to modern art), and *Vanity Fair*, a leading style and fashion magazine. By 1929 he was advertising director for Calkins & Holden, where he headed an industrial styling department until it was discontinued in 1936. He wrote *Consumer Engineering* with Roy Shelton in 1932, and designed the Higgen's ink bottle, A&P packages, including 8 O'clock coffee, the classic KitchenAid stand mixer, and the Phillip Morris trademark.

Ashbee, Charles Robert (1863–1942) English architect and designer educated at Wellington College who studied under architect George Frederick Bodley. A follower of William Morris, in 1888 he set up a guild and school of handicraft and by 1890 had workshops at Essex House in London, making

metalwork, jewelry, and furniture. In 1902, his works moved to Chipping Camden in the Cotswolds, but in 1907, his guild was liquidated.

Bach, Alfons (1904–1999) U.S. industrial designer, born in Magdeburg, Germany, who worked in film set design and studied architecture at the Reimann School and the University of Berlin before immigrating to the U.S. in 1926. In 1932 he established his own firm, Alfons Bach Associates, in New York City. Clients included Heywood-Wakefield Furniture Company, Lloyd Manufacturing Company, International Silver, Philco and TWA. He settled in Stamford, Connecticut, in 1937, where he designed and developed Ridgeway Shopping Center. He became president of the American Designers Institute (ADI) in 1943, moved to Palm Beach, Florida, in 1959, where he continued his practice, and retired to Pensacola, Florida, in 1992.

Bayer, Herbert (1900–1985) Born in Haag, Austria, he studied architecture at Linz and Darmstadt and painting under Wassily Kandinsky at the Bauhaus from 1921 to 1923. He returned to the Bauhaus as master of the Bauhaus print workshop in 1925, teaching visual communication and typography, and initiated lowercase sans serif type for all Bauhaus printing. He designed Universal typeface in 1927, and left the Bauhaus in 1928 for an advertising agency in Berlin. After organizing a 1938 Bauhaus exhibition at the New York Museum of Modern Art, he stayed in the U.S. as consultant to major corporations. His association with the Container Corporation of America (CCA) started in 1946. It was here that he developed the Great Ideas of Western Man advertising series, and the *World GeoGraphic Atlas* from 1949 to 1952, a landmark of communication design. He spent his last ten years in California, painting.

Beck, George A. (1908–1977) U.S. industrial designer who graduated from the Chicago Academy of Fine Arts and worked under Ann Swainson at Montgomery Ward, then at Sears, Roebuck in the 1930s. He started at General Electric (GE) in 1934, working under Ray Patten from 1936 to 1942. In 1946 he was named manager of industrial design in GE's new electronics department in Syracuse, New York, and in 1957 he established a new industrial design subsection in GE's Light Military Electronics department. In 1961, he received ALCOA's annual industrial design award.

BecVar, Arthur N. (1911–2003) U.S. industrial designer who graduated with a BFA from Notre Dame in 1933 and received an engineering certificate from Purdue University, and an MFA at the Institute of International Education, Charles University, Prague, Czechoslovakia (1933–1934). He worked from 1935 to 1939 with John Gordon Rideout in Cleveland, Ohio, and later with Revere Copper and Brass. He joined General Electric in 1944 and headed industrial design there starting in 1948. In 1950, he became manager of industrial design for GE Major Appliances, Louisville, Kentucky, where he remained until his retirement in 1976. He was president of ASID in 1955.

Behrens, Peter (1868–1940) German architect and designer born in Hamburg who studied painting at Karlsruhe and the Düsseldorf schools of art from 1886 to 1889. He cofounded the Munich Vereinigte Werkstätten für Kunst im Handwerk (United Workshops for Art in Handcraft) in 1897, and was professor of the artist's colony in Darmstadt from 1900 to 1903. He directed the Düsseldorf School of Arts and Crafts from 1903 to 1907. He was appointed chief artistic advisor at AEG from 1907 to 1914 and was a founder/member of the Deutsche Werkbund. Walter Gropius, Le Corbusier and Mies van der Rohe all studied under him in the office he opened in 1908. During and after World War I, he continued to practice as an architect. In 1922 he was appointed to the Vienna Academy of Graphic Arts, and in 1936 to a master's architecture program at the Preussische Academy of Art in Berlin. In 1939, he designed a new administration building for AEG in Berlin.

Bel Geddes, Norman (1893–1958) Born in Adrian, Michigan, he studied briefly at Cleveland Institute of Art and the Art Institute of Chicago. He began work as an advertising draftsman in Chicago and Detroit in 1913 and established a highly successful career in theatrical set design in New York. He began work as an industrial designer in 1927 at the suggestion of Ray Graham of Graham-Paige Motors Company and proceeded to design prototype cars for him. He became known as the "P.T. Barnum" of the new field, with futuristic and visionary transportation designs. In 1932, he published his book *Horizons*, and in 1939, he designed General Motors' Futurama at the New York World's Fair. Based on his studies of transportation, he published *Magic Motorways* in 1940, an inspiration for the interstate system of highways.

Bellini, Mario (b. 1935) Italian designer who graduated in architecture from Milan Polytechnic in 1959 and opened his own architecture and design office there in 1962. He consulted with Olivetti, Lamy, Artimede and many others. Among his many award-winning designs are the Divisumma 18 printing calculator of 1972 and the 1973 Lexikon 82 typewriter, both for Olivetti. Starting in 1986, he became editor-in-chief of *Domus* magazine. In 1987, the Museum of Modern Art exhibited a one-man show of his work accompanied by a museum publication. A number of his designs are in the museum's permanent collection.

Bertoia, Harry (1915–1978) Sculptor and furniture designer who was born in Italy, emigrated to the U.S. in 1930, and became a citizen in 1947. He studied at Cranbrook Academy from 1937 to 1940 and became a teacher there. He produced molded plywood products for the war effort at Evans Products Company in Venice, California, in 1943, where he also designed chairs with Charles Eames and took a position with him in 1949. In 1950 he established his own studio in Pennsylvania and became an independent designer in 1952 for Knoll Associates, for whom he designed Bertoia chairs. After 1953, he devoted himself almost exclusively to sculpture.

Bill, Max (1908–1994) Swiss exhibition, stage, graphic and industrial designer, painter, sculptor, architect, and theorist who studied as a silversmith in Zurich (1924–1927) and in art at the Bauhaus in Dessau (1927–1929). In 1931 he embraced the concepts of Theo van Doesburg and played a major role in the Swiss school of graphic design development. In the early 1950s he designed buildings at Ulm Hochschule für Gestaltung, of which he became director until 1956. He later worked as a freelance designer for watchmakers Junghans and Omega.

Birren, Faber (1900–1988) U.S. artist, author, and color consultant who was probably the most influential man of the century in research, education, and the functional use of color in industry, medicine, and the military. He studied at the Art Institute of Chicago and the University of Chicago, settled in Stamford, Connecticut, and from the 1920s to the 1980s, lectured and authored over 30 books and 200 articles on all aspects of color and human responses to it. He consulted with *House and Garden*, Walt Disney Studios, the Hoover Company, the U.S. Navy, U.S. Army, and U.S. Coast Guard, among many others.

Blaich, Robert IDSA, FRSA (b.1930) U.S. industrial designer who received a BFA in industrial design from Syracuse University. He worked in design and marketing before starting with the Herman Miller Furniture Company in 1953; he served as its vice president of corporate design and communications from 1968 to 1979. In 1980 he was appointed head of the Concern Industrial Design Centre at Philips Electronics in the Netherlands, where he integrated the disciplines of engineering, marketing and design to build a new corporate image of advanced global design. He was president of ICSID (1985–1987). In 1990, he received an honorary doctorate in design from Syracuse University and in 1991 he was knighted by Queen Beatrix of the Netherlands. He remained at Philips until his retirement in 1992, when he founded Blaich Associates in Aspen, Colorado. He wrote *Product Design and Corporate Strategy* (1993), and *New & Notable Product Design* (1995).

Bordinat, Eugene, Jr. (1920–1987) U.S. automotive designer who graduated from the University of Michigan and studied art at Cranbrook Academy. He joined General Motors in 1939 and became a supervisor of the wartime tank program at Fisher Body. He joined Ford in 1947 as supervisor of advanced styling, working mostly with the Lincoln-Mercury Division. He became vice president of design in 1961 and served in that capacity until his retirement in 1980.

Bourke, Robert E. (1916–1996) U.S. automotive designer born in Chicago who studied at the Chicago Art Institute and the Armour Institute. He started working at Sears, Roebuck and Company in the design department. In 1940 he was hired by Studebaker and worked in the internal design department. In 1944 Bourke replaced Exner as designer on the 1947 Studebaker and by 1949 he was head of Loewy's Studebaker group. He designed the 1950 Studebaker with its distinctive "bullet" nose, and in 1953 the elegant Studebaker Starline coupes. He left Loewy in 1955 and established a design consultancy with Clare Hodgman, in Westport, Connecticut, Hodgman-Bourke, Inc. Clients included Volvo, Mack trucks, and GAF cameras. Both he and Hodgman retired in 1969.

Brandt, Marianne (1893–1983) German industrial designer associated with the Bauhaus. She studied painting and sculpture in Weimar, Germany, in 1911, became a student there in 1923, an instructor

there starting 1924, and briefly, headed the Bauhaus metal workshops in 1928. Her designs as a student were influential to the modern movement. In 1929 she moved to Berlin as a designer in the studio of Walter Gropius. After World War II she taught industrial design at the School of Fine Arts in Dresden from 1949 to 1954, and at an industrial design school in Berlin from 1951 to 1954 before retiring.

Bredendieck, Hin (1904–1995) German industrial designer who enrolled in Bauhaus in 1927 and graduated in 1930. He began practice in the Berlin studio of László Moholy-Nagy and Herbert Bayer, and then he worked at the B.A.G. Lighting Manufacturing Company in Switzerland. Later he returned to Germany to work with Herman Gautel, a furniture manufacturer. In 1937 he was invited by Moholy-Nagy to join the faculty at the New Bauhaus in Chicago. In 1952 he became the first director of a new design program at Georgia Institute of Technology, a position he held until his retirement in 1971.

Bressler, Peter W. (b. 1946) U.S. industrial designer who graduated from the Rhode Island School of Design. In 1970 he founded Designs for Medicine, Inc., in Philadelphia, which later became Bresslergroup, and also taught design at the Philadelphia College of Art. He authored over 70 patents and his firm has won 60 design awards. In 1987 he was an invited consultant and lecturer to the Peoples Republic of China. He was president of IDSA from 1989 to 1990, and has been a fellow since 1992.

Breuer, Marcel (1902–1981) Designer and architect associated with the Bauhaus. Born in Pecs, Hungary, he studied at the Vienna Academy of Art before becoming a student at the Bauhaus in 1920. As a student, he experimented with steel tubing as a construction material for furniture. In 1925 he became Bauhaus master of interior design and worked on a number of furniture designs significant to the modern movement, including chairs of steel tubing. In 1928 he left the Bauhaus to establish his studio in Berlin. In 1937 he was invited by Walter Gropius to the U.S. to teach design at Harvard. He moved to New York in 1946 to establish an office with Herbert Beckhard, Robert Gatje, and Hamilton Smith. Later, he became associated with IBM's design program under the direction of Eliot Noyes.

Budlong, Robert Davol (1902–1955) U.S. industrial designer born in Denver, Colorado, who studied art at Cummings School of Art in Iowa, graduated from Grinnell College, Iowa, in 1921 and studied art at the Chicago Academy of Fine Art. He soon opened an advertising office in Chicago. He began his career in industrial design in 1933 with the Hammond Clock Company, and consulted with Zenith, from 1934 until his death, designing radios. Budlong's business was acquired by **Kenneth P. Schory** (1921–1991) in 1955 and became Ken Schory Associates. Schory then partnered with Tom Steinbach (Schory-Steinbach Associates, later Creative Corporation), and in the 1970s under Steinbach alone, the business became the Design Lab.

Buehrig, Gordon Miller (1904–1990) U.S. automotive designer who studied at Bradley Polytechnic in Peoria, Illinois, before becoming an apprentice at the Gotfredson Body Company, Detroit, in 1924. He also worked for Dietrich, Inc., Stutz, and General Motors. He was stylist for the Auburn Automobile Company and in 1936 designed the classic 810 Cord Westchester Sedan and the 812 model that followed, both of which became design classics. In 1944 and 1945 he headed Raymond Loewy's Studebaker group in South Bend. He later worked for Ford until retirement.

Carriero, Joseph A. (1920–1978) U.S. industrial design educator who chaired the program at the Philadelphia Museum School of Art (now the University of the Arts). In 1957 he cofounded and served as the first president of the Industrial Design Education Association. By 1973, he was chairman of the Department of Design and Environmental Analysis, New York State College of Human Ecology, Cornell University, New York.

Chapman, David (1909–1978) An architectural graduate of Armour Institute of Technology (later Illinois Institute of Technology) in Chicago, he worked on the Century of Progress Exposition in 1933. That same year, he joined Montgomery Ward as an architect and was appointed head of product design in the Bureau of Design, where he had a staff of eighteen by 1935. He left in 1936 to open his design office, Dave Chapman Inc., later renamed Goldsmith Yamasaki Specht, Inc. The firm worked during the war to readapt companies to peacetime production, and major clients included International Harvester, Brunswick-Balke-Collender, and Scovill Manufacturing Company. He was president of the Society of Industrial Designers in 1950 and in 1954 organized a subsidiary company, Design

Research, Inc., providing long-range planning for clients. In 1955, he returned to Montgomery Ward to reorganize the Bureau of Design.

Chippendale, Thomas (1718–1799) London cabinetmaker, interior designer, and furniture designer who in 1754 became the first cabinetmaker to publish a book of his designs, *The Gentlemen and Cabinet Maker's Director*. His designs were in the mid–Georgian, English Rococo, and Neoclassical styles and were copied and modified throughout the world. His workshop was in Otley, West Yorkshire. His son, Thomas Chippendale the younger (1749–1822), who worked in the Neoclassical and Regency styles, continued his business after his death.

Cole, Henry (1808–1882) English designer (under pseudonym Felix Summerly) and civil servant who lobbied the British government to improve design standards. He urged the crown to host the 1851 Great Exhibition in London, and was appointed one of its commissioners to plan for the event. In 1849 he founded the *Journal of Design*, commenting critically on a variety of products. Cole was instrumental in the development of the Royal College of Art, and was the first director of the South Kensington Museum, from 1857 to 1873, which later became the Victoria and Albert Museum. He was knighted by Queen Victoria in 1875.

Le Corbusier (1887–1965) Probably the most influential figure in modern architecture between 1920 and 1960, he was born Charles-Edouard Jeanneret Gris, the son of a watchcase engraver in La Chaux-de-Fonds in Swiss Jura. In 1907 he met Josef Hoffmann and worked in the office of Parisian architect Auguste Perret from 1908 to 1909 and with Peter Behrens from 1910 to 1911. He settled in Paris in 1917, took the pseudonym Le Corbusier in 1920, and edited the art journal *L'Esprit Nouveau* from 1920 to 1925, proposing theories of modern design in terms of visual masses and stripping away human experience to reveal pure form, color, and effect. He designed the famous *L'Esprit Nouveau* exhibit at the 1925 Paris Exposition Internationale, a range of furniture shown in 1929, and his famous church of Notre Dame-du-Haut at Ronchamp (1950–1954).

Cousins, Morison S. (1934–2001) U.S. industrial designer who was born in Brooklyn, New York, and graduated from Pratt Institute in 1955. He worked initially for International Harvester and then served in the U.S. Army. In 1963 he formed Morison S. Cousins & Associates with his brother, **Michael Cousins**, in New York City. They became known for the European flair of their designs, many of which are in the Museum of Modern Art's permanent collection. The firm became Cousins Design in 1984, and that year, the American Academy in Rome awarded Morison a Rome Prize to study design. In 1990, Morison became vice president of design for Tupperware, Inc., a position he held until his death.

Dailey, Donald Earl (1914–1997) U.S. industrial designer born in Minneapolis, Minnesota, who attended art classes at Minneapolis Institute of Art. He studied marketing and engineering at the University of Toledo (1934–1936) and design at the Toledo Museum School of Design (1936–1937). He began his career in 1937 as design director for Harold Van Doren and Associates of Toledo, and opened a second office for Van Doren in Philadelphia in 1940. He established his own firm in Philadelphia in 1946, and in 1950 he became product manager at Servel, Inc. In 1952, he was named Servel's vice president in charge of product planning and is credited with inventing the term "product planning" and its role for designers in corporations. He left Servel in 1955 to reestablish Don Dailey Associates, Inc., in Evansville, Indiana, which he operated until 1995.

Darrin, Howard A. "Dutch" (1897–1982) U.S. automotive designer who in 1920 worked for coachbuilders Brewster & Co. in Long Island City, New York. In 1923 he left Brewster and partnered with Tom Hibbard in an independent car design firm, Hibbard & Darrin, in Paris, France, to design luxury car bodies. In 1941 he designed the Packard Clipper with Werner Gubitz, head of Packard design, and in 1954 he contributed to the design of the Kaiser and Frazer cars.

Deskey, Donald (1894–1989) U.S. industrial and package designer who was born in Blue Earth, Minnesota, studied architecture at the University of California, Berkeley, California, and painting at the California School of Design, the School of the Art Institute of Chicago, the Art Students League of New York, and then in Paris (1920–1922). He operated a New York office with Phillip Vollmer from 1927 to 1931, specializing in furniture and lighting. He cofounded the American Union of Decorative Artists and Craftsmen (AUDAC) in 1928. He won the competition for the design of Radio City Music

Hall and his work there (1931–1934) popularized Art Deco. He was one of the founders of the Society of Industrial Designers (SID) in 1944, and postwar Donald Deskey Associates became known for the bold use of modern materials in interiors and in notable packaging for consumer products such as Joy, Cheer, Gleem, and Micrin.

Diamond, Freda (1905–1998) U.S. industrial designer born New York City. After graduation from the Women's Art School at the Cooper Union, she taught there while working as a designer in a furniture store. She became a designer and consultant to many U.S. and international manufacturers and department stores in consumer home furnishings. Starting in 1942 she worked for 40 years with Libbey Glass, which had sold 25 million of her designs by 1954. She wrote *The Story of Glass* in 1953. Diamond designed kitchen canisters for the Continental Can Company, which sold 12 million units, and designed wrought iron furniture for Baumritter, which sold 75,000 pieces in 1954. She worked abroad as an advisor to Italian craftsmen after World War II, to the Japanese government in 1957, to Israel in 1969, and to the World Trade Organization from 1973 to 1981. She was on the advisory board to the Cooper Union Museum, which became the Cooper-Hewitt National Design Museum, Smithsonian Institution.

Dietrich, Raymond (1894–1980) U.S. car designer who joined Brewster and Company coachbuilders in 1913, where he studied at the Andrew F. Johnson Technical School in Manhattan and graduated in 1917. In partnership with Thomas Hibbard, he established Le Baron Carrossiers in New York in 1920. He left Le Baron in 1925 to become the internal design resource for the Murray Corporation of America. He joined Chrysler as a consultant in 1932, serving as head of its art and color department until his resignation in 1940. In 1949 he founded Ray Dietrich, Inc., and worked with Checker, Lincoln and Mercury until his retirement in 1969.

Diffrient, Niels (b. 1928) U.S. industrial designer who was born in Star, Minnesota, and graduated from Cranbrook Academy of Art in 1954. He worked in the office of Eero Saarinen from 1948 to 1953, with the Walter B. Ford office from 1953 to 1954, and with Henry Dreyfuss Associates from 1955 to 1980, becoming an associate in 1967 and a partner in 1970. He was awarded a 1954 Fulbright fellowship to Italy, where he practiced with Marco Zanuso and with whom he won the Medaglio D'Oro in 1957 for the Borietti sewing machine. He taught graduate level industrial design at the University of California from 1961 to 1969 and established a studio in Ridgefield, Connecticut, in 1981, concentrating on furniture design.

Doblin, Jay (1920–1989) Industrial designer and educator born in Brooklyn, New York, who graduated from Pratt Institute in 1942. He worked for Raymond Loewy (1942–1955) directing the Frigidaire account and designing vending machines for Coca-Cola, razors for Schick, and pens for Eversharp. He was briefly a partner with Lippincott & Margulies and directed the night school at Pratt from 1947 to 1952. He became director of IIT's Institute of Design in Chicago from 1955 until 1969. Doblin had several books published, including *Perspectives: A New System for Designers* (1955) and *One Hundred Great Product Designs* (1970). He was president of ASID in 1956 and of IDEA in 1962. In 1969 he joined Unimark, a firm specializing in corporate identity programs, as senior vice president until 1972, when he left Unimark and founded Jay Doblin & Associates.

Dohner, Donald R. (1892–1943) U.S. industrial designer who grew up in Indiana and studied at John Herron Art Institute, Indianapolis, the Academy of Fine Arts, Chicago, and the Art Institute of Chicago. In 1918 he went to Pittsburgh to study set design at Carnegie Institute of Technology (CIT) (now Carnegie Mellon University). But while waiting for classes to begin, he took a teaching job as industrial arts instructor in the Pittsburgh public school system and then became a design faculty member of CIT. He started with Westinghouse as a consultant in 1926 as an "art engineer," and was hired as director of art in 1929. In 1934, he initiated the world's first degreed program in industrial design, at CIT. He left CIT in 1935 to initiate a similar program at Pratt Institute in Brooklyn, becoming its supervisor. In 1943 he opened a design office with J. Gordon Lippincott, Dohner and Lippincott. Dohner died unexpectedly on Christmas Eve 1943 and was replaced at Pratt by Alexander Kostellow.

Dresser, Christopher (1834–1904) English designer and author born in Scotland who trained in botany at the London Government School of Design and lectured there after graduation. In 1860 he began a career in design and wrote several books on the subject. By 1873, when he published *Principles of Decorative Design*, he had the largest practice in the UK, consulting with industrial manufacturers,

lecturing, and promoting Japanese export products. He produced simple, functional designs that were incredibly advanced for the times, based on his understanding of the organic forms of botany. From 1875 to 1885 he was designing products for Liberty & Co., a shop run by Sir Arthur Liberty. The "Liberty" styles became popular and from 1895 to 1905 dominated the world known as Art Nouveau.

Dreyfuss, Henry (1904–1972) U.S. industrial designer born in Brooklyn, New York, to a family in the theatrical materials supply business. He completed studies as an apprentice to Norman Bel Geddes in 1924 and produced 250 theatre stage sets for a number of theatres between 1924 and 1928. He opened his office in 1929 for stage and industrial design activities. He focused on design problems related to the human figure, working on problems from "the inside out," and believed that machines adapted to people would be the most efficient. Major clients included Bell Telephone Labs, AT&T, John Deere, and Polaroid. His books included an autobiography, *Designing for People*, published in 1955, that included his famous "Joe" and Josephine" anthropological charts, and *The Measure of Man*, published in 1960. He became the first president of IDSA upon its formation in 1965. He retired in 1969 and died in Pasadena, California.

Dryden, Helen (1887–1981) U.S. artist and industrial designer born in Baltimore with unusual artistic ability, designing and selling clothes for paper dolls that appeared in newspaper fashion sections. She trained in landscape painting under Hugh Breckenridge but moved to New York and began her career in fashion design illustration at *Vogue* magazine, where she worked from 1909 to 1922. In the late 1920s, she was art director for the Dura Company, designing chrome decorative objects, textiles and glassware. She was paid $100,000 annually by Studebaker (1934–1937) and was credited in its ads as the stylist of the 1937 Studebaker President. She was acclaimed as the "highest paid woman artist."

Eames, Charles (1907–1978) Born in St. Louis, Missouri, and studied architecture at Washington University (1924–1926). He worked with an architectural firm in St. Louis (1925–1927) and then as a partner of Gray and Eames (1930–1937). In 1937 he became head of the department of experimental design at Cranbrook Academy and worked with Eero Saarinen investigating plastics and plywood. They collaborated to win a MoMA furniture design competition in 1941. He married Ray Kaiser in 1941 and moved to Los Angeles to design film sets for MGM but continued his experiments with plywood. His workshop became part of the Evans Products Company in 1943, laminating glider parts. At war's end, the company turned to production of Eames chairs. He sold the rights for his chairs to the Herman Miller Furniture Company in 1946. Eames produced some of the most creative design work of the century in furniture, film, and exhibits.

Eames, Ray Kaiser (1916–1988) U.S. graphic and industrial designer who trained as a painter with Hans Hofmann in the 1930s. Her work was shown in 1936, and she was a founding member of the American Abstract Artists. She studied at Cranbrook Academy (1940–1941), married Charles Eames, and practiced as a graphic designer. Between 1942 and 1944, she designed more than half the covers for the new magazine *California Arts and Architecture*. After World War II, she became her husband's professional creative partner in a range of design projects and in 1981 was awarded honorary membership in the Industrial Designers Society of America.

Earl, Harley J. (1893–1969) U.S. automotive designer born in Hollywood, California, who attended the University of Southern California in 1912, and studied engineering at Stanford University from 1914 to 1917. He began his career with the firm his father founded in 1908, the Earl Automobile Works, which built custom car bodies for film stars starting in 1911. Don Lee, West Coast Cadillac distributor, bought the company and employed Harley in 1919. Earl's talents were soon recognized by Larry Fisher, Cadillac's division president, and he was sent to Detroit in 1925, established General Motors' art and color department in 1927, became GM vice president in 1940, and dominated GM design policies until his retirement in 1958. In 1945 he established his own firm, Harley Earl, Inc., to design products in non-automotive fields. In 1964 the firm merged with Walter B. Ford Design Associates, Inc., to form Ford & Earl Design Associates.

Eastlake, Charles Locke (1836–1906) British architect and furniture designer trained by architect Philip Hardwick (1792–1870) who popularized William Morris's Arts and Crafts styles. He made no furniture himself, but had his designs produced by professional cabinetmakers. In 1868 he published *Hints on Household Taste in Furniture, Upholstery and Other Details*, which was influential in Britain and also in the U.S., when his book was published there in 1872.

Egan, Philip S. (1920–2008) U.S. industrial designer who studied aeronautical engineering at Stewart Technical Institute, New York, who started work with Harry Preble, Jr., in 1941. He served in the U.S. Army Air Corps from 1943 until 1946, when he joined J. Gordon Lippincott and was assigned to the Tucker '48 project, working with Alex Tremulis at the Tucker Corporation. Starting in 1948 he worked with Sears, Roebuck & Company on a variety of products and in 1960 he opened his office in Fairfax, California, Phil Egan Design. His book, *Design and Destiny: The Making of the Tucker Automobile*, was published in 1989.

Ekuan, Kenji (b. 1929) Japanese industrial designer born in Tokyo who graduated from the Tokyo National University of Fine Arts and Music in 1955, and from the Art Center College of Design in 1957. After graduation he established and became president of GK Industrial Design Associates, an organization he still chairs today. In 1970 he became president of JIDA (Japan Industrial Designers Association) and in 1976 president of Icsid. In 1985 he was appointed director of the Kawakawa Design School and in 1998 chairman of the Design for the World, a humanitarian organization.

Engel, Elwood P. (d. 1986) U.S. automotive designer who graduated from Pratt Institute and joined General Motors as an engineer in 1940. After the war, he worked for George Walker and joined Ford with Walker in 1955 when Walker became Ford's vice president of styling. In 1961 he joined Chrysler, succeeding Virgil Exner as head of design, where he remained until his retirement in 1973, and after that as consultant until 1974.

Esslinger, Hartmut (b. 1945), German industrial designer who was trained in engineering and design and established his office in Altensteig, Federal Republic of Germany (FRG), in 1969. He named it frogdesign in 1982, when he opened additional offices in California and later in Tokyo. His design of the Apple IIc computer and the NeXT workstation for Steve Jobs catapulted frogdesign into international recognition and put Esslinger on the cover of *Business Week* magazine in 1990, headlined as "Rebel with a Cause."

Exner, Virgil Max (1909–1973) U.S. automotive designer who was born in Ann Arbor, Michigan, and studied art at Notre Dame University. Hired by Harley Earl at General Motors in 1933, he became Pontiac styling chief and designed its "Silver Streak" hood ornament. In 1938 he joined Raymond Loewy Associates, and in 1939 he headed Loewy's Studebaker office in South Bend. In 1944, he was fired by Loewy and hired directly by Studebaker. In 1948 he returned to Detroit to work for Chrysler, was named director of styling in 1953, and developed their 1957 Forward Look. He became vice president of Chrysler in 1957 and served in that capacity until 1961.

Fabergé, Peter Carl (1846–1920) Russian jeweler born in St. Petersburg apprenticed to a jeweler in Frankfurt, Germany. In 1885 he became court goldsmith for Czar Alexander III and designed a jeweled Easter egg for the Tsarina, Maria. The annual tradition continued under Czar Nicholas after 1894 until 1917, when Fabergé fled from the Revolution. In 1900, Fabergé's company was the largest jewelry business in Russia and employed 500 with headquarters in St. Petersburg, and branches in Moscow, Odessa, Kiev, and London. His work represented Russia at the 1900 World's Fair in Paris.

Ferar, Montgomery (1910–1982) U.S. industrial designer born in Boston, Massachusetts, who received bachelor and master degrees in architecture at MIT in 1932 and studied in Europe in 1933. He worked for several architectural firms in Boston before moving to Detroit to join General Motors' art and color section, where he met **Carl Sundberg**. In 1934 they both left GM to establish Sundberg-Ferar, Inc., designing major appliances for Sears, Roebuck and Whirlpool. In the 1970s they designed mass transit systems for many U.S. cities. They both retired in 1975, but Sundberg-Ferar still maintains four U.S. offices and a location in the Far East.

Fitch, John (1743–1798) American inventor, clockmaker, and bronzesmith who built his own steam engine and a 45-foot steamboat that was demonstrated on the Delaware River to delegates at the Constitutional Convention in 1787. He was granted a patent in 1791.

Flaxman, John (1755–1826) English sculptor who studied at the Royal Academy in London and exhibited there. In 1774 he joined Josiah Wedgwood as a modeler of classic friezes, plaques, ornamental vessels, and medallion portraits. His work there over the next six years enhanced the reputation of the famous company and himself. He also designed metal castings for Matthew Boulton's Soho Foundry.

Frankl, Paul Theodore (1887–1958) Austrian furniture designer and member of the Munich Secession movement of 1897 who emigrated to the U.S. in 1914 and established a gallery selling his own work in New York in 1922 and later in Los Angeles. He was known for his "skyscraper" style furniture in the late 1920s. He wrote *New Dimensions* in 1928 and *Form and Reform* in 1930. He designed pieces for the Johnson Furniture Company in the 1940s and after World War II, relocated to California, working in a style typical of "California Modern."

Fuller, Richard Buckminster (1895–1983) One of the century's most intellectual and radical inventor/designers, he studied mathematics at Harvard from 1913 to 1915, worked with Armour & Co. until 1922, when he became president of a wall-building systems company. In 1927, he formed the 4-D Company to develop his inventions, including his Dymaxion Car, prototyped in 1933, his Dymaxion Bathroom, prototyped in 1938, and his Dymaxion House, produced as the Wichita House in 1946. In 1949, he started development of his geodesic dome and patented it in 1954. It was used extensively for exhibition enclosures, including the U.S. pavilion at Expo '67 in Toronto. Beginning in 1959, he was a research professor at Southern Illinois University. In 1969, he published *Operating Manual for Spaceship Earth* and was nominated for the Nobel Peace Prize. In 1985, he was posthumously honored by the naming of a newly created form of carbon molecule (C_{60}) as buckminsterfullerene (nicknamed buckyballs) and others in its class (fullerenes), such as buckeytubes, discovered in 1991.

Fulton, James Franklin (1930–2003) U.S. industrial designer who received a 1951 certificate in industrial design and a 1976 bachelor's degree from Pratt Institute. He worked for the Towne Silver Company in 1951, and the same year joined Owens-Corning Fiberglas Corporation in Toledo as its first staff designer. He worked from 1953 to 1958 as senior designer with the office of Harley Earl, Inc. In 1958 he was appointed design director of Raymond Loewy's Paris office and in 1960 became director of product design and transportation with Loewy/Snaith, Inc., in New York, where he became vice president in 1962 and senior vice president in 1964. He established his own office in New York, Fulton & Partners, Inc., in 1966 and added a Paris affiliate, Endt & Fulton in 1975. He was president of IDSA (1975–1976) and was chairman of Design Publications, Inc., which he cofounded in 1977 to publish *Industrial Design* magazine. In 1969 he became a trustee of Pratt Institute and served as its chairman.

Girard, Alexander (1907–1993) U.S. architect and interior designer who trained in London, Florence and Rome and returned to the U.S. in 1932 to open a design office in New York. In 1937 he relocated to Detroit and continued to bring color and pattern to interiors and products during the 1950s and 1960s that were counter to the International Style. Starting in 1952 he was design director of upholstery for the Herman Miller Furniture Company. He designed Braniff's creative identity program, including its colorful planes. His extensive collection of folk art was donated to the Museum of International Folk Art, Santa Fe, New Mexico, in 1976, for which he designed a new wing and permanent exhibition.

Giugiaro, Giorgetto (b. 1938) Influential Italian car designer and key figure in the firm of ItalDesign whose grandfather and father were painters of frescos. He studied at Turin Academy of Fine Arts before joining Fiat as an apprentice in 1965 at age 17, where his work included the Fiat Spider of 1965. In 1968 he became head of styling at Carrozzeria Bertone. He worked after that briefly at Ghia as lead designer and in 1968 founded ItalDesign with former Fiat engineer Aldo Mantovani. In 1981 he founded ItalDesign-Giugiaro, which expanded into consumer products, and in 1987 he founded Giugiaro SpA for clothing and accessories.

Glass, Henry P. (1911–2003) U.S. industrial designer born in Vienna, Austria, who studied architecture at the Technical University of Vienna (1929–1936). He emigrated to the U.S. in 1939 and worked for Gilbert Rohde and Russel Wright. In 1940 he moved to Chicago and studied under László Moholy-Nagy and Gyorgy Kepes at the Institute of Design. In 1946 he opened a studio in the Furniture Mart and began teaching at the Art Institute of Chicago, where he served as a full professor until 1969. He joined the American Designers Institute in 1939, was chair of the Chicago chapter of ASID (1959–1960), and became a fellow of IDSA in 1965.

Goddard, John (1724–1785) American cabinetmaker in Newport, Rhode Island, a Quaker and disciple of Chippendale known for his secretary desks in mahogany, with carvings with shell motifs. He apprenticed under his father-in-law, Job Townsend (1699–1765). Goddard's son, Thomas (1768–1858) was also a well-known cabinetmaker.

Goldsmith, William M. (1917–1987) U.S. industrial designer born in Rochester, New York, who graduated from Carnegie Institute of Technology in 1939. He joined the Chicago firm of Dave Chapman, Inc., becoming a partner and eventual chairman of the board as the firm became Chapman Goldsmith Yamasaki, Inc., in 1955, and Goldsmith Yamasaki Specht, Inc., in 1970. He was president of IDSA (1971–1972), an IDSA fellow, and received the Society's Personal Recognition Award in 1980.

Gostelowe, Jonathan (1744–1795) American cabinetmaker in Philadelphia who served in the Revolutionary War and was a principal in the Gentlemen Cabinet and Chair Makers, a Philadelphia Trade Association.

Graser, Clarence F. "Cal" (1923–2000) U.S. industrial designer born in Toledo, Ohio, who served with the Army Air Force in World War II and graduated from the University of Michigan in 1948. He worked as an industrial designer for General Electric and then joined IBM in 1959 as manager of industrial design. In 1964 he joined Westinghouse as director of a new Consumer Products Design Center in Columbus, Ohio, where he remained until Westinghouse sold their consumer products business in 1974. He then joined Richardson/Smith in Worthington, Ohio, and worked there until his retirement to Venice, Florida, in 1978.

Gray, Eileen (1878–1976) Irish interior, furniture, and architectural designer who studied at the Slade School of Art in London before moving to Paris in 1902, where she became expert in Japanese lacquer techniques. Not incidentally, she was an aviation enthusiast who in 1909 crossed the English Channel in a balloon with Charles S. Rolls of Rolls-Royce fame. After World War I, she expanded her work into furniture and carpets and opened a gallery in Paris in 1922. A 1924 issue of Dutch design magazine *Wendigen* was devoted to her work. She designed a house at Rocquebrune and in the 1930s designed in Art Deco style with chromium-plated metals and glass. She was forgotten after World War II but rediscovered in 1980 by the Museum of Modern Art, which mounted an exhibition of her work with a published catalogue.

Greenough, Horatio (1805–1852) American sculptor who graduated from Harvard in 1825 and studied art in Rome. He is best known as a sculptor for his life-size statue of George Washington done in 1840, but also for his essays on art and design. In particular, he urged the abandonment of ornamentation and suggested simpler, functional design styles similar to the functional forms of animals and the gracefulness of sailing ships.

Gregorie, Eugene Turrenne "Bob," Jr. (1908–2002) U.S. automotive designer who was born in New York City and started as a draftsman at Elco Boat Works in Bayonne, New Jersey, then worked with yacht designers Cox & Stevens in New York in 1928. In 1929 he joined General Motors but lost his job in the depression. In 1931 he joined the Lincoln Motor Company as a draftsman and in 1935 was placed in charge of the new styling group at Ford, where he designed the 1936 Lincoln Zephyr and the 1940 Lincoln Continental. He remained at Ford until 1946, when he retired to sail on a trawler he designed. In the mid–1970s, he retired to St. Augustine, Florida.

Gropius, Walter Adolph (1883–1969) German architect and educator with a pivotal role in the modern movement who was born in Berlin, studied architecture in Munich and Berlin, and worked in the office of Peter Behrens. He joined the Deutsche Werkbund in 1910 and supported Henry van de Velde on the principle of the creative individual over standardization. After serving in World War I, he became director of the Weimar School of Arts and Crafts where he established the Bauhaus, considered by many to be the first educational program of modern design. He resigned from the Bauhaus in 1928 and set up an office in Berlin. After working in London, he came to the U.S. in 1937 to become a professor at the graduate school of design at Harvard, working in partnership with Marcel Breuer. In 1945 he founded The Architects Collaborative (TAC). Gropius received the Kaufmann International Design Award in 1962 for achievement in design education.

Guild, Lurelle Van Arsdale (1898–1985) U.S. industrial designer who received a degree in painting in 1920 from Syracuse University and began his career in the furniture and antiques field. He soon began illustrating and writing for magazines. In 1924 he opened his own studio, Lurelle Guild Associates, and in 1928 he titled his business "Guild of Industrial Design." He started a door-to-door decorating business that employed over 100 women. One client was Alcoa Aluminum, for whom he designed a line of Kensington Ware kitchen utensils and showrooms. Another was Electrolux, for

which he designed its 1937 tank vacuum cleaner. He was one of the founders of the Society of Industrial Designers in 1944.

Haggstrom, Olle E. U.S. industrial designer who received a certificate of industrial design from Pratt Institute and a BS in industrial design from the University of Bridgeport. He worked in major appliance design at General Electric (GE) from 1946 to 1960 and in 1960 was named manager of General Electric Housewares industrial design, where he remained until his retirement in 1985.

Hardy, Tom U.S. industrial designer who graduated in industrial design from Auburn University, joined IBM in 1970, entered management in 1981 and became corporate manager of the IBM design program, directing worldwide identity activities and coordinating fifteen design centers around the world. The 1992 IBM ThinkPad and other award-winning products were designed under his direction. He then became an independent design strategist for Samsung (1996 to 2003), Polaroid, and others.

Harrison, Charles (b. 1931) U.S. industrial designer who graduated from the School of the Art Institute of Chicago in 1954. He served in the U.S. Army and in 1956 continued graduate studies at the Art Institute. In 1958 he began working for several design firms, including Henry Glass, Ed Klein, and Robert Podall. He joined Sears, Roebuck & Co. in 1961, and over the next 30 years, designed 750 products, eventually becoming the company's chief designer. His best-known work was the redesign of the classic 1958 View-Master with Robert Podall Associates. In 2008 he received a Lifetime Achievement National Design Award from Cooper-Hewitt National Design Museum. Currently he teaches design at Columbia College in Chicago.

Hauser, Jon William (1916–1999) U.S. industrial designer who was born in Sault Ste. Marie, Michigan, and began his career with General Motors in 1936. He worked for Chrysler (1941–1943), Sears, Roebuck as director of design (1943–1945), Dave Chapman (1945–1946), Barnes & Reinecke (1946–1949), Reinecke Associates (1949–1952), and as executive vice president of Raymond Loewy's Chicago office (1960–1961). He established his Chicago office, Jon W. Hauser, Inc., in 1952, which became Hauser Design, Inc., in 1970 and was headed later by his son, Jon W. Hauser II. He was president of IDI (1962–1963). After retirement, he served as visiting professor of design at the University of Illinois in Champaign-Urbana.

Hepplewhite, George (?1727–1786) English furniture designer whose wife, in 1788, published his *The Cabinetmaker and Upholsterer's Guide*. The book gave his name to furniture that was fashionable from 1775 to 1800.

Hodgeman, Clare E. (1911–1992) U.S. industrial designer born in Buchanon, Michigan, who started his career with General Motors in the early 1930s working in the Oldsmobile Studio. He left GM in 1934 to join the Sears, Roebuck design group in Chicago, where he designed the 1935 Coldspot refrigerator under consultant Raymond Loewy. In 1938, he joined Raymond Loewy's London office under Carl Otto and then relocated to Loewy's South Bend Studio to work on the 1939 Studebaker Champion. After the war he worked in Loewy's New York office heading product design. In 1955 he partnered with Robert Bourke to establish Hodgeman-Bourke, Inc., in Westport, Connecticut. He retired to Daytona, Florida, in 1969.

Hodges, Audrey Moore (1918–1996) Automotive designer who was born in Plymouth, Michigan, and attended the Detroit Art Academy and the Meinzinger School of Art specializing in industrial design. She started work at the J.L. Hudson Company as a fashion illustrator, and during the war she worked in the drafting department at Willow Run, where B-24 bombers were made. In 1944 she was hired by Virgil Exner in Loewy's Studebaker studio and worked on the 1947 Studebaker, for which she designed its "torpedo" hood ornament. In 1946 she was hired by the Tucker Company to work on interior designs for the 1947 Tucker. She later worked as a designer for the Formfit Company in Chicago.

Hoffmann, Josef (1870–1956) Austrian architect and former student of Otto Wagner who studied architecture in Munich and Vienna and worked with Wagner from 1895 to 1899. He was a professor at the Viennese School of Fine Arts (1899–1941) and cofounder in 1903 of the Wiener Werkstätte, for which he produced designs until 1931. He designed several chairs for Thonet but his major architectural masterpiece was the Palais Stoclet in Brussels (1905–1911).

Hope, Thomas (1769–1831) Dutch and British author, interior and furniture designer, artist and art collector who wrote the first book on interior design, in 1807, *Household Furniture and Interior Decoration*, which included sketches of his own furniture designs. He acquired a large collection of paintings, sculptures and books through extensive travels to the Middle East in the 1790s and made over 350 drawings. He became known as "the costume and furniture man."

Howe, Elias (1819–1867) American inventor of the sewing machine, which was patented in 1846. He successfully defended his patent against Isaac Singer and earned royalties on all Singer machines. He served in the U.S. Army during the Civil War and in 1865 established the Howe Machine Company in Bridgeport, Connecticut. His machine won the gold medal at the Paris Exhibition of 1867.

Hubbard, Elbert (1856–1915) U.S. businessman and writer who was born in Bloomington, Illinois, and worked for the Larkin Soap Company in 1875. In 1883, after becoming its most successful salesman, he sold his interest in the company and published *The Philistine*, a successful magazine in East Aurora, New York. He was inspired by William Morris and the Arts and Crafts movement in England, and founded the Roycroft workshops in 1896 to produce high quality furniture. In 1897, he founded a print shop to promote his craft philosophy, "Not How Cheap But How Good." He was a dashing figure with long hair, broad-brimmed hat, cane, and loose black satin bow tie. Frank Lloyd Wright would emulate his unconventional costume during Wright's entire career. Hubbard and his wife perished on the *Lusitania*, but his son Elbert II maintained Roycroft until 1938.

Iannelli, Alfonso (1888–1965) U.S. sculptor and industrial designer who was born in Italy, came to the U.S. in 1898 and trained with sculptor Gutzon Borglum in New York. He went to Chicago in 1914 to work with Frank Lloyd Wright on Midway Gardens and founded Iannelli Studios there in 1915. Beginning in 1933, he entered the new field of industrial design and from 1948 to 1954 designed a range of products for the John Oster Manufacturing Company, including mixers, hair dryers, knife sharpeners and hair clippers.

Jaray, Paul (1889–1974) Austro-Hungarian engineer who started working in 1914 at the Flugzeugbau Friedrichshafen, a seaplane offshoot of the Zeppelin Works, in Germany. In 1916 he built a wind tunnel for aircraft testing and in 1921 began testing automobile models in it. He had a full-scale model built, the Ley T6, by Rudolph Ley, an Armstadt, Germany, automaker, and filed patents for it. Hans Ledwinka used them in designing the 1933 Tatra 77. Jaray's "streamline" patents also enabled him to collect royalties from the 1934 Chrysler Airflow.

Jensen, George Arthur (1866–1935) The best known Danish silversmith, he studied sculpture at Copenhagen Academy, and beginning in 1895, he worked in ceramics with Joachim Petersen, where he was heavily influenced by the Arts and Crafts movement. He opened a shop in 1904 to produce and retail his work, and was joined by Harald Nielsen and Johan Rohde (1856–1935). The Jensen firm opened a U.S. branch in 1922 in New York. Count Sigvard Bernadotte of Sweden later joined the firm. Jensen's son, sculptor Søren George Jensen (b. 1917), headed the firm from 1952 until 1974, when he retired.

Jensen, Gustav (b. 1898) U.S. industrial designer who was born in Sweden and settled in New York City, where he began work in industrial design in 1928. In 1930 he designed a Monel metal sink for the International Nickel Company. Other designs included a telephone concept for an AT&T competition that was won by Henry Dreyfuss and a water heater for L.O. Koven & Brothers. He was featured in the influential February 1934 *Fortune* article about industrial design.

Jones, Owen (1809–1874) English architect, educator, and designer who was a close associate of Henry Cole. He designed interiors and layouts for exhibits at the Great Exhibition of 1851 and formulated decorative art principles for the founding of the South Kensington Museum Schools. In 1856, he published *The Grammar of Ornament*, urging designers to abandon literal copying of nature and invent stylized, innovative abstractions. He was a mentor of Christopher Dresser.

Kandinsky, Wassily (1866–1944) Along with Kazimir Malevich and Piet Mondrian, he was one of the three founding fathers of 20th century abstract painting. He was born in Moscow and in 1896 broke off a career in science to take up painting. He studied in Munich and was a member of the Berlin Secession movement. He founded Neue Künstlervereinigung in 1909 and founded the Blaue Reiter with Franz Mark in 1911. He returned to Moscow during World War I, as his sympathies were

with the Revolution, and he was made a professor at the reorganized Academy of Fine Arts in Moscow in 1918. He became a member of Commissariat for Education and director of the new State Museum of Pictorial Culture in 1919. In 1920 he was appointed professor at the University of Moscow, and in 1921 he founded the Academy of Arts and Sciences and served as its vice president. He returned to Germany in 1921 and was called to teach at the Bauhaus in 1922. He remained there until 1933, when he immigrated to France.

Kändler, Johann Joachim (1706–1775) German sculptor in the court at Dresden in 1723 who became court sculptor to the elector of Saxony in 1730. He was appointed modeler at the Meissen porcelain factory, where he became Modellmeister (master modeler) in 1733. He influenced Meissen design for 40 years and raised the art of porcelain modeling to new heights with his animal sculptures and delicate figures.

Kaufmann, Edgar, Jr. (1910–1989) U.S. industrial design spokesman and historian who was the son of Edgar Kaufmann, Sr., a wealthy Pittsburgh merchant who founded a department store there. He attended Kunstgewerbeschule of the Oesterreichisches Museum für Angewandte Kunst in Vienna in the late 1920s, studied painting and typography with Victor Hammer in Florence, and was an apprentice architect at Frank Lloyd Wright's Taliesin Foundation (1933–1934). He strongly supported his father's decision to commission Wright to design Fallingwater, the Kaufmann summer home. In 1940, he wrote to Alfred Barr of the Museum of Modern Art (MoMA) proposing an Organic Design in Home Furnishings Competition in 1940. He served in the U.S. Air Force and joined MoMA in 1946 as director of the industrial design department, a position he held until 1955. He initiated MoMA's Good Design program in 1950.

Kelley, David M. (b. 1951) U.S. industrial designer who received a degree in Engineering from Carnegie Mellon University and a graduate degree in product design from Stanford University. He founded Hovey-Kelley Design, which worked on improvements to the Engelbart computer mouse for Apple. In 1984 he established Dave Kelley Design in Palo Alto, California, and Onset, a partnership to capitalize design entrepreneurs. He teaches engineering at Stanford University and in 1990, with Bill Moggridge, he became a cofounder of IDEO, the highly successful design firm.

Kepes, Gyorgy (1906–2001) Hungarian-born painter, designer, educator and author who graduated from the Royal Academy of Fine Arts, Budapest, in 1928. He worked in stage and exhibit design in London and in the Berlin studio of Laszlo-Moholy-Nagy (1936–1937) before coming to the U.S. in 1937. He taught at the Institute of Design in Chicago (1937–1946) and from 1946 until his retirement in 1974 was professor of visual design at MIT. He wrote *Language of Vision* in 1944, and was guest editor of the *Vision & Value* Series by MIT Press in 1966. His paintings are in many major museums.

Kersting, Walter Maria (1892–1970) German industrial designer, graphic artist, and engineer who attended Technische Hochschule in Hanover (1912–1914) where he worked as a graphic artist. He worked from 1922 to 1932 in Weimar and Cologne, designing furniture, lighting, and radios, in particular the 1933 Volksempfänger (Peoples Radio). He wrote *The Living Form* in 1932 and taught graphics and book design from 1933 to 1934 at Staatliche Kunstacademie in Düsseldorf. Then he opened his own industrial design studio, designing a variety of products, including audio equipment, sewing machines, and telephones into the 1960s.

Klimpt, Gustav (1862–1918) Austrian symbolist and architectural painter who graduated from Vienna School of Arts and Crafts in 1883. He was commissioned in 1894 to produce paintings for the Great Hall of the University of Vienna. They were completed by 1900 but were criticized as pornographic and not displayed. In 1897 he became a founding member and president of the Wiener Sezession (Vienna Secession). His paintings of females in costumes were highly ornamental and popular.

Knoll, Florence Schust Bassett (b. 1917) U.S. architect and designer born Florence Schust in Saginaw, Michigan. She studied at Cranbrook Academy, the Architectural Association in London, and the Illinois Institute of Technology under Mies van der Rohe. She worked briefly in Chicago before going to New York, where she met and married Hans Knoll, with whom she cofounded Knoll Associates in 1946. She established the Knoll Planning Unit, an interior design service of Knoll. Through her, Knoll Associates had contacts with leading figures in architecture and design. She played an important role in selling modern furniture design to postwar corporate America. She served as president of

Knoll Associates from 1955 until 1959, when she sold her interests but remained as design director until her retirement in 1965. She married H. Hood Bassett in 1958 and divides her time between Florida and Vermont.

Knox, Archibald (1864–1933) British Art Nouveau designer influenced by Celtic art who, along with Christopher Dresser, designed a wide range of products for Liberty & Co. in the 1870s and 1880s, including jewelry, tea sets, and inkwells. He taught at the Redhill School of Art in Surrey starting in 1897, and the Kingston School of Art at Kingston University in London in 1899.

Kogan, Belle (1902–2000) Among the first female industrial designers in the U.S., she was born in Ilyashevka, Russia, and emigrated to the U.S. in 1906. In 1920 she began working in her father's jewelry store while studying at Pratt Institute and the Art Students League. In 1929 she was employed by the Quaker Silver Company, which trained her as a silver designer at New York University, Rhode Island School of Design, and a Pforzheim, Germany, art school. She soon headed a department of twenty at Quaker in Attleboro, Massachusetts. She opened her own New York office, Belle Kogan Associates, in 1932 and designed many houseware products. In 1944 she was secretary-treasurer of IDI. She closed her New York office in 1970 and moved to Israel under contract with KV Design and set up a studio offering comprehensive design services. In 1972 she left the studio to work as a consultant.

Kostellow, Alexander Jusserand (1896–1954) A design educator born in Persia (Iran), who studied in Paris and at the University of Berlin. He came to the U.S. in 1916 and studied painting at the National Academy, the Art Students League, and the Kansas City Art Institute, where he met and married Rowena Reed. Both came to Pittsburgh in 1929 to teach at Carnegie Institute of Technology, he in painting and she in sculpture. In 1934 he helped Donald Dohner initiate an industrial design program at CIT. He left in 1936 for Pratt Institute, where he headed the industrial design program in 1944 after Dohner's death; he remained there until his own death.

Krippendorff, Klaus U.S. communications educator and designer born in Germany who graduated from the State Engineering School in Hanover in 1954, from the Ulm School of Design in 1961, and received a doctorate from the University of Illinois Urbana in 1967. In 1970 he began teaching at the Annenberg School of Communications at the University of Pennsylvania. In 1984 he worked with professor of industrial design Reinhart Butter from Ohio State University to develop the theory of product semantics, which had considerable influence in postmodern industrial design.

Krolopp, Rudolph W. U.S. industrial designer who served with the U. S. Marine Corp from 1948 to 1952 and received a BFA in fine and applied arts at the University of Illinois in 1956. He joined Motorola that same year and studied advanced business at Lake Forest College. He became manager of industrial design at Motorola in 1960 and director in 1982, a position he held until his retirement in 1997. In 1984 he designed the first handheld cell phone, the DynaTAC 8000. In 1994 he taught as an associate professor of design at the University of Illinois and lectured on design at many universities.

Kuhler, Otto (1894–1977) U.S. industrial designer born in Germany who worked at designing car bodies. After serving in the German army during World War I, he studied at the Academy of Art in Dusseldorf. In 1923 he emigrated to the U.S. and worked as a commercial artist in Pittsburgh. He became a citizen in 1928 and opened a studio in Manhattan, styling trains and trolleys for the J.G. Brill Co. He designed streamlined Hiawatha locomotives and observation cars for the Milwaukee Railroad in 1934, including interiors and accessories, and a "bullet nose" locomotive for the B&O's Royal Blue train in about 1937. In 1944 he developed double-deck sleepers and subway cars.

LaGassey, Homer (b. 1934) U.S. automotive designer who received the first General Motors Industrial Design Scholarship; he started at GM in 1942. After serving as a World War II bomber pilot, he graduated from Pratt Institute in 1947 and returned to GM. He joined Chrysler in about 1954 and Ford about 1959, where he managed the Mustang studio (1968–1972). In 1959 he established an automobile design program for the Center for Creative Studies in Detroit, where he taught for 28 years. He retired to paint World War II air battles, and in 1994 he was inducted into the Automotive Hall of Fame.

Landor, Walter (1913–1995) Born Walter Landauer in Munich, Germany, he was founder-partner of the Industrial Design Partnership in London (1935–1939). Traveling in the U.S. in 1939, he became

associate professor of industrial design and interior architecture at the California College of Arts and Crafts in 1940. In 1941 he founded Walter Landor Associates in San Francisco, which would later establish regional headquarters in New York, London, and Tokyo, specializing in corporate identity, branding and packaging. In 1964 he moved to a floating office, the *Klamath* ferryboat at San Francisco Pier 5, which author Tom Wolfe dubbed "the flagship of packaging design."

Latham, Richard S. (1920–1991) U.S industrial designer born in Kansas City, Missouri, who studied engineering at Kansas City Engineering School and design at the Armour Institute in Chicago under Mies van der Rohe (1940–1942). He started with Montgomery Ward in 1942 and joined Raymond Loewy's Chicago office in 1945 after his military service, working on Greyhound buses and aircraft interiors. He later became director of design for Loewy's Chicago office. He spent five years with the German porcelain industry, establishing Rosenthal's Studio Line in 1954. In 1955 he founded Latham Tyler Jensen, Inc., with two other Loewy designers, Robert D. Tyler and George Jensen. He was president of ASID in 1959 and of ICSID in 1965. In about 1970 he founded Richard S. Latham & Associates, Inc., where he pioneered in product planning, becoming design advisor for Bang & Olufsen of Denmark, and for Land's End, which he helped found.

Lepper, Robert (1906–1991) Artist, sculptor and design educator who was born in Aspinwall, Pennsylvania, graduated from Carnegie Institute of Technology (CIT) in 1927, and spent a year in Europe absorbing art and design trends. He joined the CIT faculty in 1930, where he painted machine art and was a participant in the first degree-granting program in industrial design in 1934. In 1938 he published *The Elements of Visual Perception*, linking art elements to manufacturing processes. He taught in CIT's industrial design program until his retirement in 1975.

Lippincott, J. Gordon (1909–1998) U.S. industrial designer who graduated from Swarthmore College in 1931 as an engineer and obtained a master's degree in architecture and civil engineering at Columbia University. He joined the faculty at Pratt in 1936 with Donald Dohner to assist in the establishment of its design education program and began consulting as an industrial designer while teaching. He wrote *Economics of Design* in 1937. He opened a design office in New York with Donald Dohner in 1943, Dohner & Lippincott, in partnership with the Douglas T. Sterling Company of Stamford, Connecticut. Upon Dohner's death, he continued editing the industrial design section of *Interiors* magazine and the firm became J. Gordon Lippincott and Company in 1944. In 1944 Walter Margulies joined him and the firm was renamed Lippincott & Margulies in 1947. He wrote *Design for Business*, published by Paul Theobold in 1947. Lippincott retired in 1969, selling his interests to Margulies, and engaged in travel, investments and consulting.

Loewy, Raymond (1893–1986) Probably the best known industrial designer, Loewy was born in Paris, studied engineering, served in the French army in World War I, and arrived in the U.S. in 1919. He worked as a fashion illustrator and costume designer before opening his office in New York in 1929 and was one of the founders of SID in 1944. He was on the cover of *Time* magazine in 1949, wrote *Never Leave Well Enough Alone* in 1951, and established a Paris office in 1952. By 1960 his office, Raymond Loewy Associates (RLA), had a staff of 180. Loewy's major designs included the 1932 and 1934 Hupmobiles, the 1934 GG-1 locomotive for Pennsylvania Railroad, the 1947 and 1953 Studebakers, the 1962 Avanti, the 1966 Exxon logo, the 1970 U.S. Post Office logo, Air Force One livery and interiors (1973), NASA Skylab 2 space station interiors (1973), and Concorde interiors (1976). His New York office closed in 1977. Primary Loewy archives are at the U.S. Library of Congress and the Hagley Museum & Library in Wilmington, Delaware.

Loos, Adolf (1870–1933) A writer who was born in Czechoslovakia, he studied building at Liberec (1887–1888), and then at Dresden Institute of Technology in Germany. He worked in the U.S. from 1893 to 1896 as an architect. Returning to Vienna, he set up an architectural practice and designed furniture. His greatest influence was in his writings, particularly *Ornament and Crime*, in 1910, but he founded a review, *Das Andere* (*The Other*) in 1903, in which he wrote of his admiration for British and American simplicity. His Steiner House (1910) set a precedent and standard for the removal of all decoration, and greatly influenced Le Corbusier, Erick Mendelsohn, and Walter Gropius.

Mackintosh, Charles Rennie (1868–1928) Scottish architect, designer, and foremost exponent of Art Nouveau in Britain, he trained at Glasgow School of Art and apprenticed in an architectural office in Glasgow in 1889. He traveled to Europe in the 1890s and was influenced by Celtic designs. His

posters were exhibited in the 1896 Arts and Crafts Exhibition. His wife, Margaret Macdonald, her sister Frances, and Frances' husband, J. Herbert MacNair, were his closest associates in Glasgow. They were known as "The Four." His best known work is the Glasgow School of Art building, for which he won a competition in 1897 and which was completed in 1909. He moved to London in 1914 and after 1923 devoted himself to painting.

Madawick, Tucker (1917–2006) U.S. industrial and automotive designer born in New York City, where he attended Brooklyn Technical High School and the Art Students League, who graduated from Pratt Institute in 1938. He joined Ford in 1939, where he worked on the first Mercury and on the Lincoln Continental. In 1942 he joined Ford's aircraft team and from 1943 to 1946 worked at the B-24 bomber facility at Willow Run. Later he was production coordinator for the Convair B-32 and B-36 bomber programs. In 1946 he joined J. Gordon Lippincott and was involved with development of the Tucker car. He joined Raymond Loewy Associates in 1947 and reestablished Loewy's London office. In 1950 he joined Loewy's team in South Bend, Indiana, to work on the 1953 Studebaker Starliner. In 1959 he joined RCA as manager of radio, phonograph, tape and television design, became vice president of the RCA Advance Design Center in 1968, and was divisional vice president of Consumer Electronics from 1971 until his retirement in 1980. He was president of IDI in 1964.

Malevich, Kasimir (1878–1935) Russian artist who, along with Piet Mondrian and Wassily Kandinsky, was one of the three founding fathers of 20th century abstract painting. He studied at Kiev Drawing School (1895–1896) and the Moscow School of Art. He was influenced by Cubism and Futurism (1910–1920) and in 1915 launched Suprematism. After the Revolution, he began teaching at the First State Free Art Studios in Moscow, a forerunner of VKhUTEMAS, and then he replaced Marc Chagall as director of the Vitebsk Institute of Art and Practical Work in 1919. In 1920, he founded the UNOVIS group that included El Lissitsky and Nikolai Suetin. After 1919 he turned from painting to the design of cities and housing. In 1927 he visited the Bauhaus in Dessau, which revived his ideas; he disseminated them in a book, *The Non-Objective World*.

Margulies, Walter (1914–1986) U.S. architect and interior designer who worked for the Schine Company chain of hotels and theatres. He joined with J. Gordon Lippincott in 1944, who renamed his firm Lippincott & Margulies in 1947. Soon after 1947, he married the daughter of Henry A. Wallace, Franklin Roosevelt's vice president (1941–1945). Upon Lippincott's retirement in 1969, he purchased Lippincott's interests and headed the firm until 1982, when he sold it to Clive Chajet. The firm is now known as Lippincott Mercer.

Marinetti, Filippo Tommaso (1876–1944) Italian poet, editor, and founder of the Futurist movement in 1909. The movement promoted speed, technology, youth, automobiles, airplanes, fascism, and war (called the world's only hygiene), as well as the destruction of museums, renaissance art, academies and libraries as symbols of a dying culture.

Mayhew, Fritz (b. 1942) U.S. automotive designer who was born in Pittsburgh, Pennsylvania, graduated with a BFA in industrial design from Carnegie Mellon University in 1963, and was selected as IDSA's outstanding college graduate of that year. He joined Ford Motor Company design staff and led the design team for the 1986 Ford Taurus. As executive director for North American Design through the 1990s, he was responsible for all Ford cars and trucks, including the retro 2002 Thunderbird. A fine artist, as well, his paintings have been exhibited widely in the south and midwest, where he has had 15 one-man shows. Since 1998, he has divided his time between his studios in Harbor Springs, Michigan, and Naples, Florida.

Mayo, Noel (b. 1937) U.S. industrial designer and educator who received his BFA from the Philadelphia College of Art and Design (PCAD) in 1960 and was awarded an honorary doctorate in fine arts from Massachusetts College of Arts in 1981. He founded the first African American design firm, Noel Mayo Associates in Philadelphia and served as chair of the industrial design department at PCAD for 11 years. In 1989 he became an Eminent Scholar and professor of industrial design at Ohio State University.

Mays, J (b. 1954) U.S. automotive designer who was born in Pauls Valley, Oklahoma, attended the University of Oklahoma, and then the Art Center College of Design in Pasadena, graduating in 1980. He joined Audi and designed the 1991 Audi Avus concept car. In 1989 he became head of Volkswagen's U.S. design center, where he and Freeman Thomas designed the Concept One retro Beetle, unveiled

in 1994 and introduced in 1998 as the new Beetle. In 1995 he became vice president for design development at SHR Perceptual Management in Scottsdale, Arizona, and in 1997 became corporate vice president of design at Ford.

McCobb, Paul (1917–1969) U.S. furniture designer who studied painting at Vesper George School of Art in Boston and began work as a muralist, then as an interior designer with Jordan Marsh. He established his own New York firm in 1945. He formed an organization in 1950, with B. G. Mesberg as distributor and Winchendon Furniture Company as manufacturer, to produce his Planner Group furniture that was distributed in department stores across the country. *Business Week* magazine called him the "creator of the contemporary look for young moderns."

McCoy, Katherine J. (b. 1945) U.S. designer and educator who was born in Decatur, Illinois, studied industrial design at Michigan State University before joining Unimark International in 1967 and went on to work at Chrysler Corporation and Omnigraphics, Inc. In 1971, She became cochair, with her husband, Michael McCoy, of the graduate design program at Cranbrook Academy of Art, which they continued to direct until 1995 and concurrently maintained their design consultancy, McCoy & McCoy. She is past president and fellow of the Industrial Designers Society of America and was president of the American Center for Design and vice president of the American Institute of Graphic Artists.

McCoy, Michael (b. 1944) U.S. industrial designer and educator who graduated from Michigan State University. In 1971 he became cochair of the graduate design program at Cranbrook Academy of Art with his wife, Katherine, with whom he also maintained their consultancy, McCoy & McCoy. He served as distinguished visiting professor at the Royal College of Art in London from 1994 to 1996. He and his wife support High Ground, offering workshops to practicing design professionals.

McFarland, Donald L. U.S. industrial designer who received a BS in aeronautical engineering from Rensselaer Polytechnic Institute and worked at Chance Vought aircraft to create the first carrier jet fighter. In 1951 he became manager of product planning for General Electric in Bridgeport, Connecticut, and in 1957 he became head of all small appliances. He was president of ASID in 1958. In 1960 he joined with Latham Tyler Jensen, Inc., as a partner and established its West Coast office. In 1973 he established McFarland Design, Inc., in Santa Barbara, California.

Meyer, Adolph (1881–1929) German architect born in Mechernich-Eifel who studied at Düsseldorf Arts and Crafts School. He worked for Peter Behrens (1907–1908) and for Bruno Paul (1909–1910). He was Walter Gropius' partner in his architectural business from 1911 until 1925. After that, he directed a consulting office for city planning in Frankfurt and taught an architectural class at the art school there.

Mies van der Rohe, Ludwig (1886–1969) German architect and furniture designer who is famed for his quote "Less is more," and his steel and glass International Style architecture, now known as "Miesian." He was born in Germany, trained as a stonemason in his father's business, and apprenticed with furniture designer Bruno Paul. He trained with Peter Behrens from 1908 to 1912, when he established the office he maintained until 1938. He was a member of the Deutsche Werkbund starting in 1921. He designed the German pavilion and his famous chairs for the Barcelona International Exhibition in 1927, as well as a cantilever steel chair of that era. He was the third and last director of the Bauhaus, from 1930 to 1933. He emigrated to the U.S. in 1938, and designed buildings for the Illinois Institute of Technology (Armour Institute) until 1940. He became its director of architecture in 1948. He designed the Seagram Building in New York in 1958.

Mitchell, William (1912–1988) U.S. automotive designer who was born in Cleveland, Ohio, studied art at Carnegie Institute of Technology and the Art Students League, and worked briefly as a commercial artist. He joined General Motors in 1935 and worked in the Cadillac studio where he designed the Cadillac script logotype and the 1938 Cadillac 60 Special. As the protégé of Harley Earl, he became vice president of styling in 1958, upon the announcement of Earl's retirement in 1959. Mitchell retired in 1977.

Moggridge, Bill (b. 1943) U.S industrial designer born in the UK who graduated from the Royal College of Art and worked as a designer with the Hoover Company, Ltd., until he established his own office, Moggridge Associates, in London in 1969. In 1979, he emigrated to the U.S. and established

ID Two in Palo Alto, California, with compatriot Mike Nuttal. In 1980, he designed the first laptop computer, the GriD Compass. In 1990, ID Two merged with Matrix (started by Nuttall in 1983) and David Kelley to form IDEO. By 1993, IDEO was the largest and most successful design office in the U.S.

Moholy-Nagy, László (1895–1946) Hungarian painter, photographer, filmmaker, typographer and educator who studied law in Budapest and later served in World War I. After the war, he began painting and experimenting with photography in Berlin. He joined the Bauhaus in 1923, where he ran the metal workshop until his departure in 1928. In 1929, he wrote *Von Material zu Arckitektur*, which was translated in 1932 as *The New Vision*. He worked in Berlin, Amsterdam and, from 1935 to 1937, London. In 1937 he came to Chicago at the invitation of Walter Gropius to become director of the school of design at the Association of Arts and Industries in Chicago, which he promptly renamed the New Bauhaus: American School of Design. He concurrently founded the Chicago Institute of Design Research with Sigfried Gideon as director and wrote *Vision in Motion* in 1946.

Mondrian, Piet (1872–1944) Dutch artist born Pieter Cornelis Mondriaan near Amsterdam. Along with Kasimir Malevich and Wassily Kandinsky, he was one of the three founding fathers of 20th century abstract painting. He took drawing lessons from his father, a lithographer, and studied at Rijksacademie in Amsterdam. He went to Paris in 1912, where he took up cubism, but he returned to Amsterdam in 1914 to explore abstraction during the war. In 1919 he returned to Paris to write essays for *De Stijl*. In 1938 he went to England as war approached and in 1940 went on to New York.

Morgan, John Richard "Jack" (1903–1986) U.S. industrial designer born in Guatemala City who joined Harley Earl's Art & Color Group at General Motors in 1929. He headed Sears, Roebuck's first design department in Chicago from 1934 to 1944 and designed its Waterwitch outboard motor, displayed at the 1934 Machine Art Show, as well as washing machines, vacuums, and kitchen cabinet ensembles. From 1947 to 1952 he partnered with Mel Boldt in Chicago, and from 1948 he was a design consultant for Dormeyer Corporation housewares.

Morris, William (1834–1896) English architect, furniture and textile designer who was born in London and in 1852 entered Exeter College, Oxford. In 1856 he apprenticed with Gothic revival architect G.E. Street. In 1861 he founded the design firm later known as Morris & Co., with a number of Oxford friends, which designed a broad range of furniture, textiles, carvings and jewelry. Morris was influenced by John Ruskin, an influential social critic who saw industrialization as a threat to humanity. Morris sought to base his own design business on romantic medieval guilds, with a number of handcraft workshops producing high quality work. This moralistic principle became known as the Arts and Crafts movement throughout the world, and Morris became its founder and champion.

Moser, Koloman (1868–1918) Austrian artist, graphic and furniture designer who studied in Vienna at the Academy (1886–1892) and the School of Arts and Crafts (1892–1895), where he taught from 1899 onward. His graphic design progressed from organic to geometric, typical of the 1897 Wiener Sezession (Vienna Secession), of which he was a cofounder. He was also a cofounder of the Wiener Werkstätte (Viennese Workshops) in 1903.

Müller-Munk, Peter (1904–1967) Industrial designer who was born in Germany, studied as a silversmith at the University of Berlin, and emigrated to the U.S. in 1926. He worked at Tiffany's in New York as a metalworker (1926–1929), and then established his own silver studio in 1929, exhibiting in New York shows. In 1935 he accepted a position at Carnegie Institute of Technology in Pittsburgh as head of the industrial design program. He remained there until 1944, when he left to devote his time fully to the industrial design office in Pittsburgh he established in 1938. Major clients included Waring, for which he designed its classic blender, and in 1943 the Dow Chemical Company, for which he designed concepts to stimulate postwar public interest in plastics. In 1954, he was president of the Society of Industrial Designers and in 1957 the first president of the International Council of Societies of Industrial Design (ICSID).

Muthesius, Hermann (1861–1927) German architect, writer and spokesman for design, who in 1893 became the official architect of the Prussian government where he helped reform schools of design. In 1896 he was appointed to the German Embassy in London to study and report on English design developments. There he met Charles Rennie Mackintosh, and published numerous articles in *Dekorativ Kunst* on the Arts and Crafts movement. In 1903, he was appointed to the Prussian Ministry of

Trade and Commerce in charge of art education. He published *Das Engliche Haus* in 1904 and urged the establishment of the Deutscher Werkbund in 1907.

Myers, C. Stowe (1906–1995) U.S. industrial designer who was born in Altoona, Pennsylvania, and received a BA in architecture from the University of Pennsylvania in 1930. Norman Bel Geddes hired him in 1932 to create illustrations for his book, *Horizons*. He joined Walter Dorwin Teague in 1934, was named a partner in 1945, and headed Teague's Los Angeles office until it closed in 1949. From 1950 to 1952, he managed Loewy's Chicago office and from 1954 to 1970, headed Stowe Myers Design in Evanston, Illinois. He retired in 1976 to paint, and was named official artist of the U.S. Air Force in 1978. He moved to Louisiana in 1988.

Nizzoli, Marcello (1887–1969) Italian industrial designer who studied painting, architecture and graphics at the Academy of Fine Arts in Parma (1910–1913). He established a studio in Milan, working with Giuseppi Terragni (1931–1936). In 1936 he became chief consultant designer to Olivetti and was hired full time in 1938. He designed the Lettera 22 typewriter (1950) and the Lexicon 80 (1948) and headed design for Olivetti until the 1960s.

Noguchi, Isamu (1904–1988) U.S. sculptor and designer who was born in Los Angeles and spent his childhood in Japan. He returned to the U.S. in 1918 to study medicine, but abandoned it to study at the Leonardo da Vinci Art School in New York, under Onorio Ruotolo (1922–1926). He studied sculpture in Paris (1927–1928) with Constantin Brancusi before making pottery in Kyoto. He returned to the U.S. in 1931, where he built his reputation as a well-known public works sculptor and settled in 1960 in Long Island City, New York, which became the site of the Isamu Noguchi Garden Museum after his death. His important product designs include a glass-topped sculptural coffee table for the Herman Miller Furniture Company and the Akari lamp for Knoll.

Northup, Amos 1889–1937) U.S automotive designer born in Bellevue, Ohio, who attended Cleveland Polytechnic Institute to study design. He began his career in 1908 as a furniture and interior designer. In 1918 he joined Pierce Arrow as a truck designer and soon was designing colors and interiors for passenger cars. In 1921 he opened his own studio in Buffalo, New York, designing luxury cars. In 1927 he joined the Murray Corporation of America, where he designed the 1928 Hupmobile. In 1928 he joined Willys-Overland and designed the 1930 Willys Plaidside roadster and restyled the 1930 Willys Whippet line. He returned to Murray in 1929 to design many cars. His most famous designs were the 1931 Reo Royale and the 1932 Graham Blue Streak, both very influential as turning points in automotive design. Another was the "sharknose" hood for the 1938 Graham, copied by most manufacturers in the late 1930s.

Noyes, Eliot Fette (1910–1977) U.S. architect and industrial designer born in Boston, Massachusetts, who studied architecture at Harvard (1932–1938), and was employed by Marcel Breuer and Walter Gropius after graduation. He worked as a curator at the Museum of Modern Art and was appointed director of its new department of industrial design in 1940. During World War II, he served as a major in the air force. After the war he served as design director for Norman Bel Geddes, until 1947, when he opened his own office. Thomas J. Watson, Jr., of IBM retained him in 1948 for product design and in 1956 to develop a unique corporate style similar to Olivetti. He did so with help from Paul Rand, Marcel Breuer and Charles Eames. In 1960, he was retained by Westinghouse to repair their deteriorating image, again using Paul Rand for graphic design. He died in New Canaan, Connecticut.

Olbrich, Joseph Maria (1867–1908) Austrian architect who studied architecture at the Wiener Staatsgewerbeschule and the Academy of Fine Arts in Vienna where he won several prizes. In 1893, he started working for architect Otto Wagner. Olbrich was a cofounder of the Wiener Sezession (Vienna Secession) in 1897. In 1899 he designed the "Wedding Tower" exhibition hall for the Künstler-Kolonie (Artist's Colony) in Darmstadt, Germany, working closely with Peter Behrens.

Oros, Joe (b. 1917) U.S. automotive designer who graduated from Cleveland Institute of Art in 1939 and started his career with George Walker, where he worked on the 1940 Lincoln Continental and the 1949 Ford. His wife and college classmate, **Elizabeth Thatcher Oros,** was the first woman to work in an automotive studio, on the 1941 Hudson. Joe joined Ford full time in 1955 when Walker was named head. Oros became head of Ford's styling studio from 1956 until 1968, when he became vice president of Ford Europe. In 1974, he became executive director for Lincoln-Mercury until his retirement in 1975.

Otto, Carl (d. 1986) U.S industrial designer born Carl Louis Otto in Michigan who trained as an engineer at Michigan State. He began his career as a draftsman with Duesenberg, and then came to New York to work for Norman Bel Geddes. In 1935 he joined Raymond Loewy to work on Pennsylvania Railroad designs. He opened Loewy's prewar office in London in 1938, which he headed until 1940 when he became a Loewy associate. One of his accounts was Standard Auto (Triumph). He resigned in 1951 and returned to the U.S. to open his own firm, with offices in New York, Stockholm and London, which operated until 1954. His best-known designs include the Schick 20 razor and the Edison Voicewriter.

Oud, J.J.P. (1890–1963) Dutch architect born Jacobus Johannes Pieter Oud who was trained in Amsterdam and Delft, worked briefly in Germany, and returned to practice in Leyden. He met Theo van Doesburg and Gerrit Rietveld in 1915 and became associated with the De Stijl movement. In 1918 he became Rotterdam city architect. The best examples of his work are the Houses at the Hook of Holland (1926–1927) and the Kiefhoeck project in Rotterdam.

Papanek, Victor J. (1925–1998) U.S. industrial designer, anthropologist, writer, and teacher who was born in Vienna, Austria, arrived in the U.S. in 1932, and graduated in architecture and industrial design from the Cooper Union in 1948. He opened his consulting office in 1953 and was dean of the School of Design at California Institute of the Arts. In the early 1970s he became chairman of design at the Kansas City, Missouri, Art Institute and wrote a number of books, including *Design for the Real World* (1972), and *How Things Don't Work*, (1977). Beginning in 1981, he taught architecture and design at the University of Kansas.

Parriott, Joseph Marshall (1920–2000) U.S. industrial designer and design educator who was born in Moundsville, West Virginia, and was raised in Colorado. He attended Colorado University and Pratt Institute and served with the U.S. Army in World War II. He worked for Raymond Loewy/William Snaith as manager of product design, and then became a consultant for Becker & Becker. In 1965, as an officer of IDI, he participated in the formation of IDSA in 1965 and was its president in 1966. He also became chairman of Pratt's industrial design department in 1966, a post he held for 24 years. He retired in 1992 to Cooperstown, New York.

Patten, Raymond E. (1897–1948) U.S. industrial designer born in Malden, Massachusetts, who attended Harvard University and studied engineering at the Massachusetts Institute of Technology. In 1928 he became a consulting designer for the Edison General Electric Company (GE) in Chicago to supervise appearance design. In 1933 he designed exhibits for GE at the Century of Progress Exhibition. That same year, GE established an internal industrial design group in Bridgeport, Connecticut, and Patten was named as head. He relocated there in 1934 and held the position until his death. He designed ranges, dishwashers, and locomotives, and was a charter member of the Society of Industrial Designers when it was formed in 1944.

Paul, Bruno (1874–1968) German architect, illustrator, interior designer, and furniture designer who trained at the Saxon Academy of Fine Arts and the Munich Academy. In 1897 he joined the Munich Workshops, for which he designed 2000 furniture patterns, and in 1898, he joined the Berlin Secession. In 1903 he was appointed to head the Industrial Art School in Berlin as a leading artist of the Jugenstil movement, and in 1907 was a founding member of the Deutsche Werkbund. His students at the Berlin school, much larger in scope and number of students than the Bauhaus, included Ludwig Mies van der Rohe, Adolph Meyer, and Kem Weber.

Phyfe, Duncan (1768–1854) American cabinetmaker and manufacturer whose family emigrated in 1784 from Scotland to Albany, New York, where he completed his apprenticeship. By 1794, he had established a cabinetmaker business on Broad Street in New York, and introduced English Regency and Neoclassical styles. His finest work was done between 1800 and 1820, when he employed over 100 workers at his workshop on Partition Street, in 1817 renamed Fulton Street.

Plumb, William Lansing (b. 1932) U.S. industrial designer who graduated from Cornell University and pursued postgraduate studies at the Politechnico di Milano in Italy. He joined the firm of Eliot Noyes and worked on the IBM account, and in 1963 established his own firm with IBM as his major account. In 1986 he was awarded the Prix de Rome by the American Academy in Rome.

Ponti, Giovanni "Gio" (1891–1979) Italian architect, designer and champion of industrial design

born in Milan. He studied architecture at Polytechnic in Milan. He worked as a designer for the ceramics firm of Richard Ginori, and helped organize the Triennale in 1923 before establishing an architectural firm with Emilio Lancia in 1927. In 1928, he founded and edited *Domus*, the magazine serving as the mouthpiece for the Novecento group he founded in 1926, and which had brought the influence of the Wiener Werkstätte to Italy. He was professor at Polytechnic from 1936 to 1961. He edited *Stile*, a design magazine, from 1940 to 1947, and helped organize the Compasso d'Oro and the Associazione per il Disegno Industriale (ADI). In the 1950s, he created seminal pieces of furniture, including the Distex armchair and the Superleggera chair.

Pulos, Arthur Jon (1917–1997) U.S. industrial designer, educator and design historian, born in North Vandergrift, Pennsylvania. He graduated in art education from Carnegie Institute of Technology in 1939 and earned a masters in silversmithing at the University of Oregon in 1943. He served in the air force during World War II, was chairman of the silversmith department at the University of Oregon, and became associate professor of design at the University of Illinois from 1946 to 1955. He went to Syracuse University in 1955 to direct the industrial design program, becoming chairman of the Department of Design in 1970 until his retirement in 1982. He founded Pulos Design Associates in 1958 and remained in active practice until 1988. He was the last president of IDEA, in 1964, was president of IDSA (1973–1974), and president of ICSID (1979–1981). He wrote *American Design Ethic* (1983) and *American Design Adventure* (1988).

Quistgaard, Jens (1919–2008) Danish designer and son of a sculptor father who soon learned to use the tools of craftsmanship. Before World War II he served as an apprentice at the Georg Jensen Smithy in Copenhagen. After the war he became a freelance designer and won a number of design awards. In 1954, with U.S. entrepreneur/engineer Ted Nierenberg, he established Dansk and designed many of its most successful products over the next 20 years.

Rams, Dieter (b. 1932) German industrial designer who studied architecture and design at Wiesbaden Werk-Kunstschule (1947–1953). He started with Braun AG in 1955, and in 1957 was appointed head of its design program, a program which earned worldwide acclaim. After 1957 he designed furniture for Otto Zapf, for Vitsoe & Zapf, and for Niels Weise Vitsoe. He remained in a lead role at Braun for many years, and concluded his career there as chairman of the board.

Randolph, Benjamin (1737–1791) American joiner and cabinetmaker who by 1762 was an established craftsman and entrepreneur in Philadelphia, with a shop located on Chestnut Street. Between 1768 and 1786, his business was the most prolific in the city, devoted entirely to making the finest Chippendale chairs. He employed two skilled London-trained carvers, Hercules Courtenay (?1744–1784) and John Pollard (1748–1787). In 1775, Thomas Jefferson commissioned him to make the portable writing desk upon which he drafted the Declaration of Independence.

Reinecke, Jean (1909–1987) U.S. industrial designer who was born in Bourbon County, Kansas, attended Kansas State Teachers College, and studied art at Washington University in St. Louis, Missouri. He started as a display artist at General Display Studios in St. Louis, soon becoming a partner. In 1930, he opened a Chicago office to work on displays for the Chicago Century of Progress Exposition (1933–1934). In 1934 he joined with James Barnes to form Barnes & Reinecke. He designed the Toastmaster model 1B12 in 1938 for McGraw Electric Company (later McGraw-Edison), the first to exploit the curvature of chrome shells. He designed Scotch tape dispensers for 3M starting in 1938, including its ubiquitous 1940 plastic disposable dispenser. In 1948, he sold his interest in the partnership and established J.O. Reinecke & Associates, with offices in Chicago, and later, Pasadena, California, where he designed until 1986. He was president of SID in 1952.

Revere, Paul, Jr. (1734–1818) American silversmith, son of a French Huguenot silversmith, Apollos Rivoire, who apprenticed at age 13 with his father. After fighting in the British army in the French and Indian Wars, he took over his father's shop in about 1764 working as a silversmith, engraver and dentist. He created a silver bowl in tribute to the 92 authors of the Massachusetts constitution in 1768. He is famed for his horseback ride to warn of British troop movements toward Lexington on April 18, 1775. After the Revolutionary War, he opened a hardware store and by 1788 had established an iron and brass foundry in Boston, which grew into a large corporation, Revere Copper and Brass, Inc.

Rhead, Frederick Hurten (1880–1942) U.S. ceramics designer who was born in England, emigrated to the U.S. in 1902 to work in Ohio, and in 1904 became art director of the Roseville pottery there. In 1908 he joined the William Jervis Pottery on Long Island, and in 1909 was a pottery instructor in St. Louis. From 1911 to 1913 he was with the Arequipa Pottery in California and in 1916 published an industry magazine, *The Potter*. He returned to Ohio in 1917 and in 1927 joined the Homer Laughlin Company, where he designed Fiesta in 1936 and Harlequin in 1938, and headed the design department until his death.

Richardson, Deane W. (b. 1930) U.S. industrial designer who was an industrial design graduate of Pratt Institute and with classmate David B. Smith cofounded Richardson/Smith (R/S) in Columbus, Ohio, in 1959 to capitalize on a central midwest location. R/S correctly foresaw dramatic changes within the profession, corporate structures, and global design markets, and pioneered a participative management style and multidisciplinary staff environment for design offices that later become common practice. By 1985 R/S had a staff of over 150. In 1988 R/S became a subsidiary of Fitch & Company, PLC, founded in 1971 by Rodney Fitch, a British architect. The new firm was known as Fitch Richardson Smith, Inc., with a combined staff of 500, and in 1993 became known as Fitch, Inc. Deane Richardson was president of ICSID (1992–1993).

Rideout, John Gordon (1898–1951) U.S. industrial designer born in St. Paul, Minnesota, who studied at St. Paul Academy and in architecture at the University of Washington, but left school to serve in the navy in World War I. He worked in the 1920s as a graphic designer in Chicago, where he was one of the founders of the Chicago Society of Typographic Arts. In 1931 he went to Toledo, Ohio, to partner with Harold Van Doren in a design office. Rideout left the firm in 1935 to start his own office in Cleveland, Ohio, John Gordon Rideout and Staff. The advent of World War II in 1941 closed his office, but he reopened it in 1943 in Chagrin Falls, Ohio. In 1944 he joined with architect Ernest Payer to combine industrial design and architecture. Their relationship ended in 1946. Rideout was a cofounder of SID.

Riemerschmid, Richard (1868–1957) German architect and furniture designer who studied painting at the Munich Art Academy and wrote for *Jugend* magazine. He was a cofounder of the Munich Workshops with Peter Behrens in 1897 and taught in Nurenburg from 1902 to 1905. In 1903 he worked in the Dresden Workshops and in 1907 was a founding member of the Deutsche Werkbund and planned the first German garden city in Dresden-Hellerau until 1913. He was then director of the Munich Kunstgewerbeschule, and from 1925 to 1931, director of the Cologne Werkschulen.

Rietveld, Gerrit (1888–1964) Dutch architect and designer who trained as a cabinetmaker in his father's workshop, and worked for goldsmith Casrel Begeer from 1906 to 1911. He designed his Red/Blue Chair in 1918 and joined the De Stijl movement, in 1919, which used his chair as its symbol. In 1924 he designed and built a dramatic house for Truus Schröder called the Schröder house. He participated in the Congrés Internationaux D'Architecture Moderne in 1928 and continued to practice architecture until his death.

Rodchenko, Aleksandr (1891–1956) A leading proponent of Russian Constructivism who studied at the Art School in Kazan from 1910 to 1914. He moved to Moscow and became acquainted with Kasimir Malevich and Vladimir Tatlin. Rodchenko, with his wife, Varvarya Stepanova, and Alekseye Gan, formed the first working group of the Constructivists in 1921. From 1923 on he designed posters for government trading organizations, the cinema, and the journal LEF (Left Front of the Artists) until 1929.

Rohde, Gilbert (1894–1944) U.S. furniture designer who was born in New York and studied at the Art Students League and Grand Central School of Art in New York. He became a drama and music critic, cartoonist, reporter, and furniture illustrator. He opened his office in New York in 1927 designing furniture and showrooms. In 1932 he was appointed director of design of the Herman Miller Furniture Company in Zeeland, Michigan, where he served until his death. He was a member of the American Union of Decorative Artists and Craftsmen (AUDAC) in the early 1930s, one of the founders of the Designers Institute of the American Furniture Mart in 1933, director of the Design Laboratory School from 1935 to 1938, and head of an industrial design program at New York University's School of Architecture from 1939 to 1943. He designed major exhibits for the New York World's Fair in 1939.

Saarinen, Eero (1910–1961) U.S. architect and furniture designer born in Kirkkonummi, Finland, the son of Eliel Saarinen. Eero emigrated to the U.S. in 1923 with his parents, studied sculpture at Academie de la Grande Chaumiere in Paris (1929–1930) and received a degree in architecture from Yale University (1930–1934). He traveled and studied in Europe, the Middle East, and Africa on a fellowship (1934–1936). In 1935 he joined his father at Cranbrook, and worked with Charles Eames, who was hired as head of experimental design there in 1937. They explored the use of new plastics in furniture design together. Eero taught architecture at Cranbrook from 1939 to 1941, and continued his father's practice as Eero Saarinen Associates after 1950. He married Aline Bernstein Louchheim, who became well known as articulate architectural critic Aline Saarinen (1914–1972). With Charles Eames, Eero won first prize in a 1941 furniture design competition sponsored by the Museum of Modern Art. He Joined Knoll Associates in 1947 and designed its 1948 Womb chair and its 1956 line of Pedestal furniture. He is also well known for his architectural designs of the TWA terminal at John F. Kennedy airport (1962), Dulles Air Terminal (1958), and the Gateway Arch in St. Louis (1965).

Saarinen, Eliel (1873–1950) Finnish architect who began his practice in 1896 in Helsinki in partnership with Herman Gesellius and Armas Lindgren, and who was known as Finland's "National Architect." In 1923 he won second prize for design of Chicago Tribune Tower design competition (Raymond M. Hood and John Mead Howells won the first prize), and emigrated to the U.S. He joined the staff at the University of Michigan, and then cofounded Cranbrook Academy of Art in 1925, becoming its president in 1932. He brought Charles Eames, Harry Bertoia, and his son, Eero Saarinen, together on the teaching staff.

Sakhnoffsky, Alexis Wladimirovich de (1901–1964) Automotive designer who was born in Russia, studied engineering in 1914 at the University of Lausanne, Switzerland, and arts and crafts at the Ecole des Arts et Métiers in Brussels starting in 1920. He began work for coachbuilder Van den Plas in Belgium and became its art director in 1924. In 1928, as art director for the Hayes Body Company in Grand Rapids, Michigan, he designed the 1929 American Austin. When Hayes failed in 1931, he was recruited by Auburn and became known as an outspoken futurist and stylist. In 1963, he executed a portfolio of classic car drawings for *Automobile Quarterly*.

Sakier, George (1897–1988) U.S. industrial designer who was born in France, became interested in art and emigrated to the U.S. in the early 1920s. As an engineer in New York, he designed machinery and taught machine design while writing and practicing in fine art. He exhibited his landscape art in galleries and designed glassware for Fostoria Glass in Moundsville, West Virginia, for over 50 years. In 1927, while continuing his independent practice, he headed the Bureau of Design Development at the American Radiator & Standard Sanitary Corporation. He also designed exhibits for the 1939 World's Fair.

Sandin, Raymond C. (c. 1915–c. 1986) U.S. industrial designer born in Sweden who came to the U.S. at age 20. He studied architecture at Illinois Institute of Technology before joining the Hotpoint Division of General Electric in 1935 as a one-man design department. He headed Hotpoint design the remainder of his career. By 1965, he had a staff of 13.

Sant'Elia, Antonio (1888–1916) Italian architect born in Como who studied in Milan and at the University of Bologna. He established himself as an architect in 1912, and prepared a number of drawings of buildings and town planning shown at an exhibition, La Citta Nuovo (The New City), in 1914. His work became a public expression of Futurism. He was killed in the battle of Monfalcone in World War I.

Savery, William (1721–1787) American furniture maker in Philadelphia who had a shop on 2nd Street below Market. A Quaker, he produced furniture in Chippendale styles, and was very prosperous by 1780.

Schreckengost, Viktor (1906–2008) U.S. industrial designer born in Sebring, Ohio, and studied cartooning at the Cleveland School of Art and at the Kunstegewerbschule in Austria. In 1930, he joined the faculty at the Cleveland School of Art and worked part time at Cowan Pottery Studio. He worked for a variety of other industrial and ceramic firms, and then began an industrial design program at

the Cleveland Institute of Art in 1933, which became well known for its automotive design. He created stage and costume designs from 1938 to 1943, and served with the navy in World War II. After the war, he designed many products and produced outstanding commercial sculptures and watercolors. In 2001, he was honored with a full-scale retrospective at the Cleveland Museum of Art, *Victor Schreckengost and 20th Century American Design*. In 2006, at age 100, he was presented with the National Medal of Arts at the White House by President and Mrs. George W. Bush.

Semper, Gottfried (1803–1879) German architect, art critic, and educator who lived in London (1851–1854) and taught applied arts at South Kensington School. He studied architecture in 1825 at the University of Munich. He argued that legacies of the crafts must be abandoned to create a new industrial art, based on acceptance and command of mechanization.

Sheraton, Thomas (1751–1806) English furniture designer who in 1790 set up a consulting business in London, teaching perspective, architecture and cabinet design for craftsmen. In 1793 he published *The Cabinet Maker's and Upholsterer's Drawing Book* in four volumes. It was widely influential throughout Europe and the new United States. His styles were quite fashionable in the 1790s and early 1800s. He did not make the furniture he designed, but they were based on classical architecture, knowledge of which was an essential part of a designer's education. In 1803 he published *The Cabinet Directory*, and in 1805, *Cabinet Maker, Upholsterer and General Artist's Encyclopaedia*.

Sinel, Joseph "Jo" Claude (1889–1975) Self-described as the first industrial designer in the U.S. (he used the title on his letterhead in 1920). Born in Auckland, New Zealand, he attended the Elam School of Art, and after working in Australia and England, he immigrated to San Francisco in 1918, where he wrote *A Book of American Trademarks and Devices*. Working for the Lennon Mitchell advertising agency in New York, he began designing Art Deco products for clients in 1923. His package designs were featured in a 1934 issue of *Fortune* magazine. He taught at the California College of Arts and Crafts in the 1920s and returned there in the 1940s. One of the 14 founders of the Society of Industrial Designers in 1944, he also taught at a number of other design schools, including Pratt Institute in Brooklyn and Chouinard in Los Angeles.

Smith, David B. (b. 1932) U.S. industrial designer who studied at Ohio State University and graduated in industrial design from Pratt Institute. He started his career as a staff designer for the Kelvinator Division of American Motors Corporation, later working for Chrysler and then AEG in Germany. In 1959, with Pratt classmate Deane Richardson, he co–founded Richardson/Smith in Columbus, Ohio. In 1989 Richardson/Smith merged with the London-based firm Fitch & Company, PLC. In 1994 he became the Nierenberg Distinguished Professor of Industrial Design at Carnegie Mellon University and received the Alumni Achievement Award from Pratt Institute. He served as chairman, president and treasurer of the Association of Professional Design Firms and was a member of the Human Factors Society. Over the years he has received additional awards, patents, recognition and articles, including IDSA's Personal Recognition Award in 1995.

Smith, F. Eugene (b. 1923) U.S. industrial designer who graduated from the Cleveland Institute of Art in 1946. He spent a year with the George Walker office in Detroit, and then teamed with his classmate, Samuel Scherr, and Bernard McDermott to establish the Akron, Ohio, firm of Smith, Scherr & McDermott in 1947. In 1960, Smith left the firm to establish his own office, F. Eugene Smith Associates, Inc., and in 1966, lectured against the ugliness and visual chaos of urban environments. In 1977, he founded F. Eugene Smith/Design Management, Inc., in Akron, Ohio.

Smith, Robert G. (b. 1922) U.S. industrial designer who, after five years in the U.S. Merchant Marine, reentered Pratt Institute and graduated in 1951. He worked for Harley Earl Associates from 1954 to 1956, for Raymond Loewy Associates from 1956 to 1959, and from 1959 to 1967 was vice president of product development at Lippincott & Margulies. He joined J.C. Penney in 1967, where he organized and headed an internal product design staff, and in 1974 implemented an award-winning corporate identity program. He was president of IDSA (1981–1982) and remained with Penney until his retirement in 1983.

Snaith, William (1908–1974) U.S. industrial designer who was born in Brooklyn, New York, studied architecture at New York University, art at the Ecole des Beaux-Arts, and at the Fontainebleau Academy of Fine Arts in Paris. He worked as an architectural draftsman and set/costume designer until

offered a job by Raymond Loewy in 1936, leading to his partnership in the Loewy office specializing in marketing. He became president of Raymond Loewy/William Snaith in 1961 when Loewy became chairman.

Sottsass, Ettore, Jr. (1917–2007) Leading postwar Italian architect and industrial designer who was born in Austria, studied at Turin Polytechnic University and began his architectural career in 1947. He worked for George Nelson briefly in 1956, and then started the same year with Olivetti, where he designed a number of acclaimed products, including the brilliant red Valentine typewriter in 1969. In 1980 he founded Sottsass Associati and in 1981 created an avant-garde furniture design group called Memphis, for which he designed its signature post–modern Casablanca sideboard. Memphis dissolved in 1988, and in 1997 he designed the Malpensa 2000 international airport in Milan.

Spilman, Raymond (1911–2000) U.S. industrial designer who was born in Wichita, Kansas, studied at Kansas State University (1933–1934), worked for General Motors as a stylist from 1935 to 1939, joined Walter Dorwin Teague Associates in 1940 as a staff designer, and worked for Henry Dreyfuss Associates in New York. In 1942 he joined Johnson/Cushing/Nevell as director of product design before opening his own office in 1946 in Darien, Connecticut. He was president of ASID (1960–1962). An avid watercolorist, he retired to Cape Cod, Massachusetts, around 1999.

Stam, Mart (1899–1986) Dutch architect, born Martinus Adrianus Stam, who was associated with members of the Bauhaus and the Constructivists. He was the inventor of the tubular steel cantilever chair concept first shown in 1927. Stam worked as an architect in the Soviet Union from 1930 to 1934 before taking up directorships of art academies in Amsterdam, Dresden, and East Berlin from 1939 until his retirement in 1966.

Stark, Phillipe Patrick (b. 1949) French industrial designer known for his whimsical post–modern designs. He was educated at the École Nissim de Camondo in Paris and opened his own firm in 1968, a member of which was Pierre Cardin. Since 1975 he has worked independently as a product and interior designer. In 1982 his design of French president Mitterand's apartments made him famous. His furniture designs for Kartell, kitchen accessories for Alessi, and inexpensive product designs for Target in 2002 all have distinctive appearances.

Steinhilber, Budd (b. 1924) U.S. industrial designer was born in New York City, grew up in Woodstock, New York, and studied at the High School of Music and Art in New York City. He apprenticed at the Loewy office in New York while still a student at Pratt Institute. He graduated in 1943 and started work with Dohner & Lippincott in New York. In 1947 he became part of the team that designed the Tucker car. In 1949 he joined Read Viemeister in Yellow Springs, Ohio, as a partner. In 1964 he relocated to San Francisco and established a partnership with Gene Tepper (Tepper & Steinhilber Associates). In 1975 he partnered with graphic designer Barry Deutsch, forming Steinhilber & Deutsch, Inc. He taught at the Dayton Art Institute and lectured at many other schools. In 1987 he relocated to Kailua-Kona, Hawaii, and served as secretary-treasurer of IDSA from 1989 to 1990. Since 1989 he has served as a design advisor to Konawaena High School Solar Car Team and in 1997 was an NGO delegate to the Global Warning Conference in Kyoto.

Stevens, Brooks (1911–1995) U.S. industrial designer who was born in Milwaukee, Wisconsin, studied architecture at Cornell from 1929 to 1933, and immediately entered the profession by designing trademark materials for his father's firm, Cutler-Hammer. He worked on outboard motors for Evinrude starting in 1934 and established his own office. He redesigned the Steam-O-Matic steam iron in 1938 and in 1941 redesigned the Hiawatha Skytop Lounge for the Chicago, Milwaukee & St. Paul Railroad. He was one of the founders of SID in 1944 and became a consultant to Willys-Overland for postwar Jeep vehicles, including the Jeepster in 1949 and the Wagoneer in 1963. He designed for Studebaker from 1962 to 1967 and designed the famous Oscar Mayer Wienermobile. After 1979, Brooks Stevens Design Associates continued under his son, Kipp. From 1983 until his death, Stevens taught at the Milwaukee Institute of Art & Design.

Stickley, Gustav (1857–1942) American designer and follower of the Arts and Crafts movement who entered the furniture business with many brothers in 1886 and established his own firm in 1898, designing and making what became known as Mission furniture. In 1905 he moved to New York, but by 1915 he was bankrupt due to widespread imitation of his style by competitors. In 1884, Gustav's

brother, **Charles Stickley,** formed the Stickley-Brandt Furniture Company in Binghamton, New York, and produced Victorian design furniture until the company went bankrupt in 1919. Two brothers, **George and Albert Stickley,** moved to Grand Rapids, Michigan, in 1891 and made furniture similar to Gustav's at their firm, Stickley Brothers Company, which closed in 1907. Two other brothers, **Leopold and J. George Stickley,** opened a factory in Fayetteville, New York, under the name L. and J.G. Stickley Company, and made designs similar to Gustav's, as well as some designed by Frank Lloyd Wright. In 1916, Leopold and George purchased Gustav's factory after his bankruptcy and continued to operate it as the Stickley Manufacturing Company.

Stout, William Bushnell (1880–1956) U.S. automotive and aeronautical designer who was born in Quincy, Illinois, and graduated from the University of Minnesota. He became the technical editor of the *Chicago Tribune* in 1912, worked for Packard in 1916, and in 1917 became an advisor to the National Aircraft Board in Washington, D.C. He founded the Stout Engineering Laboratories in 1919, and developed the first all-metal plane, the Ford Tri-Motor, in 1925. In 1932 he began to operate the Stout Research Division of Consolidated Vultee Aircraft Corporation. In 1934 he developed a Pullman "Railplane," and in 1935 the Scarab car. From 1931 to 1945 he developed four airplane/automobile "Skycar" concepts.

Stumpf, William (1936–2006) U.S. industrial designer who received a degree in industrial design from the University of Illinois in 1959, and a masters in environmental design from the University of Wisconsin in 1968. In 1970 he joined the Herman Miller Furniture Company as director of research. In 1973 he established a consulting practice, Stumpf Associates, in Winona, Minnesota, and designed the 1976 Ergon chair for Herman Miller. He joined with Don Chadwick in 1977 to form Chadwick Stumpf and Associates and the result was the 1984 Equa chair and Ethospace System, both for Herman Miller.

Sundberg, Carl (1910–1982) U.S. industrial designer who was born in Calumet, Mississippi, and attended Wicker Art School in Detroit. He began his career in 1927 designing custom car bodies with the Raymond Dietrich Body Company. He then worked in plastics design at Kurz-Kasch, Inc., and later at General Motors where he met **Montgomery Ferar.** In 1934, he and Ferar left GM and formed the lifelong partnership of Sundberg-Ferar, designing major transportation systems as well as major appliances for Sears, Roebuck and Whirlpool. He retired in 1975.

Swainson, Anne (ca. 1900–1955) Swedish designer who emigrated to the U.S. and studied fine and applied arts at Columbia University. She taught textile and applied design at Berkeley, worked as a fashion coordinator at Chase Revere Copper & Brass, and then founded and headed the Bureau of Design at Montgomery Ward in Chicago in 1931.

Tatlin, Vladimir (1885–1953) Leading theorist of Russian Constructivism who studied painting at the Moscow School of Painting, Sculpture, and Architecture from 1902 to 1904, and at Penza Art School from 1904 to 1910. He was then linked to Russian Futurism. After the Revolution, he became responsible for Lenin's Plan for Monumental Propaganda and moved to Petrograd in 1919 to prepare a model of the Monument to the Third International, exhibited in 1920. From 1927 on, he taught industrial design (called "production art") at the VKhUTEMAS design school.

Teague, Walter Dorwin (1883–1960) U.S. industrial designer who was born in Decatur, Indiana, and is considered by many to be the dean of industrial design. He studied at the Art Students League in New York from 1903 to 1907. He worked as an illustrator, establishing his own commercial art studio in 1911. By the mid–1920s, he was well known for his elegant advertising drawings. He left advertising to open one of the first industrial design firms in 1927 and received his first contract with Eastman Kodak in 1928. He was on the board of design for the 1939 World's Fair, where he also designed the Ford and U.S. Steel pavilions. In 1944, he was one of the founders of the Society of Industrial Designers, becoming its first president. After World War II, he became a major consultant for Boeing, designing many interiors of the jet age.

Telnack, John J. "Jack" (b. 1937) U.S. automotive designer who graduated from Art Center College in 1958 and joined Ford. He worked on the fastback version of the Mustang in the late 1960s. He was transferred to Australia, then to Ford of Europe, where he worked on the 1977 Fiesta. He returned to the U.S. and headed Ford's North American design studio, focused on the design of the aero-look

1983 Thunderbird and then on the 1985 Taurus and Sable. He became vice president of corporate design at Ford in 1987, a position he held until his retirement in 1997.

Terry, Eli (1772–1852) American clock maker who apprenticed with Daniel Burnap from age 13 and opened his own shop in East Windsor, Connecticut, in 1793. He is noted for his innovation of wooden clock parts in lieu of brass, to reduce cost by half in order to enable nonspecialists to make parts and to produce higher quantities. By 1806 he had orders for 4000 clocks and had established a new low-cost market.

Thonet, Michael (1796–1871) German-Austrian cabinetmaker who began his practice in Boppard, Germany, in 1819. In 1830 he began experiments on furniture made with innovative glued and laminated wood slats. He sold the business and in 1849, after immigrating to Vienna, Austria, established a new business, Gebrüder Thonet, with a number of his sons. His bentwood Vienna Chairs won a bronze medal at the Great Exhibition in London in 1851. By 1855, when he won the silver medal at the Paris World's Fair, he employed 70 workers and was exporting to foreign countries. His most famous chair, the 1859 No. 14 "coffee shop chair," of which 50 million were produced before 1930, won a gold medal at the 1867 Paris World's Fair.

Tiffany, Louis Comfort (1848–1933) American artist and designer who studied painting in New York and Paris. He became interested in glassmaking in 1875 and in 1879 partnered with Candace Wheeler in interior decorating. He established his own glassmaking firm, the Tiffany Glass Company, in 1885 to produce dramatic color effects, and by 1895 he employed 300 workers. His popular lamps and vases were sold in Paris in the Art Nouveau style. In 1902, his firm was renamed Tiffany Studios.

Tjaarda, John (1897–1962) U.S. automotive designer who was born in Holland, trained in aeronautical design in England, and served as a Dutch air force pilot. He emigrated to the U.S. in 1923 and worked on custom car bodies in Hollywood, then pioneered on monocoque, streamlined designs. He worked for Duesenberg from 1928 to 1930 and for Harley Earl from 1930 to 1932, when he became chief of body design for the Briggs Manufacturing Company. His streamlined concept Briggs Dream Car for Ford displayed at the Century of Progress Exhibition in 1933 led to the development of the 1936 Lincoln Zephyr.

Tremulis, Alex Sarantos (1914–1994) U.S. automotive designer who was born in Chicago, started at Duesenberg in 1933, and became chief stylist in 1936. In 1937 he joined General Motors, then Briggs-LeBaron. In 1939 he consulted with Crosley and American Bantam but returned to Briggs to work on the 1941 Chrysler Thunderbolt and Packard Clipper. He entered the air force in 1941, where he worked on advanced aircraft concepts. After the war, he worked with Tammen and Denison until Preston Tucker hired him in 1947 to work on the Tucker 48. He later worked at Ford advanced styling, and in California for Subaru, where he designed the Brat.

Urban, Joseph (1872–1933) Austrian architect who studied at Vienna's Academy of Fine Arts and became a member of the Vienna Secession of 1897. By 1908 he was an illustrator and designer of theatrical sets, and in 1911 he emigrated to the U.S. to become artistic director of the Boston Opera. In 1918 he moved to New York and became famous as set designer for the *Ziegfeld Follies* until 1933. From 1922 to 1924 he operated a New York branch of the Wiener Werkstätte. In 1925 he opened his own office in New York where he practiced interior design, designed Art Deco furniture, and continued as a set designer.

Van de Velde, Henry (1863–1957) Belgian painter–designer-architect and one of a group known as Les Vingt (The Twenty), who absorbed the principles of the English Arts and Crafts movement and the French Symbolists and transformed them into the Art Nouveau style. He founded his own firm and factory near Brussels c. 1899; his Art Nouveau furniture designs were well known. In 1902 he founded the Weimar Kunstgewerbeschule (Weimar School of Arts and Crafts), the precursor of the Bauhaus, which became public in 1907. He was a founding member of the Deutsche Werkbund; but he had a disagreement in 1914 with Hermann Muthesius, who believed in the standardization of design. Van de Velde resigned his post when World War I began, recommending Walter Gropius as his successor. In 1917, Van de Velde moved to Switzerland, in 1920 to the Netherlands, and in 1947 returned to Switzerland.

Van Doesburg, Theo (1893–1931) Dutch artist born in Utrecht, the Netherlands, whose given name

was Christian Emil Marie (C.E.M.) Kupper. He took his pseudonym from his stepfather. He began as a painter but was drawn to architecture in 1916 by J.J.P. Oud. He was the founder and leader of the De Stijl movement, disseminating its ideas through lecture tours and its magazine, *De Stijl*, published from 1917 until his death. He taught briefly at the Bauhaus in 1922.

Van Doren, Harold (1895–1957) U.S. industrial designer who was born in Chicago, Illinois, and graduated from Williams College in 1917. He studied at the Art Students League in New York (1920–1921) and in Paris (1922–1924). In 1927 he became assistant director of the Minneapolis Institute of Arts. He opened a design office in 1931 with John Gordon Rideout in Toledo, Ohio. In 1935, Rideout left, and the firm became Harold Van Doren & Associates, which relocated to Philadelphia in 1940, the same year Van Doren wrote the book *Industrial Design: A Practical Guide*. He became a co–founder of SID in 1944, the same year his firm was expanded to include a New York office, known as Van Doren, Nowland & Schladermundt. In 1950, the partners separated, with Van Doren retaining his office in Philadelphia. Upon his death, the firm became known as Harper Landell & Associates, and later, Bresslergroup, Inc.

Vassos, John (1898–1985) U.S. industrial designer who was born in Constantinople (now Istanbul), Turkey; he was the son of a Greek publisher. While serving on a suicide minesweeper in World War I, he was torpedoed and rescued; he landed in Boston in 1919. He studied art and illustration with John Singer Sargent at the Fenway Art School. He came to New York, in 1924, where he studied at the Art Students League and opened an industrial design studio. He published and illustrated a number of books from 1929 to 1931. In 1933 he established the first internal design department at RCA, remaining its consultant until 1964. He was the first president of the American Design Institute (ADI), in 1938. During World War II, with a predecessor of the CIA, he helped organize the Greek underground and developed camouflage techniques. He was elected the first chairman of the board of IDSA when it was formed in 1965.

Viemeister, Read (1923–1993) U.S. industrial designer who graduated from Pratt Institute in 1943 along with Budd Steinhilber; both started work with Dohner & Lippincott in New York, with Read becoming its first director of styling. He married Beverly Lipsett in 1946, moved to Yellow Springs, Ohio, and organized Vie Design Studios with Budd Steinhilber as partner in 1947. Both were on the team that designed the 1948 Tucker automobile. In 1949 they worked together to establish a department of industrial design at the Dayton Art Institute, where they both taught and lectured. When Budd left for San Francisco in 1964, Read maintained Vie Design with the help of Frank Burrer and others until the 1990s.

Viemeister, Tucker (b. 1948) U.S. industrial designer and son of Read Viemeister, he was born in Yellow Springs, Ohio, received a BFA from Pratt Institute in 1974, then worked in his father's industrial and graphic design firm, Vie Design Studios. In 1979 he cofounded Smart Design, Inc., in New York City with Davin Stowell, Tom Dair and Tamara Thomsen. Their best-known designs are GoodGrips kitchen tools for Oxo International in 1990. In 1997 he headed frogdesign's New York studio; in 1999, he became executive vice president of the Research and Development Department at Razorfish; and in 2001, he became president of Springtime-USA. He then became lab chief, heading R&D for the Rockwell Group.

Von Nessen, Walter (1889–1943) German lighting and furniture designer who emigrated to the U.S. in 1925. In 1927 he opened a studio in New York to design and fabricate architectural lighting and associated with leading designers of the times. He followed Art Deco and functional styles. In the 1930s he designed his most famous lamp, the versatile swing arm classic that is still being manufactured by Nessen Lamps, Inc., using his original fabricating methods.

Vossoughi, Sohrab (b. 1956) U.S. Industrial designer who was born in Tehran, Iran, in 1956, and moved to the United States in 1971. After studying mechanical engineering for three years, he switched to study industrial design, graduated from San Jose State University's Department of Industrial Design in 1979, and joined the Hewlett-Packard Corporation. In 1982, he began independent consulting for startup companies in Portland, Oregon, and by 1984 had launched a product development firm he named ZIBA Design. In 1991 a Ziba office was established in Tokyo. By 1994, Ziba had a staff of 28 and had won more design awards than any other U.S. design firm.

Wagenfeld, Wilhelm (1900–1990) Craftsman and educator associated with the Bauhaus who was born in Germany, trained as a goldsmith, and studied drawing at Hanau before becoming a Bauhaus student in 1923 in the metal workshops under László Moholy-Nagy. He left the Bauhaus in 1929 and worked in porcelain and glass with Lausitzer Glasverein (1935–1938) and with Jenaer Glaswerke. He taught design at the Berlin Hochshule für Bildende Künste. He designed an unusual 1938 Zigzag ink bottle for Pelican that is still in production, and in 1954 he established a workshop in Stuttgart. He was a co-founder of the New Werkbund in 1947 and of the journal *Form* in 1957.

Wagner, Otto (1841–1918) Austrian architect, designer and city planner who was a leading force in the Wiener Sezession (Vienna Secession) formed in 1897. Considered by many to be the world's first modernist, he was trained at the Vienna Polytechnic and the Bauakademie in Berlin, and in 1894 became the leading professor at the Akademie der bildenden Künst in Vienna. In 1895 he moved to a form of early modernism, and in 1900 became the city architect of Vienna. His most important work is considered to be the Vienna Postal Savings Bank (1904–1912).

Walker, George W. (1896–1993) U.S. automotive designer who trained at Otis Institute, Los Angeles, in 1916, continued at Cleveland School of Art, and headed his own industrial design office in Detroit by the 1930s. His firm worked for Nash (1937–1945) and in product design as well. His role at Ford began in 1945 as an independent consultant working on the 1949 Ford, Ford's first true postwar model. He became Ford's first vice president of styling in 1955, where he remained until his retirement in 1962.

Wallance, Don (1909–1990) U.S. furniture and metal-ware designer, received a BA from New York University and trained at the Design Laboratory, New York (1935–1939), where he was awarded a 1938 prize by the Museum of Modern Art for a chair design for its new building. During World War II he researched mass-produced furniture for the armed forces and studied plywood storage units that won a prize at Museum of Modern Art's low-cost furniture competition. He designed Lauffer's Design 1 and other stainless steel flatware patterns. He designed contract seating for Philharmonic Hall and Lincoln Center and wrote *Shaping America's Products*, in 1956.

Wasserman, Arnold S. (b. 1935) U.S. industrial designer who was born in Chambersburg, Pennsylvania, and graduated from Carnegie Institute of Technology in 1956. In 1975 he formed Tag, Inc., to produce soft luggage he had designed. In 1980, as director of corporate industrial design at the National Cash Register Corporation, he implemented comprehensive corporate design strategy and standards. He later held similar corporate design strategy positions at Xerox and Unisys. In 2003 he became chairman of the Idea Factory in Singapore, redesigning the educational system, media and design industries there. He teaches an interdisciplinary course at the University of California, Berkeley, Haas Graduate School of Business.

Weber, Kem (1889–1963) German industrial designer born as Karl Emanuel Martin (K.E.M.) in Berlin. He apprenticed as a cabinetmaker, studied with Bruno Paul, and graduated in 1912 from the School of Decorative Arts in Berlin. In 1915 he was sent as a designer for Germany's exhibit at the Panama-Pacific Exposition in San Francisco, was stranded there by World War I, and settled in California. From 1922 to 1927 he was art director for the Baker Brothers store in Los Angeles where he introduced his modern style furniture to a shop he designed there. After 1927 he worked for numerous manufacturers. His best-known work was his 1935 Airline chair. For the remainder of the decade, he worked on interiors and architecture.

Wegner, Hans Jorgensen (1914–2007) Danish furniture designer who started apprenticeship as a cabinetmaker at age 14 and completed it in 1931. He trained as a furniture designer at the School of Arts and Crafts in Copenhagen, and by 1938 was in the office of Arne Jacobsen and Eric Moller. In 1940 he began an association with the Copenhagen cabinetmaker Johannes Hansen. His first important chair was the Peacock chair (1947), and his most important was the Round chair (1949).

Wheeler, Candace (1827–1923) An amateur flower painter, Wheeler had been inspired by embroideries from the Royal School of Art Needlework at the 1876 Philadelphia Centennial Exhibition. In 1877 she founded the Society of Decorative Art in New York to help women artists gain training in the applied arts. In 1879 she was co-founder, with Louis Comfort Tiffany, of the interior design firm of Tiffany Wheeler, specializing in textiles. In 1883 she founded her own textile design firm.

Woodring, Cooper (b. 1937) U.S. industrial designer who graduated from the University of Kansas and earned a master's in industrial design from Cranbrook Academy of Art. He spent two years working for F. Eugene Smith Associates in Akron, Ohio, and four years with B.F. Goodrich Company in New York. In 1969, he joined the JCPenney Company working in product design under Robert G. Smith. When Smith retired in 1983, Woodring replaced him. Woodring became president of IDSA from 1985 to 1986. In 1986 JCPenney dissolved its design operations and he began a new career as an expert witness in design litigation.

Wright, Frank Lloyd (1867–1959) Widely regarded as the most significant architect of the 20th century and certainly the best known, he was born in Wisconsin and studied engineering at the University of Wisconsin (1885–1887). In 1888 he joined the architectural office of Adler and Sullivan, but left in 1893 to establish a partnership with a coworker, Cecil Corwin, and designed the Winslow House. He opened his own office in 1896 and soon perfected his "Prairie Style" in the Roberts House (1904) and Robie House (1909). In 1911 his work was published in Europe in the *Wasmuth Edition*, by which time he had adopted his signature costume, emulating Elbert Hubbard. From 1915 to 1922 he was in Japan designing the Imperial Hotel in Tokyo, which survived an earthquake in 1923. In 1936 he completed *Fallingwater*, his most famous work, and the S.C. Johnson building in Racine, Wisconsin (1936–1939). His Guggenheim Museum in New York was completed in 1959.

Wright, Russel (1904–1976) U.S. industrial designer who, between 1921 and 1924, attended the Art Students League in New York and the Columbia University of Architecture. He began his career in the theater as an apprentice with Norman Bel Geddes, then worked as a stage designer. He began a business with his wife, Mary, in 1930, designing and producing spun–aluminum accessories for the home. He designed American Modern furniture for Macy's in 1935, and in 1939 American Modern ceramic dinnerware. He retired to Dragon Rock, his 79-acre estate on the Hudson River, in 1941. He was one of the founders of SID in 1944 and championed informal postwar living. His 1953 melamine plastic Residential table service was one of the earliest designs in plastic. He closed his office in 1958 and toured Asia developing cottage industries for the Department of State, and in 1967, he began consulting with the National Park Service.

Zanuso, Marco (1916–2001) Italian designer who studied architecture at Politecnico in Milan, where he became a teacher and director of the architectural faculty. He established his practice at the end of World War II and served as editor of *Domus* and *Casabella* magazines, as well as designing a number of Triennales between 1947 and 1955. His Borletti sewing machine won a Compasso d'Oro in 1956. In 1958 he began collaboration with Richard Sapper, with whom he designed a range of BrionVega television products. He has also designed industrial plants and offices for Olivetti.

Zeisel, Eva (b. 1906) Ceramics designer, born Eva Striker in Budapest, Hungary, trained at the Kép-zomuveszeti Academia (Academy of Fine Arts). She opened a studio in Hungary in 1925 and worked in Germany from 1928 to 1931. From 1932 to 1937 she worked in Leningrad and Moscow, becoming art director of the china and glass industry of the Russian Republic in 1935. She went to England in 1938, where she married Hans Zeisel and emigrated to New York with him. She started teaching in 1939 at Pratt Institute and after World War II won a competition by the Museum of Modern Art to design Museum Service dinnerware. She worked for Red Wing Potteries, Italcraft, and Hall China, and taught ceramics at Pratt until 1953 and at RISD until the 1960s. In 1982, she returned to Hungary to work in a ceramics factory. Back in the U.S., she was honored by exhibitions of her work mounted by the Brooklyn Museum and another at the Musée des Arts Décoratifs in Montreal in 1984.

Zwart, Piet (1885–1977) Dutch industrial designer voted the "Designer of the Century" in 2000 by the Association of Dutch Designers. His best known design was the modern kitchen he designed in 1937 for Bruynzeel, the first modular kitchen integrating stoves, refrigerators, and cabinets into an organized whole. He was influenced by the De Stijl movement and Russian Constructivism, and preferred to be called a "form engineer."

Past Presidents of Industrial Design Organizations

American Designer's Institute (ADI) founded in 1938, became the Industrial Designers Institute (IDI) in 1951. Industrial Designers Education Association (IDEA) was founded in 1957. Society of Industrial Designers (SID), founded in 1944, became American Society of Industrial Designers (ASID) in 1955. All merged to become the Industrial Designers Society of America (IDSA) in 1965.

1938		John Vassos* (ADI)	
1939		John Vassos* (ADI)	
1940		Belle Kogan* (ADI)	
1941		Edward Wormley* (ADI)	
1942		C.E. Waltman* (ADI)	
1943		Alfons Bach* (ADI)	
1944		Belle Kogan*(ADI)	Walter Dorwin Teague* (SID)
1945		Harper Richards* (ADI)	Walter Dorwin Teague* (SID)
1946		Alexander Kostellow* (ADI)	Raymond Loewy* (SID)
1947		Robert Gruen* (ADI)	Henry Dreyfuss* (SID)
1948		Ben Nash* (ADI)	Harold Van Doren* (SID)
1949		Francesco Gianninoto* (ADI)	Egmont Arens*(SID)
1950		Robert Goldberg (ADI)	Dave Chapman*(SID)
1951		Walter Margulies* (IDI)	Russel Wright* (ASID)
1952		Walter Margulies* (IDI)	Jean Reinecke* (ASID)
1953		Paul McAlister* (IDI)	Robert Hose* (ASID)
1954		Stuart Pike*(IDI)	Peter Muller-Munk* (ASID)
1955		George Beck*(IDI)	Arthur BecVar* (ASID)
1956		George Beck*(IDI)	Jay Doblin* (ASID)
1957	Joseph Carriero* (IDEA)	Robert Redmann (IDI)	William Goldsmith* (ASID)
1958	Joseph Carriero* (IDEA)	Robert Redmann (IDI)	Donald McFarland (ASID)
1959	James Shipley* (IDEA)	H. Creston Doner* (IDI)	Richard Latham* (ASID)
1960	James Shipley* (IDEA)	H. Creston Doner* (IDI)	Raymond Spilman* (ASID)
1961	James Alexander* (IDEA)	Leon Gordon Miller*(IDI)	Raymond Spilman* (ASID)
1962	Jay Doblin*(IDEA)	Jon W. Hauser* (IDI)	William Renwick* (ASID)
1963	Edward Zagorski (IDEA)	Jon W. Hauser* (IDI)	William Renwick* (ASID)
1964	Arthur Pulos*(IDEA)	Tucker Madawick* (IDI)	Donald Dailey* (ASID)
1965	Henry Dreyfuss (IDSA)		
1966	Joseph M. Parriott* (IDSA)		
1967–68	Robert Hose* (IDSA)		
1969–70	Tucker Madawick* (IDSA)		
1971–72	William Goldsmith* (IDSA)		
1973–74	Arthur Pulos* (IDSA)		
1975–76	James Fulton* (IDSA)		

* indicates *deceased.*

1977–78	Richard Hollerith (IDSA)
1979–80	Carroll Gantz (IDSA)
1981–82	Robert G. Smith (IDSA)
1983–84	Katherine J. McCoy (IDSA)
1985–86	Cooper C. Woodring (IDSA)
1987–88	Peter H. Wooding (IDSA)
1989–90	Peter W. Bressler (IDSA)
1991–92	Charles Pelly (IDSA)
1993–94	David Tompkins (IDSA)
1995–96	James Ryan (IDSA)
1997–98	Craig Vogel (IDSA)
1999–00	Mark Dziersk (IDSA)
2001–02	Betty Baugh (IDSA)
2003–04	Bruce Claxton (IDSA)
2005–06	Ron Kemnitzer (IDSA)
2007–08	Michelle Berryman (IDSA)
2009–10	Eric Anderson (IDSA)

Chapter Notes

Chapter 1

1. Benjamin Franklin, quoted by Leonard Woods Larabee, *The Papers of Benjamin Franklin*, vol. 2 (New Haven: Yale University Press, 1960), 419, quoted by Arthur Pulos in *American Design Ethic* (Cambridge: MIT Press, 1983), 15.

2. Adam Smith, in *An Inquiry into the Nature and Causes of the Wealth of Nations* (1778, reprt., New York: Modern Library/Random House, 1937), 347, quoted by Pulos in *American Design Ethic*, 64.

3. John Adams, quoted by Thomas Jefferson, *The Writings of Thomas Jefferson*, ed. H. Washington (Washington, D.C.: Taylor and Maury, 1853), 148, quoted by Pulos in *American Design Ethic*, 65.

4. Thomas Jefferson, quoted by Paul Leicester Ford, ed., *Thomas Jefferson, Notes on the State of Virginia*, vol. 7 (New York: Putnam, 1892), 405, quoted by Pulos in *American Design Ethic*, 65.

5. Thomas Jefferson, quoted by Philip S. Foner in *Writings of Thomas Jefferson* (New York: Wiley, 1944), 745, quoted by Pulos in *American Design Ethic*, 65.

6. Pennsylvania Society for the Encouragement of Manufactures and the Useful Arts, quoted by Pulos in *American Design Ethic*, 67.

7. George Washington, quoted by Fred L. Israel, ed., in *The State of the Union Messages of the Presidents* (New York: Chelsea House, Robert Hector, 1966), 2, quoted by Pulos in *American Design Ethic*, 67–68.

8. George Washington, in his 1790 address to Congress, quoted by Pulos in *American Design Ethic*, 70.

9. U.S. Patent Office, quoted by Pulos in *American Design Ethic*, 70.

10. Commissioners to the municipality of Bordeaux, Washington, January 4, 1793, 58th Congress, 2nd session, Report No. 646, reprinted in *Documentary History of the Construction of the United States Capitol Buildings and Grounds* (Washington, 1904), 21, quoted by Neil Harris in *The Artist in American Society* (Chicago: University of Chicago Press, 1966 and 1982), 44.

11. Grace Greenwood [Mrs. Sara Lippincott], *Haps and Mishaps of a Tour in Europe* (Boston: Ticknor, Reed and Fields, 1854), 33, quoted by Harris in *The Artist in American Society*, 44.

12. *American Museum* 2 (November 1787): 421, quoted by Harris in *The Artist, American Society*, 35.

Chapter 2

1. Friedrich Klemm, *A History of Western Technology* (Cambridge: MIT Press, 1964), 317, quoted by Arthur Pulos in *American Design Ethic* (Cambridge: MIT Press, 1983), 86.

2. British Parliament select committee, quoted by Pulos in *American Design Ethic*, 119.

3. *Journal of the Franklin Institute* (August 1838): 129, 119–120.

4. William Dunlap, *History of the Rise and Progress of the Arts of Design in the United States*, originally published 1834 by the author as diaries; revised and republished by Frank William Bayley and Charles Eliot Goodspeed (vol. 3) (Boston: C.E. Goodspeed, 1918).

5. *Franklin Journal and American Mechanics* (January 1826): 7, quoted by Pulos in *American Design Ethic*, 87.

6. Alexis de Tocqueville, *Democracy in America*, vol. 1 (New York: Schocken, 1961), 44, quoted by Pulos in *American Design Ethic*, 88.

7. Alexis de Tocqueville, *Democracy in America*, vol. 2 (New York: Schocken, 1961), 58, quoted by Pulos in *American Design Ethic*, 171.

8. *Ibid.*, 122.

9. Information by the United Society of Shakers, Sabbathday Lake, Maine, June Sprigg, *Shaker Design*, catalog of an exhibition by the Whitney Museum of American Art, New York, May 29–August 31, 1986, 17.

10. John Durbin, *Observations in Europe*, vol. 1 (New York: 1844), 267, quoted by Neil Harris in *The Artist in American Society* (Chicago: University of Chicago Press, 1966 and 1982), 161.

11. Journal entry for June 6, 1833, from *The journals and Miscellaneous Notebooks of Ralph Waldo Emerson*, ed. William H. Gilman et al. (Cambridge, MA: Belknap Press of Harvard University, 1960–1982), vol. 4, 188, quoted by Harris in *The Artist in American Society*, 161.

12. *Journal of the Franklin Institute* (April 1842): 352, quoted by Pulos in *American Design Ethic*, 134.

Chapter 3

1. Richard Redgrave, in an early issue of the *Journal of Design* (founded 1849), quoted by John Heskett in *Industrial Design* (New York: Thames & Hudson, 1985), 20.

2. *Journal of Design*, quoted by Heskett in *Industrial Design*, 21.

3. William Dyce in a lecture published by the *Journal of Design* and quoted by John Heskett in *Industrial Design* (New York: Thames & Hudson, 1985), 21–23.

4. Joseph Whitworth, quoted by T.K. Derry and Trevor I. Williams in *A Short History of Technology from the Earliest Times to A.D. 1900* (New York: Dover, 1993), 355–356.

5. *London Times*, September 2, 1851, 4, quoted by Arthur Pulos in *American Design Ethic* (Cambridge: MIT Press, 1983), 116.

6. Charles T. Rogers, *American Superiority at the World's Fair* (Philadelphia: Hawkins, 1852), quoted by Pulos in *American Design Ethic*, 118.

7. Horatio Greenough, *The Travels, Observations, and Experience of a Yankee Stonecutter* (New York: Putnam, 1852), 136–141, 202–203, quoted by Carma R. Gorman in *The Industrial Design Reader* (New York: Allworth, 2003), 12–13.

8. *Ibid.*

9. *Ibid.*

10. Horatio Greenough to Ralph Waldo Emerson (28 December 1851), in N. Wright, ed., *Letters of Horatio Greenough, American Sculptor* (Madison: University of Wisconsin, 1972), 400–401; H. Greenough, *The Travels*, quoted by Jeffrey L. Meikle, *Design in the USA* (New York: Oxford University Press, 2005), 47.

11. Henry Cole, quoted by Pulos in *American Design Ethic*, 119.

12. Gottfried Semper, quoted by Heskett in *Industrial Design*, 1985, 27–28.

13. 1853 New York World's Fair guidebook, quoted by B. Silliman and C.R. Goodrich, eds., *The World of Science, Art, and Industry Illustrated from Examples in the New York Exhibition, 1853–1854* (New York: Putnam, 1854), xi, quoted by Meikle, *Design in the USA*, 47.

14. Silliman and Goodrich, eds., *The World of Science, Art, and Industry*, xi, 15, 16, 169, quoted by Meikle, *Design in the USA*, 47.

15. John Ruskin, "The Cestus of Aglaia," *Art Journal* (1865), quoted by Heskett in *Industrial Design*, 26.

16. Owen Jones, *Grammar of Ornament* (1856, reprt., London: Bernard Quaritch, 1910), 16, 77–78, 154, quoted by Carma R. Gorman in *The Industrial Design Reader* (New York: Allworth, 2003), 19–21.

17. James Jackson Jarvis, *The Art-Idea* (Cambridge: Belknap Press of Harvard University Press, 1960; originally published in 1864), quoted by Pulos in *American Design Ethic*, 158–159.

18. Catherine E. Beecher and Harriet Beecher Stowe, *The American Woman's Home* (New York: J.B. Ford, 1869), quoted by Pulos in *American Design Ethic*, 172.

19. Catherine E. Beecher and Harriet Beecher Stowe, *The American Woman's Home* (New York: J.B. Ford, 1869), Eugene Rimmel, *Recollections of the Paris Exhibition of 1867* (London: Chapman and Hall, 1868), 253.

20. Henry Leland, *Americans in Rome* (New York: C.T. Evans, 1863), 40, 161–162, quoted by Neil Harris in *The Artist in American Society* (Chicago: University of Chicago Press, 1966 and 1982), 236.

21. Christopher Dresser, *Principles of Decorative Design* (London: Cassell Petter & Galpin, 1873), 1–2, 22–25, quoted by Gorman in *The Industrial Design Reader*, 28–32.

22. *Ibid.*

23. *Ibid.*

24. Charles Eastlake, *Hints on Household Taste in Furniture, Upholstery, and Other Details*, 4th revised edition (London: Longmans, Green, 1878), 2–4, 91–92, 167, 172, quoted by Gorman in *The Industrial Design Reader*, 26–27.

25. Eastlake, *Hints on Household Taste*, London, 2–4, 91–92, 167, 172, quoted by Gorman in *The Industrial Design Reader*, 25.

Chapter 4

1. President Ulysses S. Grant, quoted in Frank Leslie, *Illustrated Historical Register of the Centennial Exposition* (New York: Paddington, 1876), quoted by Arthur Pulos in *American Design Ethic* (Cambridge: MIT Press, 1983), 142.

2. American Watch Company statement, quoted by Pulos in *American Design Ethic*, 158.

3. Quotation from *Encyclopedia Americana*, 1957, vol. 29; John Lander Bishop, *A History of American Manufactures, 1608–1868* (New York: Johnson Reprint, 1967), 11, quoted by Pulos in *American Design Ethic*, 158.

4. Walter Smith, *The Masterpieces of the Centennial International Exhibition*, vol. 2 (Philadelphia: Gebbie and Barrie, 1876), 7, quoted by Pulos in *American Design Ethic*, 142.

5. Smith, *The Masterpieces*, vol. 2, 56, quoted by Pulos in *American Design Ethic*, 144.

6. Smith, *The Masterpieces*, vol. 2, 475, quoted by Pulos in *American Design Ethic*, 157.

7. Quoted by Herwin Shaefer, *Nineteenth Century Modern: The Functional Tradition in Victorian Design* (New York: Praeger, 1970), 169, quoted by Pulos in *American Design Ethic*, 159–160.

8. William Morris, excerpts from a lecture, "The Lesser Arts," delivered before the Trades' Guild of Learning, December 4, 1877, and published in pamphlet form as *The Decorative Arts: Their Relation to Modern Life and Progress* (London: Ellis & White, 1878); reprinted in *The Collected Works of William Morris*, vol. 22 (London: Longmans, Green, 1914), 5–6, 22–27, quoted by Carma R. Gorman in *The Industrial Design Reader* (New York: Allworth, 2003), 35–40.

9. Thorstein Veblen, *The Theory of the Leisure Class; An Economic Study of Institutions* (1899; repr., New York: Macmillan, 1905), 126–129, 130–131, 159–162, quoted by Gorman in *The Industrial Design Reader*, 49–51.

10. Henry Van de Velde, from *A Chapter on the Design of Modern Furniture*, vol. 3, (Berlin: Pan Berlin, 1897), 260–64, trans. Tim Benton and Charlotte Benton, reprinted in *Form and Function: A Source Book for the History of Architecture and Design, 1890–1939*, ed. Tim Benton and Charlotte Benton (London: Crosby Lockwood Staples in association with the Open University Press, 1975), 17–19, and quoted by Gorman in *The Industrial Design Reader*, 47–48.

11. Alexander Koch, quoted in *Designing Modernity: The Arts of Reform and Persuasion 1885–1945*, ed. Wendy Kaplan (London: Thames & Hudson, 1995), in conjunction with an exhibit of the same name.

12. Quoted by John Heskett in *German Design 1870–1918* (New York: Taplinger, 1986).

Chapter 5

1. Josef Hoffmann, quoted in Guy Julier, *The Thames and Hudson Encyclopedia of 20th Century Design and Designers* (London: Thames & Hudson, 1993).

2. Henry Van de Velde, *Geschichte Meines Lebens* (Munich: Piper, 1962), 210–211; quoted by Frank Whitford, *Bauhaus* (London: Thames & Hudson, 1984), 25.

3. Frank Lloyd Wright, "The Art and Craft of the Machine" (an address to the Chicago Arts and Crafts Society, March 6, 1901, reprinted in the catalogue *Fourteenth Annual Exhibition of the Chicago Architectural Club*, 1901), quoted by Carma R. Gorman in *The Industrial Design Reader* (New York: Allworth, 2003), 55–61.

4. Josef Hoffmann and Koloman Moser, in *Katolog mit Arbeitsprogramm der Wiener Werkstätte*, 1905, quoted by Gorman in *The Industrial Design Reader*, 62.

5. Hermann Muthesius, quoted by John Heskett in *Industrial Design* (London: Thames & Hudson, 1985), 88.

6. Hermann Muthesius, quoted in *Industrial Design* (March 1960).

7. Charles Robert Ashbee, *Craftsmanship in Competitive Industry: Being a Record of the Guild of Handicraft, and Some Deductions from their Twenty-one Years' Experience* (Campden [Gloucester] and London: Essex House, 1908), 5–7, 9–11, 15–18, 20, quoted by Gorman in *The Industrial Design Reader*, 64–70.

8. Peter Behrens, quoted in Thomas Hauffe, *Design: An Illustrated Historical Overview* (Barron's Educational Series, 1996), first published in 1995 in Germany by DuMont Buchverlag GmbH und Co. Kommanditgesellschaft, Köln.

9. Joseph August Lux, "The Artistic Problem of Industry," *Innendekoration* (*Interior Design*) (1908), quoted by John Heskett in *German Design 1870–1918* (New York: Taplinger, 1986).

10. Filippo Marinetti, *The Foundation and Manifesto of Futurism*, in F.T. Marinetti, *Marinetti: Selected Writings*, ed. R.W. Flint and trans. R.W. Flint and Arthur A. Coppotelli (New York: Farrar, Straus and Giroux, 1972), originally published in *Le Figaro* (February 20, 1909), quoted by Gorman in *The Industrial Design Reader*, 70–74.

11. Adolf Loos, "Ornament und Verbrechen" (*Der Sturm*, 1910), trans. Wilfried Wang, in *The Architecture of Adolf Loos: An Arts Council Exhibition*, ed. Yehuda Safran and Wilfried Wang (London: Arts Council of Great Britain, 1985), 100–103, quoted by Gorman in *The Industrial Design Reader*, 74–81.

12. Camillo Olivetti, quoted by Peter Gorb, *Design Talks* (UK: Design Council, 1988).

13. Christine Frederick, *Household Engineering: Scientific Management in the Home* (Chicago: American School of Home Economics, 1920), quoted by Gorman in *The Industrial Design Reader*, 92–96.

14. Christine Frederick, quoted by Arlene Voski Avakian and Barbara Haber, *From Betty Crocker to Feminist Food Studies* (Liverpool: Liverpool University Press, 2005).

15. Walter Gropius, quoted by Reyner Banham, *Theory and Design in the First Machine Age* (MIT Press, 1992), 80, reprint of the 1st edition by Architectural Press, London, 1960.

16. Hermann Muthethius, statement from the Werkbund conference of 1914 (quoted from *Bauwelt 27* (Berlin: Ullstein, 1962), English translation © 1970 Lund Humphries, London, and the Massachusetts Institute of Technology, Cambridge, 28–31; quoted by Gorman in *The Industrial Design Reader*, 88–92.

17. Henry van de Velde, *Geschichte Meines Lebens*, 210–211.

18. Geoffrey Scott, *The Architecture of Humanism: A Study in the History of Taste* (New York: Houghton Mifflin, 1914).

19. *New York Tribune*, 24 October 1915, sect. IV, 2, quoted by Thomas Hughes, *American Genesis* (New York: Viking Penguin, 1989), 329.

20. Francis Picabia, *New York Tribune*, 24 October 1915, sect. IV, 2, quoted by Hughes, *American Genesis*, 329.

Chapter 6

1. Vladimir Lenin, *Collected Works* (Moscow INRA Publishing Society, 1936), quoted by Thomas Hughes, *American Genesis* (New York: Viking Penguin, 1989), 256.

2. Aleksandr Rodchenko and Varvara Stepanova, *Programme of the First Working Group of Constructivists*, 1922, quoted by Carma R. Gorman in *The Industrial Design Reader* (New York: Allworth Press, 2003), 104.

3. Theo Van Doesburg, "The Will to Style" (text of a lecture given at Jena, Weimar, and Berlin, 1922), in *De Stijl*, ed. Hans L.C. Jaffe (London: Thames & Hudson, 1970), quoted by Carma R. Gorman in *The Industrial Design Reader* (New York: Allworth, 2003), 102, 103.

4. Walter Gropius, *Bauhaus Dessau: Principles of Bauhaus Production*, printed sheet, Bauhaus Dessau, March 1926, quoted by Hans Wingler, *The Bauhaus* (Cambridge: MIT Press, 1969), 110.

5. László Moholy-Nagy, quoted by Reyner Banham, *Theory and Design in the First Machine Age* (Cambridge: MIT Press, 1992), 282, reprint of 1st edition by Architectural Press, London, 1960.

6. Walter Gropius, quoted by Frank Whitford, *Bauhaus* (London: Thames & Hudson, 1984), 185.

7. Adolf Hitler, *Mein Kampf*, vol. 2 (Munich: Franz Eher Nachfolger, 1926), 495–497.

8. Paul Jaray, quoted by Tucker Madawick, *Continental Comments*, "The Bob Gregorie Story," Part 2 (May–June 1997), 23.

9. Walter Sargent, "The Training of Designers," *American Magazine of Art*, September 1918, quoted by Arthur Pulos in *American Design Ethic* (Cambridge: MIT Press, 1983), 261.

10. Ibid, 265.

11. Richard F. Bach, "Mobilizing the Art Industries," *New York Times Magazine*, June 9, 1918, p. 65, quoted by Pulos in *American Design Ethic*, 265.

12. H.M. Kurtzworth study, 1919, quoted by Pulos in *American Design Ethic*, 266.

13. Charles R. Richards, *Art in Industry* (National Society for Vocational Education and the Department of Education of the State of New York, 1922), quoted by Pulos in *American Design Ethic*, 271.

14. Lewis Mumford, "Machinery and the Modern Style," *New Republic* 27, no. 3 (August 1921), quoted by Thomas Hughes, *American Genesis*, (New York: Viking Penguin), 1989, 297.

15. Lewis Mumford, "The City," in *Civilization in the United States: An Inquiry by 30 Americans* (New York: Harcourt, Brace, 1922), quoted by Hughes, *American Genesis*, 297.

16. Richard F. Bach, quoted by Frank Purdy, *The New Museum* (December 1920), quoted by Pulos in *American Design Ethic*, 272.

17. Leon Volkmar, *New York Times*, April 16, 1922, quoted by Pulos in *American Design Ethic*, 295.

18. W.F. Morgan, quoted by Frank Purdy, *The Taste of the American People* (November 1920): 38, quoted by Pulos in *American Design Ethic*, 293.

19. William L. Harris in *New York Times*, February 26, 1922, II, 4, quoted by Pulos in *American Design Ethic*, 293.

20. Helen Appleton Read, "The Exposition in Paris," Parts 1 and 2, *International Studio* (November and December 1925): 93–96, 161–162, quoted by Gorman in *The Industrial Design Reader*, 115.

21. Herbert Hoover (telephone address to the 4th Annual Exposition of Women's Arts and Industries, New York City, September 2, 1925), Hoover Institute Archives, Box 7, Stanford University, quoted by Pulos in *American Design Ethic*, 304.

22. Helen Appleton Read, "The Exposition in Paris," Parts 1 and 2, quoted by Gorman in *The Industrial Design Reader*, 116.

23. *Report of Commission to International Exposition of Modern Decorative and Industrial Arts in Paris, 1925* (U.S. Department of Commerce, 1925), quoted by Pulos in *American Design Ethic*, 304.

24. *Selected Collection of Objects from the International Exposition of Modern Decorative and Industrial Art* (catalog of exhibit), February 1926, American Association of Museums, quoted by Pulos in *American Design Ethic*, 316.

25. Helen Appleton Read in "The Exposition" (1925) and "Creative Design in Our Industrial Art," *International Studio* 83 (March 1926): 56, quoted by Richard Guy Wilson et al., *The Machine Age in America–1918–1941* (Brooklyn Museum in association with Harry Abrams, 1986), 51.

26. Tucker Madawick, "The Bob Gregorie Story," Part 1, *Continental Comments*, March–April 1997, 25.

Chapter 7

1. Paul Frankl, *Form and Re-Form* (New York: Harper, 1930), quoted by Arthur Pulos in *American Design Ethic* (Cambridge: MIT Press, 1983), 336.

2. E.B. White, "Machine Age," The Talk of the Town, *New Yorker*, May 21, 1927, 13.

3. "General Management Series Number 99," American Management Association, 1929, quoted by Pulos in *American Design Ethic*, 330.

4. Ibid., 330–332.

5. Ibid., 332.

6. Ibid., 332.

7. "Color in Industry," *Fortune*, February 1930, 85–

86, quoted by Carma R. Gorman in *The Industrial Design Reader* (New York: Allworth, 2003), 124–125.

8. Jim Lesko, "Industrial Design at Carnegie Institute of Technology, 1934–1967," *Journal of Design History* 10, No. 3 (1997, Design History Society).

9. Ernest Elmo Calkins, introduction to *What Consumer Engineering Really Is* (New York: Harper, 1932), quoted by Gorman in *The Industrial Design Reader*, 130.

10. Ibid., 131.

11. Philip Johnson, quoted by Meryle Secrest, *Frank Lloyd Wright* (New York: HarperCollins, 1992), 392.

12. Norman Bel Geddes, *Horizons* (Boston: Little, Brown, 1932), 3.

13. Ibid., 53.

14. Alfred H. Barr in *Machine Art* catalog, 1934, Museum of Modern Art, quoted by Gorman in *The Industrial Design Reader*, 133–134.

15. Alfred H. Barr in *Machine Art* catalog, Museum of Modern Art, 1934, quoted by Phil Patton, *Made In USA* (New York: Penguin, 1992), 33.

16. "Both Fish and Fowl," *Fortune*, February 1934.

17. Lesko, *Industrial Design at Carnegie* 10, no. 3.

18. Onnie Mankki, "Coming Trends in Stove Design," *Stove Builder*, 1934, quoted by Arlene Voski Avakian and Barbara Haber, *From Betty Crocker to Feminist Food Studies* (Liverpool: Liverpool University Press, 2005), 50.

19. Belle Kogan, in an interview with Marcy Babbitt, "As a Woman Sees Design," *Modern Plastics* 13, no. 4 (December 1935): 16–17, 49, 51, quoted by Gorman in *The Industrial Design Reader*, 137, 138, 139.

20. Belle Kogan, "Making the Most of Materials," *Electrical Manufacturing*, October 1934.

21. Tucker Madawick, "The Bob Gregorie Story," Part 2, *Continental Comments*, May–June 1997, 24.

Chapter 8

1. *Business Week*, May 1936, quoted by John Heskett in "The Emergence of the Industrial Design Profession in the United States," in *Toledo Designs for a Modern America* 73 (Toledo Museum of Art, Hudson Hills Press, 2002).

2. 1939 World's Fair official guidebook.

3. Walter Dorwin Teague, *Design This Day* (New York: Harcourt Brace, 1940).

4. Harold Van Doren, *Industrial Design: A Practical Guide* (New York: McGraw-Hill, 1940).

5. Eugene Raskin, architect, in *Pencil Points*, April 1939, 238, quoted by Arthur Pulos in *The American Design Adventure* (Cambridge: MIT Press, 1988), 30.

6. *Architectural Record*, May 1940, quoted by Pulos in *The American Design Adventure*, 30.

7. Douglas Haskell, architectural critic, in *Architectural Record*, June 1940, quoted by Pulos in *The American Design Adventure*, 30.

8. Elliot Noyes, *Organic Design in Home Furnishings*, "A Note on the Competition," (inside cover), Museum of Modern Art, 1941, quoted by Pulos in *American Design Ethic*, 411.

9. Ibid., 145.

10. Charles Eames, quoted by Ralph Caplan in *By Design* (New York: McGraw-Hill, 1984), 187–188.

11. *Interiors*, October 1945, 16, quoted by Pulos in *The American Design Adventure*, 201.

12. Margaret Glace and Florence Beeley in *Conference of Schools of Design*, Metropolitan Museum of Art, June 22–23, 1944 (published 1946), quoted by Pulos in *The American Design Adventure*, 175.

13. Harold Van Doren, "Industrial Designers Will Influence Many Post-War Products," *Product Engineering*, July 1944.

14. Henry Dreyfuss, in a taped interview with Ray Spilman, March 18, 1969, quoted by Arthur Pulos in *The American Design Adventure*, 198.

15. Society of Industrial Designers flyer, 1945, quoted by Pulos in *The American Design Adventure*, 200.

Chapter 9

1. Arthur Pulos in *The American Design Adventure* (Cambridge: MIT Press, 1988), 174.

2. Walter Dorwin Teague, in a letter to Richard Bach, June 28, 1946, quoted by Pulos in *The American Design Adventure*, 176.

3. *The House in the Museum Garden*, Fall 1946, 1(bulletin of the Museum of Modern Art), quoted by Pulos in *The American Design Adventure*, 64.

4. George Nelson and Henry Wright, *Tomorrow's House: A Complete Guide to the Home Builder* (New York: Simon & Schuster, 1945), quoted by Jonathan M. Woodham, in "Twentieth Century Design," *Oxford History of Art*, 1997.

5. Walter Dorwin Teague, "Industrial Design in Partnership with Engineering," *Electrical Engineering*, October 1946.

6. J.D. Ratcliff, "Designer for Streamlined Living," *Coronet*, June 1947.

7. Society of Industrial Designers, *U.S. Industrial Design 1949–1950* (New York: Studio Publications, 1949).

8. Harold Van Doren, "Streamlining: Fad or Function?" *Design* (October 1949) (monthly Journal of the British Council of Industrial Design).

9. Henry Dreyfuss, "The Industrial Designer's Best Friend and Severest Critic" (address to the American Society of Engineering Educators, December 28, 1949, Stanford University, California).

10. Henry Dreyfuss, *Designing for People* (New York: Simon & Schuster, 1955), title page.

11. Theodore G. Clement, "The Industrial Designer on a Large Corporation Staff," *Shop Talk* (Society of Industrial Design newsletter), October 1949.

12. George Nelson, "Business and the Industrial Designer," *Fortune*, July 1949.

13. Peter Muller-Munk, "Industrial Designers Can Face Today's Challenge," *Electrical Manufacturing*, June 1951.

14. *Interiors*, February 1953, 85, quoted by Pulos in *The American Design Adventure*, 110.

15. *Industrial Design* (March–April 1982): 44, quoted by Pulos in *The American Design Adventure*, 110.

16. Edgar Kaufmann, "What Is Modern Design?" *Bulletin of the Museum of Modern Art* 14 (Fall 1946), revised and published as *What Is Modern Design?* New York, 1950, quoted by Kathryn B. Hiesinger et al., in

Design Since 1945, xiii (Philadelphia Museum of Art, 1983).

17. Eliot F. Noyes, "The Shape of Things: Good Design in Everyday Objects," *Consumer Reports*, January 1949, 26, quoted by Kathryn B. Hiesinger et al. in *Design Since 1945*, xiii (Philadelphia Museum of Art, 1983).

18. Henry Dreyfuss, "The Silent Salesman of Industry" (dinner address, May 28, 1952, at the Industrial Design Conference, 81st annual meeting of the Canadian Manufacturing Association, Toronto, Canada, reprinted from the July 1952 *Industrial Canada*).

Chapter 10

1. Walter Dorwin Teague, "A Quarter Century of Industrial Design," *Art & Industry* (London), October 1951.

2. Kenji Ekuan, *The Esthetics of the Japanese Lunchbox* (Cambridge: MIT Press, 1998), 79, 81, 177–8, 180, quoted by Gorman in *The Industrial Design Reader*, 228–229.

3. Eero Saarinen, in a speech to the annual meeting of the American Society of Industrial designers (ASID), October 8, 1955, Washington, D.C.

4. Seymour Freedgood, "Old Business, This Industrial Design," *Fortune*, February 1959.

5. Raymond Loewy, in the keynote address to the 15th annual conference of the American Society of Industrial Designers, New York, November 1959.

6. Walter Dorwin Teague, "The Responsibilities of the Industrial Designer" (speech at a dinner of the Detroit chapter of the Industrial Designers Institute, June 9, 1959).

7. Brooks Stevens, quoted by Glenn Adamson, *Industrial Strength Design* (Cambridge: MIT Press, 2003), 129.

8. Ernest Elmo Calkins, "Advertising Art in the United States," *Modern Publicity* 7 (1930): 130, quoted by Pulos in *American Design Ethic*, 357–358.

9. William Snaith, "Designers: Men Who Sell Change," *Business Week*, April 12, 1958, 110–120.

10. Brooks Stevens, quoted by Adamson, *Industrial Strength Design*, 130.

11. Raymond Loewy, "The Classic Criterion: Quality" (opening address at the 18th Annual Design Conference of IDSA, Industrial Design and Its Relationship to the Arts, Waldorf Astoria, New York City, November 1, 2, 3, 1962).

12. August Heckscher, "The Place of Industrial Design in American Culture" (speech at the 18th Annual Design Conference of IDSA, Industrial Design and Its Relationship to the Arts, Waldorf Astoria, New York City, November 1, 2, 3, 1962).

13. Jay Doblin, "The 'U.S.A.' Theory of Design," *Home Appliance Builder*, November 1964.

Chapter 11

1. Victor Papanek, *Industrial Design* (April 1969).

2. Dave Chapman, "U.S. Steel Design Seminar," 1970, 5.

3. Victor Papanek, *Design for the Real World* (New York: Pantheon, 1972), book jacket.

4. Victor Papanek, *Design for the Real World* (New York: Bantam, 1973), 15.

5. Ibid.

6. Ibid.

7. Ibid., 113.

8. Ibid., 333.

9. Joseph Carreiro (chair of the Department of Design and Environmental Analysis at Cornell University), *Industrial Design Education in the USA: A Factual Summary*, conducted in 1973.

10. David H. Rice, "What Color Is Design?" *Interior Design* 63, no. 1 (January 1992): 34–35, quoted by Gorman in *The Industrial Design Reader*, 221.

11. IDSA membership directory and Website (www.idsa.org).

12. Michael Graves (keynote address at the IDSA Annual Conference, Disney World, Orlando, Florida, 1996).

13. Barbara Radice, *Memphis: Research, Experiences, Results, Failures, and Successes of New Design,* (New York: Rizzoli, 1984), 185–187, quoted by Gorman in *The Industrial Design Reader*, 204–207.

14. Alejandro de Tomaso, in *Business Week*, October 15, 1984, 170H.

15. Ada Louise Huxtable, "Design Notebook," *New York Times*, May 24, 1979.

16. Klaus Krippendorf and Reinhart Butter, "Product Semantics: Exploring the Symbolic Qualities of Form," *Innovation* 3, no. 2 (Spring 1984): 4, 6, 8–9 (quarterly journal of the Industrial Designers Society of America), quoted by Gorman in *The Industrial Design Reader*, 201–202.

17. Michael S. McCoy, quoted by Alex M. Freedman, "Forsaking the Black Box: Designers Wrap Products in Visual Metaphors," *Wall Street Journal*, March 26, 1987.

18. Robert Blaich, ibid.

19. Niels Diffrient, "Design Entrepreneurs," *Venture*, October 1984.

20. Arnold Wasserman, ibid.

21. Tom Peters, *Newsweek*, quoted by Jeffrey L. Meikle in *Design in the USA* (Oxford University Press, 2005), 187.

22. Cooper Woodring, "Connecting: Past Present, and Future," *Design Perspectives* 25, no. 7 (August 2007) (newsletter of the Industrial Design Society of America).

Chapter 12

1. David Kelley, "Design and Quality: The Designer's View," *Managing Automation*, August 1989.

2. Tucker Viemeister, "Industrial Design: Romancing the Commonplace," *Metropolitan Home,* January 1988.

3. Quoted in Patricia Leigh Brown, "Soft Tech: The Feel of Things to Come," *New York Times,* November 2, 1989. Available at www.nytimes.com/1989/11/02/garden/soft-tech-the-feel-of-things-to-come.html

4. Ibid.

5. Bruce Nussbaum, "Is In-House Design on the Way Out?" *Business Week,* September 25, 1995.

6. Brian Vogel, quoted in Nussbaum, "Is In-House Design on the Way Out?"

7. Louis Lenzi, "Making It All Better," *Washington Post,* Home, June 26, 1997, 4.

8. Quoted in William H. Hamilton, "Stealth Design: You're Not Getting Older, Products Are Getting Better," *New York Times,* June 27, 1999. Available online at www.nytimes.com/1999/06/27/weekinreview/the-nation-stealth-design-you-re–not-getting-older-products-are-getting-better.html

9. Bill Moggridge, quoted in Hamilton, "Stealth Design," New York Times, June 27, 1999.

10. Linda Hales, quoting Bill Moggridge, in "Sleek Chic: As the Pendulum Swings," *Washington Post*, as reported in IDSA *Design Perspectives* 7 (July 2001).

11. Jim Kaufman, "U.S. Design Educators in China," *Design Perspectives* (August 8–September 2, 2002) (newsletter of the Industrial Design Society of America).

12. Bruce Claxton, "New Business Model for New Economy," *Design Perspectives* (December 2002–January 2003): 3 (newsletter of the Industrial Design Society of America).

13. Peter Plagens, "Froufrous with 'Tude," *Newsweek,* April 28, 2003, 62.

14. Bruce Nussbaum, "Raising the Bar," *Innovation* (Fall 2006): 17.

15. Hu Jintao, quoted by Lorraine Justice in "Going East," *Innovation,* (Summer 2007): 39.

16. Lorraine Justice, "Going East," 40,

17. Eric Anderson, "Chicago Museum Showcases ID's 'Talented Tenth,'" *Design Perspectives* 25, no. 2 (March 2007): 1.

18. Bruce Nussbaum, "Social Responsibility on the World Stage," *Innovation* (Fall 2008): 13.

19. Budd Steinhilber, "A Look Back ... and Forward," *Innovation* (Spring 2008): 55.

20. Gregg Davis, ed., *Innovation* (Spring 2009): 6.

21. Larry H. Hoffer (publisher), *Innovation,* (Fall 2009): 6.

Bibliography

Adamson, Glenn. *Industrial Strength Design.* Cambridge, MA, and London: MIT Press. 2003.

Arens, Egmont, and Roy Shelton. *What Consumer Engineering Really Is.* New York: Harper, 1932.

Art Institute of Chicago. *Against the Grain.* Seattle: University of Washington Press, 1993.

Avakian, Arlene Voski, and Barbara Haber. *From Betty Crocker to Feminist Food Studies.* Liverpool: Liverpool University Press, 2005.

Baker, Eric, and Jane C. Martin. *Great Inventions, Good Intentions.* San Francisco: Chronicle, 1990.

Banham, Reyner. *Theory and Design in the First Machine Age.* Cambridge: MIT Press, 1992. First published 1960 by Architectural Press, London.

Barber, Benjamin, and Patrick Watson. *The Struggle for Democracy.* Boston: Little, Brown, 1988.

Bassalla, George. *The Evolution of Technology.* Cambridge History of Science Series. Cambridge: Cambridge University Press, 1988.

Bayley, Stephen. *In Good Shape.* New York: Van Nostrand Reinhold, 1979.

Bel Geddes, Norman. *Horizons.* Boston: Little, Brown, 1932.

_____. *Magic Motorways.* New York: Random House, 1940.

Boorstin, Daniel J. *The Creators: A History of Heroes of the Imagination.* New York: Random House, 1992.

Bunch, Bryan, and Alexander Hellemans. *The Timetables of Technology.* New York: Simon & Schuster, 1993.

Burke, James. *Connections.* Boston and Toronto: Little, Brown, 1978.

Caplan, Ralph. *By Design.* New York: McGraw-Hill, 1984.

_____, and the Industrial Designers Society of America. *Design in America.* New York: Mc-Graw-Hill, 1969.

Chapelle, Howard I. *The History of American Sailing Ships.* New York: W.W. Norton, Bonanza, 1935.

Conway, James. *The Smithsonian: 150 Years of Adventure, Discovery and Wonder.* Washington D.C.: Smithsonian Books; New York: Alfred A. Knopf, 1995.

Cowan, Ruth Schwartz. *More Work for Mother.* New York: Basic Books, 1983.

De Noblet, Jocelyn. *Industrial Design: Reflection of a Century.* Paris: Flammarian/APCI, 1993.

Derry, T.K., and Trevor I. Williams. *A Short History of Technology from the Earliest Times to A.D. 1900.* New York: Dover, 1993.

Doordan, Dennis P. *The Alliance of Art and Industry: Toledo Designs for a Modern America.* Toledo Museum of Art, 2002. Distributed by Hudson Hills.

Dreyfuss, Henry. *Designing for People.* New York: Allsworth, 2003. First published 1955 by Simon & Schuster.

Dunlap, William. *History of the Rise and Progress of the Arts of Design in the United States.* Originally published 1834 by the author as diaries. Revised and republished by Frank William Bayley and Charles Eliot Goodspeed. Vol. 3. Boston: C.E. Goodspeed, 1918.

Edwards, Sandra, ed. *Product Design 2.* Glen Cove, NY: PBC International, 1987.

Egan, Philip S. *Design and Destiny: The Making of the Tucker Automobile.* Orange, CA: On the Mark, 1989.

Ferebee, Ann. *A History of Design from the Victorian Era to the Present.* New York: Van Nostrand Reinhold, 1970.

Ferguson, Eugene S. *Engineering and the Mind's Eye.* Cambridge: MIT Press, 1992.

Flinchum, Russel. *Henry Dreyfuss: Industrial Designer, the Man in the Brown Suit.* New York: Rizzoli International, 1997.

Frankl, Paul. *Form and Re-Form.* New York: Harper, 1930.

Gantz, Carroll. *Design Chronicles.* Atglen, PA: Schiffer, 2005.

Gartman, David. *Auto Opium.* London: Routledge, 1994.

Gelertner, David. *1939.* New York: Free Press, 1995.

Gorman, Carma R. *The Industrial Design Reader.* New York: Allworth, 2003.

Harris, Neil. *The Artist in American Society: The Formative Years, 1790–1860.* Chicago: University of Chicago Press, 1966 and 1982.

Hauffe, Thomas. *Design: An Illustrated Historical Overview*. Barron's Educational Series. New York: Hauppauge, 1996. First published 1995 in Germany by DuMont Buchverlag GmbH und Co. Kommanditgesellschaft. Köln.

Heath, Adrian, Ditte Heath, and Aage Lund Jensen. *300 Years of Industrial Design*. New York: Watson-Guptill, 2000.

Heskett, John. *German Design, 1870–1918*. New York: Taplinger, 1986.

_____. *Industrial Design*. New York and London: Thames & Hudson, 1993.

Hiesinger, Kathryn B., et al. *Design Since 1945*. Philadelphia Museum of Art, 1983.

Hiesinger. Kathryn B., and George H. Marcus. *Landmarks of Twentieth Century Design*. New York: Abbeville, 1993.

Hughes, Thomas P. *American Genesis*. New York: Viking Penguin, 1989.

Julier, Guy. *The Thames and Hudson Encyclopedia of 20th Century Design and Designers*. London: Thames & Hudson, 1993.

Kaplan, Wendy. *Designing Modernity: The Arts of Reform and Persuasion, 1885–1945*. London: Thames & Hudson, 1995.

Knoblaugh, Ralph R. *Modelmaking for Industrial Design*. New York: McGraw-Hill, 1958.

Lippincott, J. Gordon. *Design for Business*. Chicago: Paul Theobald, 1947.

Loewy, Raymond. *Industrial Design*. Woodstock, NY: Overlook, 1979.

_____. *Never Leave Well Enough Alone*. New York: Simon & Schuster, 1951.

Matranga, Victoria. *America at Home*. Rosemont, IL: National Housewares Manufacturers Association, 1997.

McDermott, Catherine. *Design Museum 20th Century Design*. Woodstock, NY: Overlook, 2000.

Meikle, Jeffrey L. *Design in the USA*. UK and New York: Oxford University Press, 2005.

_____. *Twentieth Century Limited: Industrial Design in America*. Philadelphia: Temple University Press, 1979.

Meinig, D.W. *The Shaping of America*. Vol. 1, *Atlantic America 1492–1800*. New Haven, CT: Yale University Press, 1986.

Papanek, Victor. *Design for the Real World*. Toronto: Bantam, 1973.

Patton, Phil. *Made In USA*. New York: Penguin, 1992.

Phillips, Kevin. *Wealth and Democracy*. New York: Broadway, 2002.

Platt, Richard. *Smithsonian Timeline of Inventions*. New York: Dorling-Kindersley, 1994.

Pulos, Arthur. *The American Design Adventure*. Cambridge: MIT Press, 1988.

_____. *American Design Ethic*. Cambridge: MIT Press, 1983.

Pursell, Carroll. *The Machine in America: A Special History of Technology*. Baltimore: Johns Hopkins University Press, 1995.

Scott, Geoffrey. *The Architecture of Humanism: A Study in the History of Taste*. New York: Houghton Mifflin, 1914.

Secrest, Meryle. *Frank Lloyd Wright*. New York: Harper, Perennial, 1993.

Society of Industrial Designers. *Industrial Design in America 1954*. New York: Farrar, Straus & Young, 1954.

Sprigg, June. *Shaker Design*. New York: Whitney Museum of American Art in association with Norton, 1986.

Teague, Walter Dorwin. *Design This Day*. New York: Harcourt Brace, 1940.

Van Dolken, Stephen. *Inventing the 20th Century*. New York: New York University Press, 2000.

Van Doren, Harold. *Industrial Design: A Practical Guide*. New York: McGraw-Hill, 1940.

Weir, Alison. *Henry VIII: The King and His Court*. New York: Ballantine, 2001.

Whitford, Frank. *Bauhaus*. New York: Thames & Hudson, 1984.

Wilson, Richard Guy, et al. *The Machine Age in America, 1918–1941*. New York: Brooklyn Museum in association with Harry Abrams, 1986.

Wingler, Hans. *The Bauhaus*. Cambridge: MIT Press, 1969.

Woodham, Jonathan M. *Twentieth Century Design*. UK and New York: Oxford University Press, 1997.

Index

Numbers in **_bold italics_** indicate pages with photographs.